THE

NATIONAL PORTRAIT GALLERY

COLLECTION

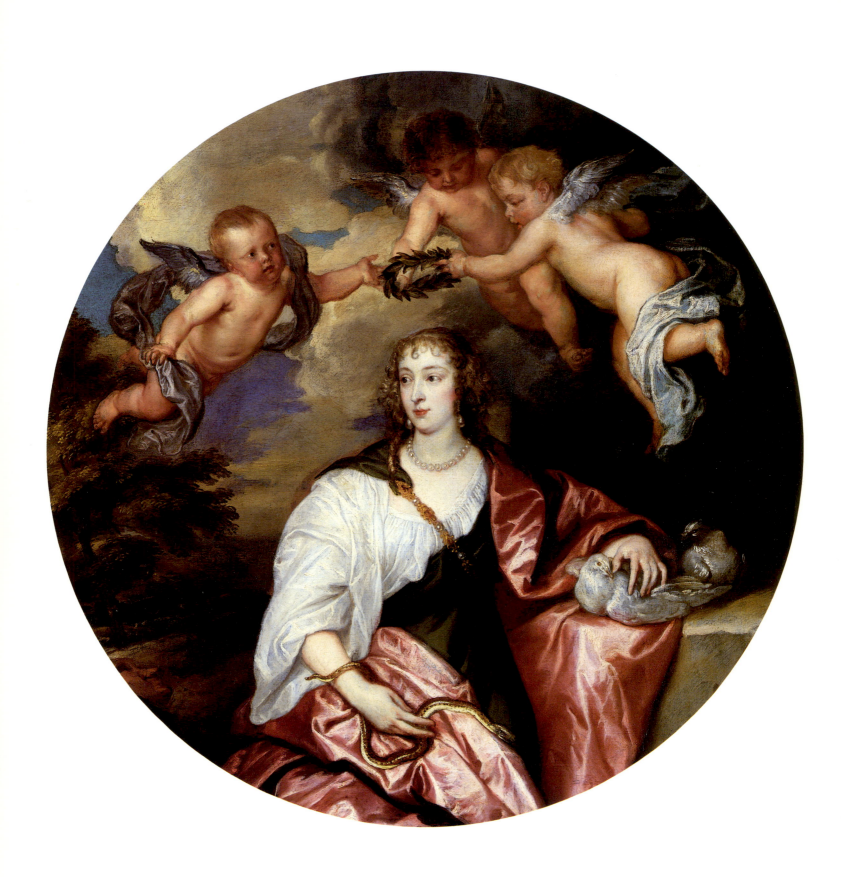

VENETIA STANLEY, LADY DIGBY
by Sir Anthony van Dyck
(detail)

THE NATIONAL PORTRAIT GALLERY COLLECTION

By

Susan Foister
Robin Gibson
Malcolm Rogers
Jacob Simon

With an introduction by John Hayes

NATIONAL PORTRAIT GALLERY PUBLICATIONS
LONDON

CAMBRIDGE UNIVERSITY PRESS
CAMBRIDGE NEW YORK NEW ROCHELLE MELBOURNE SYDNEY

SPONSORED BY

Published by National Portrait Gallery Publications,
The National Portrait Gallery,
St Martin's Place,
London WC2H 0HE,
England.

Copyright © National Portrait Gallery, 1988

Published in North America by
The Press Syndicate of the University of Cambridge,
32 East 57th Street,
New York,
NY 10022,
U.S.A.

British Library Cataloguing in Publication Data:

National Portrait Gallery, Great Britain
 The National Portrait Gallery Collection
 1. Portraits, 1450–1988. Catalogues, indexes
 I. Title II. Foister, Susan
 704.9´42´074

 ISBN 0 904017 89 3 (cloth)
 ISBN 0 904017 90 7 (paperback)

A C-I-P Catalog Record for this book is available from the Library
of Congress.

 ISBN 0 521 37392 1 (cloth)

Designed by Tim Rawle
Set in Linotron 202 Baskerville by Goodfellow & Egan, Cambridge
Printed in England by Balding + Mansell U.K. Limited on Parilux
matt white 150 gsm

Acknowledgements

For this long-awaited successor to *The National Portrait Gallery in
Colour* (Studio Vista, 1979), we owe a great debt to all who have given
of their energy, time and expertise to bring it into being.

 Mobil North Sea Oil has given generous sponsorship which has
enabled us to produce this book to the highest standard.

 We should also particularly like to thank Tim Rawle for his elegant
design, Melissa Denny of Diptych for her copyediting, John Vice for
his indexing, Malcolm Rogers for working as General Editor and
Gillian Forrester as Publications Editor.

John Adamson
Head of Publications, National Portrait Gallery

Pictorial Acknowledgements

The copyright photographs on pages 215, 223 and 231 are by
courtesy of the National Trust. The picture of Montacute House was
taken by John Bethell and that of Beningbrough Hall by Horst Kolo.
The photograph of Bodelwyddan Castle on page 239 was specially
taken for the National Portrait Gallery by Martin Trelawney.

The portrait of The 1st Viscount Montgomery of Alamein on page 185
is reproduced by courtesy of The Right Honourable The Viscount
Montgomery. The portrait of Dame Margot Fonteyn de Arias on
page 194 is the property of Dr Roberto E. Arias.

Authors' Note

For all pictures illustrated in this book, dimensions are given (height
× width) in centimetres, with the size in inches shown in parentheses.
The National Portrait Gallery accession number is given in paren-
theses after the date in each case.

Front cover portrait:
ELIZABETH I by an unknown artist, *c.*1575
Back cover portraits (top left to bottom right):
RICHARD III by an unknown artist, sixteenth century
VIVIEN LEIGH by Angus McBean, 1952
CHARLES I by Gerrit van Honthorst, 1628
DAME ALICE ELLEN TERRY by George Frederic Watts, 1864
LADY HAMILTON by George Romney, *c.*1785
SIR JOSHUA REYNOLDS, Self-portrait, *c.*1747
CATHERINE OF ARAGON by an unknown artist, *c.*1530
THOMAS STEARNS ELIOT by Patrick Heron, 1949
Contents page (right):
PRINCE JAMES FRANCIS EDWARD STUART AND HIS
SISTER PRINCESS LOUISA by Nicholas de Largillière, 1695

All of the above portraits are illustrated in full within the book.

Contents

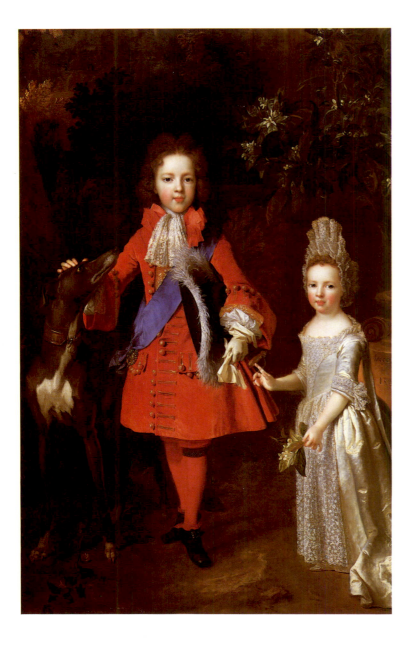

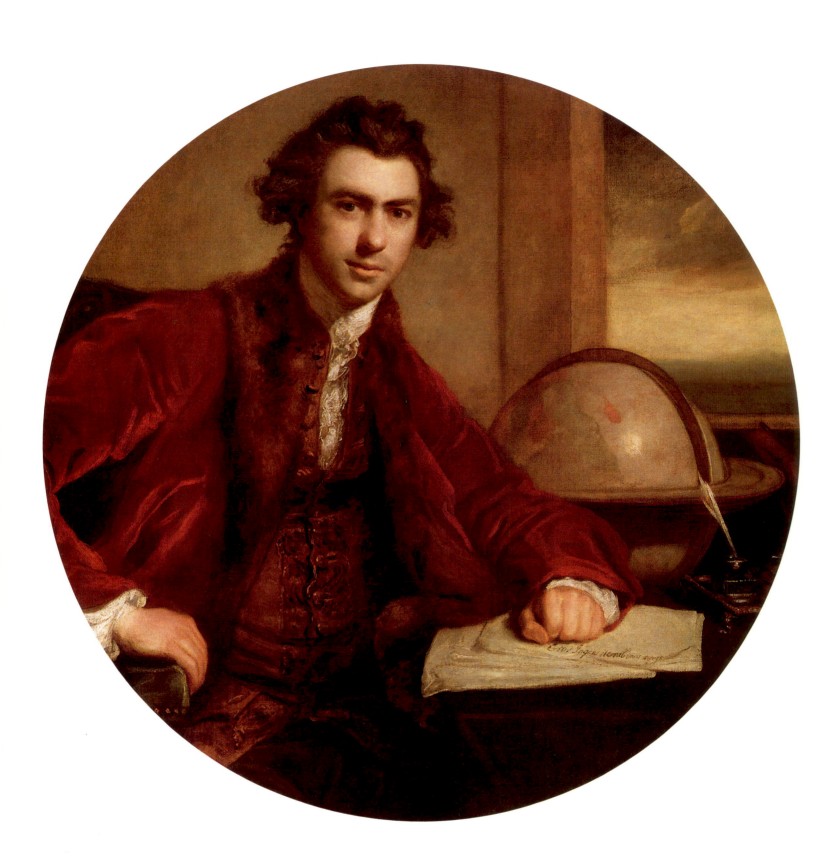

SIR JOSEPH BANKS
by Sir Joshua Reynolds
(detail)

When, in the sixteenth century, Francis Bacon wrote that
'*A crowd is not company, and faces are but a gallery of pictures*',
he could not have anticipated the riches of
The National Portrait Gallery.

There, the pictures and the faces are one and the same,
and what splendid faces (and pictures) they are.
As sponsor of the book of that collection, Mobil is more than honoured
to keep such august company.

Robert W. White
Chairman and President
Mobil North Sea Limited

Introduction

BRITISH HISTORY has been better served by portraiture than the history of any other land. Why, one wonders, should this be so? The French, for example, are no less proud of their national achievement, and have a magnificent tradition of portrait painting and sculpture. But the French prefer history in action, and the walls of Versailles (the home of the French national portrait gallery and archive) are crowded with Napoleonic battle scenes. On the continent portraiture was regarded as a lesser art form than, say, history painting. The British have been perhaps more prosaic, and had more personal concerns. Wealthy patrons of the eighteenth century commissioned pictures of their estates, their houses, their horses and their dogs, as well as of themselves and their families, almost as they might keep account books.

No assembly of centuries of family portraits is as rich and comprehensive as that in the British Royal Collection. While other kinds of artist have found it difficult to make a living in this country – significantly, the topographical artist has also been an exception – the portraitist has always flourished. No wonder that foreign portrait painters have consistently been led to seek their fortunes in London: Holbein, Van Dyck, Lely, Kneller, Winterhalter, Sargent, to name but a few of the best known. It is not so surprising, therefore, that the National Portrait Gallery – although founded as late as 1856, and then without the benefit of a nucleus in the form of some established historical collection – is unique among the (surprisingly few) portrait galleries of the world in its size, range and quality.

The pages which follow provide a chronological survey of over five centuries of portraiture – broadly the way in which the portraits are displayed in the galleries, although in each period there are thematic sub-divisions. I should like to linger here on just a few of the Gallery's portraits which, for one reason or another, have given me particular pleasure.

Lady Scudamore (p.221), a masterpiece of Jacobean painting by Marcus Gheeraerts the Younger – as precise and delicate in its rendering of the complex patterns of the embroidery as the exquisite costume itself – hangs at Montacute House, Somerset. It reminds me of the pride and excitement of establishing our first outstation far from London. The Gallery now has four outstations in different parts of the country, all represented in this book; this distribution, for wider public enjoyment, of some of our finest portraits, organized in carefully considered displays which focus on particular historical periods, is a policy to which we attach particular importance – for we believe that the word 'National' in 'National Portrait Gallery' has a specific intent.

Laurence Sterne (p.89), one of Sir Joshua Reynolds's finest early portraits, inspired by Titian, brings back memories of a different kind. It was acquired by public appeal, our annual purchase grant having run out, at the very beginning of my time as director. Innumerable members of the public demonstrated their love of the Gallery in donations large and small; the National Art-Collections Fund, the 'fairy godmother' to which museums and galleries up and down the country owe so much and which over the years has helped us to buy just on a hundred portraits, made a substantial contribution, as did the Pilgrim Trust; nonetheless, by the day before the time limit was up, we had only managed to raise less than half the sum required. The picture was saved from being sold abroad by the action of a single munificent benefactor; a surprise telephone call to my office from this public-spirited person, whose name was then quite unknown to me, resulted in the promise of the balance.

The sensitive modelling of a beautiful piece of marble sculpture gives me as great a feeling of exhilaration as the sensuous manipulation of paint of a Gainsborough or a Lawrence. The superlative bust of Lord Chesterfield (p.82) is such a work. Executed by one of those immigrant artists who have so deeply enriched our artistic tradition, in this case a Frenchman from Lyons, Louis François Roubiliac, the sculpture depicts an unusually cultivated man of his age, steeped in the civilization of ancient Rome, international in his outlook, stoic, witty and urbane. It was an expensive acquisition, bought after we had been the under-bidder at auction. Neither this nor several of the other masterpieces recently purchased for the Gallery (which have confirmed its place among the great galleries of the world) could possibly have been acquired without the wholehearted support of the National Heritage Memorial Fund, a body which, in a short space of time, and at a time of steeply rising prices, has achieved wonders in saving Britain's cultural inheritance.

Two other favourites must suffice. Gwen John's *Self-portrait* (p.151) is quite simply great painting. It is a picture I had admired long before I joined the staff of the Gallery. The subdued colours, and exquisite sense of tone (somewhat akin to perfect pitch in music), the way in which the forms build up towards the head, the austere expression, all contribute towards an image of quiet determination. Gwen John's *Self-portrait* shows that power and breadth in painting have nothing to do with scale.

Humphrey Ocean's *Philip Larkin* (p.211), my last choice, is another small and quiet picture; restrained in colour and sensitive in tone, it is a perfect match for the reserved temperament of the poet. This portrait was painted for the Gallery, as one of a series of commissions which began in 1980 with Bryan Organ's searching character study of the Prince of Wales (p.207). It is also a happy reminder of the success which the annual John Player Portrait Award and exhibition has had in encouraging younger painters to turn to portraiture, and prospective patrons to commission their work, for Humphrey Ocean was a first prize-winner in the competition.

These five choices illustrate very well the diversity of portrait styles and the variety of circumstances in which portraits come into being. Of course, there is a sense in which any historical portrait, however halting or mediocre, is of interest to us; as the great historian, Carlyle, expressed it: 'Any representation made by a faithful human creature of that face and figure which he saw with his eyes, and which I can never see with mine, is now valuable to me, and much better than none at all'. We are curious to know what someone looked like, whether he or she was short or tall, had blue eyes or brown. 'Likeness', declared Gainsborough, 'is the principal beauty & intention of a Portrait'. Gainsborough's portrait of Lord Chesterfield is no doubt very like: it shows an ageing countenance, the mouth drawn in by lack of teeth. But few people want to be portrayed in this fashion; they want their looks to be improved; Pepys (p.61), carried away by vanity, hired a special gown to be painted in. There were occasions when even Picasso liked 'to improve his sitters' circumstances for them'. Roubiliac, in his portrait of Lord Chesterfield, concentrated on the sitter's nobility of character, presenting him to us like a Roman senator, a wise and dignified patrician; we don't stop to think, or find it strange, that the bust should show him unclothed. Reynolds customarily idealized his sitters; Laurence Sterne is cast in the role of the great author, deep in thought, his forefinger pressed against his forehead (a traditional visual symbol for contemplation). When the Gallery was founded, it was one of the intentions that it should provide a source of inspiration for contemporary portraitists 'to soar above the mere attempt at producing a likeness'.

In looking at portraits, we need to know what the portraitist was intending to do; but we should remember the travails, too. Not only the vanity of a sitter, but the way in which he or she can 'freeze' in front of the artist; the difficulty in coming to terms even with physical features in just a few sittings; the press of business for the society portraitist, what Gainsborough somewhat sourly called 'the continual hurry of one fool upon the back of another'. At the time of his death, Sir Thomas Lawrence had hundreds of unfinished portraits in his studio; many of those he did finish manifest more of the unmistakable high gloss of a Lawrence than they do of the individuality of a sitter. The artist who is not a professional society portraitist may have more time at his disposal, but he has to stalk his sitter, and establish a rapport; Philip Larkin was an obsessively elusive subject and required patience as well as sensitivity on the part of the painter. Graham Sutherland (p.201), conscious that 'layer upon layer of wrappings cover personality', wrote that he had to be 'as absorbent as blotting paper and as patient and watchful as a cat . . . letting the subject gradually reveal himself unconsciously so that by his voice and gaze as well as by his solid flesh your memory and emotions are stirred and assaulted'. Annigoni needed no less than eighteen sittings for his portrait of Her Majesty The Queen (p.195).

Many great artists have preferred to paint their friends, whose characters they already knew well. Gainsborough's best portraits are of his family and friends; Francis Bacon and Lucian Freud customarily paint no-one else. The self is at once the most available and – because how little we know ourselves even when we dare to look hard – the most demanding subject; Rembrandt wrote his autobiography in self-portraits. In the very greatest portraits the artist uses all his human responses and all the resources of his craft – design, colour, tone, texture, line (mass, patination in the case of sculpture) – to reveal the complexity of the personality he has before him. Cumulatively, and in the hands of a master, photographs and film can be every bit as penetrating and profound as more traditional means of representation. Gainsborough loved the theatre; how he would have loved the cinema! 'Only a face, confined to one View, and not a muscle to move to say here I am, falls very hard upon the poor Painter who perhaps is not within a mile of the truth in painting the Face only'. Browsing through this book or walking through the rooms in the National Portrait Gallery, one can have the fun of gauging for oneself how many got 'within a mile of the truth' in their confrontations with the great names in British history.

John Hayes
Director, National Portrait Gallery

THE MEDIEVAL & TUDOR PERIOD

On 22 August 1485 at Bosworth Field 20,000 men joined in the last battle of the Wars of the Roses between the rival houses of Lancaster and York. Here Richard III, head of the house of York, was defeated and killed, and Henry Tudor, heir to the house of Lancaster, proclaimed king as Henry VII. Less than a year later Henry married Elizabeth of York, uniting the two dynastic factions.

The kingdom Henry won was weakened by years of war and plague; lawlessness and injustice permeated many aspects of life, and artistically England lagged behind much of Europe. His rule, however, slowly brought stability and prosperity, and he left to his son, Henry VIII, a full treasury, with which to finance ambitious plans at home and abroad.

A true Renaissance prince, Henry VIII had a love of magnificence, a passion for building, was a considerable scholar, and had a genuine interest in the arts. Though conservative by nature, the lack of a son and heir led him to seek a divorce from his first wife, Catherine of Aragon, in order to remarry. In the process he made momentous political and religious changes, his reign seeing the break with the Church of Rome and the dissolution of the monasteries; the end of many medieval institutions and the growth of the modern state.

The men who helped Henry to bring this about were self-made and ambitious, and they knew that the price of failure was death. The king and his court were immortalised by Hans Holbein, one of the greatest artists ever to work in England.

Intellectually precocious, self-willed and sickly, Edward VI succeeded his father, Henry VIII, in 1547 at the age of nine. He ruled at first through a Council of Regency appointed by his father, but his uncle, the Duke of Somerset, set this aside and established himself as Protector. Edward was, like Somerset, an ardent Protestant, and together they introduced radical religious reforms, masterminded by Archbishop Cranmer, including the introduction of the first prayer book in English and the passing of the Act of Uniformity (1549).

By 1552 Edward's health was clearly failing, and the Duke of Northumberland, who had engineered Somerset's fall, devised a plan to safeguard the Protestant succession and maintain his own position. Under this, Edward, bypassing his half-sisters the Princesses Mary and Elizabeth, willed the throne to his cousin, Lady Jane Grey, Northumberland's daughter-in-law, and the grand-daughter of Henry VIII's sister, Mary. On Edward's death Lady Jane was proclaimed queen and 'reigned' for ten brief days until captured by supporters of Queen Mary.

While Edward VI was staunchly Protestant, his half-sister, Mary, was a fervent Roman Catholic, and she rapidly set about the task of returning England to Catholicism. She restored Papal supremacy, and tried to reintroduce forcibly the full Catholic rite, vainly seeking support from her unhappy marriage with Philip II of Spain. This marriage and the persecution of her Protestant subjects – some three hundred were put to death in her reign – meant that she died deeply unpopular. With her died Catholic hopes of winning back the English church.

The omens for what was to be one of the golden periods in British history did not look particularly auspicious when Elizabeth I ascended the throne in 1558. She inherited a nation weakened by political and religious conflict, and a prey to pressures from more powerful neighbours. She was a young woman inexperienced in affairs of state but, from the first, she showed herself to be a ruler of rare intelligence and ability. The Anglican settlement, though it satisfied neither Roman Catholics nor Puritans, appealed to a broad section of opinion, and established a secure church. She united the nation around the figure of the Virgin Queen, who became a symbol of national resurgence. She dealt firmly with problems at home: conspiracies and the perennial threat from Scotland.

Abroad she played off her powerful neighbours against each other, keeping them guessing about her real intentions until she felt strong enough to resist them. It took Philip II of Spain thirty years to discover that England was one of the most implacable of his enemies, and unregenerately Protestant. The defeat of the Spanish Armada in 1588 was not only a great naval victory, but a vindication of Elizabeth's foreign policy of procrastination and prevarication. Conflict with Spain was intensified by commercial and colonial rivalry. For years English privateers raided the Spanish Main, seeking opportunities for trade and expansion in the New World. The growth of trade brought new wealth to the developing nation.

Elizabeth's court was a dazzling one. Though noted for her parsimony, she dressed magnificently, and delighted in masques and other entertainments. And the men she attracted to her service were dashing and talented. Under her patronage literature and the arts flourished as never before, giving us not only the greatest dramatist of the English-speaking world, William Shakespeare, but a host of other writers. Elizabethan art and music are elegant and exquisite. The jewelled miniatures by Nicholas Hilliard reflect a brilliant, shadowless world, a world of strange symbolic allusions and vivid, heraldic colour. And the portraits in large by artists like Marcus Gheeraerts the Younger are no less decorative and striking.

Under Elizabeth the country prospered, intellectual and artistic life flowered; the Renaissance came to England. No wonder that during the troubled reigns of James I and Charles I people looked back nostalgically to the glorious days of 'Good Queen Bess'.

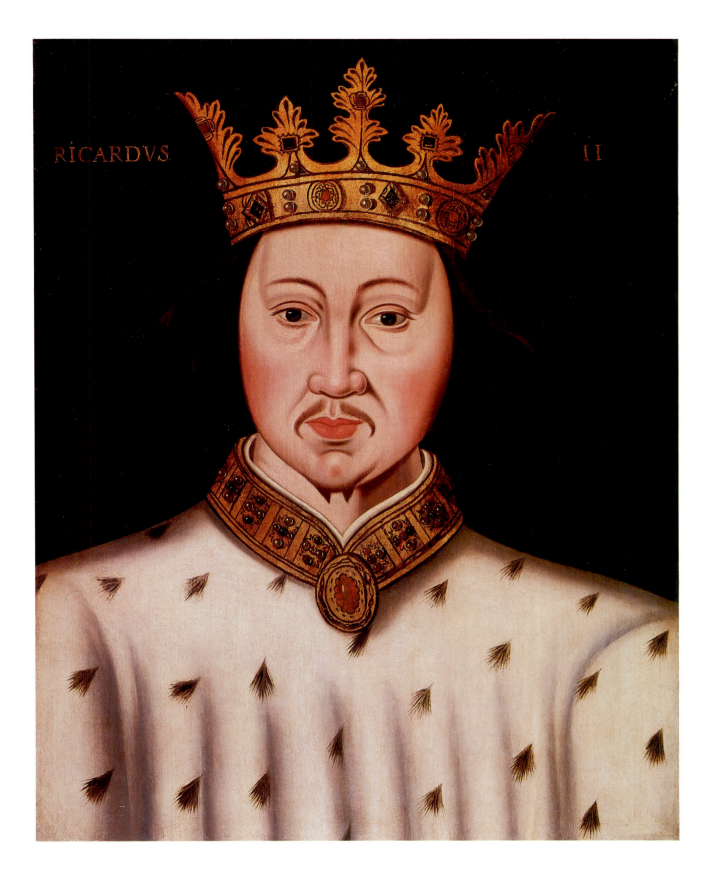

RICHARD II 1367–1400
Oil on panel, 60.3 × 45.7 (23¾ × 18)
By an unknown artist, sixteenth century (565)

The younger son of the Black Prince, Richard succeeded his grandfather Edward III in 1377 while still a minor. Throughout his reign he was involved in power struggles with the nobility, and he was finally deposed by his cousin, Henry Bolingbroke, later Henry IV. He died soon after in suspicious circumstances at Pontefract Castle.

Richard was almost certainly the first English king to sit to an artist for his portrait, and three taken from life survive: a full-length painting in Westminster Abbey, the Wilton Diptych in the National Gallery, and his tomb effigy, also in Westminster Abbey. The Gallery's portrait derives from the first of these, and was painted in the sixteenth century, almost certainly as one of a set of portraits of kings of England commissioned to hang in the long gallery of a great house. Though crudely painted, such portraits were boldly patterned and brightly coloured, and could be displayed to great decorative effect.

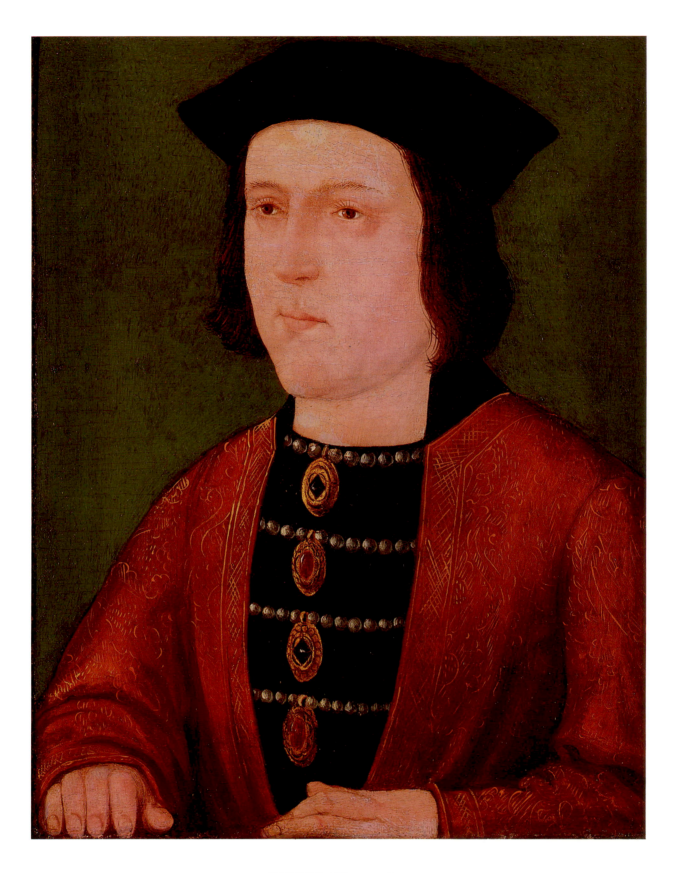

EDWARD IV 1442–83
Oil on panel, 33 × 27.3 (13 × 10¾)
By an unknown artist, sixteenth century (3542)

After the death of his father, the 3rd Duke of York, Edward became head of the house of York and returned from exile in France to defeat the Lancastrian forces at Mortimers Cross and Towton in 1461, and to proclaim himself king in place of Henry VI. In 1470 he was driven into exile, but a year later returned. He captured and murdered Henry VI and his son, the Prince of Wales, and finally secured the throne for himself.

Like that of Richard II (p. 11) this portrait was almost certainly part of a set of the kings of England. No *ad vivum* likeness of Edward is known, and this one is, like most Tudor portraits of early kings, imaginary. Although the artist is unknown, he was a more accomplished craftsman than the painter of the Richard II portrait; a number of his works can be identified on stylistic grounds, and for obvious reasons he is sometimes called the Master of the Cast Shadow.

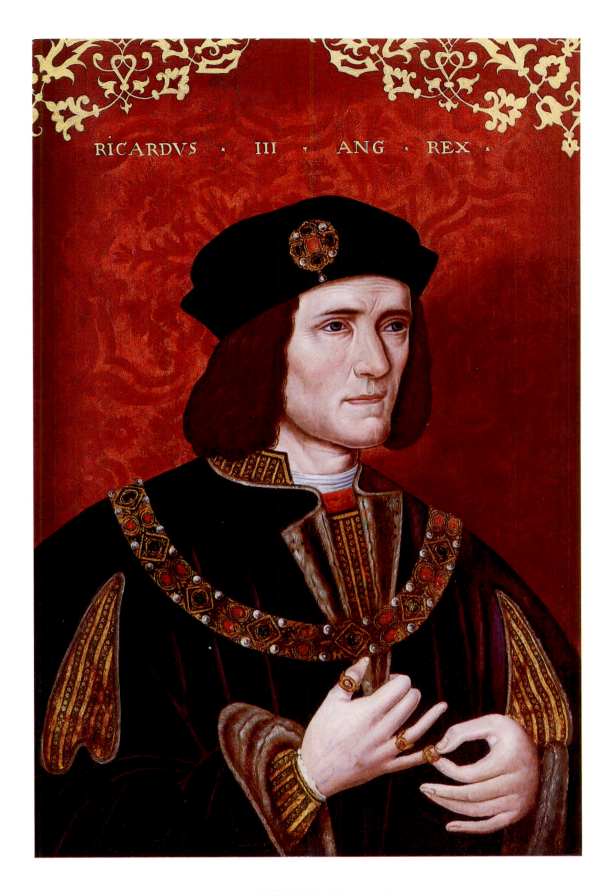

RICHARD III 1452–85
Oil on panel, 63.8 × 47 (25⅛ × 18½)
By an unknown artist, inscribed, sixteenth century (148)

The last Plantagenet king of England, Richard was, as Duke of Gloucester, a staunch supporter of his elder brother, Edward IV, against the Lancastrians, but after Edward's death steadily assumed power during the minority of Edward V, and had himself crowned in his place. He forfeited much of his support when Edward and his brother, the Duke of York, disappeared from the Tower of London in 1483. He was killed at the battle of Bosworth. As a result of Shakespeare's portrayal, Richard has come to represent an archetypal figure of villainy. His nickname 'Crouchback' had its origin in a real, though probably slight, bodily deformity, of which there is little or no trace in this portrait, which derives from an original, probably *ad vivum*, portrait in the Royal Collection.

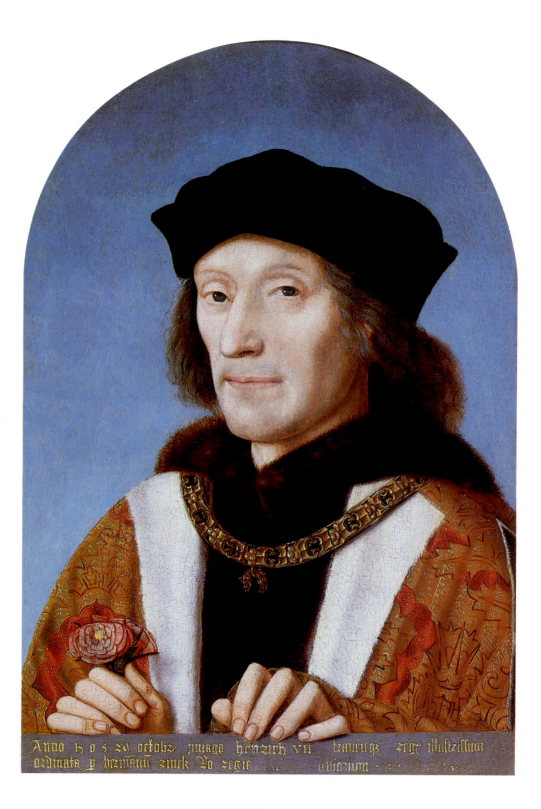

HENRY VII 1457–1509
Oil on panel, 42.5 × 30.5 (16¾ × 12)
Attributed to Michiel Sittow, inscribed and dated 1505 (416)

The son of Edmund Tudor, Earl of Richmond, and Margaret Beaufort, and head of the house of Lancaster after the death of Henry VI in 1471, Henry defeated the Yorkist Richard III (p.13) at the Battle of Bosworth in 1485, the last battle of the Wars of the Roses, and was crowned king. His marriage in the following year to Elizabeth of York, the daughter of Edward IV, united the Houses of York and Lancaster, and firmly established the Tudor dynasty. As his portrait suggests, he was a shrewd and efficient ruler, who left to his son, Henry VIII, a full treasury and a secure throne.

This portrait, which shows Henry wearing the Order of the Golden Fleece and holding the red rose of Lancaster, is uniquely important as a historical document, for we know the occasion, time and purpose for which it was painted. As the inscription on the ledge at the bottom of the composition records, it was painted on 20 October 1505 by order of Herman Rinck, agent of the Emperor Maximilian I, whose daughter, Margaret, the widowed Duchess of Savoy, Henry hoped to marry as his second wife, and was sent to her in exchange for two portraits of herself. The marriage did not take place, but Margaret kept the portrait until her death. It is plausibly attributed to 'Master Michiel', who had trained in Bruges, and was the Duchess's court painter.

14

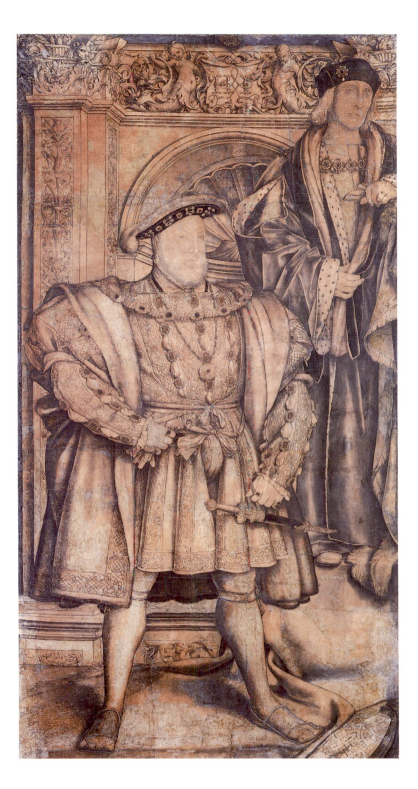

HENRY VIII 1491–1547 AND HENRY VII 1457–1509
Ink and watercolour on paper, 257.8 × 137.2 (101½ × 54)
By Hans Holbein, 1536–7 (4027)

This very large drawing is all that survives of one of the most important of Henry VIII's artistic projects. To commemorate the strength and triumphs of the Tudor dynasty and the birth of his son, Prince Edward, later Edward VI (p. 25), he commissioned from Holbein for the Privy Chamber of Whitehall Palace a wall-painting, which was completed in 1537. This very large drawing is the preparatory drawing or cartoon for the left-hand section of that painting. The right-hand section showed Henry VIII's third wife, Jane Seymour, and his mother, Elizabeth of York. Holbein's painting was destroyed in the Whitehall Palace fire of 1698, and the cartoon for the right-hand section is lost. The appearance of the whole painting is however recorded in a mid-seventeenth century copy by Remigius van Leemput in the Royal Collection.

The cartoon is on several joined sheets of paper, and the figures of the kings and their faces are cut-outs pasted on to the backing paper. It is exactly the same size as the finished painting, and was used to transfer Holbein's design to the palace wall. To do this the main outlines of the composition were pricked out and the cartoon was then fixed in the intended position on the wall. Chalk or charcoal dust was then brushed into the holes made by pricking, thus transferring the outline to the wall. Holbein could then proceed with filling in his design.

The majestic figure of Henry VIII as conceived by Holbein is one of the most memorable images of royalty ever created.

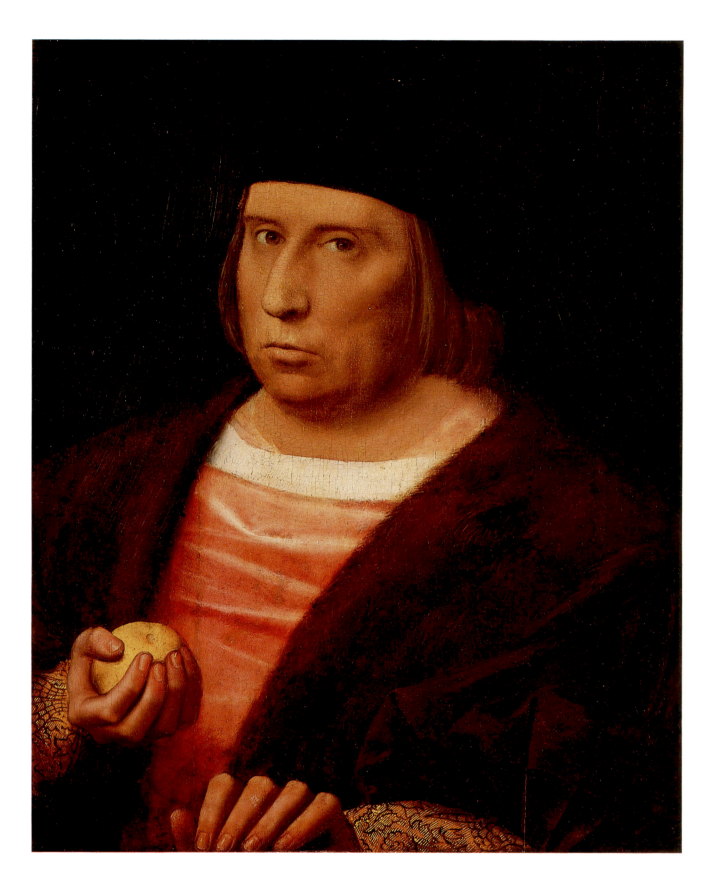

JOHN BOURCHIER, 2nd BARON BERNERS 1467–1533
Oil on panel, 49.5 × 39.4 (19½ × 15½)
By an unknown Flemish artist, *c*.1520–6 (4953)

Lord Berners served Henry VIII as Chancellor of the Exchequer (1516), assisted in the negotiations for an alliance with Spain two years later, and attended the king at the Field of the Cloth of Gold in 1520. While serving as Lord Deputy of Calais a more scholarly strain in his character emerges, for here, at Henry's suggestion, he devoted his leisure hours to translating the French historian Froissart's *Chronicles*. In style

his translation (published 1523–5) is vigorous and lucid, and it created the taste for historical reading in England. Berners died and was buried in Calais.

This portrait, which so perceptively characterises this able and cultivated man, was almost certainly painted by a Flemish artist during Berners's residence in Calais, and is a rare early example of an Englishman sitting for his portrait while abroad.

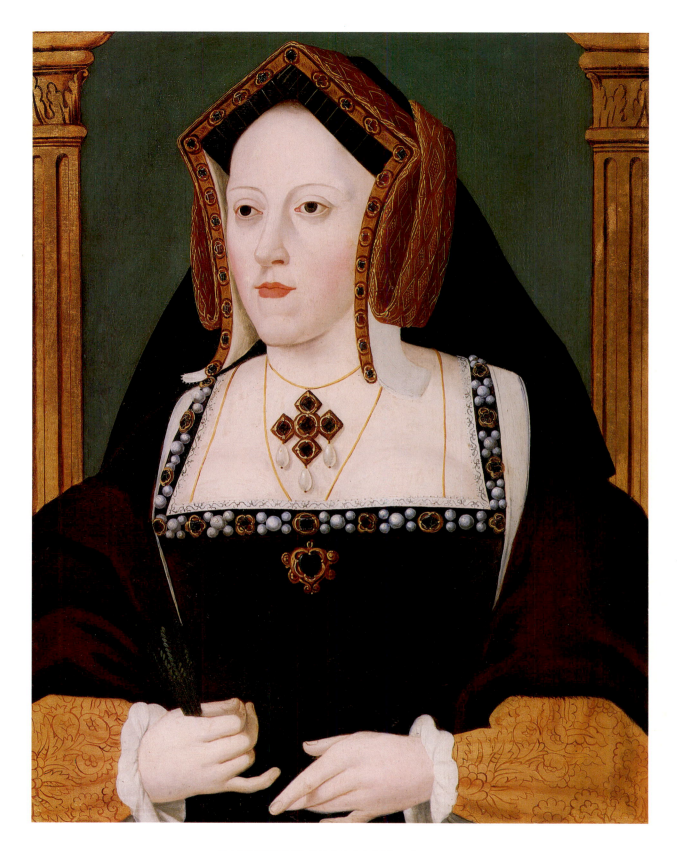

CATHERINE OF ARAGON 1485–1536
Oil on panel, 55.9 × 44.5 (22 × 17½)
By an unknown artist, c.1530 (163)

Catherine, the youngest child of Ferdinand and Isabella of Spain, was first married to Prince Arthur, Henry VII's eldest son, who died in 1502. In 1509 she married his younger brother, Henry VIII, five years her junior, and bore him five children, of whom only Princess Mary (later Mary I [pp. 28–29]) survived. Eager for a son and heir and keen to marry his mistress, Anne Boleyn, Henry was led in the later 1520s to question the validity of his marriage to Catherine, which was finally annulled in 1533, after years of debate, by

Archbishop Cranmer (p. 26). It was a momentous step, which led to Henry's excommunication by the Pope, and the break with the Church of Rome. Throughout her long humiliation Catherine remained steadfast and dignified. She was described by a contemporary as: 'not of full stature, rather small. If not handsome she is not ugly; she is somewhat stout, and has always a smile on her countenance'. This portrait of about 1530 was painted in the midst of her troubles.

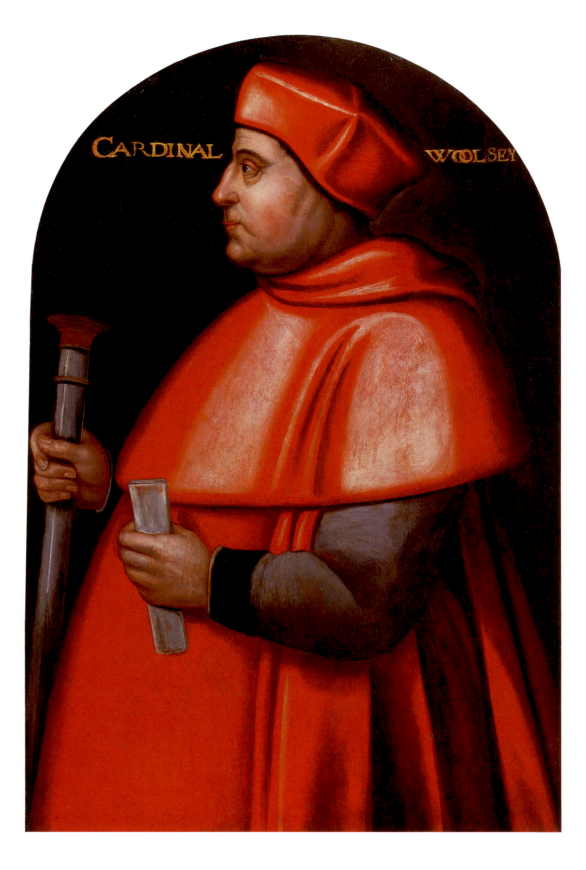

THOMAS WOLSEY 1475?–1530
Oil on panel, 83.8 × 55.9 (33 × 22)
By an unknown artist, inscribed, sixteenth century (32)

'Very handsome, learned, extremely eloquent, of vast ability, and indefatigable', this butcher's son rose rapidly to become Cardinal and Henry VIII's Lord Chancellor (1515), and was for nearly twenty years the most influential man in England next to the king. He promoted Henry's ambitious foreign policy, and accompanied him to the Field of the Cloth of Gold in 1520, but fell from favour when he failed to obtain the king's divorce from Catherine of Aragon. He died at Leicester on his way to London to answer a trumped-up charge of treason. He founded Christ Church, Oxford, and built Hampton Court, both of which remain as monuments to his vision.

Portraits of Wolsey are rare, and generally of depressing artistic quality. The Gallery's picture is one of the best, and, by its very lack of sophistication, conveys something of Wolsey's forcefulness and power. In its unusual profile format it is perhaps influenced by contemporary medals.

18

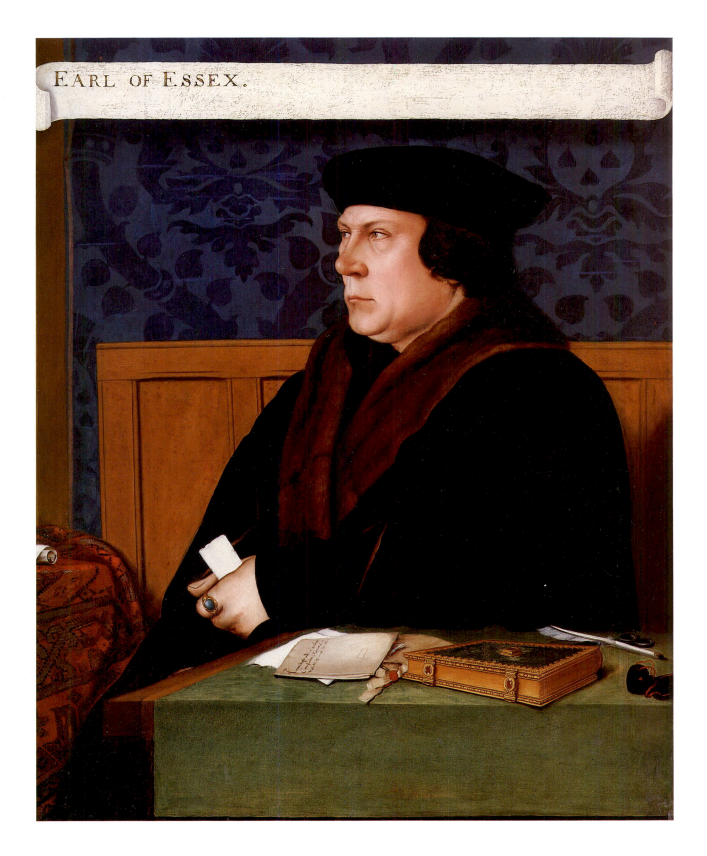

EARL OF ESSEX.

THOMAS CROMWELL, 1st EARL OF ESSEX 1485?–1540
Oil on panel, 78.1 × 61.9 (30¾ × 24⅜)
By an unknown artist after Hans Holbein, inscribed, 1533–4 (1727)

Cromwell rose to power as the right-hand-man of Cardinal Wolsey (p. 18), and triumphantly survived his master's fall. It was he who suggested to Henry VIII that he make himself head of the church in England to facilitate his divorce from Catherine of Aragon, and he ruthlessly set about the dissolution of the monasteries. He negotiated Henry's marriage to Anne of Cleves in 1539, and was created Earl of Essex a year later. However, he enjoyed his honours for only a short time. In the same year he was accused of treason by the Duke of Norfolk, and the king, who was already dissatisfied with Anne of Cleves, did nothing to prevent his execution.

This painting is a good version of Holbein's portrait of Essex, the original of which is lost, and which was perhaps destroyed when Cromwell's goods, as a traitor, were seized. In the portrait he holds a letter from his royal master addressed 'To our trusty and right wellbeloved Counsaillor Thomas Cromwell Maister of our Jewellhouse'.

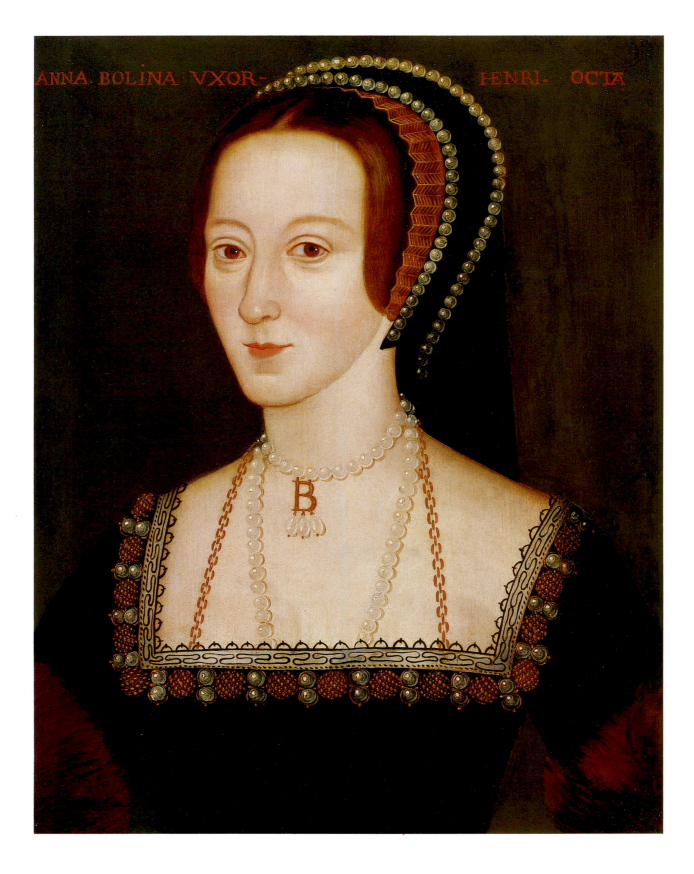

ANNE BOLEYN 1507–36
Oil on panel, 54.3 × 41.6 (21⅜ × 16⅜)
By an unknown artist, 1530s (668)

The vivacious second wife of Henry VIII, Anne Boleyn was described by a contemporary as 'not one of the handsomest women in the world; she is of middling stature, swarthy complexion, long neck, wide mouth, bosom not much raised, . . . eyes which are black and beautiful'. Although she had been the King's mistress for several years, she did not marry him until January 1533, and then in secret. His marriage to Catherine of Aragon was subsequently declared null, and

Anne was crowned on Whit Sunday that year, and gave birth to their daughter Princess Elizabeth (later Elizabeth I) in September. But Henry soon tired of her, and still longing for a male heir, he had her charged with criminal intercourse with several persons, including her own brother, and beheaded.

This portrait is a good example of the only authentic portrait type of Anne, the identity confirmed by the 'B' jewel which the queen wears round her long neck.

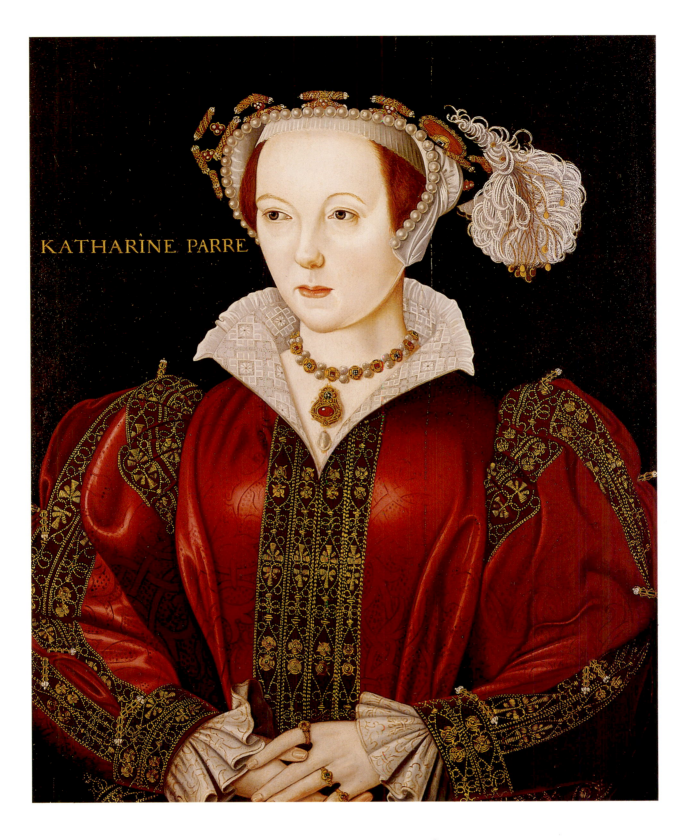

KATHARINE PARRE

CATHERINE PARR 1512–48
Oil on panel, 63.5 × 50.8 (25 × 20)
By an unknown artist, inscribed, *c.*1545 (4618)

Catherine, the sixth and last wife of Henry VIII, was forced to take him as her third husband in 1543, less than four years before his death. She interceded on behalf of the victims of his religious persecutions, and showed great kindness to his daughters by previous marriages, Mary and Elizabeth, who had for some years been proclaimed bastards and treated badly. She had them restored to their rightful position as princesses, and supervised their education, as well as that of Prince Edward. In the King's declining years she was his close companion, nursing his ulcerated leg, and on occasion dis-

cussing theology with him, and was in every way a dutiful wife. But after his death she swiftly married Lord Seymour of Sudeley, uncle of Edward VI, apparently with the young king's approval. Her happiness was however short-lived, for she died in childbirth a year later.

This portrait is the only authentic likeness known of Queen Catherine, a woman who combined 'a pregnant wittiness . . . with right wonderful grace of eloquence'. Although previously attributed to William Scrots, it is more likely to be by an English follower of Holbein.

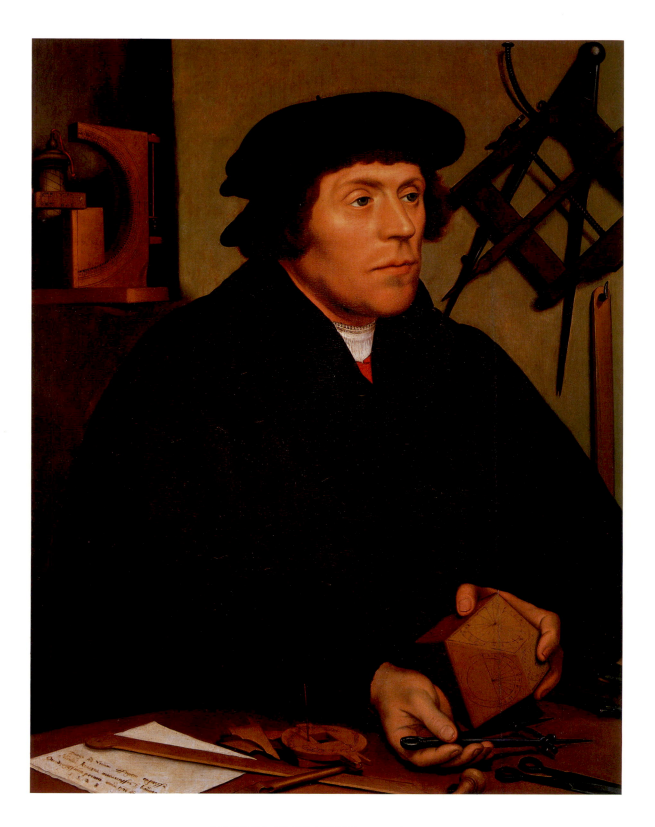

NICHOLAS KRATZER 1497–?1550
Oil on panel, 81.9 × 64.8 (32¼ × 25½)
By an unknown artist after Hans Holbein, inscribed and dated 1528 (5245)

A mathematician, astronomer and maker of sundials, Kratzer, a native of Munich, came to Cambridge in 1517. By 1520 he had been appointed Henry VIII's astronomer, and is said to have excused his shortcomings in English to the king on the grounds that thirty years were not enough to learn the language. He was the friend of Dürer, and Erasmus, and probably met Holbein at the house of Sir Thomas More (p.23), where he was tutor in mathematics and astronomy. The two men worked on several projects together, including the design of a painted ceiling on an astronomical theme for a theatre in Greenwich.

In this portrait, an early version of an original in the Louvre, Kratzer is shown with the emblems of his art, in a dazzling display of the artist's skill as a still-life painter. He holds a pair of dividers and an unfinished polyhedral dial, the gnomons for which lie on the table, with a pivoting rule, ruling knife, burin, scissors and another dialling instrument. On the wall hang large dividers, a ruler and a parallel rule and square. On the shelf are a cylinder dial and an unusual adjustable vertical dial. His paper is inscribed in Latin: 'The portrait of Nicolaus Kratzer of Munich, a Bavarian, taken from life when he was completing his forty-first year'.

22

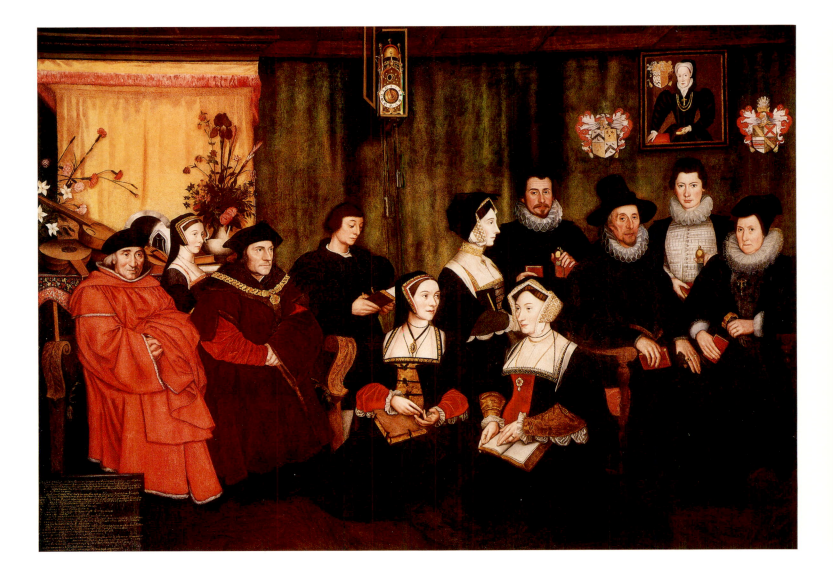

SIR THOMAS MORE 1478–1535, HIS FAMILY AND DESCENDANTS
Oil on canvas, 227.4 × 330.2 (89½ × 130)
By Rowland Lockey, partly after Hans Holbein, inscribed and dated 1593 (2765)

This group portrait was commissioned from the little-known artist Lockey by Thomas More II (1531–1606), grandson of Sir Thomas More, and constitutes a genealogical memorial of the staunchly Roman Catholic More family over five generations and a span of more than sixty years. The sitters, with their coats of arms displayed above them, are (left to right):

1. Sir John More 1451?–1530, Judge
 Father of Sir Thomas More
2. Anne Cresacre 1511–77
 Wife of John More II (see also 12)
3. Sir Thomas More 1478–1535
 Lord Chancellor
4. John More II ?1509–47
 Only son of Sir Thomas More
5. Cecily More, born 1507, wife of Giles Heron
 Youngest daughter of Sir Thomas More
6. Elizabeth More, born 1506, wife of William Dauncey
 Second daughter of Sir Thomas More.
7. Margaret More, 1505–44, wife of William Roper
 Eldest daughter of Sir Thomas More
8. John More III 1557–before 1599
 Eldest son of Thomas More II

9. Thomas More II 1531–1606
 Son of John More II
10. Christopher Cresacre More 1572–1649
 Fourth son of Thomas More II
11. Maria, 1534–1607, wife of Thomas More II
 Daughter of John Scrope
12. Anne More 1511–77 (portrait hanging on wall). Anne also appears in the group as no. 2 above.

Seven of the figures (nos. 1–7) derive from Holbein's lost group portrait *Sir Thomas More with his Family and Household* (1527–8), which was destroyed in the eighteenth century. Its appearance is recorded in a copy by Lockey at Nostell Priory, Yorkshire, and in Holbein's preliminary drawing in the Kunstmuseum, Basle.

Four of the figures (nos. 8–11) were probably painted from life by Lockey. The portrait of Anne More (no. 12), hanging in the background, is presumably a copy of a portrait of *c*.1560.

Although Lockey's technique has nothing of Holbein's virtuosity and refinement, this ambitious composition nevertheless remains remarkably faithful to the spirit of the great artist's original, its feeling of family unity touched with an atmosphere of gravity and decorum.

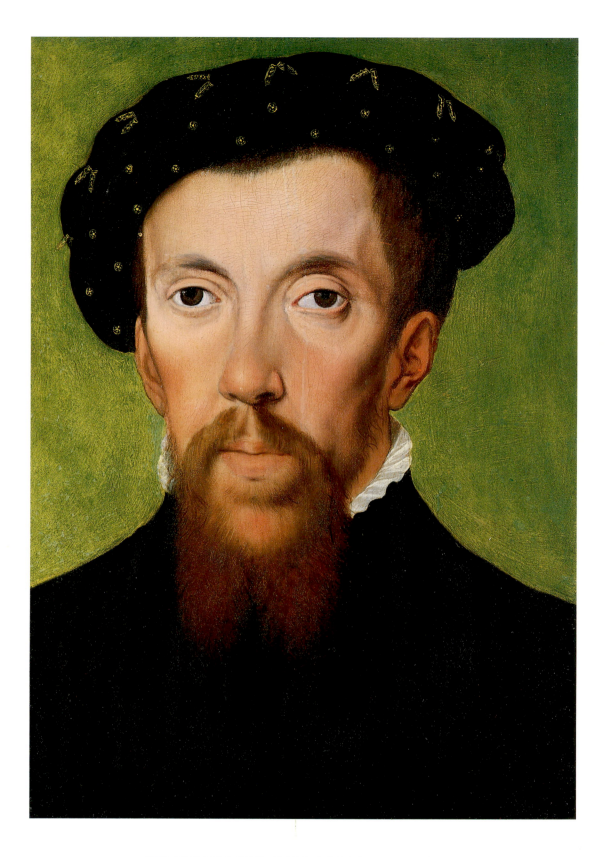

HENRY HOWARD, EARL OF SURREY 1517?–47
Oil on panel, 48 × 30.1 (18⅞ × 11⅞)
Attributed to William Scrots, 1546(?) (4952)

This intensely concentrated portrait of the poet Surrey no doubt derives some of its effect from the fact that it is almost certainly a fragment of a larger composition, perhaps even of a full-length. When and under what circumstances it was reduced in size are matters for speculation, but it is possible that it relates to the portrait on a 'great table' (large panel) which was confiscated from Scrots's studio shortly after Surrey's execution on a spurious charge of treason.

The son of the Duke of Norfolk, Surrey was a member of the inner court circle, the companion of Henry VIII's illegitimate son the Duke of Richmond, and at one time proposed as a husband for Princess Mary (later Mary I [pp. 28–29]). His failure as a military commander in France led to his downfall in 1546, but to posterity he survives as a poet, who introduced blank verse to England, and, like Thomas Wyatt, experimented with Petrarchan verse forms. His *Songs and Sonnets* were published posthumously in 1557.

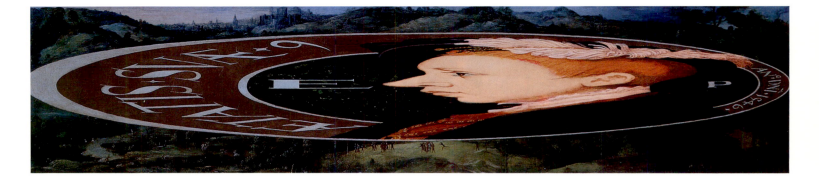

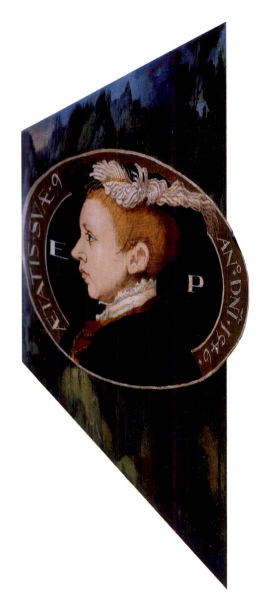

EDWARD VI 1537–53
Oil on panel, 42.5 × 160 (16¾ × 63)
By William Scrots, formerly signed; dated 1546 (1299)

This portrait of Prince Edward was painted when he was aged nine, a year before he became king. He is shown in distorted perspective (for which the technical term is anamorphosis), and the painting is primarily intended to display the virtuosity of the painter and amaze the spectator, rather than reveal the personality of the sitter, whom we know to have been precocious and strong-willed. When viewed through a peephole on the right the prince is seen in correct perspective. The painting was originally in the Royal Collection, and displayed at Whitehall Palace, where it was mounted on a free-standing apparatus to facilitate viewing, and was considered an object of great wonder. It was, however, sold off after the execution of Charles I in 1649 for a mere £2.

Until at least the eighteenth century the painting was signed on the frame 'Guilhelmus pingebat' (William painted this), and the artist was almost certainly the obscure William Scrots, who entered royal service in succession to Holbein in 1533. The landscape in the spandrels is a later addition, probably painted by a Flemish artist about 1600, perhaps when the painting was removed from its original stand and hung on a wall.

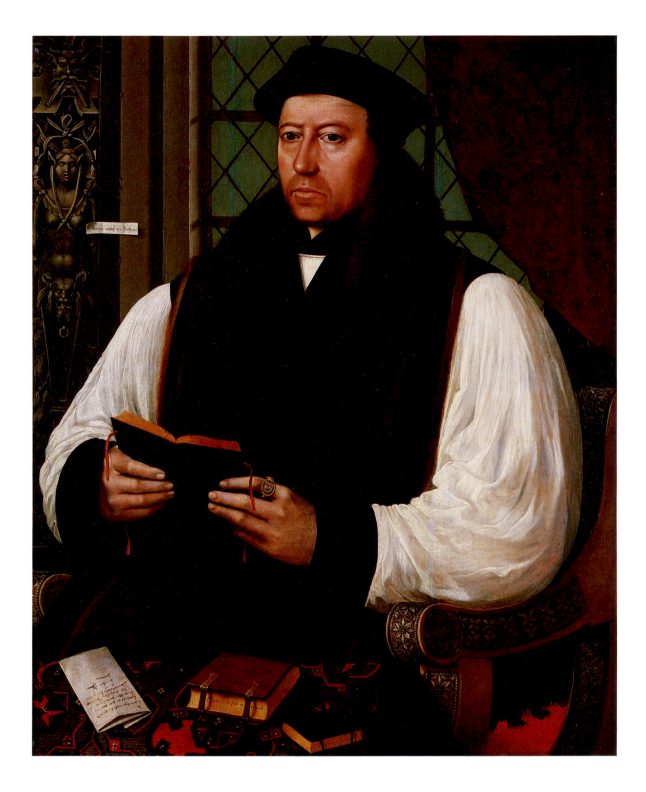

THOMAS CRANMER 1489–1556
Oil on panel, 98.4 × 76.2 (38¾ × 30)
By Gerlach Flicke, signed and dated 1546 (535)

Appointed Archbishop of Canterbury in 1533, Cranmer occupies a key position in the history of the Church of England. It was he who steered through Henry VIII's divorce from Catherine of Aragon and subsequent marriage to Anne Boleyn, and who supported the anti-papal Act of Supremacy which gave Henry authority over the church in England. He was a member of Edward VI's council of regency, and was responsible for the introduction of the first and second *Books of Common Prayer*. As Edward lay dying he acquiesced to the plot to exclude Princess Mary from the succession, in favour of Lady Jane Grey (p.27), and it is not surprising that when Mary gained the throne he was deprived of office and imprisoned. He eventually agreed to acknowledge papal

supremacy and the truth of all Roman Catholic doctrines (except for transubstantiation), but was burnt at the stake repudiating them.

This portrait by Flicke, who came to England from Osnabrück in about 1545, was painted on 20 July 1546, only months before the death of Henry VIII, and shows the Archbishop, as the Latin inscription (top left) records, aged fifty-seven. In format and in its reliance on the decorative effects of still-life it is influenced by Holbein. Cranmer is shown holding St Paul's *Epistles*, and on the table are a letter addressed to him and two books, one inscribed in Latin 'Augustine on faith and works'. His ring bears his initials 'TC' with the arms of the See of Canterbury impaling those of Cranmer.

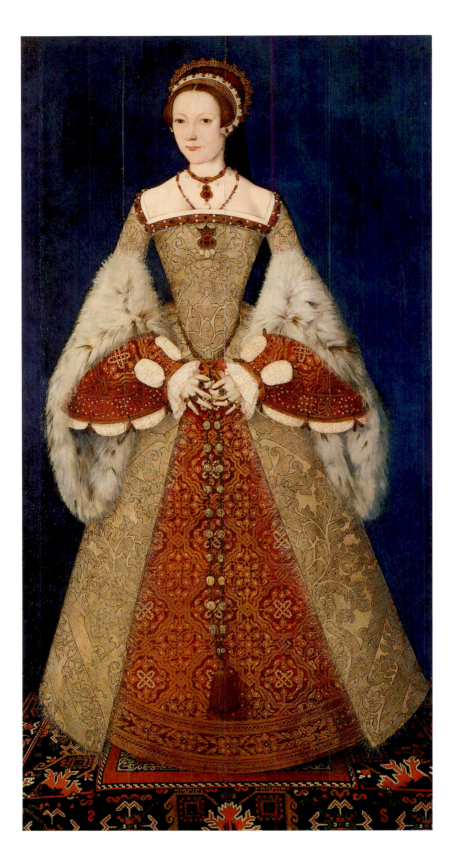

LADY JANE GREY 1537–54
Oil on panel, 180.3 × 94 (71 × 37)
Attributed to Master John, *c.*1545 (4451)

The Protestant grand-daughter of Henry VIII's sister, Mary, Lady Jane was the unwilling and innocent victim of court intrigues. In 1553 she married Lord Guildford Dudley, son of the Duke of Northumberland, under whose influence Edward VI willed her the crown in preference to his sisters, the Princesses Mary and Elizabeth. At his death she was proclaimed queen, and reigned for ten days, until she was captured by supporters of Mary Tudor and imprisoned. She and her husband were executed a year later in the aftermath of Wyatt's rebellion.

A contemporary described Lady Jane as 'very short and thin, but prettily shaped and graceful'. In this portrait by the obscure artist Master John, whose only other known work is, ironically, the portrait of Princess Mary (p.28), Lady Jane wears a splendid dress of cloth of silver lined with ermine, with an underskirt of crimson embroidered with gold braid and pearls.

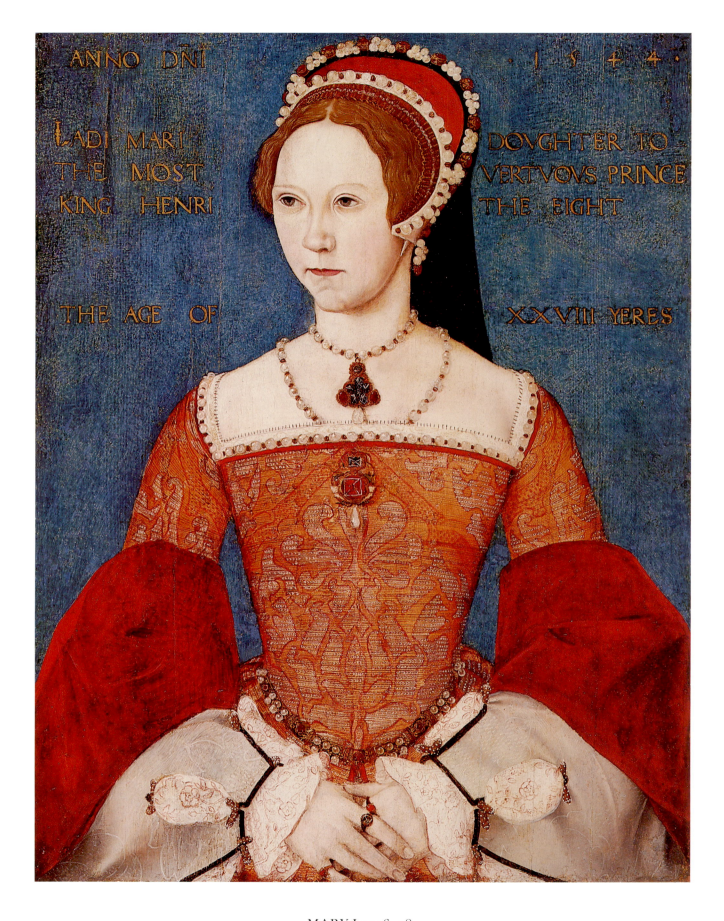

ANNO DÑI · 1 5 4 4 ·

LADI MARI DOVGHTER TO
THE MOST VERTVOVS PRINCE
KING HENRI THE EIGHT

THE AGE OF XXVIII YERES

MARY I 1516–58
Oil on panel, 71.1 × 50.8 (28 × 20)
By Master John, inscribed and dated 1544 (428)

The Roman Catholic daughter of Henry VIII and Catherine of Aragon, Mary came to the throne on a wave of popularity after the brief 'reign' of Lady Jane Grey (p.27). She restored ordered government and reconciled England with Rome, but her marriage to Philip II of Spain, the persecution of her Protestant subjects, and the war with France in which Calais was lost, meant that she died unpopular.

This portrait of her, painted before her accession, is almost certainly that for which five pounds was paid in November 1544: 'Item paid to one John that drew her grace in a table [on panel]'.

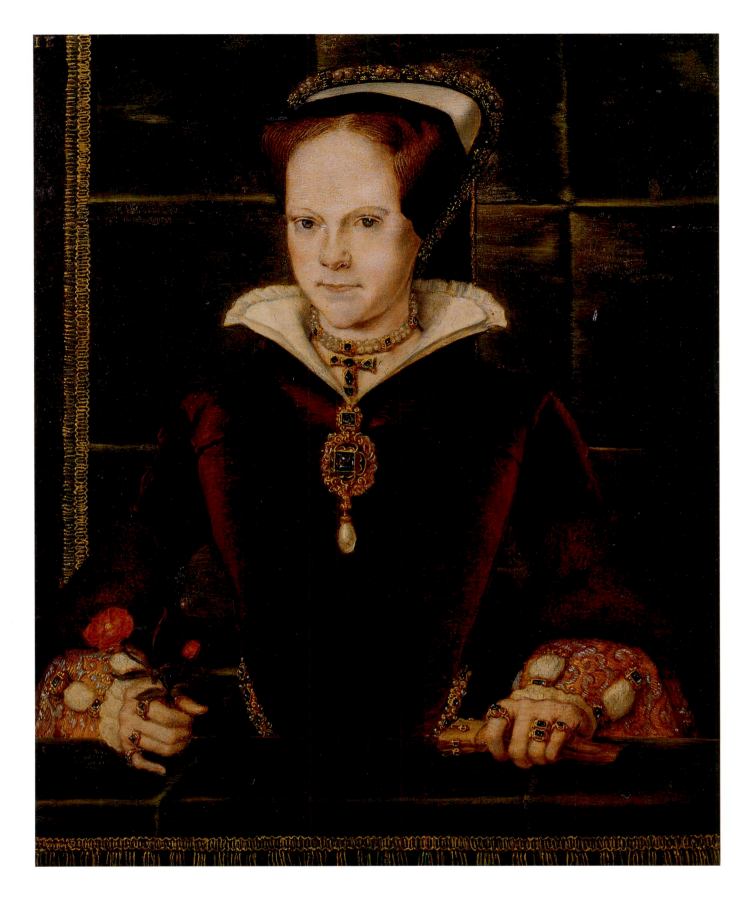

MARY I 1516–58
Oil on panel, 21.6 × 16.9 (8½ × 6⅝)
By Hans Eworth, signed, 1554 (4861)

This tiny portrait by the Flemish artist Eworth was painted twenty years after the portrait of Mary by Master John (p.28), and shows England's first queen regnant in the year after her accession and at about the time of her ill-fated marriage to Philip II of Spain. The pendant pearl attached to the jewel at her breast is probably the incomparable 'La Peregrina', given by the king to Mary at the time of their wedding. According to a contemporary account Mary appeared 'low of stature, with a red and white complexion, and very thin . . . her face is round with a nose rather low and wide; and were not her age on the decline, she might be called handsome, rather than the contrary'.

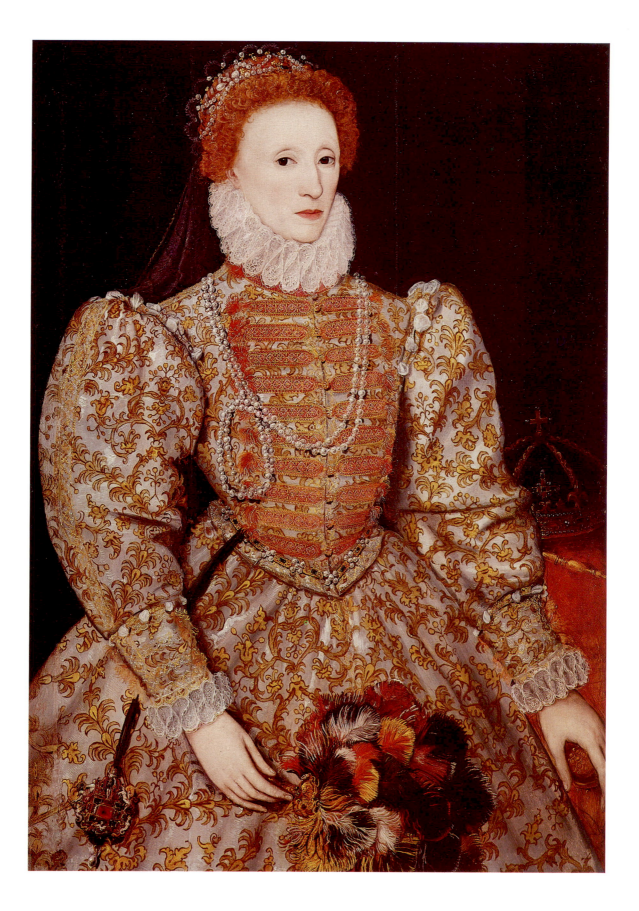

ELIZABETH I 1533–1603
Oil on panel, 113 × 78.7 (44½ × 31)
By an unknown artist, *c*.1575 (2082)

The legendary 'Virgin Queen', Elizabeth was the daughter of Henry VIII and Anne Boleyn (p.20), and had learned from childhood to survive in a world of court intrigue and danger. She came to the throne in 1558, at a critical hour in England's history, and succeeded in restoring the country to Protestantism and uniting her people. With the help of her ministers, foremost among them William Cecil, Lord Burghley (p.33), and her brave sea-captains, she made England a world power.

This portrait by an unknown, probably Netherlandish, artist is one of the most important surviving images of the queen. It was almost certainly painted from the life, and was the source of countless other derivative likenesses of her.

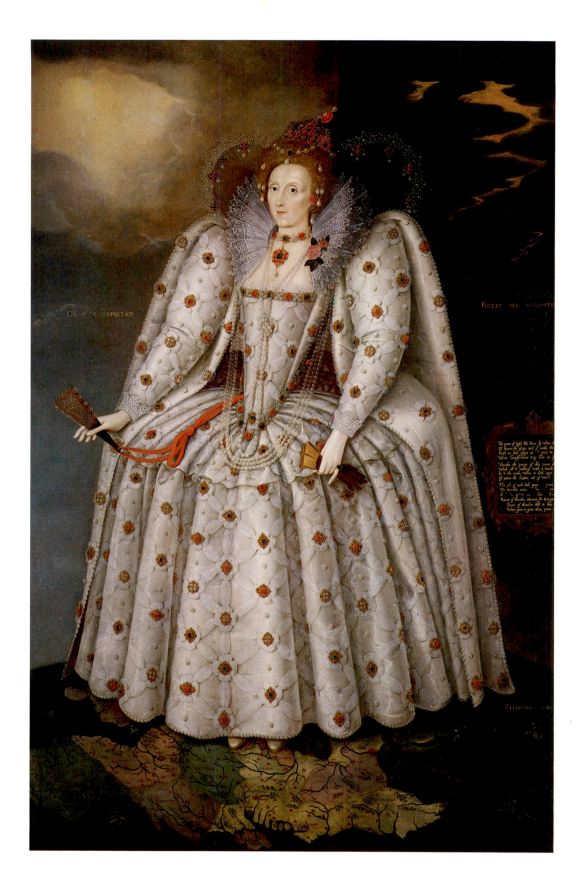

ELIZABETH I 1533–1603
Oil on canvas, 241.3 × 152.4 (95 × 60)
By Marcus Gheeraerts the Younger, inscribed, *c*.1592 (2561)

This late portrait of the queen, known as 'the Ditchley Portrait', was painted for Sir Henry Lee (p.32), the Queen's Champion from 1559–90, and commemorates Elizabeth's visit to Lee's house at Ditchley near Oxford in September 1592, on which occasion Lee devised an elaborate symbolic entertainment for her.

After his retirement in 1590 Lee lived at Ditchley with his mistress, Anne Vavasour, and the queen's visit to him there was the sign that he was forgiven for becoming 'a stranger lady's thrall'. The portrait shows Elizabeth standing on the globe of the world, with her feet appropriately on Oxfordshire. The stormy sky, the clouds parting to reveal sunshine, and the inscriptions on the painting make it plain that the portrait's symbolic theme is forgiveness.

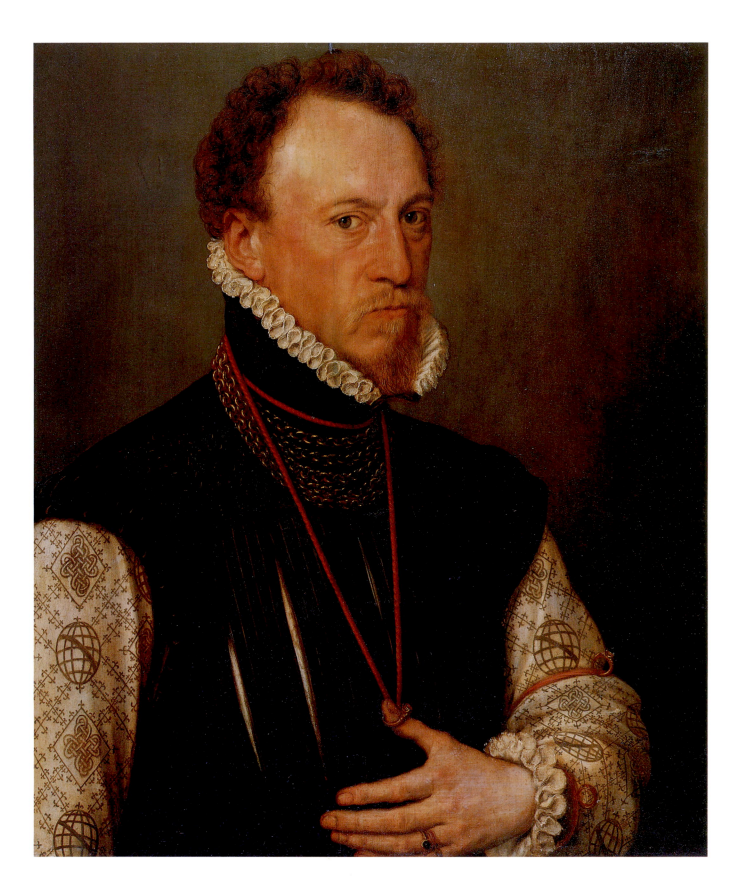

SIR HENRY LEE 1533–1611
Oil on panel, 64.1 × 53.3 (25¼ × 21)
By Antonio Mor, signed and dated 1568 (2095)

Lee was Elizabeth I's Master of the Ordnance, and a key figure in the revival of the cult of chivalry at court. On 17 November 1559, the anniversary of the queen's accession, he first issued a challenge against all comers, and he maintained his role as Queen's Champion until his retirement in 1590, arranging the annual accession day tournaments, which became ever more spectacular.

This portrait by the Flemish artist Mor, court painter to Philip II of Spain, was painted while Lee was on a visit to Antwerp. It is likely that the rings he wears in the portrait and the lovers' knots and armillary spheres embroidered on his sleeves have some personal symbolic significance which has yet to be explained. He commissioned the celebrated Ditchley portrait of Elizabeth I (p.31).

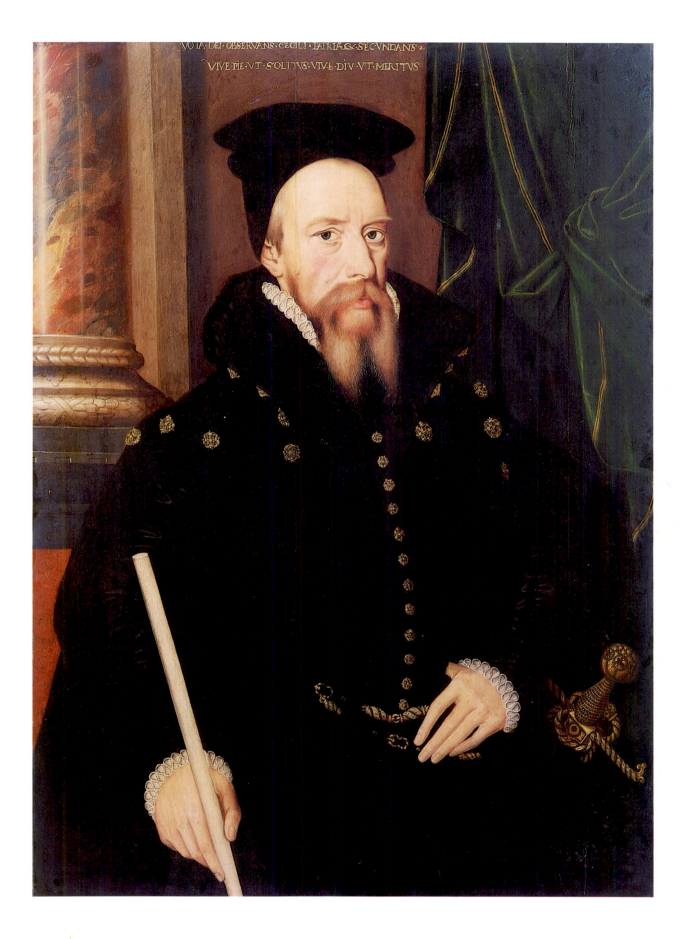

WILLIAM CECIL, 1st BARON BURGHLEY 1520–98
Oil on panel, 95.3 × 71.8 (37½ × 28¼)
By or after Arnold van Brounckhorst, inscribed, *c*.1560–70 (2184)

Elizabeth's unerring instinct for choosing the ablest men to serve her was never more in evidence than in her choice of Cecil as Secretary of State in 1558 and Lord High Treasurer from 1572. He was her principal adviser and most diligent minister for forty years, and his shrewd, trustworthy face appears in countless surviving portraits. In this portrait by the Flemish artist Van Brounckhorst, the earliest known portrait of Burghley, he holds the white wand of Secretary of State.

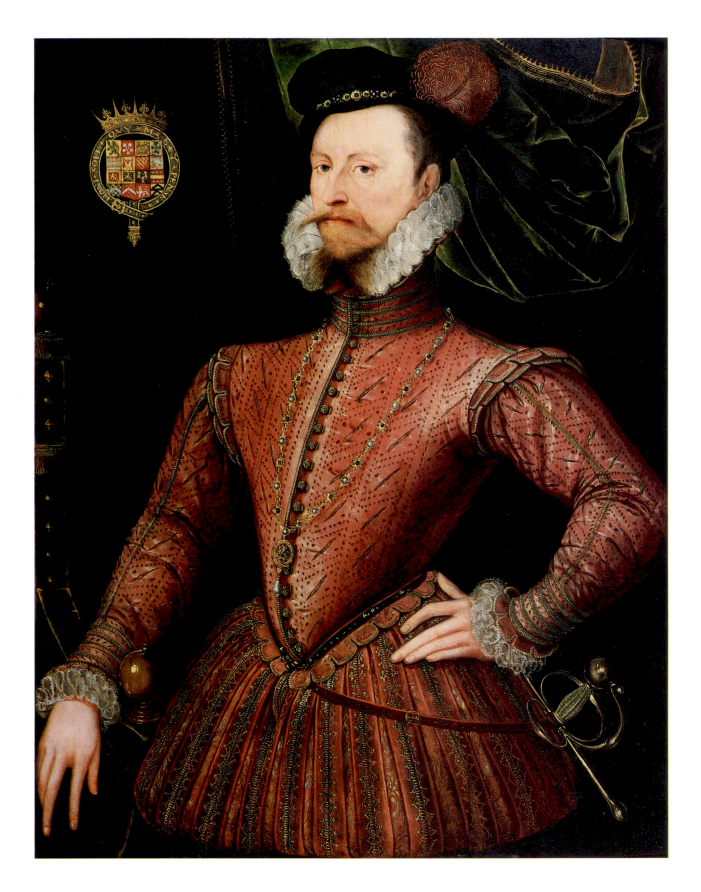

ROBERT DUDLEY, 1st EARL OF LEICESTER 1532?–88
Oil on panel, 108 × 82.6 (42½ × 32½)
By an unknown artist, *c*.1575 (447)

As the son of the Duke of Northumberland, executed for championing Lady Jane Grey (p.27), Leicester himself narrowly escaped death in Mary I's reign. His long friendship with Elizabeth I lasted from her accession in 1558 until his death. He was her only serious English suitor, until she realized that marriage to this 'light and greedy man' would be universally unpopular. In 1586 he led an unsuccessful ex-pedition to aid the Dutch in revolt against Spain, and in 1588 was appointed to command the English army. Leicester was an important patron of the arts and owned a large collection of portraits. He sat for his own portrait on numerous occasions, and the Gallery's painting testifies to his personal vanity and love of finery.

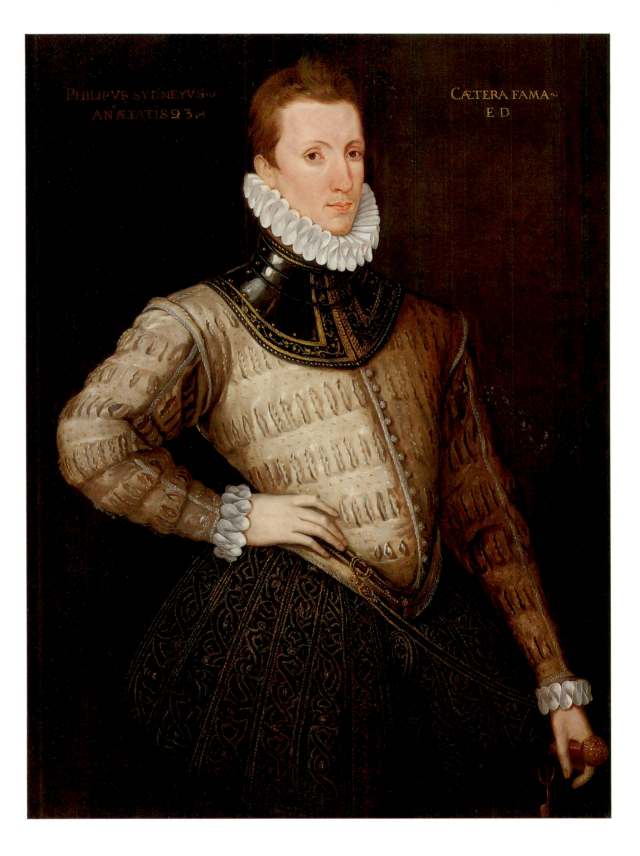

PHILIPVS SYDNEYVS
AN ÆTATIS 23.

CÆTERA FAMA~
E D

SIR PHILIP SIDNEY 1544–86
Oil on panel, 113.9 × 84 (44⅞ × 33⅛)
By an unknown artist, inscribed, *c*.1576 (5782)

Soldier, diplomat and writer, Sidney represented to his contemporaries the ideal of the Renaissance courtier. As Elizabeth's envoy to the Netherlands, he was an ardent champion of the Protestant cause and gained the admiration of William the Silent and the Dutch nobles, who were in rebellion against Catholic Spanish control in the Netherlands. He became Governor of Flushing in 1585 and joined his uncle, the Earl of Leicester (p.34), on the expedition in 1586 to aid the Dutch. Fatally wounded at the Battle of Zutphen,

he died soon afterwards. Sidney was highly cultivated, a friend and patron of poets, and a poet himself. His sonnet sequence known as *Astrophel and Stella* and his prose romance *Arcadia* were both written in the early 1580s, and published after his death. In this portrait, Sidney appears as a young soldier of twenty-three. The Latin motto, probably added after his death, signifies 'The rest is fame', and the initials ED below are perhaps those of his friend, the poet Sir Edward Dyer.

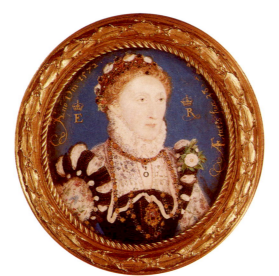

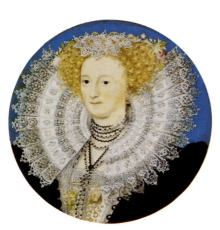

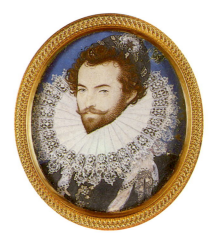

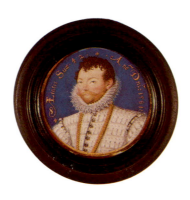

ELIZABETH I 1533–1603
Watercolour on vellum, 5.1 × 4.8 (2 × 1⅞)
By Nicholas Hilliard, inscribed and dated 1572 (108)

The earliest portrait of the queen by Hilliard, the greatest of
all British miniaturists, and a work of exquisite refinement
and freshness.

MARY SIDNEY, COUNTESS OF PEMBROKE 1561–1621
Watercolour on vellum, 5.4 (2⅛) diameter
By Nicholas Hilliard, later 1580s (5994)

The sister of Sir Philip Sidney (p.35), she suggested to him
the idea of his *Arcadia*, and after his death prepared it for
publication.

SIR FRANCIS DRAKE 1540?–96
Watercolour on vellum, 2.8 (1⅛) diameter
By Nicholas Hilliard, inscribed and dated 1581 (4851)

The naval hero, painted after his circumnavigation of the
world, and in the year in which he was knighted by the queen
at Deptford.

SIR WALTER RALEIGH 1552?–1618
Watercolour on vellum, 4.8 × 4.1 (1⅞ × 1⅝)
By Nicholas Hilliard, *c.*1585 (4106)

Painted during Raleigh's years at court when he basked in
Elizabeth I's favour, and before his voyages to America.

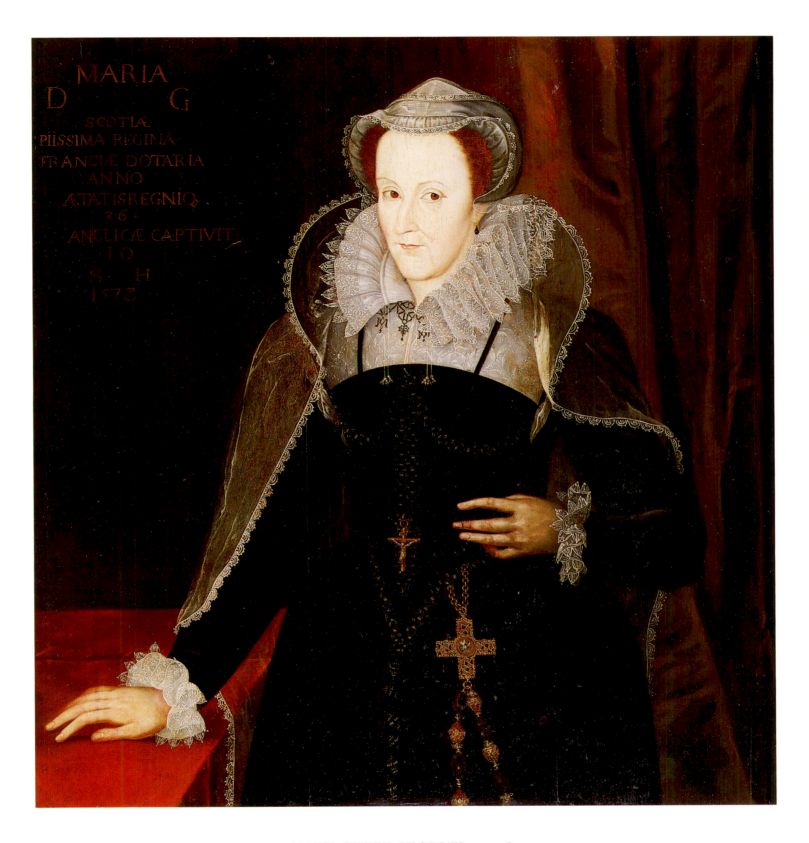

MARY, QUEEN OF SCOTS 1542–87
Oil on panel, 79.1 × 90.2 (31⅛ × 35½)
By an unknown artist after a miniature by Nicholas Hilliard, inscribed, c.1610 (429)

The daughter of James V of Scotland and Mary of Guise, Mary succeeded her father as an infant in 1542. Brought up in France a Roman Catholic, and famed for her beauty and grace, she married Francis II of France, and, from the death of Mary I, as great-grand-daughter of Henry VII, laid claim to the throne of England. After her husband's death she returned to Scotland, and ruled for seven turbulent years. In 1565 she married Lord Darnley; but, following his murder of her favourite, Rizzio, in 1566, she connived with the Earl of Bothwell at Darnley's murder, marrying Bothwell in 1567.

She was forced to flee to England a year later, where she was kept prisoner for twenty years, and finally tried and executed at Fotheringay for her alleged involvement in a plot to kill Elizabeth I.

As the inscription records, this portrait shows Mary after she had been a prisoner for ten years. The cross attached to her rosary bears the letter 'S' (for Stuart) on its four arms, and at its centre is an enamelled scene of Susannah and the Elders (symbolising the triumph of right through divine aid), surrounded by a Latin motto signifying: 'Troubles on all sides'.

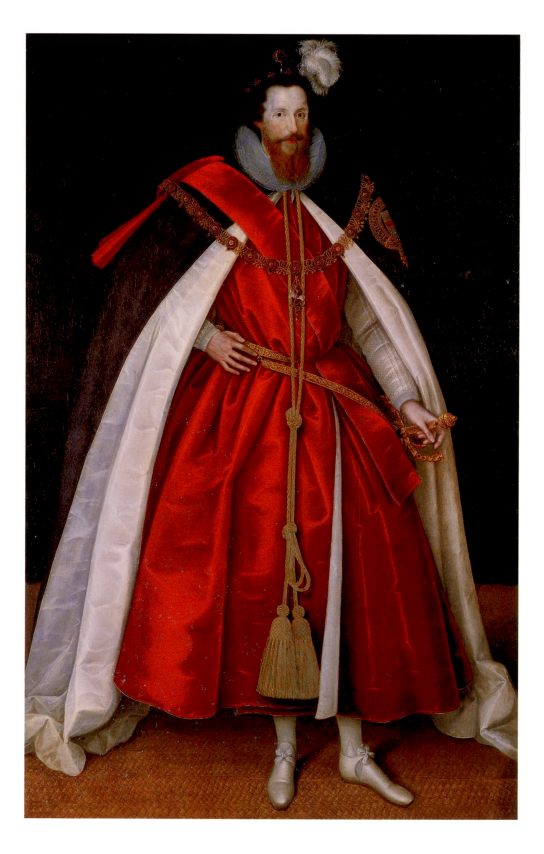

ROBERT DEVEREUX, 2nd EARL OF ESSEX 1566–1601
Oil on canvas, 218 × 127.2 (85⅞ × 54)
By Marcus Gheeraerts the Younger, *c*.1597 (4985)

Essex came to court in 1585, aged eighteen, handsome and charming, under the protection of his step-father, the Earl of Leicester (p.34). Elizabeth I was immediately captivated, and, despite his impudence towards other established favourites, she indulged his whims. He soon distinguished himself as a soldier and acquired an insatiable taste for command and glory. Desperately ambitious, he overestimated the extent to which the doting queen would allow him to meddle in state politics. As his demands were thwarted he became more rash;

'a man of nature not to be ruled'. His high-handed behaviour as Governor-General of Ireland in 1599 finally exhausted the queen's patience and he was imprisoned. Failing to restore himself to favour, he became involved in a plot against Elizabeth's ministers and tried to raise a rebellion in London. When this collapsed, he was executed for treason. This portrait was once at Ditchley, the house of Essex's friend, Sir Henry Lee (p.32), a major patron of the artist Gheeraerts. In it Essex wears the robes of a Knight of the Garter.

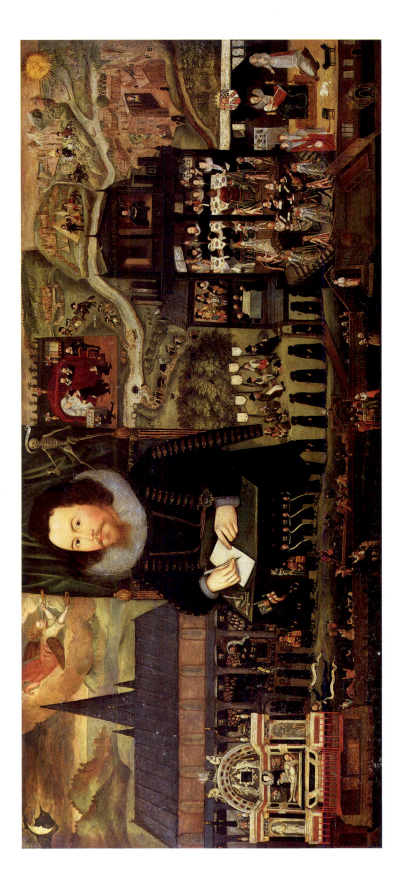

THE LIFE AND DEATH OF SIR HENRY UNTON 1557?–96
Oil on panel, 74 × 163.2 (29⅛ × 64¼)
By an unknown artist, c.1596 (710)

This highly unusual 'narrative portrait' was commissioned as a posthumous commemoration of the soldier and diplomat Sir Henry Unton by his widow, Dorothy, and is recorded in her will (1634). At the heart of the composition is the portrait of Unton, flanked by figures of Fame (top left) and Death (top right), and surrounded by scenes from his life and death, which give a rare insight into Elizabethan domestic life. These are (anti-clockwise, starting in the bottom right hand corner):

1. As an infant in the arms of his mother, Anne Seymour, formerly Countess of Warwick, at the Unton house of Ascott-under-Wychwood.

2. Studying at Oriel College, Oxford, where he took his degree in 1573.

3. Travelling beyond the Alps to Venice and Padua (1570s).

4. Serving with Leicester in the Netherlands (1585–6), with Nijmegen in the distance.

5. On his embassy to Henry IV at Coucy La Fère in north-west France, in an unsuccessful attempt to avert a peace treaty between France and Spain (1595–6).

6. On his deathbed, with a physician sent by the French king, Henry IV.

7. His body brought back to England across the Channel in a ship with black sails.

8. His hearse on its way back to his home at Wadley House, Faringdon, near Oxford.

9. (centre right); Unton's life at Wadley House, with scenes showing him sitting in his study (top), talking with learned divines (bottom left), making music (above left), and presiding over a banquet, while a masque of Mercury and Diana is performed, accompanied by musicians. From the house his funeral procession leads, past a group of the poor and lame lamenting his death, to:

10. (left) Faringdon Church with his funeral (8 July 1596) in progress, and, in the foreground, his monument with Unton's recumbent effigy and the kneeling figure of his widow.

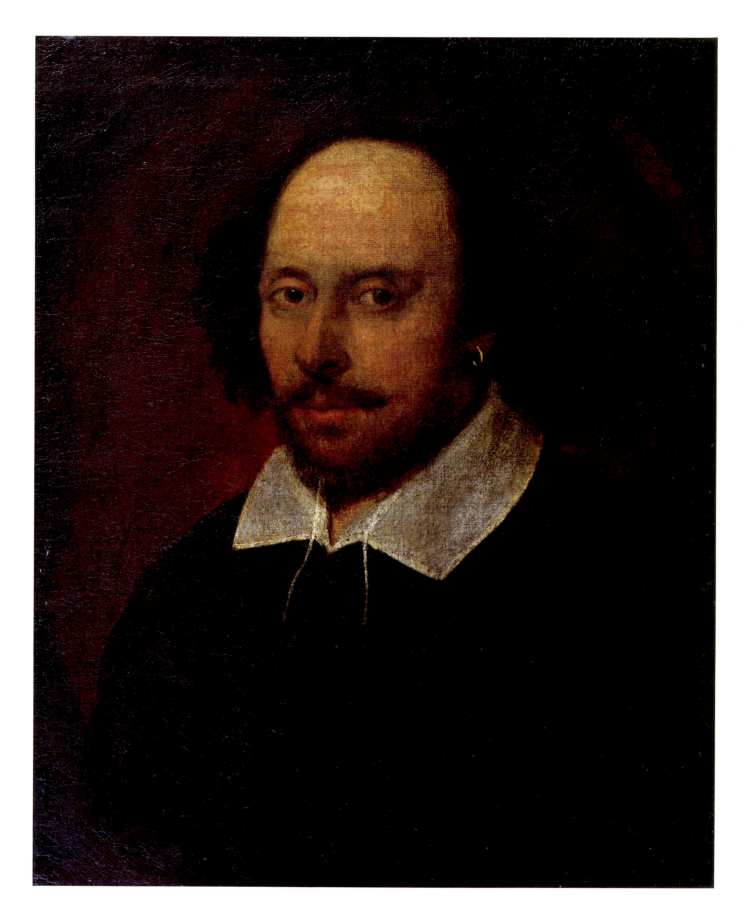

WILLIAM SHAKESPEARE 1564–1616
Oil on canvas, 55.2 × 43.8 (21¾ × 17¼)
Attributed to John Taylor, c.1610 (1)

Shakespeare is the most celebrated English poet and play-wright, and one of the great writers of all time. This is the only portrait of him which has a real claim to have been painted from life. It is thought to have belonged to the writer William Davenant, and its history can be traced without a break back to 1719. It is known as 'the Chandos portrait', after the Duke of Chandos who owned it in the eighteenth century, and it was, appropriately, the first portrait to be acquired by the Gallery. It was almost certainly painted by the obscure London artist John Taylor, and is his only known work.

THE SEVENTEENTH CENTURY

On 30 January 1649, on a scaffold erected in front of Inigo Jones's Banqueting House in Whitehall, Charles I was beheaded. This last brutal act of the Civil War was the culmination of the political disintegration of the monarchy and of its prestige which had begun with Charles's father, James I. It dashed forever the doctrine of the Divine Right of Kings, and at the same time made possible the transition to modern Parliamentary government.

The origins of this break-up can be traced to the personality of James I, fatally flawed by his early years as child-king of Scotland, when he had been the puppet of warring political factions. Feelings of insecurity and suspicion never left him; he was fiercely autocratic, extravagant, learned but pedantic, with a penchant for handsome but often ill-chosen favourites. Charles inherited from his father his extravagance, his aloof manner, and above all that most dangerous of favourites, the Duke of Buckingham. Buckingham's misconceived schemes ruined Charles's relationship with Parliament, but it was Charles's own ineptitude in political matters and his refusal to deal directly with Parliament which finally brought civil war to England.

From the chaos of the war emerged the military genius of Oliver Cromwell, whose status as a popular leader was, however, irreparably damaged by the execution of Charles. He proved unable to establish a formula by which he could govern the country with the support of Parliament. The Protectorship became a military dictatorship, and it was this failure which ultimately led to the restoration of the monarchy.

Throughout this period of political unrest the arts, by contrast, flourished. In their different ways both James and Charles were outstanding patrons of the arts, as were courtiers such as the Earl of Arundel and the Duke of Buckingham. James and his consort, Anne of Denmark, indulged their taste for the exotic through elaborately artificial court masques, written by Ben Jonson and staged with spectacular costumes and scenery by Inigo Jones. From Jones the Banqueting House in Whitehall and the Queen's House at Greenwich were commissioned. Peake, Mytens and the miniaturists Hilliard and Oliver painted the king and his court. It was the greatest age of the English commercial theatre; in the sciences Sir Francis Bacon was testing by experiment notions which had been accepted for hundreds of years.

Love of the arts was Charles I's ruling passion. He lavishly patronized living artists, and above all Van Dyck, for whom he had a profound admiration. It is largely through Van Dyck's eyes and the eyes of the artists influenced by him that we see Charles's courtiers – the cavaliers – in their easy yet elegant dress, their faces touched with a faint air of melancholy. It was a generation which, along with the king and his collections, the Civil War destroyed.

With the eagerly acclaimed restoration of Charles II in 1660 England once more had its monarchy. The new king was easy-going and, as he himself admitted, 'more lazy than I ought to be', but he brought with him all the splendour of monarchy, and was surrounded by a court which expressed in its dress, manners and morals the feeling of release after the anxieties of the Civil War and the restraint of the Interregnum.

Charles's policies reflected his personality; he was by temperament an absolutist, and was strongly influenced by Louis XIV of France. Not a deeply religious man, he favoured religious toleration, in particular for Roman Catholics, and indeed proclaimed his own Roman Catholicism on his death-bed. By exercising tact and discretion he avoided political disaster, but he never succeeded in implementing his pro-Catholic and pro-French policies.

It was his Catholicism which fatally blighted the reign of Charles's younger brother, James II. Lacking his brother's tact, James rapidly alienated an initially friendly Parliament and the bulk of his supporters by his intensely pro-Catholic policies and appointments, and made inevitable the revolution of 1688. Only with the invitation to William of Orange and his wife, Mary, (James's daughter) to take the throne of England, on terms which assured the ascendancy of the British Parliamentary and party system, was the Protestant succession finally secured.

Whatever Charles II's weaknesses of character, he showed a lively interest in the arts and sciences. He patronized a wide range of British and foreign artists, as did his fashion-conscious mistresses. Grinling Gibbons adorned his palaces with exquisite wood-carving; Sir Christopher Wren was Surveyor General of the King's Works; Henry Purcell was organist of the Chapel Royal. Charles encouraged the foundation of the Royal Society, and it was he who in 1662 gave it its first charter, thus providing a focus and means of recognition for the work of such men as Wren (who was a gifted mathematician as well as an architect), Robert Boyle, Sir Isaac Newton, and many more. He was an enthusiastic theatre-goer, and the dramatist, satirist and critic John Dryden was his Poet Laureate. The profligate Earl of Rochester was his court wit. The flourishing cultural atmosphere which he helped to stimulate had an influence far beyond his reign: the German artist Kneller, for instance, who first sought patronage at Charles's court, lived to paint George I, and captured for all time the baroque exuberance of the full-bottomed wig; Wren's masterpiece, St Paul's Cathedral, was not completed until the reign of Queen Anne, and, with his many other churches, transformed the face of London; from the Restoration comedies by Dryden and Wycherley in which Charles delighted developed the comic masterpieces of Congreve; they later inspired Sheridan and Wilde.

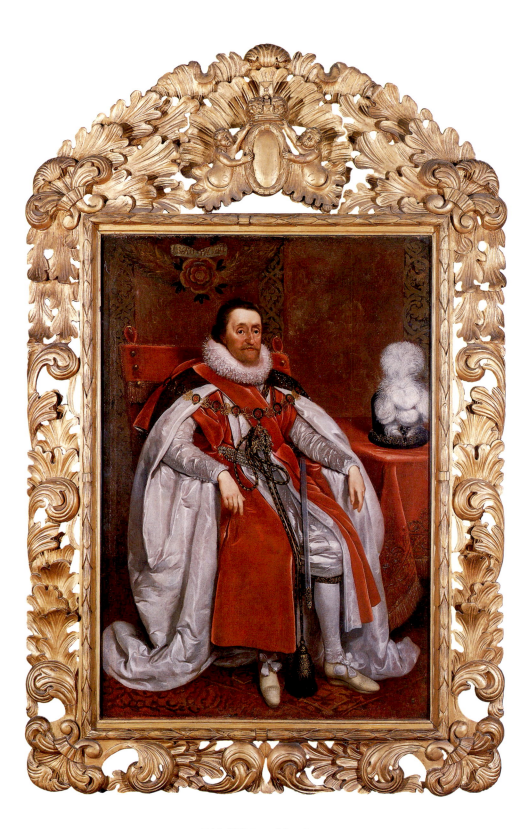

JAMES I 1566–1625
Oil on canvas, 148.6 × 100.6 (58½ × 39⅝)
By Daniel Mytens, inscribed and dated 1621 (109)

The son of Mary, Queen of Scots and Lord Darnley, and great-great-grandson of Henry VII, James succeeded to the Scottish throne while still a baby, on the abdication of his mother in 1567. In 1603 he succeeded Elizabeth I to the English throne, thus uniting England and Scotland. With a taste for unpopular favourites and in constant fear of assassination, he was undignified in appearance and conduct. Inclined to pedantry, he yet wrote poetry and encouraged spectacular theatricals at court. By his unshakeable belief in the Divine Right of Kings he nurtured the quarrel with Parliament which ultimately destroyed Charles I. To

one contemporary he appeared 'naturally of a timourous disposition . . . his eye large, ever rowling after any stranger came in his presence . . . his Beard was very thin . . . his legs were very weak . . . his walk ever circular'.

The Dutch artist Mytens, who came to England about 1618, has created an impressive image from this unpromising physical material, showing the king in the splendid robes of the Order of the Garter. Prominent in the tapestry behind him is the Tudor rose and the motto *Beati Pacifici*, 'blessed are the peace-makers'.

42

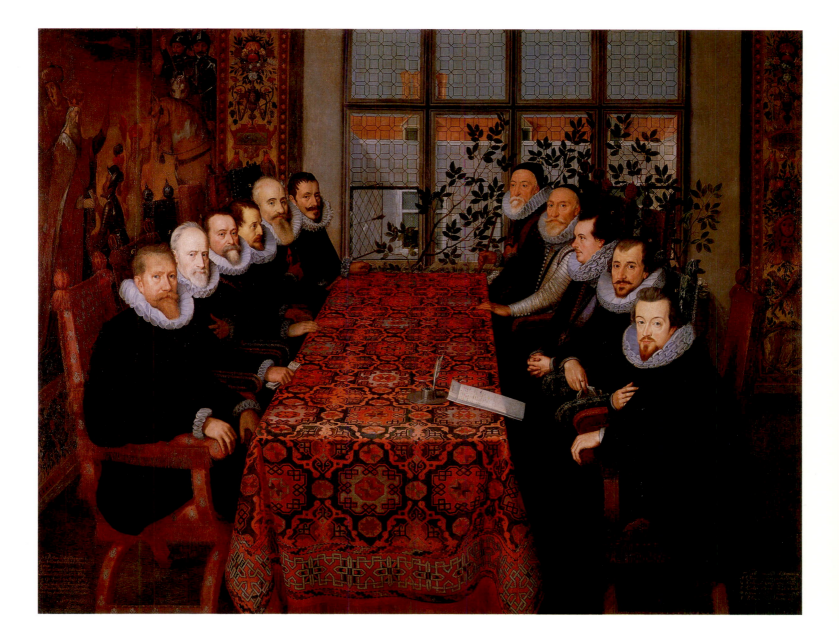

THE SOMERSET HOUSE CONFERENCE, 1604
Oil on canvas, 205.7 × 268 (81 × 105½)
By an unknown artist, inscribed, 1604 (665)

This rare group-portrait commemorates an historical event, the treaty of peace and trade between England and Spain, signed at Somerset House on 16 August 1604, and which ended almost twenty years of war.

On the left is the delegation representing Spain and the Catholic Netherlands (from the window):

Juan de Velasco, Duke of Frias, Constable of Castile
Juan de Tassis, Count of Villa Mediana
Alessandro Robida, Senator of Milan
Charles de Ligne, Count of Aremberg
Jean Richardot, President of the Privy Council
Louis Vereyken, *Audencier* of Brussels

On the right are the English delegates:

Thomas Sackville, Earl of Dorset
Charles Howard, Earl of Nottingham
Charles Blount, Earl of Devonshire
Henry Howard, Earl of Northampton
Robert Cecil, Viscount Cranborne (later 1st Earl of Salisbury)

The painting bears the false signature of the Spanish artist Pantoja de la Cruz, and is in reality probably by a Flemish artist. It is full of circumstantial detail, suggesting that it depicts the actual conference room at Somerset House.

43

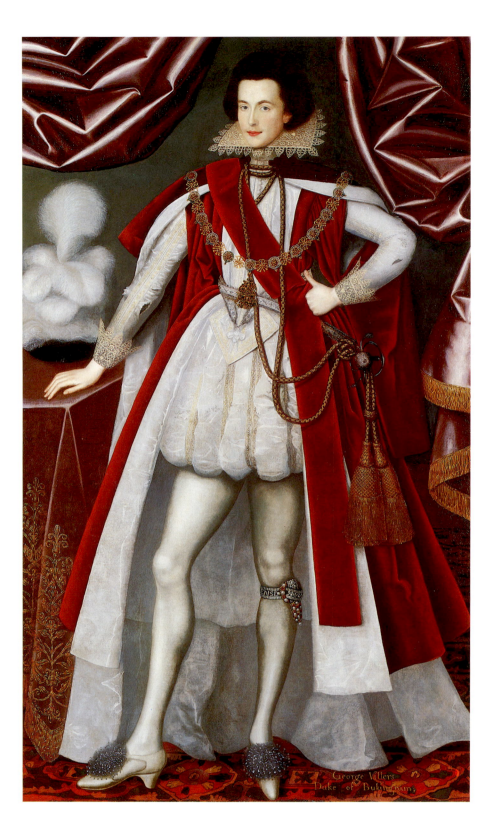

GEORGE VILLIERS, DUKE OF BUCKINGHAM 1592–1628
Oil on canvas, 205.7 × 119.4 (81 × 47)
Attributed to William Larkin, *c*.1616 (3840)

This highly ambitious son of a Leicestershire knight rose to be the favourite of James I on the strength of his charm and good looks. He was full of brave schemes, but lacked the good sense to carry them out effectively, and as Lord High Admiral he was a disaster. He travelled with Prince Charles to negotiate the latter's marriage to the Spanish Infanta, and when this failed, impetuously hurried James into war with Spain. This won him brief popularity with Parliament, which he then lost by bungling the expeditions to Cadiz and La Rochelle. He became the 'grievance of grievances' and did much to impair Charles I's relations with Parliament. He was stabbed to death by a fanatic in Portsmouth when preparing another expedition to relieve La Rochelle, besieged by Louis XIII.

This portrait, attributed to the obscure native artist Larkin, shows Buckingham in Garter Robes, and almost certainly commemorates his installation as a Knight of the Order in 1616. Larkin was no anatomist, but this portrait is undoubtedly striking, with its wiry articulation and bold two-dimensional patterning.

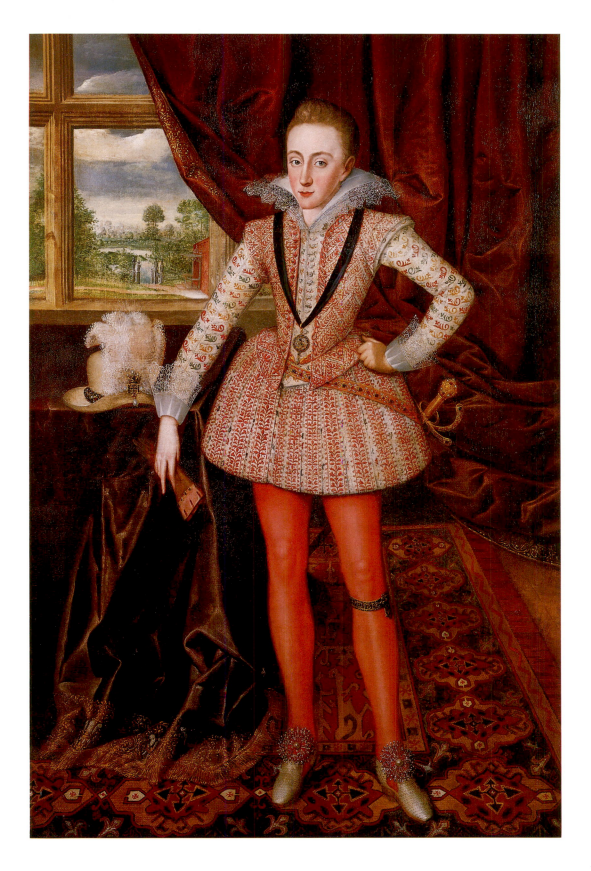

HENRY, PRINCE OF WALES 1594–1612
Oil on canvas, 172.7 × 113.7 (69 × 44¾)
By Robert Peake, *c*.1610 (4515)

Prince Henry was the talented eldest son of James I and his queen, Anne of Denmark. To his contemporaries he seemed the perfect Renaissance prince – good-looking, learned, pious, skilled in arms and with an appreciative understanding of the arts. His early death from typhoid fever, only two years after he had been created Prince of Wales, was a heavy blow to national morale. In Peake's brilliantly coloured and intricately patterned portrait, the pose of the precocious sixteen-year-old is one of absolute assurance. He wears the insignia of the Order of the Garter, while on the table is his splendid plumed hat with a jewel in the form of the letters HP, standing for *Henricus Princeps*. Prince of Wales's feathers are used as a motif in the embroidery on the edge of the table-cloth, while the vista is perhaps intended to show the park at Richmond or the grounds of St James's Palace, where the Prince carried out extensive works.

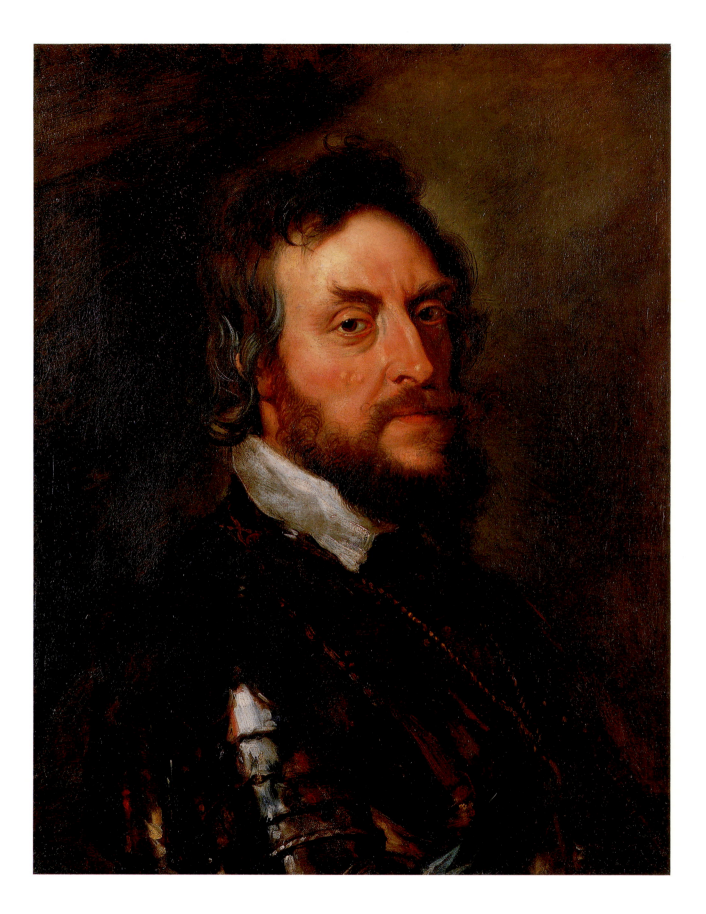

THOMAS HOWARD, 2nd EARL OF ARUNDEL AND SURREY 1585–1646
Oil on canvas, 68.6 × 53.3 (27 × 21)
By Sir Peter Paul Rubens, 1629 (2391)

Arundel was the outstanding collector-connoisseur of his generation. An active patron of living artists like Inigo Jones, Van Dyck, Wenceslaus Hollar and Rubens, he also formed a magnificent collection of old master paintings and drawings, and brought together the 'Arundel marbles', now in Oxford. Rubens called him 'an evangelist in the world of art'. His penetrating portrait is a study for the three-quarter-length painting in the Isabella Stewart Gardner Museum, Boston, painted in 1629, when Rubens was in London as ambassador from the Archduchess Isabella and her nephew, the king of Spain, to negotiate a treaty between England and Spain.

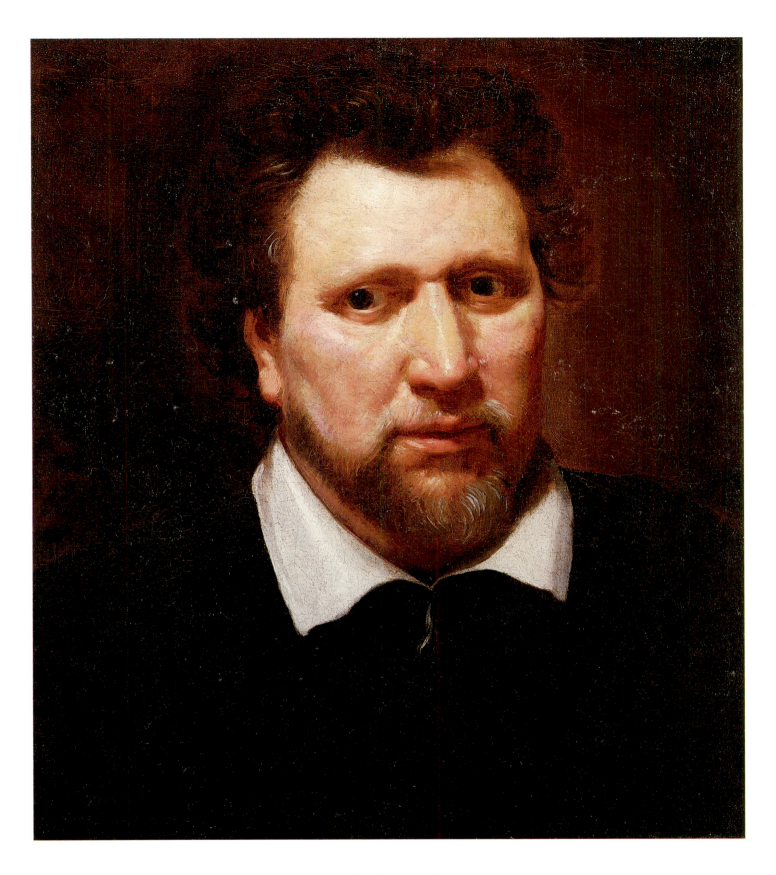

BEN JONSON 1573?–1637
Oil on canvas, 47 × 41.9 (18½ × 16½)
By Abraham van Blyenberch, *c*.1618 (2752)

The greatest English dramatist in the neo-classical tradition, Jonson, in his satirical comedies *Every Man in his Humour* (in which Shakespeare acted), *Volpone* and *The Alchemist*, combines classical notions of structure and unity with a ready intellectual wit and lyric charm. With Inigo Jones he produced a series of spectacular masques for the court, often based on abstruse allegories. John Aubrey described him as having 'one eie lower then t'other and bigger', and his dress and behaviour were unorthodox: 'he was wont to weare a coat like a coachman's coate, with slitts under the arme pitts. He would many times exceed in drinke (Canarie was his beloved liquour): then he would tumble home to bed, and, when he had thoroughly perspired, then to studie'. This unidealised portrait by the Antwerp artist Blyenberch conveys much of Jonson's belligerent bohemianism.

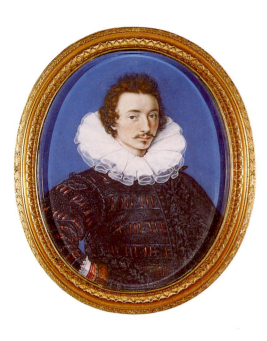

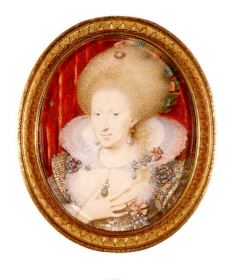

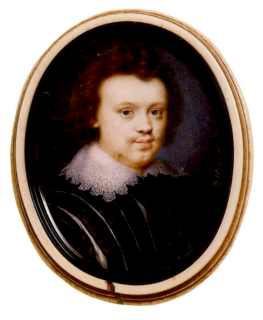

ANNE OF DENMARK 1574–1619
Watercolour on vellum, 5.1 × 4.1 (2 × 1⅝)
By Isaac Oliver, signed, c.1610 (4010)

The queen of James I, she bore him seven children, of whom
only three survived infancy. She was fond of hunting and of
royal progresses round the country, and for her Inigo Jones
and Ben Jonson devised their elaborate court masques.

ISAAC OLIVER c.1565–1617
Watercolour on vellum, 6.4 × 5.1 (2½ × 2)
Self-portrait, c.1590 (4852)

Oliver came to England from Rouen with his father, a
Huguenot refugee, in 1568. His miniatures have a boldness
and psychological insight which distinguish them from the
work of his teacher and later rival, Hilliard.

SIR KENELM DIGBY 1603–65
Watercolour on vellum, 7 × 5.5 (2¾ × 2⅛)
By Peter Oliver, signed and dated 1627 (L152(12))

The husband of Lady Digby (p.51), Sir Kenelm was con-
sidered 'the most accomplished cavalier of his time'. He
served as diplomat and naval commander, and was an early
member of the Royal Society, renowned as a conversationalist
and teller of tall stories.

PETER OLIVER
Pencil and watercolour on card, 8.6 × 6.7 (3⅜ × 2⅝)
Self-portrait, signed, c.1625–30 (4853)

The eldest son of Isaac Oliver, he trained with his father, but
developed a style of miniature painting which is softer in
focus and more naturalistic.

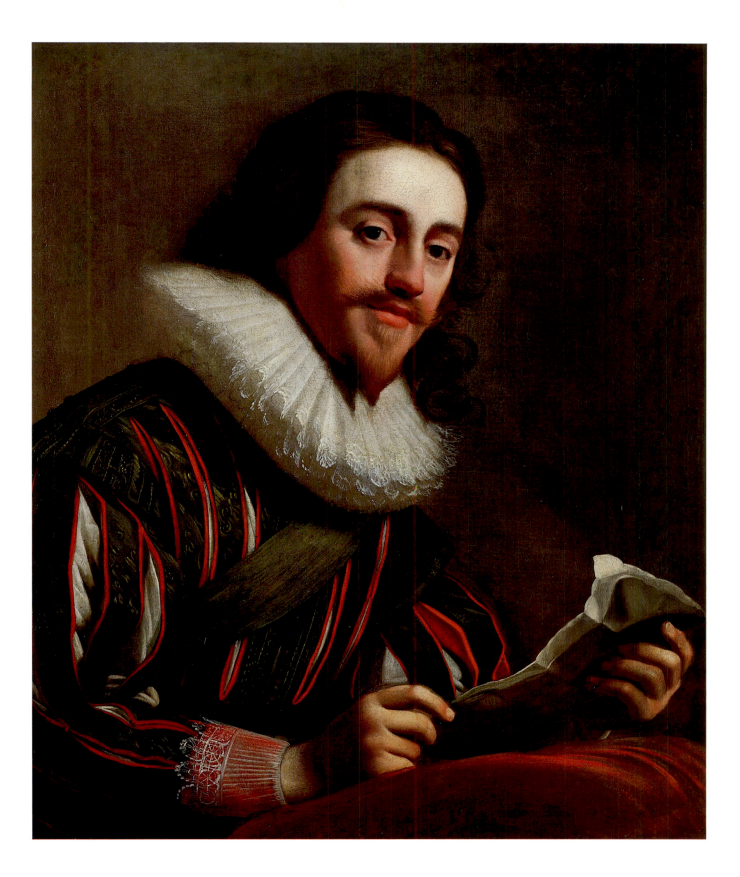

CHARLES I 1600–49
Oil on canvas, 76.2 × 64.1 (30 × 25¼)
By Gerrit van Honthorst, 1628 (4444)

In this surprisingly informal portrait of the young king read-
ing, the Dutch artist Honthorst expresses the serious-minded,
contemplative side of Charles's character – the scholar and
connoisseur, rather than the monarch. Honthorst, a follower
of Caravaggio, was in London at the king's invitation between
April and December 1628, and this portrait was almost cer-
tainly painted at that time, as an *ad vivum* study for the artist's
Apollo and Diana. This huge allegorical painting, commissioned
by the king, now hangs on the Queen's Staircase at Hampton
Court. In it Charles is shown as Apollo and the queen,
Henrietta Maria, as Diana, while the Duke of Buckingham
(p.44), the king's favourite, appears as Mercury presenting
the Seven Liberal Arts to the king. As a reward for his work
Charles created Honthorst an English citizen and gave him
munificent presents, including three thousand guilders and a
lifetime pension of a hundred pounds a year.

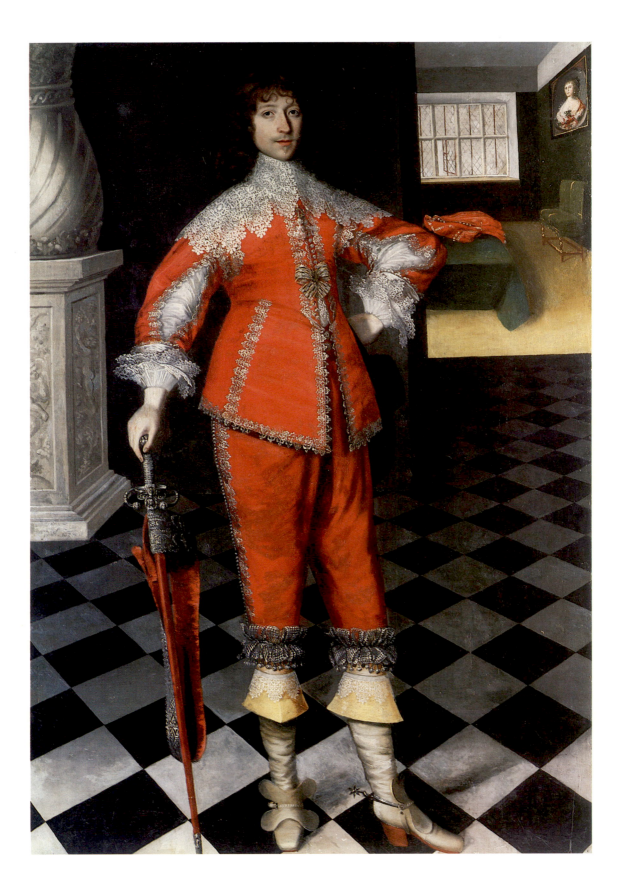

JOHN, LORD BELASYSE OF WORLABY 1614–89
Oil on canvas, 189.2 × 129.5 (74½ × 51)
By Gilbert Jackson, signed and dated 1636 (5948)

Like his father, Lord Fauconberg, Belasyse was a staunch royalist, and at the outbreak of the Civil War raised at his own expense six regiments of horse and foot for the king, fighting at Edgehill, Newbury, Naseby and numerous other engagements. At the Restoration his career was largely frustrated by his Roman Catholicism. He was deeply implicated in Titus Oates's alleged Popish Plot (1678), and spent six of his remaining years in the Tower. His portrait, which is one of the finest works of the obscure journeyman artist Jackson, was painted in happier times, as is suggested by its jaunty stance, cheery colours, and bold two-dimensional patterning. Almost certainly painted to mark Belasyse's marriage to Jane, daughter of Sir Robert Boteler, in 1636, it is presumably her portrait which hangs in the background.

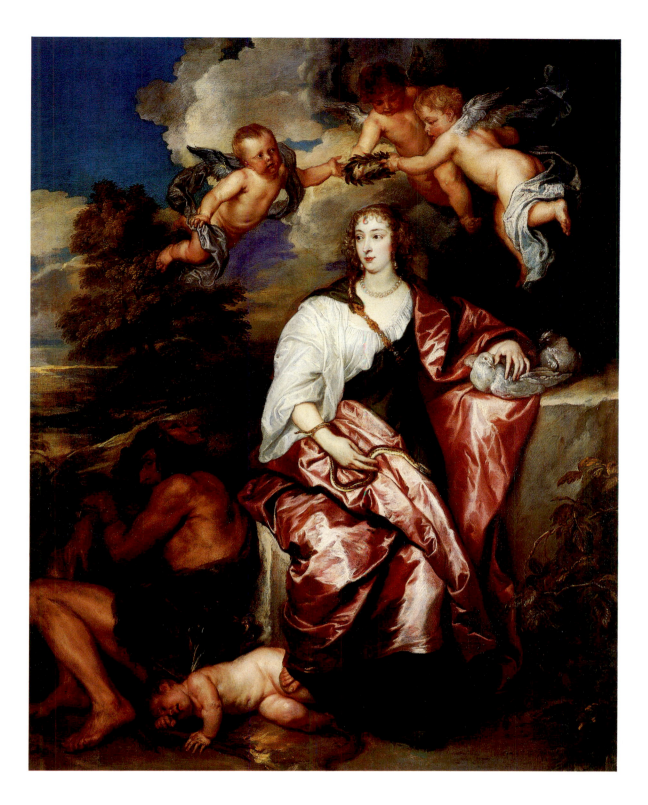

VENETIA STANLEY, LADY DIGBY 1600–33
Oil on canvas, 99.7 × 79.4 (39¼ × 31¼)
By Sir Anthony van Dyck, c.1633–4 (5727)

Venetia Stanley, a 'beautifull desireable Creature', had in her youth been 'kept as his Concubine' by the 3rd Earl of Dorset. However in 1626 she married the adventurer Sir Kenelm Digby (p.48), and proved a model wife. She died suddenly on 1 May 1633, and Digby mourned her extravagantly, causing her to be commemorated in both painting and sculpture. Digby's friend Van Dyck painted her on her death-bed (Dulwich College Picture Gallery), and later in a life-size allegorical portrait as the Virtue Prudence (Milan). Van Dyck is said to have been so pleased with this composition, that he subsequently painted a small-scale version for himself, the painting which now belongs to the Gallery. In this Lady Digby is shown with her foot on Profane Love, spurning two-faced Deceit, who lurks in the shadows, while angels crown her with victor's laurels. She fondles a pair of doves and holds a snake, in allusion to Matthew 10, verse 16; 'Behold I send you forth as sheep in the midst of wolves; be ye therefore wise as serpents and harmless as doves'.

This wholeheartedly baroque composition well illustrates those elements of fantasy and movement which Van Dyck brought to British portraiture; his refined sense of colour, delight in the fall of light on rich fabrics, and ability to capture (even in a posthumous likeness) a 'most lovely and sweet turn'd face'.

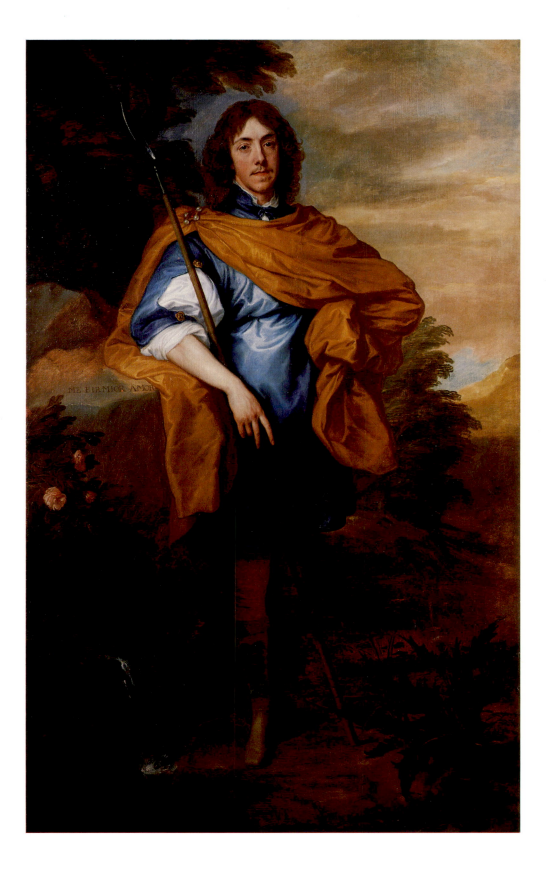

LORD GEORGE STUART, SEIGNEUR D'AUBIGNY 1618–42
Oil on canvas, 218.4 × 133.4 (86 × 52½)
By Sir Anthony van Dyck, inscribed, *c.*1638 (5964)

Lord George, the third son of the Duke of Lennox, was brought up in France as a Roman Catholic, and inherited the Seigneury of Aubigny from an elder brother in 1632. He is portrayed in Van Dyck's most poetic vein, in the guise of a shepherd, his features suffused with deepest melancholy. The rock by him is inscribed in Latin 'ME FIRMIOR AMOR', 'Love is stronger than I am', probably in allusion to his conflicting loyalties at the time of his secret marriage in 1638 to Lady Katherine Howard, daughter of the Earl of Suffolk, who in that year 'declared [herself] a papist'. Gossip said that 'love hath been the principal agent in the conversion', and the match incurred the anger of Lord George's guardian the king. At the outbreak of the Civil War he was one of the first to join the royalist side, and died in the first months of the war, covered in wounds, at the battle of Edgehill.

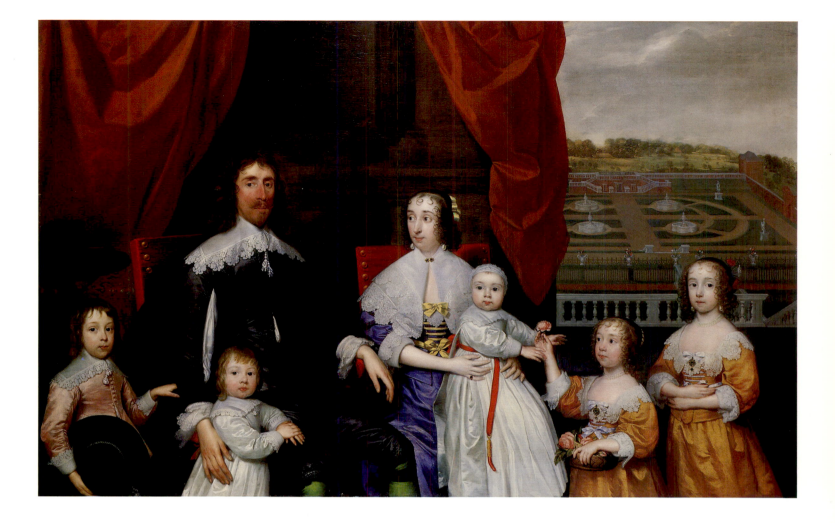

ARTHUR CAPEL, 1st BARON CAPEL 1604–49, AND HIS FAMILY
Oil on canvas, 160 × 259.1 (63 × 102)
By Cornelius Johnson, c.1640 (4759)

Arthur Capel was a devoted royalist, who suffered for his loyalty, dying on the scaffold in the same year as Charles I. This portrait of him with his wife, Elizabeth, from the years before the Civil War, is Johnson's attempt at a group portrait in the manner of Van Dyck. His work lacks Van Dyck's assurance and elegance, but has a touching simplicity of mood and a devotion to details of dress which are peculiarly his. The children are (left to right): Arthur, later 1st Earl of Essex; Charles; Henry, later Lord Capel of Tewkesbury; Elizabeth, later Countess of Carnarvon, and Mary, later

Duchess of Beaufort. The gardens behind are perhaps those of Little Hadham, the Capels' home. Elizabeth was a talented botanical artist, Mary became a distinguished horticulturalist, and Henry established a garden at Kew. Arthur was created Earl shortly after the Restoration, and held several important public offices. He was however implicated in the Duke of Monmouth's schemes (p.65), and imprisoned in the Tower. He committed suicide there in 1683 in the same cell in which his father had been held before his execution.

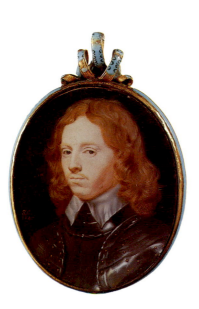

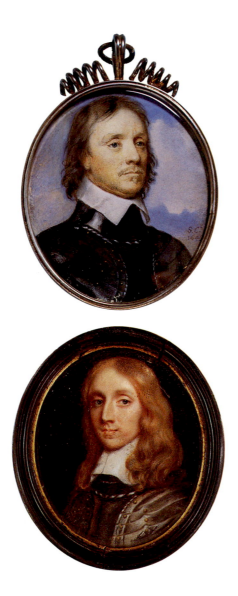

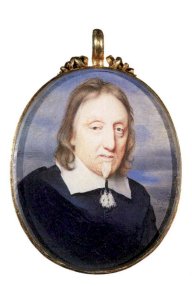

OLIVER CROMWELL 1599–1658
Watercolour on vellum, 5.7 × 4.8 (2¼ × 1⅞)
By Samuel Cooper, signed and dated 1649 (5589)

This outstandingly important miniature by Cooper, according to John Aubrey 'the prince of limners of this age', is his earliest portrait of Cromwell, painted in the year of the execution of Charles I, four years before the great soldier took office as Protector.

GEORGE FLEETWOOD 1622?–after 1664
Watercolour on vellum, 5.7 × 4.4 (2¼ × 1¾)
By Samuel Cooper, signed and dated 1647 (1925)

One of those who signed the death warrant of Charles I, Fleetwood later proclaimed Charles II at York, and surrendered himself as a regicide. He was sentenced to death, but reprieved.

WILLIAM LENTHALL 1591–1662
Watercolour on vellum, 5.4 × 4.4 (2⅛ × 1¾)
By Samuel Cooper, signed and dated 1652 (2766)

As Speaker of the turbulent Long Parliament he kept a clear head in times of crisis, as when Charles I came to Parliament to arrest the five members. After the fall of Richard Cromwell, he worked for the restoration of the monarchy.

RICHARD CROMWELL 1626–1712
Watercolour on vellum, 5.4 × 4.4 (2⅛ × 1¾)
By an unknown artist, c.1650 (4350)

Richard Cromwell succeeded his father as Protector in 1658, but 'became not greatness'. He resigned and in 1660 went into voluntary exile abroad.

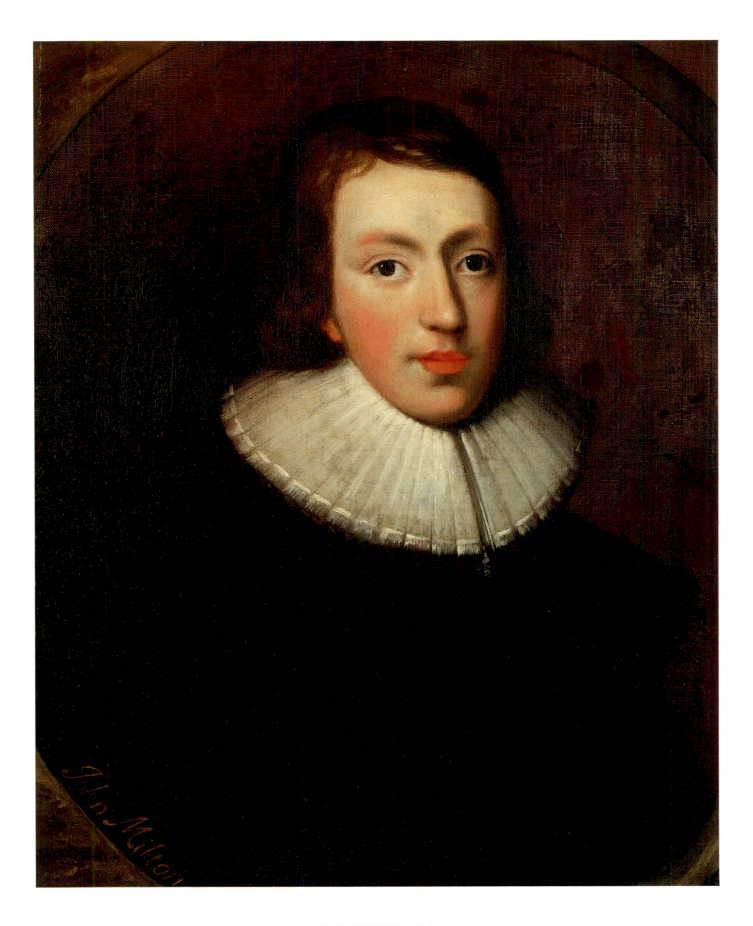

JOHN MILTON 1608–74
Oil on canvas, 59.7 × 48.3 (23½ × 19)
By an unknown artist, inscribed, *c.*1629 (4222)

This portrait of the twenty-one-year-old poet is probably that mentioned by John Aubrey: 'His widowe has his picture drawne very well & like when a Cambridge schollar. He was so faire that they called him the Lady of Christ's coll'. It is an unexpected image of the man better known as a blind vision-ary: the formidably learned author of the epics *Paradise Lost* and *Paradise Regained*, and the tragedy *Samson Agonistes*; the fierce political pamphleteer and polemicist who became Cromwell's Latin Secretary.

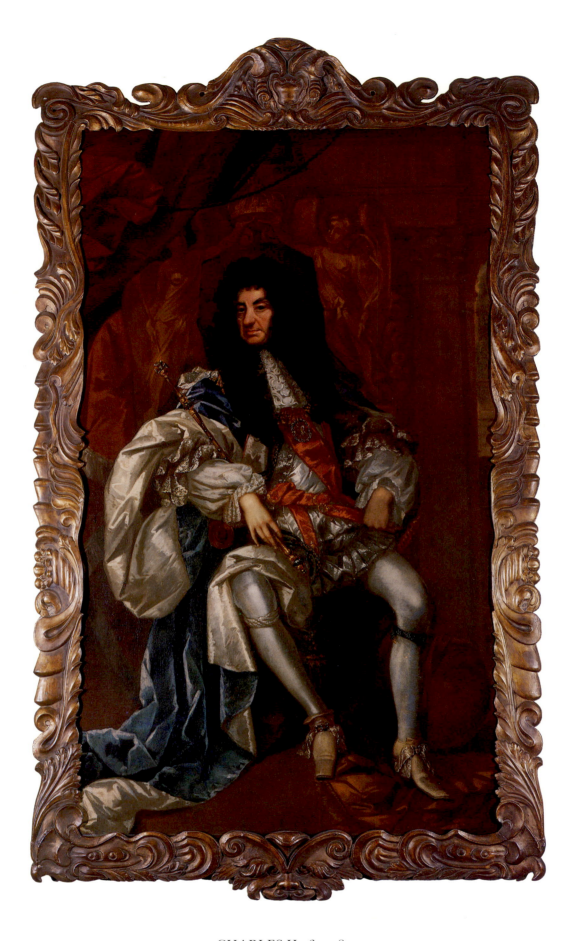

CHARLES II 1630–85
Oil on canvas, 226.7 × 135.6 (89¼ × 53⅜)
By Edward Hawker, c.1680–5 (4691)

This grand state portrait, by an obscure follower of Lely, Edward Hawker, almost certainly shows Charles towards the very end of his reign. Awkwardly posed, he seems ill at ease amongst the trappings of the baroque portrait – voluminous curtains, ornate throne and rich robes and mantle. His face is tired, speaking of years of insecurity and personal indulgence, but not without a trace of the tolerant good humour which made him popular with his subjects.

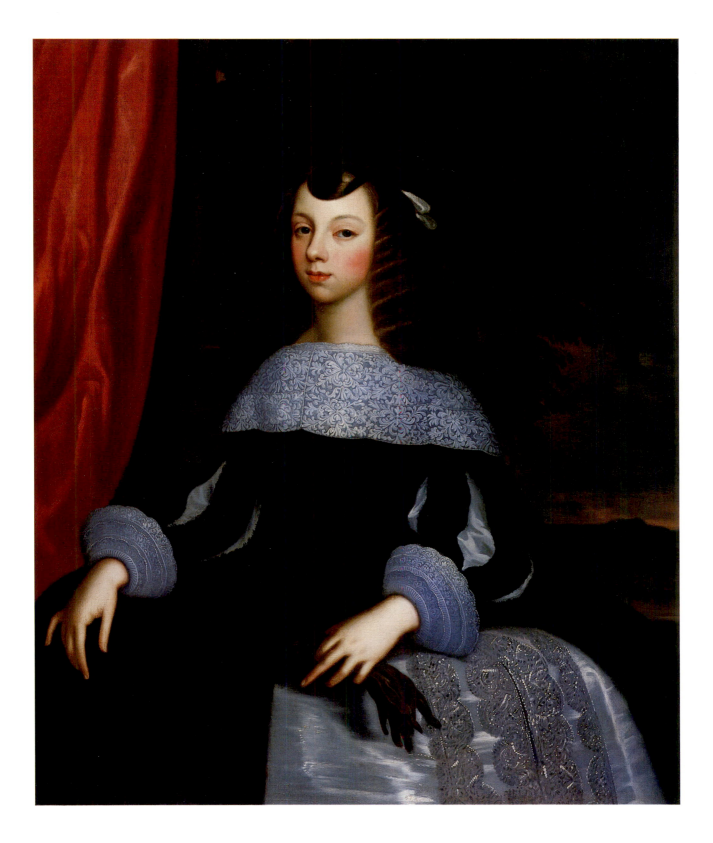

CATHERINE OF BRAGANZA 1638–1705
Oil on canvas, 123.2 × 100.3 (48½ × 39½)
By or after Dirk Stoop, *c*.1660–1 (2563)

The daughter of John, Duke of Braganza, afterwards king of Portugal, Catherine came to England as Charles II's bride in 1662, bringing with her a welcome dowry of Bombay, Tangier and £300,000. John Evelyn describes her arrival in England, and her curious Portuguese costume: 'The Queene arived, with a traine of Portugueze Ladys in their monstrous fardingals or Guard-Infantas: Their complexions olivaster, & sufficiently unagreable: Her majestie in the same habit, her foretop long & turned aside very strangely: She was yet of the handsomest Countenance of all the rest, & tho low of stature pretily shaped, languishing & excellent Eyes, her teeth wronging her mouth by stiking a little too far out: for the rest sweete & lovely enough'. The wide hooped skirt and odd looped hair-style can be seen in the Dutch artist Stoop's charming portrait, and it was a version of this picture which had been sent to England, prior to their marriage, for Charles to inspect. She was a shy and somewhat solemn girl, and devoted to her husband, who, though he wounded her by his continuous infidelity, yet had a genuine affection for her.

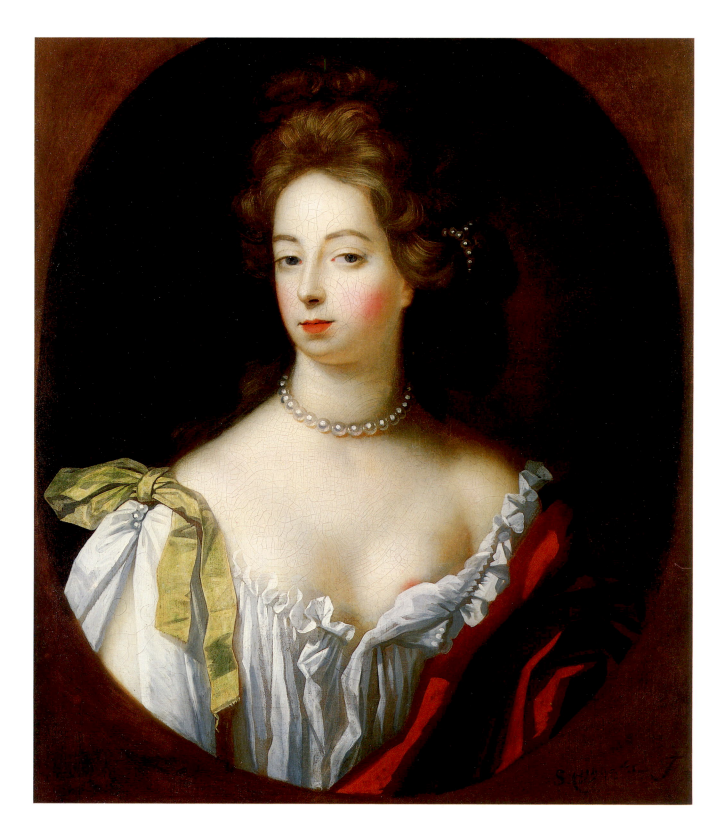

NELL GWYN 1650–87
Oil on canvas, 76.2 × 63.5 (30 × 25)
By Simon Verelst, signed, *c*.1670–5 (2496)

Nell Gwyn was the mistress of Charles II *par excellence*, an ebullient symbol of the licentious freedoms of the Restoration court. Unlike her Catholic rival, the Duchess of Portsmouth (p.59), she enjoyed great popularity: 'the Protestant whore', as she herself said, and Pepys's 'bold merry slut'. Born in Hereford, she rose from being an orange-seller at the Theatre Royal, Drury Lane, to become one of the leading comic actresses of her day – 'pretty witty Nell' – and a king's mistress. Dryden kept her supplied with a series of somewhat saucy, bustling parts which ideally suited her talents, and

Pepys thought her outstanding as Florimel in Dryden's *The Maiden Queen*. But this 'clever buffoon . . . played the part on and off the boards', and was fond of mimicking members of the court, especially her rival the Duchess of Portsmouth. Nell bore the king two sons (the elder of whom was created Duke of St Albans), and retained his favour until the end of his life. She died young of an apoplectic fit. The Dutch artist Verelst, best known for his highly artificial flower-paintings, shows her not as a real woman, but as a 'pin-up', elegant and stylised as an exotic bloom.

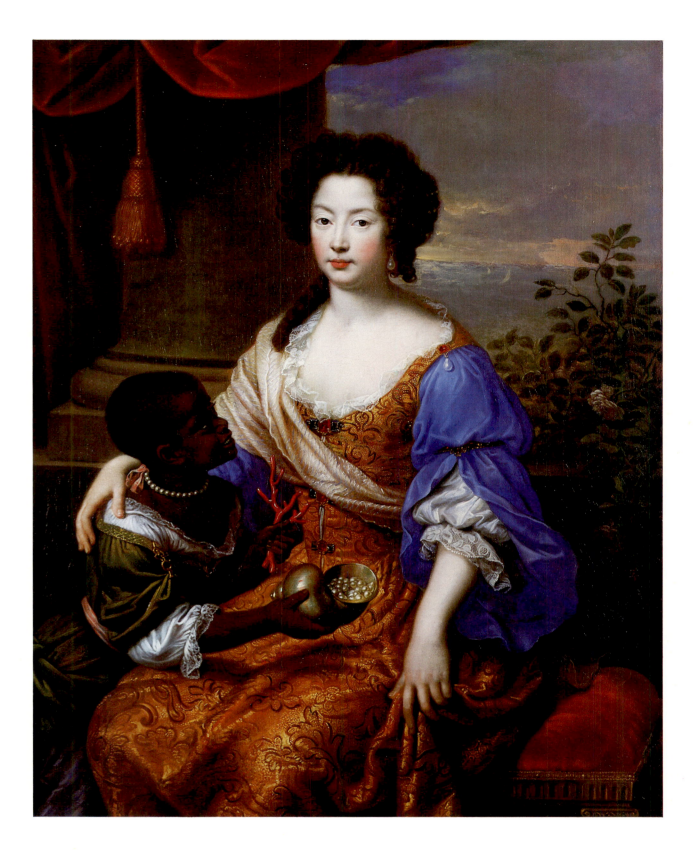

LOUISE RENÉE DE PENANCOET DE KÉROUALLE, DUCHESS OF PORTSMOUTH 1649–1734
Oil on canvas, 120.7 × 95.3 (47½ × 37½)
By Pierre Mignard, signed, inscribed and dated 1682 (497)

The duchess first came to England in 1670 as maid-of-honour to Henrietta, Duchess of Orleans, and returned to France only to be sent back to England shortly afterwards by Louis XIV to win Charles II's heart and thereby to promote French interests. This she achieved, becoming his mistress in 1671. She subsequently bore him a son, later Duke of Richmond, and was herself created duchess in 1673. John Evelyn noted her 'childish, simple and baby face', and her lavish apartments in Whitehall, which had 'ten times the richnesse & glory beyond the Queenes'. She popularized French fashions and taste at court, but was hated by the people. After Charles's death she returned to France, and Voltaire, who saw her in old age, paid tribute to her beauty. In this portrait by the fashionable French artist Mignard she is presented with coral, pearls and a shell by her negro page, and is perhaps portrayed as the sea-nymph Thetis, mother of the hero Achilles – an allusion to her son by Charles.

JOHN WILMOT, 2nd EARL OF ROCHESTER 1647–80
Oil on canvas, 127 × 99.1 (50 × 39)
By an unknown artist, c.1665–70 (804)

A member of the most dissolute and licentious court circles, Rochester with his ready wit alternately fascinated and enraged Charles II, who dismissed him from court at least once a year, but always had him immediately recalled. As a poet his name is chiefly associated with a number of obscene and porno-graphic works, but he was also a satirist and lyricist of genius. This portrait has a satirical message almost certainly of Rochester's devising, for it portrays him bestowing the poet's laurels on a jabbering monkey, squatting on some books and tearing up a manuscript.

SAMUEL PEPYS 1633–1703
Oil on canvas, 75.6 × 62.9 (29¾ × 24¾)
By John Hayls, inscribed, 1666 (211)

A naval administrator of great ability, who eventually became Secretary of the Admiralty, Pepys is today remembered above all for the *Diary* which he began on 1 January 1660, and which he laid aside in 1669, when he believed he was going blind. It is a unique social document and piece of self-revelation, written in code and only deciphered and published in 1825. His portrait is documented in the *Diary*. Pepys first sat, wearing an Indian gown which he had hired specially, on 17 March 1666: 'I . . . do almost break my neck looking over my shoulders to make the posture for him [Hayls] to work by', and on 16 May he paid Hayls £14 for the completed portrait and twenty-five shillings for the frame. He declared himself 'very well satisfied' with the portrait, in which he holds a song 'Beauty retire, thou . . .', which he had himself set to music.

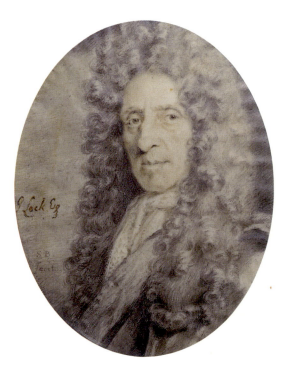

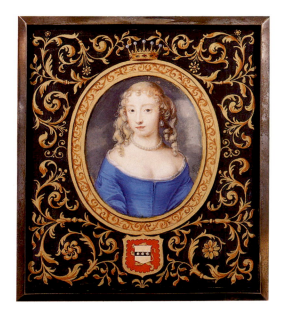

JOHN MAITLAND, 1st DUKE OF LAUDERDALE 1616–82
Watercolour on vellum, 8.6 × 7 (3⅜ × 2¾)
By Samuel Cooper, signed and dated 1664 (4198)

This ruthless, unattractive, but highly educated member of
the Cabal ministry, became at the Restoration almost absolute
ruler in Scotland. Ham House, Richmond, is the monument
to his love of the arts.

JOHN LOCKE 1632–1704
Tinted plumbago on paper, 11.1 × 8.6 (4⅜ × 3⅜)
By Sylvester Brounower, signed and inscribed, c.1685 (4061)

The great philosopher, whose *Essay Concerning Humane
Understanding* was published in 1690, is here portrayed by his
servant and secretary, Brounower, who, though clearly a very
able draughtsman, seems to have produced very few portraits.

FRANCES JENNINGS, DUCHESS OF TYRCONNEL 1647/9–1730
Watercolour on vellum, 7.3 × 6.1 (2⅞ × 2⅜)
By Samuel Cooper, signed, c.1665 (5095)

This famous beauty, 'arrayed in all the splendour of her first
youth', was a maid-of-honour at court, and elder sister of
Sarah Jennings, later Duchess of Marlborough. All her fresh-
ness and beauty are captured in the small space of this
miniature by Cooper.

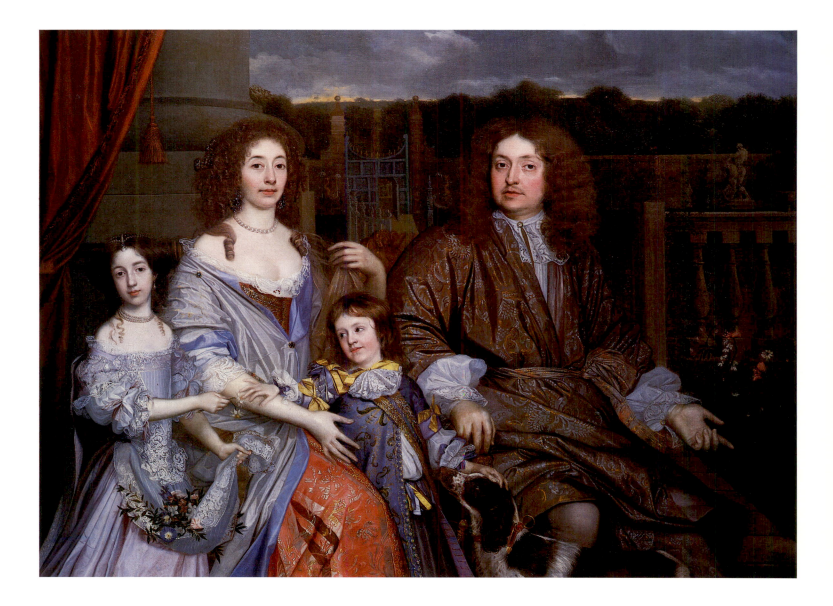

SIR ROBERT VYNER 1631–88 AND HIS FAMILY
Oil on canvas, 144.8 × 195.6 (57 × 77)
By John Michael Wright, signed, inscribed and dated 1673 (5568)

The rich goldsmith and banker Sir Robert Vyner, who made the regalia for the coronation of Charles II in 1661, is portrayed with his wife and children in the garden of their house at Swakelys in Middlesex, which, if Pepys is to be believed, was 'a place not very moderne in the gardens nor house, but the most uniforme in all that I ever saw – and some things to excess'. Vyner had married Mary Whitchurch, the wealthy widow of Sir Thomas Hyde, in 1665, and with them in the portrait are his step-daughter Bridget (later Duchess of Leeds), and their son Charles. By the time that this picture was painted Vyner was already in financial difficulties (though he was chosen Lord Mayor of London in the following year), as the government refused to repay his considerable loans. He was finally declared bankrupt in 1683 or 4. His son died aged twenty-two in 1688, and Vyner himself died two months later, it is said of a broken heart. Wright's portrait, like Cornelius Johnson's *Capel Family* (p.53), is an attractive blend of sophistication and naivety, and the Vyners, posed in all their finery, seem frozen as if for some camera; only the little boy appears to have moved.

JAMES II 1633–1701 AND ANNE HYDE 1637–71 AS DUKE AND DUCHESS OF YORK
Oil on canvas, 139.7 × 192 (55 × 75⅛)
By Sir Peter Lely, 1660s (5077)

This sumptuous double portrait was probably painted shortly after James's secret marriage to the pregnant Anne Hyde in 1660. Her father, Edward Hyde, later Earl of Clarendon, strongly disapproved of the match, but Charles II thought his sister-in-law 'a woman of great wit and excellent parts'. Pepys declared that 'the Duke of York, in all things but his amours,

is led by the nose by his wife', but she did not live to be queen. Her daughters, Mary and Anne, however, both succeeded to the throne.

At the Restoration Lely dominated the artistic scene, and this portrait, richly coloured and aristocratic in tone, epitomizes the elegance and sophistication of the court of Charles II.

64

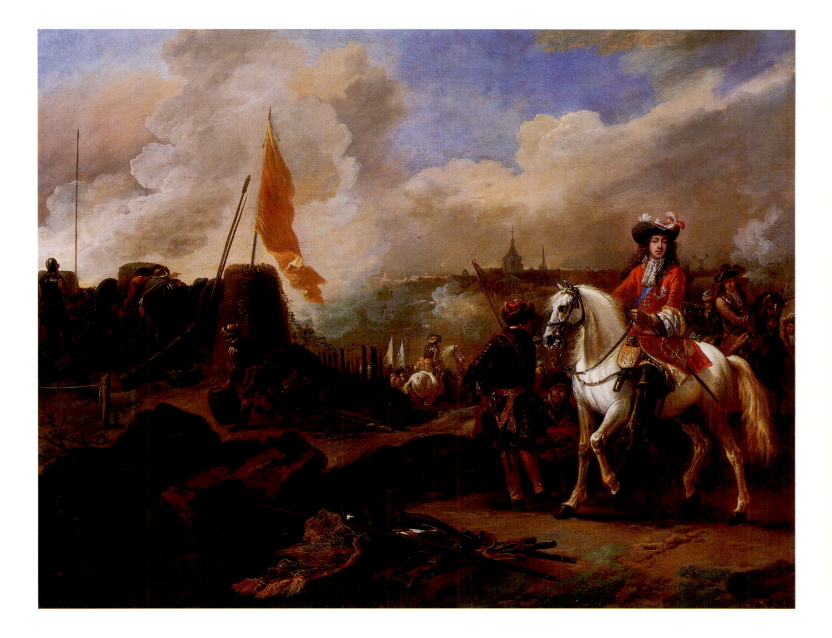

JAMES SCOTT, DUKE OF MONMOUTH AND BUCCLEUCH 1649–85
Oil on canvas, 79 × 103.8 (31⅛ × 40⅞)
By Jan van Wyck, signed, *c.*1673 (5376)

Monmouth was the son of Charles II by Lucy Walter, 'a brown, beautiful, bold but insipid creature', as Pepys described her, and some of these characteristics were inherited by her son. Charles doted on the boy, and advanced his military career. But he became the focus of powerful Protestant forces opposed to the Roman Catholic Duke of York, and on James's accession he organised a rebellion and claimed the throne. He and his virtually peasant army were defeated at Sedgemoor. Monmouth fled before the battle was over, but was captured later and beheaded on Tower Hill. This battle-piece commemorates the Duke's role as commander of the English auxiliary force against the Dutch in 1672–3, and the scene in the background may be intended to depict the siege of Maastricht in 1673.

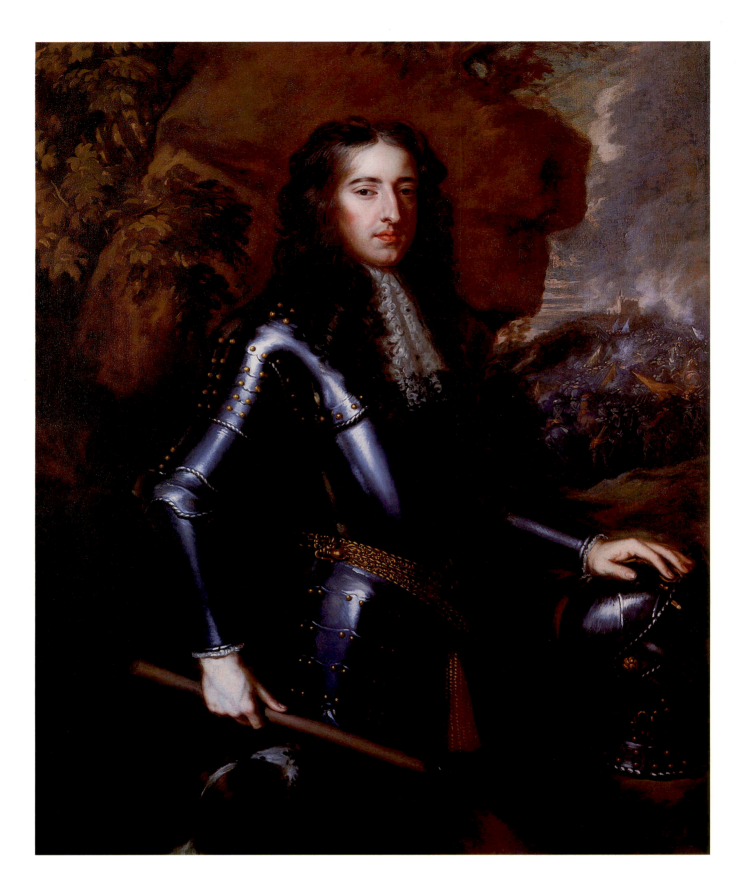

WILLIAM III 1650–1702
Oil on canvas, 124.5 × 101 (49 × 39¾)
By an unknown artist after Sir Peter Lely, *c.*1677 (1902)

William, Stadholder of Holland, grandson of Charles I and husband of Princess Mary, the daughter of James II, had a double reversionary claim to the throne of England. Thus he was invited by a group of prominent Whigs to invade England in 1688 in order to preserve Protestant liberties which were threatened by the Roman Catholic James II. James fled, and William and Mary were jointly given the throne, but on terms which banished for ever the absolutism of the Tudors and Stuarts. As a lifelong champion of European Protestantism, William formed the Grand Alliance against France and the aggressive policies of Louis XIV.

In this version of Lely's portrait, painted in the winter of 1677 when William was in England to marry Princess Mary, the king is shown in armour as a military commander.

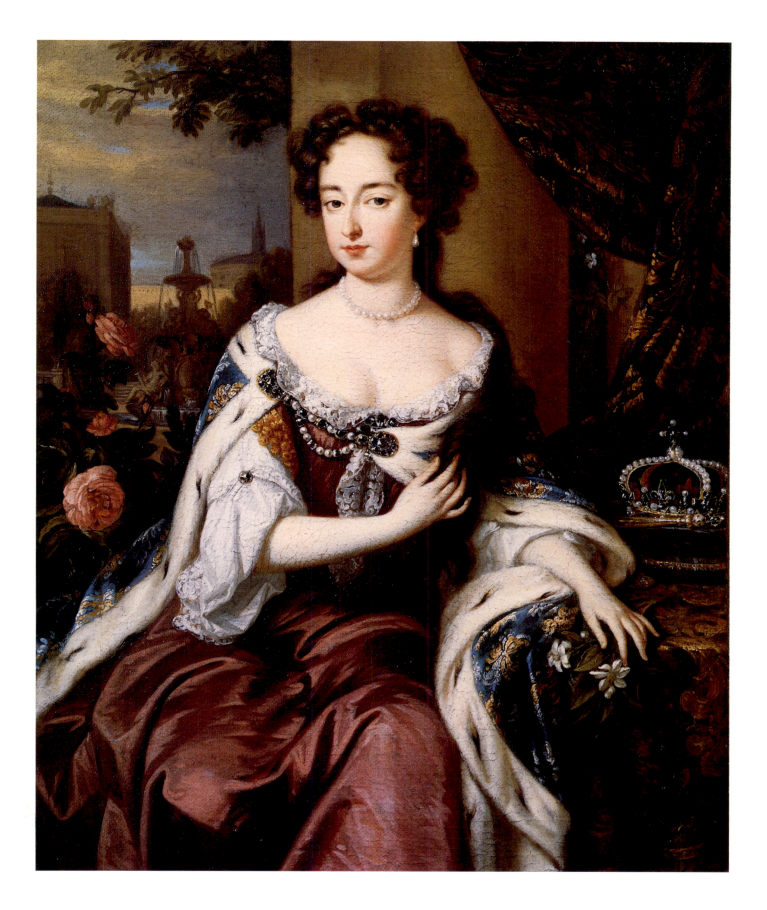

MARY II 1662–94
Oil on canvas, 39.4 × 32.4 (15½ × 12¾)
By or after William Wissing, 1685 (606)

The elder daughter of James II by Anne Hyde, Mary married William of Orange in 1677, but they had no children. In the heartbreaking dilemma of the revolution of 1688, Mary chose to support her husband and Protestantism rather than her Catholic father. She came to Whitehall 'laughing and jolly' and proved a wise and tactful queen. In William's frequent absences she ruled alone, but did not relish the experience. She died before William, of smallpox.

In this elegant portrait, an exquisite small-scale version of a portrait painted in Holland in 1685, she is shown as queen, with the crown and sceptre by her and in robes of state, surrounded by sweet-smelling flowers.

67

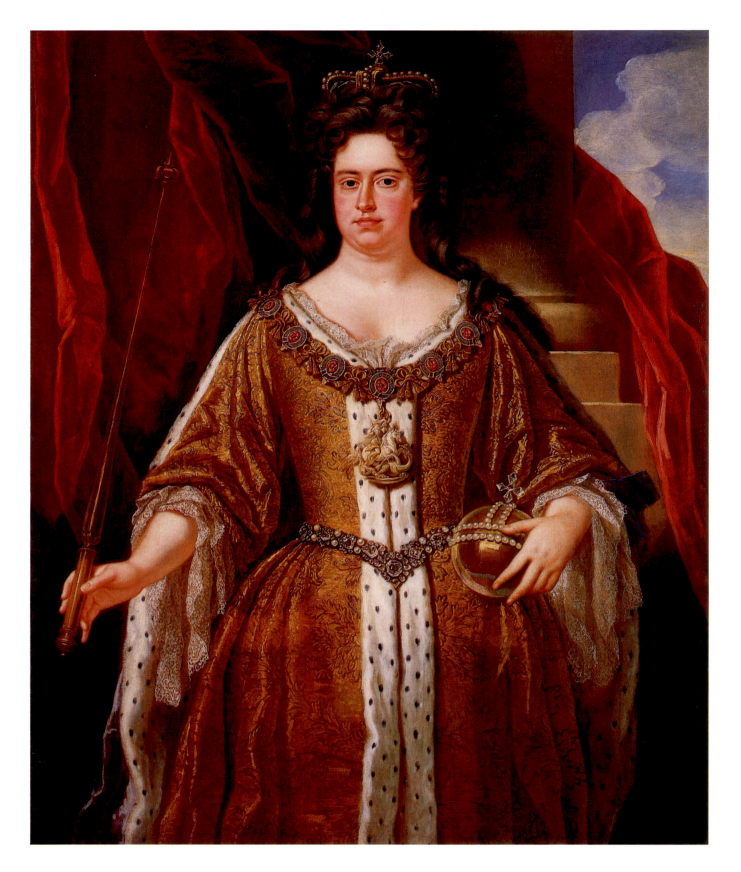

QUEEN ANNE 1665–1714
Oil on canvas, 125.1 × 102.9 (49¼ × 40½)
Studio of John Closterman, *c.*1702 (215)

The second daughter of James II and Anne Hyde (p.64), Anne married Prince George of Denmark in 1683, and succeeded William III to the throne of England in 1702. For the whole of her reign, which was a period of great glory, this kind and generous woman was surrounded by warring political factions. In her personal life she suffered greatly, all her many children dying in infancy. Only Prince William lived longer than the others, and his death aged eleven opened up the Hanoverian succession.

This formalised portrait by the German artist Closterman, showing the queen in her coronation robes, is a version of a full-length which he painted for the Guildhall in the year of her accession, and for which he was paid £100.

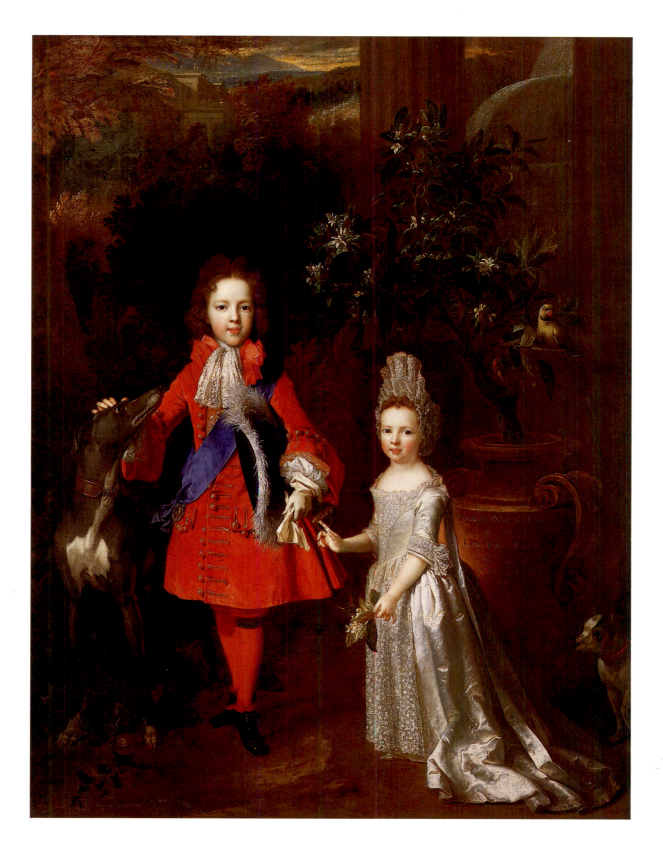

PRINCE JAMES FRANCIS EDWARD STUART 1688–1766, 'THE OLD PRETENDER',
AND HIS SISTER PRINCESS LOUISA 1692–1712
Oil on canvas, 190.5 × 143.5 (75 × 56½)
By Nicolas de Largillière, inscribed and dated 1695 (976)

It was the birth of a male heir to the Catholic James II in 1688 which precipitated the revolution of that year and James's subsequent flight. Prince James was that heir, and he is shown in Largillière's charming double portrait with all the splendour of a future monarch, in a brilliant scarlet suit which contrasts vividly with the blue Garter sash and his sister's white dress. Whatever his claims, they were doomed to disappointment. He was proclaimed king in exile in France on the death of his father in 1701, but despite a number of attempted landings in England, he never came near to ascending the throne, and died in exile in Rome. In this portrait the heads of the two children are painted on separate pieces of canvas let into the larger canvas, and it may be that these were Largillière's original studies made from the life, subsequently adapted into this grand composition.

JOHN CHURCHILL, 1st DUKE OF MARLBOROUGH 1650–1722
Oil on canvas, 92.7 × 73.7 (36½ × 29)
By Sir Godfrey Kneller, c.1706 (902)

This brilliant oil sketch shows Queen Anne's great Commander-in-Chief, the victor of Blenheim and Ramillies, in triumph. On the left is Hercules with his club and a key (possibly a symbol of submission) and a woman offering a castle; under Marlborough's horse's hooves is the dishevelled figure of Discord, while in the clouds sits Justice; below her, Victory crowns the duke with laurel. This is presumably the study for a full-scale allegorical painting which seems, however, never to have been completed. Stylistically it is heavily influenced by Rubens, while in spirit it conveys Britain's confidence as a European power.

SIR CHRISTOPHER WREN 1632–1723
Oil on canvas, 124.5 × 100.3 (49 × 39½)
By Sir Godfrey Kneller, signed, inscribed and dated 1711 (113)

This portrait by the German artist Kneller, with its assured pose and confident expression, is a noble representation of England's greatest architect. It was no doubt intended to commemorate the completion of Wren's master piece, St Paul's Cathedral, for on the table lies a plan of the west end of the cathedral. It comes as something of a shock to learn that in the year of this portrait Wren was seventy-nine years old, for his appearance is that of a much younger man. He holds in his hands a pair of compasses and on the plan rests a copy of Euclid, reminders that the man who rebuilt London's churches after the Great Fire was also one of the greatest geometers of the day and a former Professor of Astronomy. He was President of the Royal Society from 1680 to 1682, and an intimate of the foremost scientists and thinkers of his time.

THE GEORGIAN AGE

The eighteenth century was a period of political and social stability; radicalism, the mob, and the collapse of the *ancien régime* in France, were doubly feared in England because memories of the upheavals of the seventeenth century were all too vivid. The first two Georges were accepted because they had no policies, and England was effectively governed by a rich, largely Whig, aristocracy, whose great country houses, built and furnished by such architects as William Kent and Robert Adam, and filled with pictures and statues acquired on the Grand Tour, were the embodiment of their temporal power.

It was an age of increasing national wealth, of expansion overseas, of fortunes made in the West Indies and later in India; and of retribution in America and war with France. It was an age of industrial revolution: of inventions like Watt's steam-engine, far-reaching technological change and improvements in communications, the growth of large-scale enterprise and the factory system, and the spread of banking. But the expectation of life remained low – disease struck indiscriminately at all classes – and progress for the poorer members of the community meant declining independence and appalling conditions of work. In 1714 England was largely rural, with only one town of any size – London, with a population of half a million. By the 1790s the depopulation of the countryside, the result of enclosure and economic farming, had begun in earnest, and of the new industrial towns of the north, Manchester was approaching a population of 150,000. Cast iron, the mills, the canals, the turnpike roads and the stage coach had changed the face of England.

As in the seventeenth century, the court remained the centre of political, social and, to some extent, artistic life. George II and Queen Caroline patronized Handel; George III, Zoffany and West. 'Opposition' courts were even more influential on the arts: Frederick, Prince of Wales, actively encouraged the artists of the rococo; the Prince Regent, patron of Gainsborough, enriched Carlton House, and gave his name to a whole period and style. Both these princes loved painting as Charles I had. Portraiture remained the staple of the British artist; much of it now executed by itinerant or provincial artists, the most distinguished of whom was Joseph Wright of Derby, who painted Arkwright and other inventors and industrial entrepreneurs. Successive attempts to improve the status of the British artist resulted, in 1768, in the foundation of the Royal Academy, of which Joshua (later Sir Joshua) Reynolds

became the first President. Reynolds was determined that British art should emulate the academic ideals of Raphael and Poussin and the Bolognese painters of the seventeenth century, and his own work gained a calculated nobility from its borrowed compositions and poses.

The last years of the eighteenth century saw Britain at war with France, a conflict which lasted until 1815. These years witnessed the rise to influence and eventual power of the Prince Regent. The word 'Regency' immediately conjures up a vision of debauchery, gambling, heavy eating and drinking, mistresses, a flashy style of portraiture, and flamboyant if not downright vulgar architecture and decor – in fact an eponymous age reflecting the lifestyle of the Prince himself. Although the Regency itself only existed formally between 1811 and 1820, when the Prince of Wales acted legally as Regent for his insane father, the word is generally recognized to cover the first quarter of the century. England struggled, often alone, against the tyranny of Napoleon, and victories like Cape St Vincent, Trafalgar and Waterloo were climaxes in a long-drawn-out conflict, maintained at first by professional sailors and soldiers but shared eventually by the whole nation. Against this background Prinny's excesses melt into insignificance.

At the same time, another sort of revolution was taking place. Industry was benefiting from the effects of Watt's steam-engine, Arkwright's spinning-jenny and the inventions of McAdam and Brunel. The evils of slavery, convict ships, child labour and a Draconic penal system, were being met by the reforming zeal of Wilberforce, Elizabeth Fry, Burdett, John Howard and many others. Cobbett's *Rural Rides* (1830) provides a vivid account of Regency England, its farming, rural industries, country houses, rotten boroughs, and the gradual emergence of the large proportion of Englishmen from misery and starvation to form the 'backbone of England' – the Middle Class.

Parallel with these great trends ran the Romantic Movement – broadly speaking a European reaction to the sterility of classical inhibition. The giants were Beethoven, Voltaire, Rousseau, Goya and Delacroix, but the British contribution was no less formidable: Wordsworth, Coleridge and Shelley opened men's eyes to a new life: 'Bliss was it in that dawn to be alive, But to be young was very heaven!' The works of Scott, Byron's *Don Juan*, the lyrics of Keats and Blake, all added a new depth to a period of change and growing excitement.

GEORGE I 1660–1727
Terracotta bust, 62.9 (24¾) high
By John Michael Rysbrack (4156)

On the death of Queen Anne in 1714, Georg Ludwig, the Protestant Elector of Hanover, came to London to ascend the throne as George I. A great-grandson of James I, he succeeded to the British throne by virtue of the Act of Settlement (1701) which excluded the Stuart heirs of James II because they were Roman Catholics. As a German-speaker, he preferred to spend much of his time in Hanover, leaving his son, the future George II, to deputise for him in London. His reign saw the beginning of the long Whig supremacy in government, with the Tories languishing in disfavour as a result of their association with the Stuarts and the 1715 Jacobite rebellion.

This terracotta bust shows the king as a Roman emperor crowned with laurel; it is an early work of the Flemish-born sculptor Rysbrack, who received numerous commissions for portrait busts and monuments during his long career in London. The bust probably dates from the later part of George I's reign or is perhaps posthumous.

73

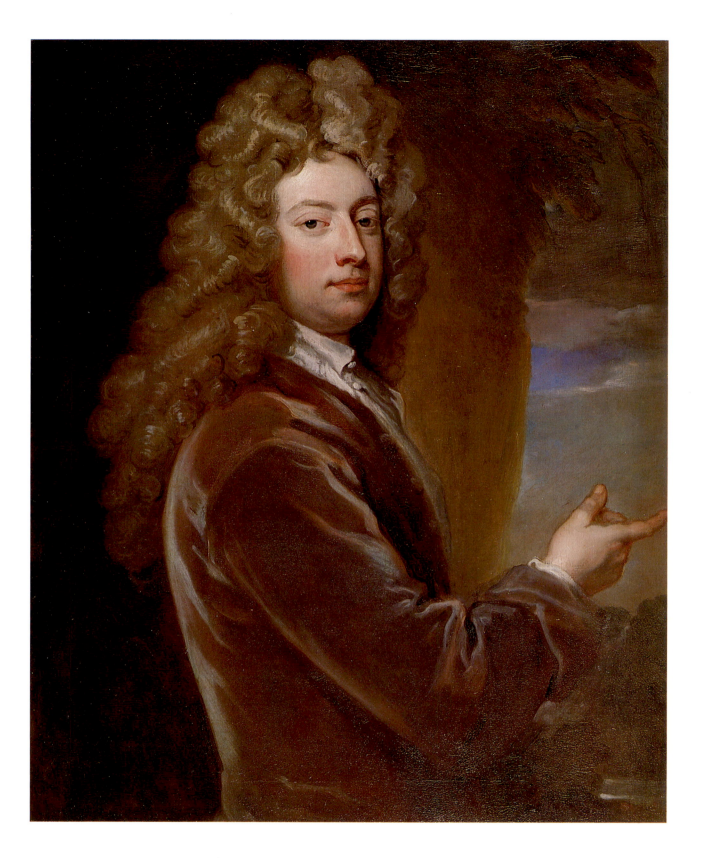

WILLIAM CONGREVE 1670–1729
Oil on canvas, 91.4 × 71.1 (36 × 28)
By Sir Godfrey Kneller, signed and dated 1709 (3199)

Before he was thirty, Congreve had dazzled society with a succession of the wittiest comedies of manners ever written for the English stage: *The Double Dealer, Love for Love* and *The Way of the World*. Dryden considered him his natural successor. Admired for his brilliant conversation, his gifts made him a favourite at court. He enjoyed the friendship of writers such as Swift, Steele and Pope.

In this painting, one of Kneller's Kit-Cat Club portraits, the artist stresses Congreve's easy conversational manner. His urbane features are topped by a magnificent periwig which almost seems like a metaphor for the wearer's profusion of elegant wit.

The portrait is painted in a format, between a half-length and a three-quarter-length, specially devised by Kneller for the Kit-Cat Club. The club, a group of leading Whig politicians and writers, took its name from its original meeting place, the tavern kept by Christopher Cat, who made delicious mutton pies known as 'kit-cats'.

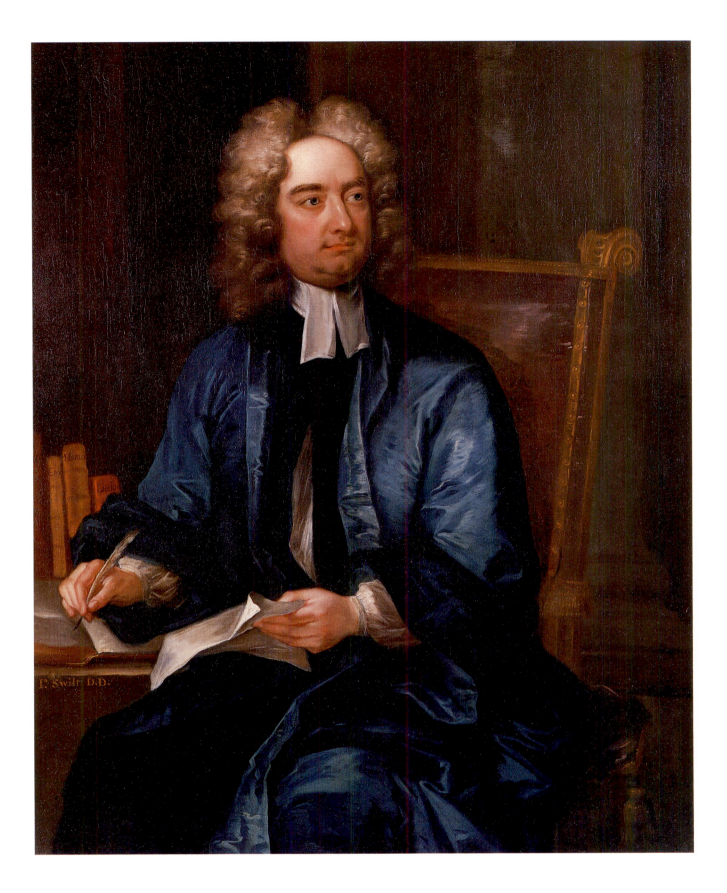

JONATHAN SWIFT 1667–1745
Oil on canvas, 123.2 × 97.2 (48½ × 38¼)
By Charles Jervas, *c*.1718 (278)

The Dean of St Patrick's Cathedral, Dublin, Swift was a political pamphleteer in the Tory cause, despite his friendship with Whig writers and wits like Addison, Steele and Congreve (p.74). With the publication of *The Tale of a Tub* and *The Battle of the Books* in 1704 he became the most pungent satirist of his day, overflowing with scorn and malice. But he never achieved the patronage and preferment he felt he deserved; in middle-age he became increasingly misanthropic, and died insane. His *Journal to Stella* gives an informal picture of contemporary London life, with glimpses behind the scenes of politics, while *Gulliver's Travels* (1726), though it may delight children, remains for adults a powerful moral fable with far-reaching implications.

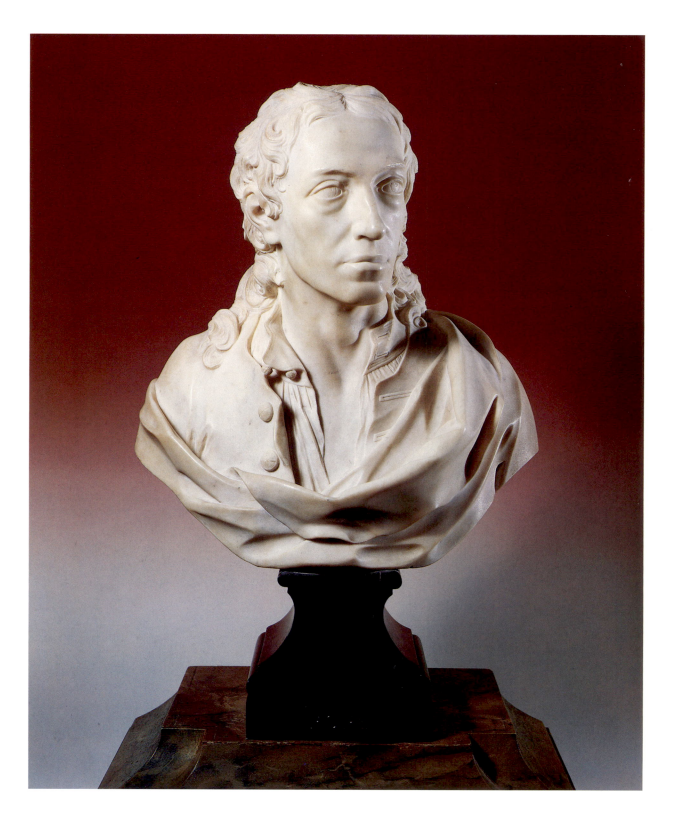

ALEXANDER POPE 1688–1744
Marble bust, 52.4 (20⅝) high
By John Michael Rysbrack, signed and dated 1730 (5854)

Pope was the first great poet of the Augustan age, and he expressed with wit and polish its concern for political and social stability and its rationalist belief in a universe controlled by unalterable laws: 'Nature and Nature's laws lay hid in night: God said, *Let Newton be*! and all was light!' The converse of his belief in Nature and Reason was his sensitivity to the irrationality and baseness of human behaviour, expressed in such bitingly satirical verse as the *Dunciad*. Friend of Swift (p.75) and Gay and a lover of town life, he was a hunchback and suffered from chronic ill health, finding solace at his suburban villa at Twickenham, where he created one of the earliest and most celebrated rococo gardens.

This penetrating characterisation is one of Rysbrack's most accomplished works and was described by Horace Walpole as 'very like'. The bust failed to meet with Pope's approval, however: he is reported by a contemporary as having 'ordered several Pictures and Busts of himself, in which he would have been represented as a Comely Person; but Mr Rysbrack, scorning to prostitute his Art, made a Bust so like him that Pope returned it without paying for it'. This bust's first owner was probably James Gibbs, the architect of Pope's Thames-side villa.

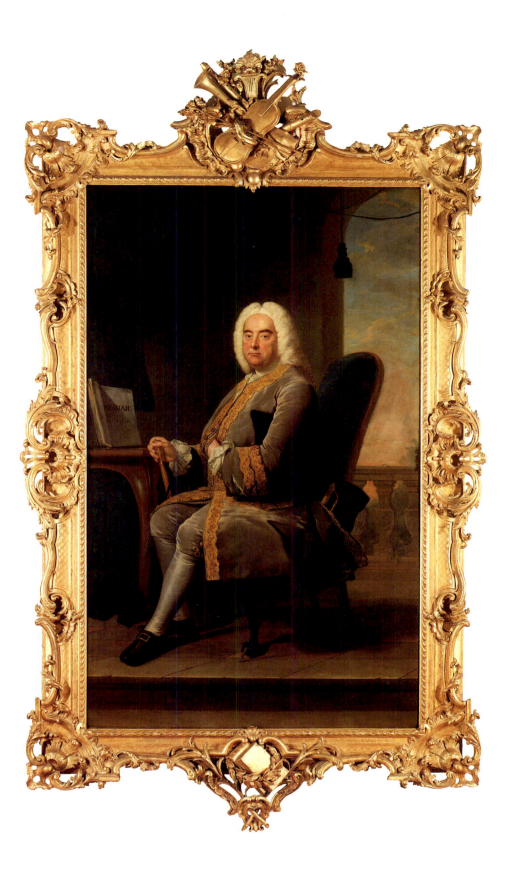

GEORGE FRIDERIC HANDEL 1685–1759
Oil on canvas, 238.8 × 146.1 (94 × 57½)
By Thomas Hudson, signed and dated 1756 (3970)

The only known painting of Handel in the blindness of his old age, the composer is shown with the score of *Messiah*, his greatest oratorio. Handel had first come from Hanover to London in 1710 and soon established himself at the forefront of the fashion for Italian Opera in London. His celebrated *Water Music* was composed for a royal journey from Whitehall to Chelsea in 1717, and he later provided the *Coronation Anthem* and the *Music for the Fireworks* to mark state occasions. But from the 1730s onwards most of his energies were devoted to the great oratorios, which have sustained the choral tradition to this day: *Saul* was first performed in 1739, and *Messiah* in 1742.

It was his friend, Charles Jennens, librettist of both oratorios, who commissioned this portrait, a late work by Thomas Hudson. The magnificent frame complete with musical trophies is in keeping with Jennens' reputation for grand effects – not for nothing was he nicknamed 'Solyman the magnificent'.

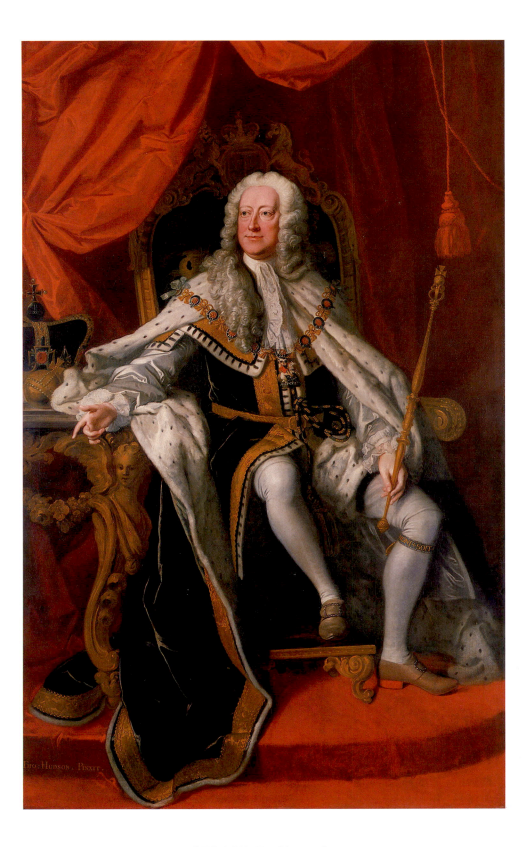

GEORGE II 1683–1760
Oil on canvas, 218.8 × 146.7 (86¼ × 57¾)
By Thomas Hudson, signed, 1744 (670)

George II first came to London with his father in 1714 when he was created Prince of Wales; he succeeded to the throne in 1727. The last British monarch to lead his troops into battle, his victory at Dettingen in Germany in 1743 made him a popular hero overnight. Vacillating in political crises, his interests lay in the pomp and ceremonial of royalty, and his favourite study was the genealogy of the German princely families.

Perhaps it was George II's success at Dettingen which encouraged the Chief Justice, Sir John Willes, to commission this portrait from Thomas Hudson to hang in the Court of Common Pleas at Westminster, where it remained until the demolition of the law courts in 1883.

George II was notoriously diffident about sitting for his portrait, and although Hudson held the leading position among portrait painters in London the king did not grant him a sitting. Nevertheless this elaborate essay in the grand baroque manner – it owes much to French royal portraiture – was thought very like and a good picture. The king wears ermine robes of state and the collar of the Order of the Garter.

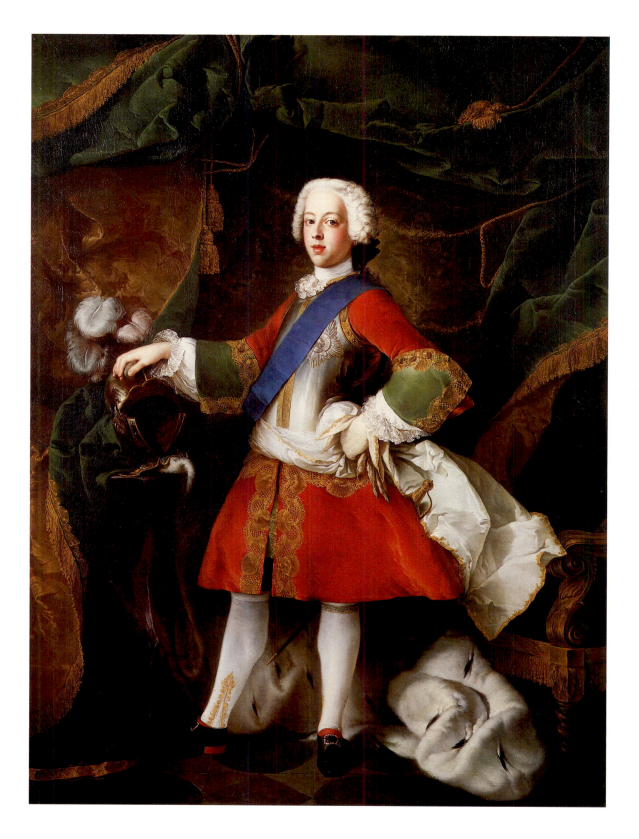

PRINCE CHARLES EDWARD STUART 1720–88
Oil on canvas, 190.5 × 141 (75 × 55½)
By Louis Gabriel Blanchet, signed and dated 1738 (5517)

The Jacobite cause, in exile centred on the court at St Germain near Paris, was revitalised by 'Bonnie Prince Charlie', the Young Pretender (grandson of James II). Securing the promise of French military support (which never materialised), the prince set sail for Scotland in 1745. Through the sheer attraction of his personality he found an enthusiastic following, occupied Edinburgh, won a victory at Prestonpans, continued to outwit the English generals, and terrified the government in London by reaching Derby. There the resolution of his staff failed to match his own, and a demoralising retreat began which ended with the slaughter at Culloden in 1746. After a legendary escape, the prince returned to France, from which however he was banished in 1748, and subsequently led a wandering life, drunken and dissolute.

This portrait, by the French artist Louis Blanchet, was painted in Rome in 1738, as a gift from the prince's father, the Old Pretender, to his great-aunt, the Duchess of Parma; it dates to a few years after his first taste of military action at the siege of Gaeta in 1734.

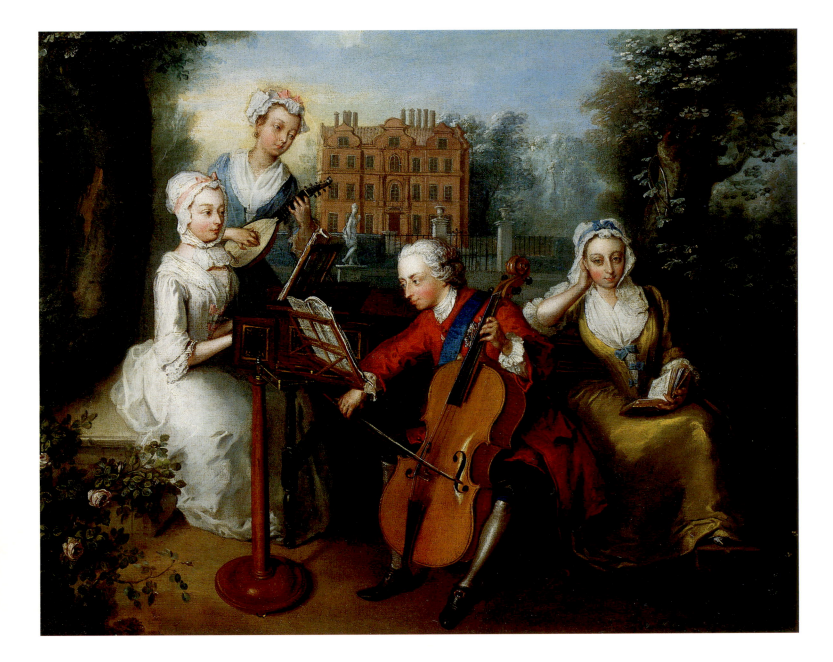

FREDERICK, PRINCE OF WALES 1707–51 AND HIS SISTERS
Oil on canvas, 45.1 × 57.8 (17¾ × 22¾)
By Philip Mercier, signed and dated 1733 (1556)

George II did not allow his son, Frederick, to come to London until the age of twenty in 1728; within a few years Frederick had set himself up as a focus of political opposition to his father and as the patron of the most avant-garde artists of the rococo. This conversation piece is the work of one such painter, Philip Mercier, German-born but French-inspired and much influenced by Watteau.

Disliked by his family – his mother called him 'the greatest liar and the greatest beast in the whole world' – Frederick commanded widespread affection in the country at large.

After his early death in 1751, Smollett called him 'a tender and obliging husband, a fond parent, a kind master, liberal, generous and humane; a magnificent patron of the arts, an unwearied friend to merit'.

Frederick is seen here playing the cello, with three of the royal princesses, his elder sisters. In the background is the Dutch House at Kew, the home of Anne, the Princess Royal; she is probably the figure at the harpsichord, with her younger sister, Princess Caroline, behind her playing the mandora, and, on the right, Princess Amelia reading from Milton.

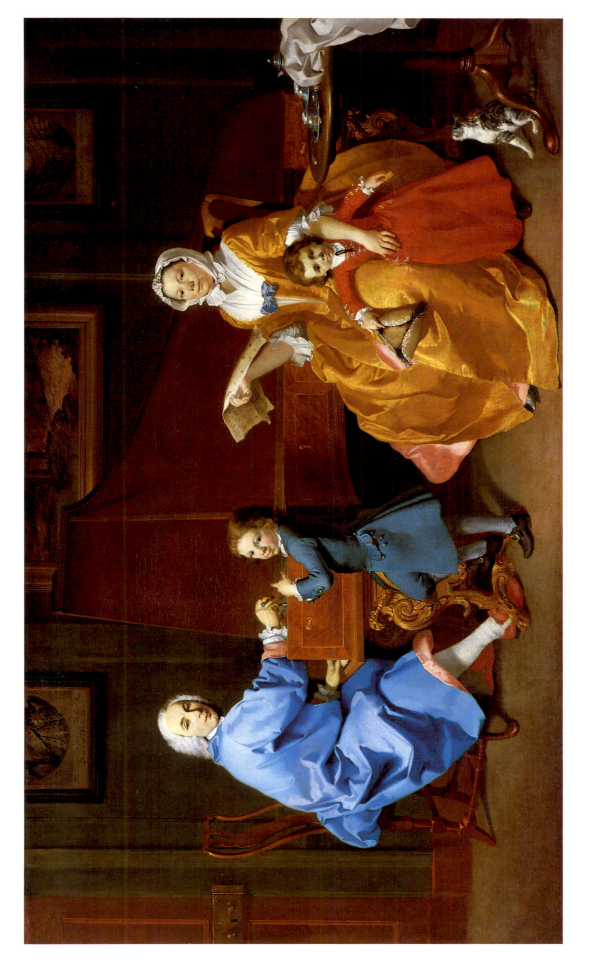

THE SHUDI FAMILY

Oil on canvas, 83.4 × 141.5 (32¾ × 55¾)
By Carl Marcus Tuscher, c.1742 (5776)

The sitters are (left to right): the harpsichord maker Burkat Shudi (1702–73), his son Joshua (1736–54), his wife Catherine (1707–58), and son Burkat (1737–1803).

The Swiss harpsichord maker and friend of Handel (p.77) moved to new premises in Pulteney Street, Soho, in 1742, and this exquisite conversation piece by his compatriot, Tuscher, was probably painted soon after. Shudi is portrayed tuning an especially magnificent harpsichord, a reminder that he was one of the most important makers working in London in the mid-century. John Broadwood, founder of the famous firm of piano makers, was later to work as Shudi's apprentice and to marry his daughter. On the walls of the room hang a landscape, said to be of Shudi's birthplace, and mezzotint portraits of his patron, Frederick, Prince of Wales (p.80) and his wife, Augusta, Princess of Wales.

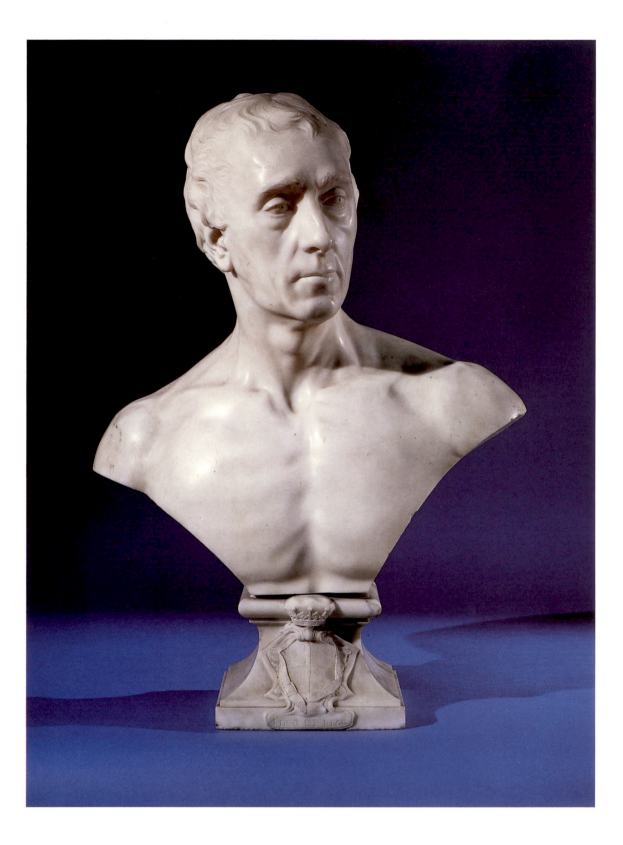

PHILIP DORMER STANHOPE, 4th EARL OF CHESTERFIELD 1694–1773
Marble bust, 57.8 (22¾)
By Louis François Roubiliac, signed and dated 1745 (5829)

One of the best-known eighteenth-century figures, Lord Chesterfield was a shrewd, indeed brilliant, politician, noted for his fine oratory. A caustic and untiring opponent of Sir Robert Walpole, he had a considerable share in the latter's downfall in 1742. He was an enlightened Lord Lieutenant of Ireland, believing that that country had more to fear from poverty than from popery.

Chesterfield took an active interest in the literary world and in his earlier years was the friend of Pope, Gay, Swift and Voltaire. His stoic philosophy of life, especially his belief in education and manners – in the continuing improvement of the mind and cultivation of the graces – is fully expressed in his celebrated letters to his illegitimate son, which were published after his death and achieved instant popularity.

This vivid marble bust represents Chesterfield as he must have wished to have been remembered, as a Roman states-man and patrician and an exemplar of Augustan gravitas and decorum. It was carved from the life in the months before his departure to take up office in Dublin in 1746.

SAMUEL JOHNSON 1709–84
Oil on canvas, 127.6 × 101.6 (50¼ × 40)
By Sir Joshua Reynolds, *c*.1756 (1597)

Massive, ungainly, plagued with nervous tics, Dr Johnson was a victim of melancholia and could not bear solitude. He had an immense circle of friends, and was one of the greatest conversationalists of all time. Though an authoritarian churchman and high Tory, overbearing and full of prejudice, yet tenderness and humanitarianism were dominant features of his character. This portrait by his friend, Reynolds, was painted shortly after the publication of the *Dictionary of the English Language* (1755), a prodigious labour, which remains a monument to his scholarship as well as to his forthright personality. It was about this time that Johnson wrote his famous letter to Lord Chesterfield (p.82) rebuking his former patron for his great neglect.

WILLIAM HOGARTH 1697–1764
Oil on canvas, 45.1 × 42.5 (17¾ × 16¾)
Self-portrait, *c*.1757 (289)

The most original and varied painter of his day, Hogarth was a campaigner for British art and a staunch opponent of old and foreign masters. What other painter would sign himself: W. Hogarth *Anglus*? Trained as a silversmith, he turned to engraving and then to painting in the late 1720s. His 'modern moral subjects', such as *The Harlot's Progress* (1731–2), *The Rake's Progress* (1735) and *Marriage à la Mode* (1743–5) were highly original, and he was the first English artist to popularize his works through engraving. So successful were his prints that they were frequently pirated and it was not until 1735, as a result of Hogarth's campaigning, that a Copyright Act was passed, protecting the work of artists and engravers.

Hogarth actively promoted the St Martin's Lane Academy as a training school for British artists, the main forerunner of the Royal Academy, and he encouraged his fellow artists to donate a history picture each to the Foundling Hospital, where they were publicly exhibited to an enthusiastic audience, the only such exhibition venue at the time.

In 1757, the year this self-portrait was begun, Hogarth was made Serjeant Painter to the king, a life-long ambition, and he gave this title to one of the many versions of the etching he made from this portrait. In the etching the figure he is painting on his canvas holds a book entitled 'Comedy', hence the picture's usual title, 'Hogarth Painting the Comic Muse'. This self-portrait amply demonstrates his determination and his pugnacious character.

GEORGE III 1738–1820
Oil on canvas, 147.3 × 106.7 (58 × 42)
Studio of Allan Ramsay, *c.*1767 (223)

George III ascended the throne in 1760 determined to break the long rule of the powerful Whig families and to restore something of the lost power of the crown. In this he was ultimately thwarted. The firmness of his views, often amounting to obstinacy, brought disaster to the country when he refused to recognise the legitimate grievances of the American colonists ('No taxation without representation'). Industrious and painstaking, he was especially interested in farming, mechanics and books: his collection forms the nucleus of the King's Library in the British Library. He founded the Royal Academy, but favoured the American painter Benjamin West rather than Sir Joshua Reynolds (p.87). As he became subject to more and more serious fits of insanity (due to porphyria), Parliament was obliged, in 1811, to pass a Regency Bill, and his last ten years were spent incapacitated by illness and blindness.

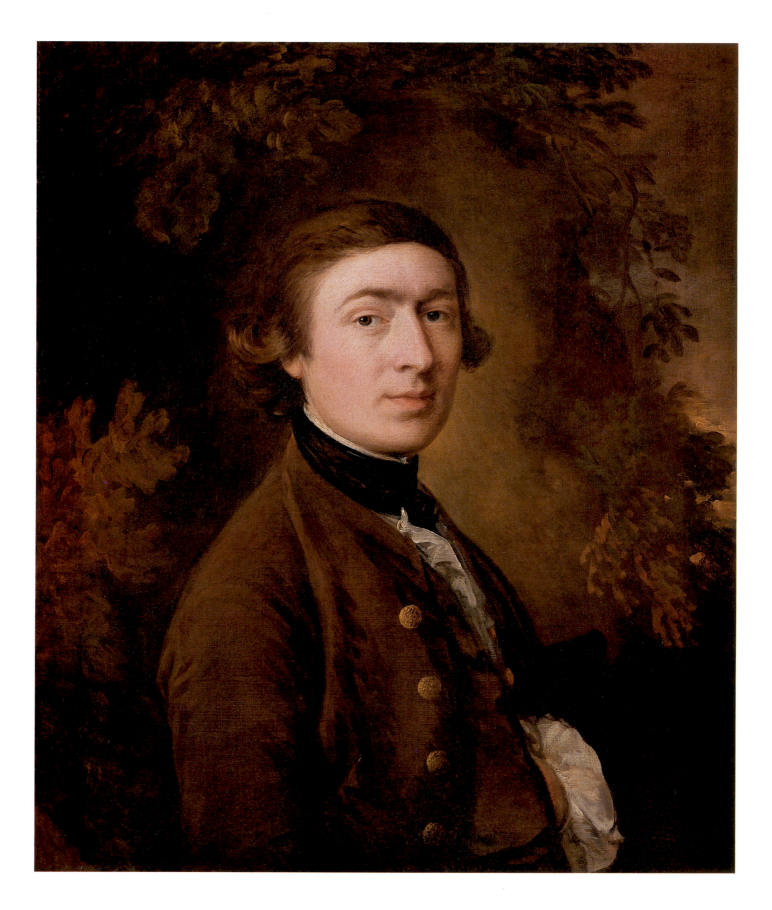

THOMAS GAINSBOROUGH 1727–88
Oil on canvas, 76.2 × 63.5 (30 × 25)
Self-portrait, *c*.1759 (4446)

Gainsborough was a professional portrait painter whose chief love was landscape. ('If the People with their damn'd Faces could but let me alone a little . . .'). Yet, unlike Reynolds (p.87) and most of his contemporaries, he customarily painted both costume and setting in his portraits with his own hand, and the sheer beauty of his handling of paint is unequalled in British art. He regarded likeness as 'the principal beauty and intention of a portrait', but his landscapes were imaginary, and expressed a nostalgic view of country life. He was the opposite of intellectual; many of his friends were musicians, and his letters have the brilliance and idiosyncrasy of the writings of Sterne (p.89).

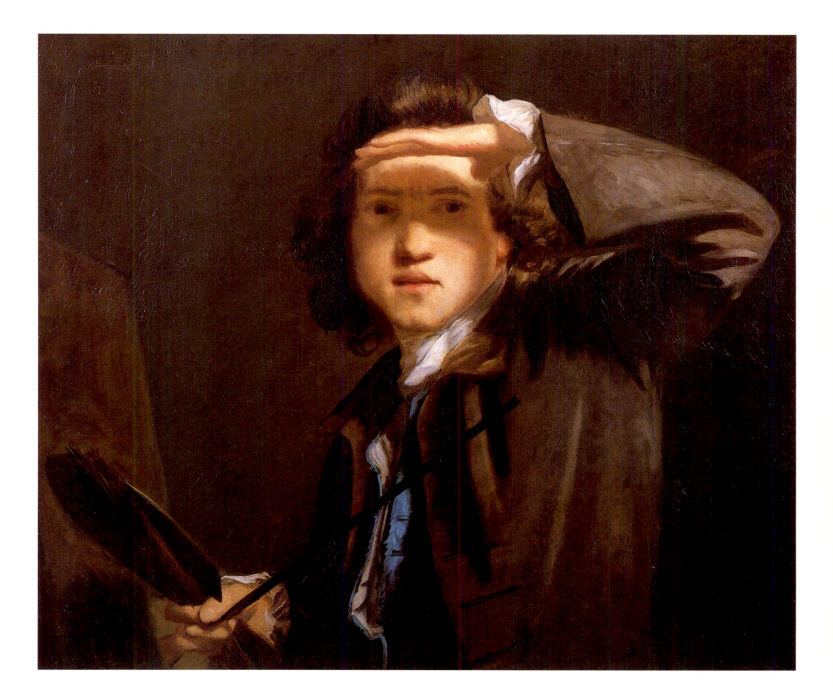

SIR JOSHUA REYNOLDS 1723–92
Oil on canvas, 63.5 × 74.3 (25 × 29¼)
Self-portrait, *c*.1747 (41)

Next to Gainsborough (p.86), Reynolds was the greatest English portrait painter of the eighteenth century, with a superb sense of design and profound understanding of character. He was largely responsible for founding the Royal Academy in 1768, of which he was the first president, and was knighted in 1769. In 1764 he founded 'The Club' in order to give Dr Johnson (p.83) 'unlimited opportunities for talking'.

This self-portrait is an early work, painted before his formative journey to Italy. The canvas has at some time been reduced in size, and, if a contemporary engraving is to be believed, has lost some 16cm at the top and 6cm at the bottom.

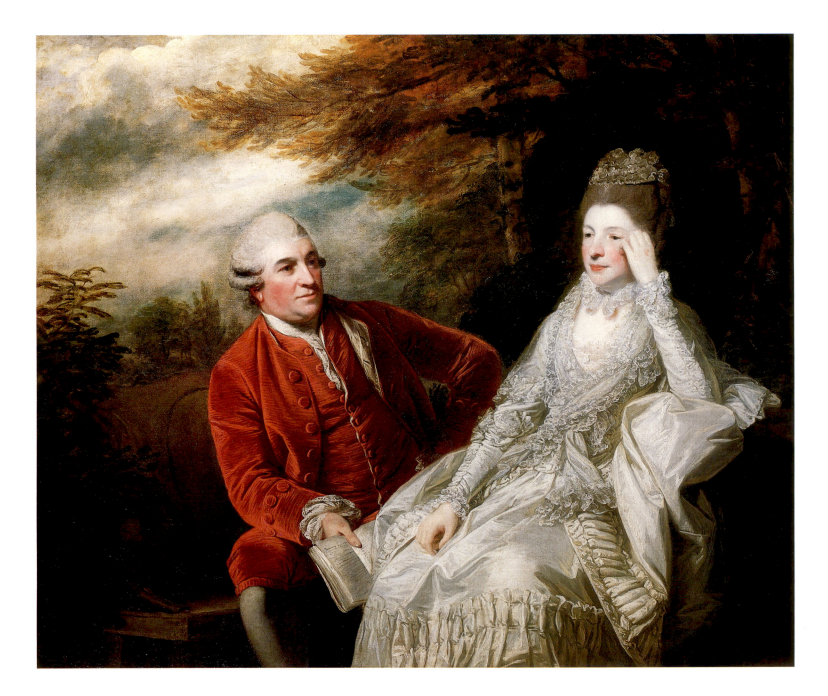

DAVID GARRICK 1717–79 AND HIS WIFE EVA MARIA 1724–1822
Oil on canvas, 140.3 × 169.9 (55¼ × 66⅞)
By Sir Joshua Reynolds, 1772–3 (5375)

The most celebrated actor of the eighteenth century, Garrick was educated at Lichfield Grammar School and at Samuel Johnson's Academy. He accompanied Johnson (p.83) to London in 1737, and made his first stage appearance in 1741. Thereafter he dominated the London stage until his retirement in 1776. He played both comedy and tragedy with equal accomplishment, which led Dr Johnson to praise his 'universality'.

In 1749 Garrick married the Viennese dancer Eva Maria Viegel, who appeared at Covent Garden under the name of 'Mlle Violette'. She outlived him by forty-three years, and died at the age of ninety-eight while waiting to set out for Drury Lane Theatre. Reynolds, who was a close friend of the actor, painted him several times, but this is the only portrait with his wife. It shows them relaxing in the garden of their country house at Hampton.

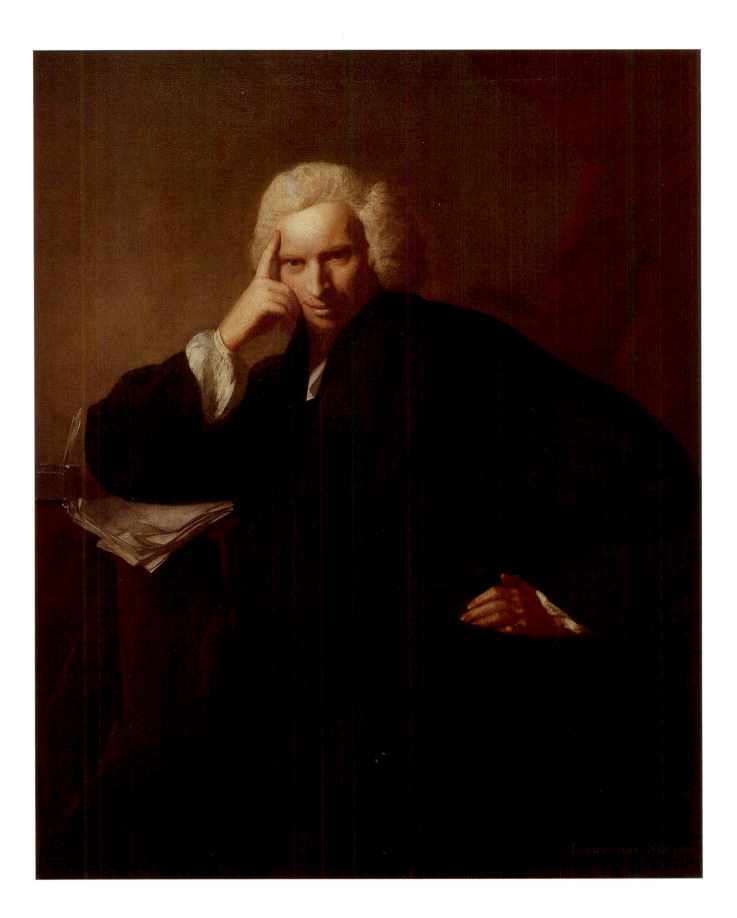

LAURENCE STERNE 1713–68
Oil on canvas, 127.3 × 100.3 (50⅛ × 39½)
By Sir Joshua Reynolds, signed and dated 1760 (5019)

Reynolds's classically composed portrait, incorporating the familiar gesture of the hand held to the forehead, traditional in portraits of philosophers and authors, represents Sterne at the moment of his greatest success, when *Tristram Shandy* was the talk of the town. Sterne's discursiveness, relaxed style and raciness of expression were a novelty in eighteenth-century literature; Richardson called the book 'execrable', and Johnson (p.83) always spoke of Sterne with scorn. Akin to the writings of Rousseau in its sensibility and lack of self-control, Sterne's *Sentimental Journey* (1768) made an instant appeal to French taste.

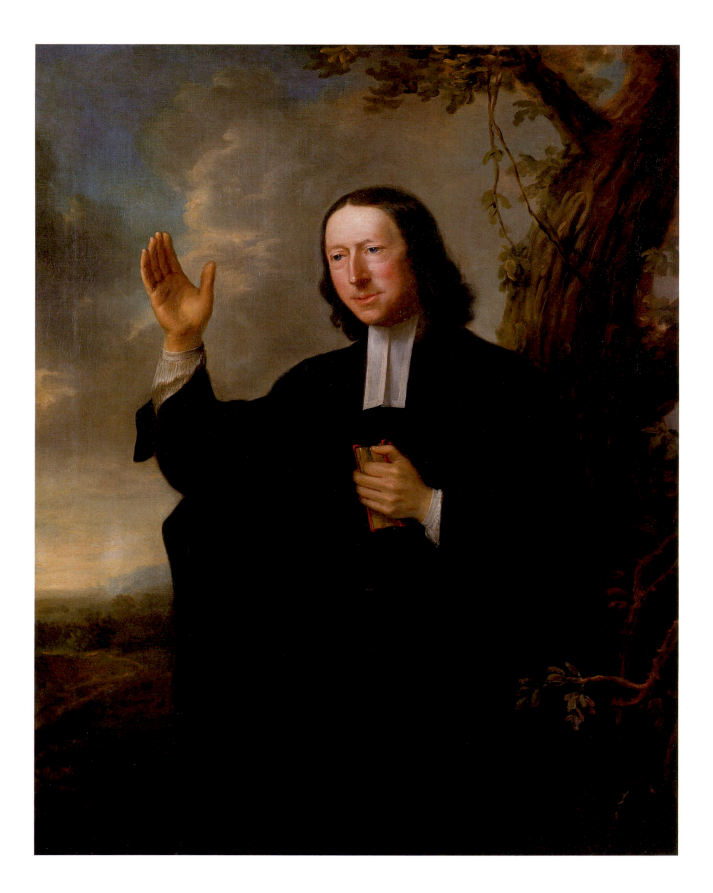

JOHN WESLEY 1703–91
Oil on canvas, 125.8 × 99.7 (49½ × 39¼)
By Nathaniel Hone, c.1766 (135)

One of the founders of Methodism, Wesley was wholly unlike most people's image of a preacher, missionary and evangelical. Good-humoured and even-tempered, with a fund of amusing stories, not in the least ascetic, he was a great swimmer and walker, and rode on horseback the estimated 250,000 miles he travelled to preach his 40,000 sermons.

A scholar and teacher of extraordinary dynamism, he hated the sleepy attitude of the established church, and started his own 'Methodist' movement (so-called from his pledge to live according to the 'methods laid down in the New Testament'), with its plain chapels in place of churches.

This portrait catches Wesley's piercing eye and his deep humanity, but gives a false impression of his short, but slim and wiry, figure.

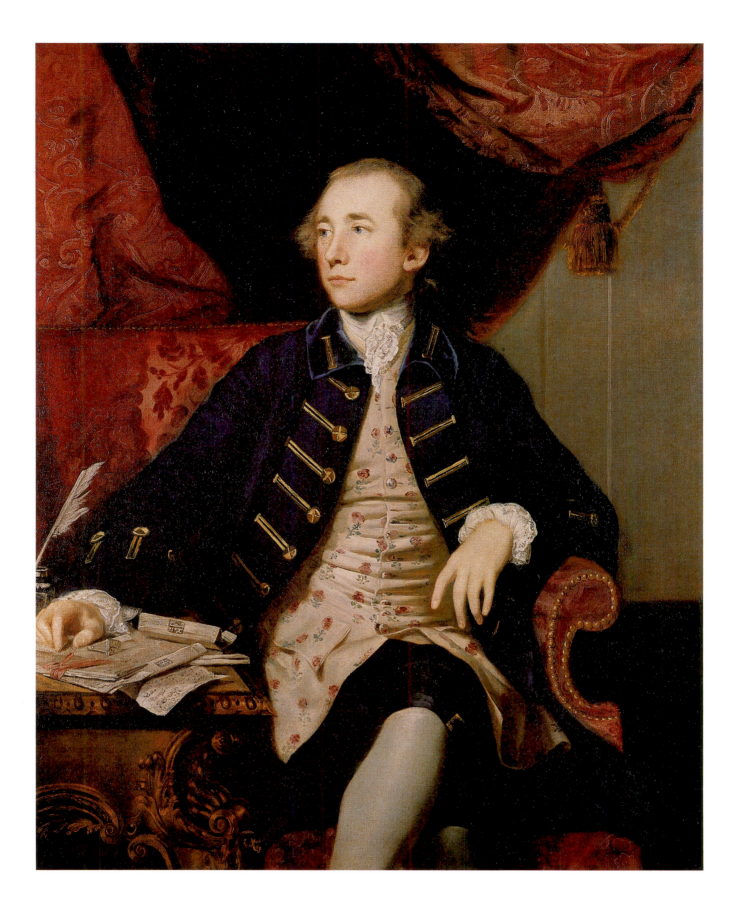

WARREN HASTINGS 1732–1818
Oil on canvas, 126.4 × 101 (49¾ × 39¾)
By Sir Joshua Reynolds, 1766–8 (4445)

As Governor of Bengal, Hastings engaged in far-reaching judicial and administrative reforms, and as the first Governor-General of India (1773) he successfully consolidated the empire established by Clive. No administrator in the complex political situation that prevailed could hope to govern without some degree of irregularity, and, largely through the vehement priggishness of Edmund Burke, Hastings was impeached for corruption on his return to England. Though finally acquitted, the trial dragged on for seven years and cost Hastings seventy thousand pounds. Reynolds's portrait, showing the young Hastings, before his health was broken by his ordeal, is one of his noblest compositions.

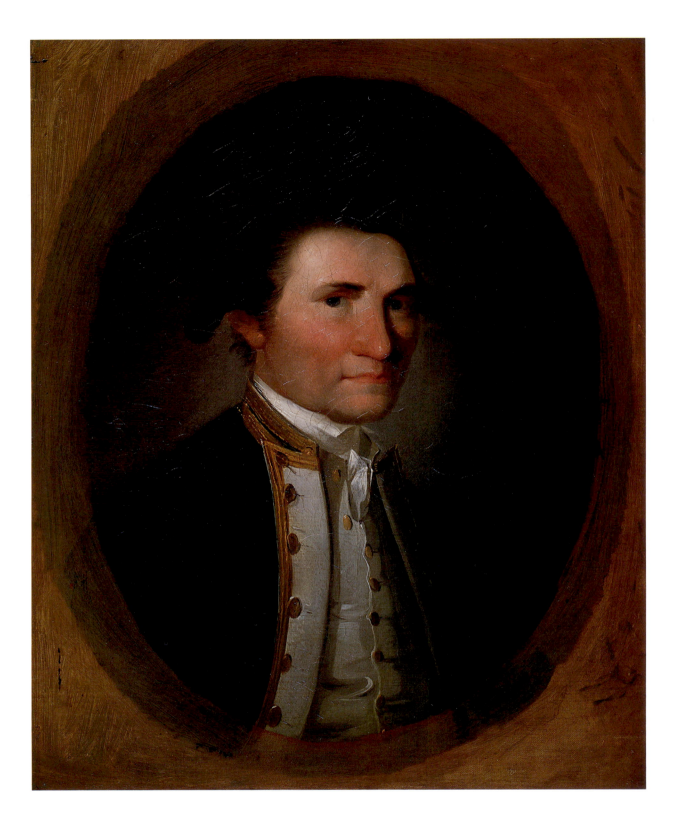

CAPTAIN JAMES COOK 1728–79
Oil on canvas, 36.8 × 29.2 (14½ × 11½)
By John Webber, 1776 (26)

Cook led three pioneering scientific expeditions to the Pacific at the instance of the Royal Society, spending over eight years at sea. On the first voyage, 1768–71, in which he lost a third of his men to disease, he charted New Zealand and the east coast of Australia; Botany Bay still retains the name given to it by Cook's naturalists, who included Joseph Banks (p.93). The object of the second expedition was to explore the myth of a great southern continent; it took Cook to the Antarctic ice-fields and was memorable for the elimination of scurvy and fever from his crew. On the third expedition, in search of a passage round the north of America, Cook was clubbed to death by the natives of Hawaii.

Cook showed enormous understanding and devotion to his men – he himself had worked his way up through the ranks – and he inspired in his crews absolute confidence in his abilities to bring his ship through the most distant and hostile waters where no European had sailed before. He was, one contemporary claimed, 'the most moderate, humane, and gentle circumnavigator that ever went out upon discoveries'. This portrait of Cook in the uniform of a naval captain is by John Webber, the draughtsman who accompanied his final expedition.

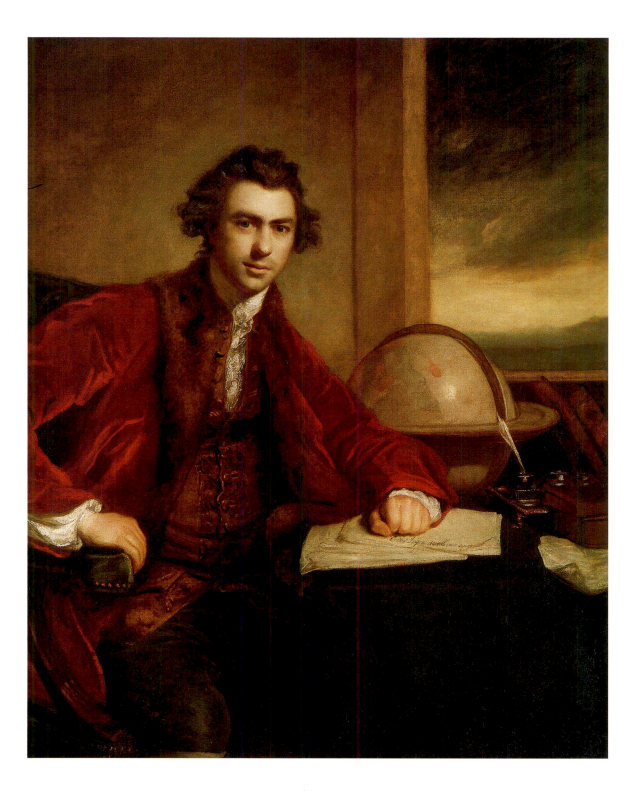

SIR JOSEPH BANKS 1743–1820
Oil on canvas, 127.3 × 101.9 (50⅛ × 40⅛)
By Sir Joshua Reynolds, 1773 (5868)

It was the young botanist, Joseph Banks, aged twenty-five, who realised the opportunities for botanical work on Captain Cook's (p.92) celebrated first voyage round the world in the *Endeavour*, starting in 1768. At his own expense he took with him naturalists and artists to record the fauna, flora, sea-life and peoples of the lands they explored. The many drawings and the hoard of strange specimens which Banks exhibited on his return home in 1771, caught the imagination of all London.

Banks sat to Reynolds for this portrait in 1772 and again, after a voyage to Iceland, in 1773, the picture being exhibited at the Royal Academy that year. It is one of Reynolds's masterpieces, a noble and powerful image of a man he greatly admired. Banks is shown half-rising from his chair, in keeping with the inscription on the letter on which his hand is resting, taken from an ode by Horace and reading 'Cras Ingens iterabimus aequor' ('tomorrow we'll sail the vasty deep again').

Banks was President of the Royal Society from 1778 until his death over forty years later. He dominated the scientific scene in Britain and had an international reputation. Perhaps the most handsome tribute was paid by Linnaeus, the Swedish botanist: 'I cannot sufficiently admire Mr Banks who exposed himself to so many dangers and has bestowed more money in the service of natural science than any other man. Surely none but an Englishman would have the spirit to do what he has done.'

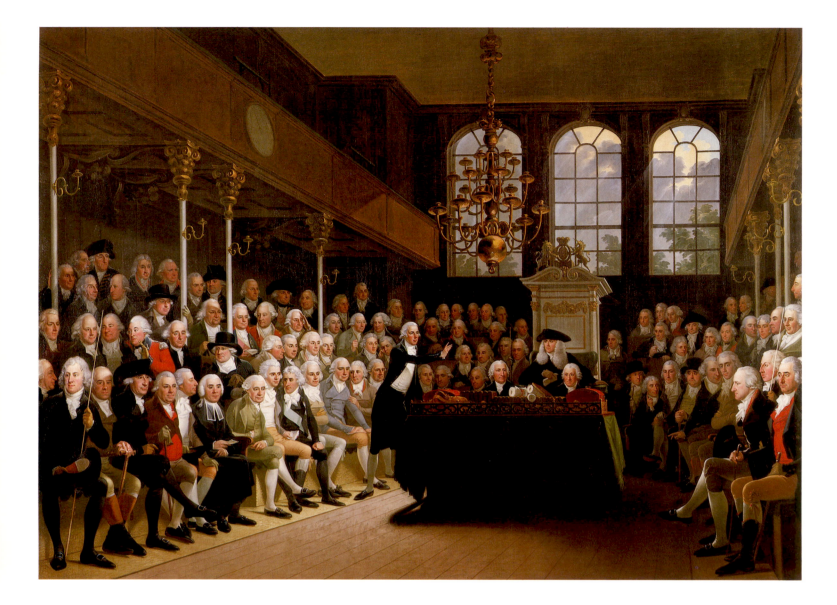

WILLIAM PITT 1759–1806 ADDRESSING THE HOUSE OF COMMONS
Oil on canvas, 322.6 × 449.6 (127 × 177)
By Karl Anton Hickel, 1793–5 (745)

Prime Minister at twenty-four, and holder of that office almost without interruption until his untimely death, Pitt was balanced, scrupulous and hard-working, and primarily a man of business, greatly respected by the City of London. Responsible for England's financial recovery after the War of American Independence, he introduced a Sinking Fund to reduce the National Debt, and advocated Free Trade. An exceptionally able administrator, he governed through a strong inner cabinet, and, in contrast to the rambling brilliance of Fox, displayed astonishing intellectual power in his speeches in the House of Commons. Reluctantly embroiled in

war against France, he died in 1806, shattered by the news of Napoleon's victories at Ulm and Austerlitz.

This scene is the work of the Austrian painter, Karl Anton Hickel, who settled in Paris shortly before the French Revolution but soon fled to England. In this painting, inspired by two House of Commons debates in February 1793 at the outbreak of war with France, Pitt is addressing the Commons from the government side; Fox (in the black hat), Sheridan and Erskine sit on the Opposition front bench. The interior is St Stephen's Chapel, destroyed by fire in 1834, looking eastwards towards Speaker Addington in the chair.

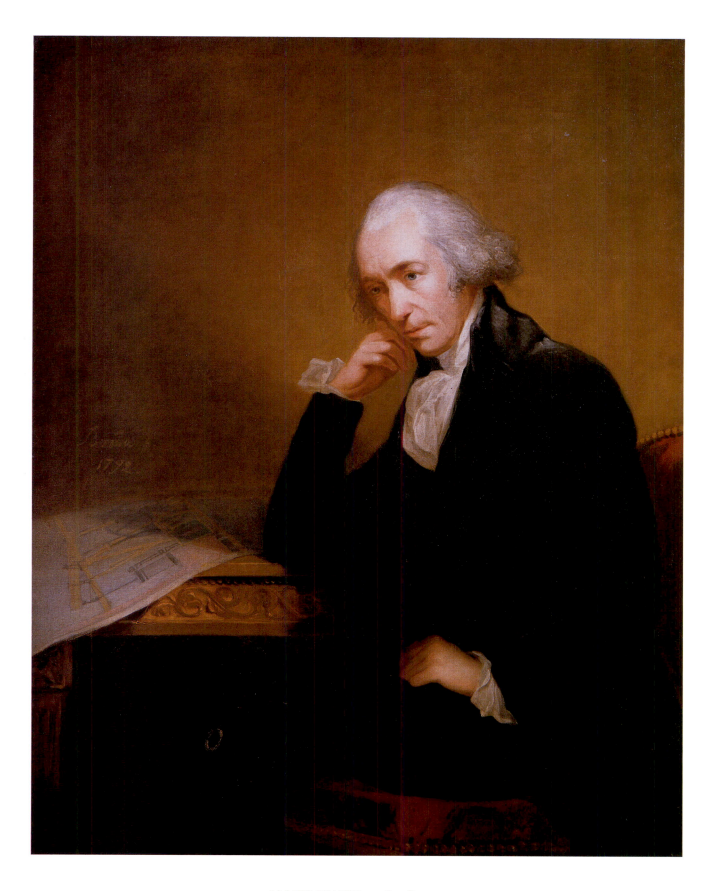

JAMES WATT 1736–1819
Oil on canvas, 125.7 × 100.3 (49½ × 39½)
By Carl Frederik von Breda, signed and dated 1792 (186a)

Watt began his working life as a scientific instrument maker for Glasgow University, where he observed the deficiencies of Newcomen's steam-engine and went on to patent his own in 1769, incorporating a special condenser and air-pump. The first practical cylindrical steam-engines were put on the market by Watt and his partner, Matthew Boulton of Birmingham. The power thus generated replaced the old-fashioned horse- and water-driven machinery, almost immediately revolutionising world industry and immortalising Watt's name, inaccurately but effectively, as 'the inventor of the steam-engine'.

The artist, Carl Frederik von Breda, a Swedish portrait painter who spent two years in Sir Joshua Reynolds's studio, has shown Watt with plans of his condenser.

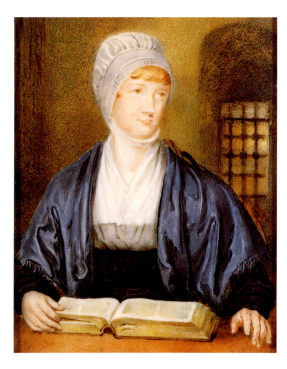

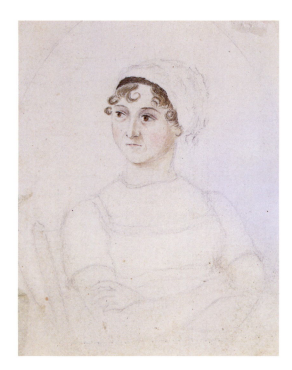

ELIZABETH FRY 1780–1845
Watercolour on ivory, 11.4 × 8.3 (4½ × 3¼)
By Samuel Drummond, c.1815 (118)

JANE AUSTEN 1775–1817
Pencil and watercolour on paper, 10.8 × 7.9 (4¼ × 3⅛)
By Cassandra Austen, c.1810 (3630)

A member of a Norfolk Quaker family, she took up the ministry after her marriage and became deeply concerned at the condition of women prisoners at Newgate, where the overcrowding of innocent and guilty alike was appalling. As a visiting American minister said, 'the wretched outcasts have been tamed and subdued by the Christian eloquence of Mrs Fry', but it was her introduction of a matron, proper supplies of clothing and even a school that really helped.

This tiny drawing by her sister Cassandra catches the alert expression of one of the sharpest observers of the human heart and character, and of the nuances and comedy of middle-class social life and relationships, in English literature.

Lively, intelligent and fastidious, Jane Austen's deceptively simple prose style has never been equalled for clarity and perfection. She never married and passed much of her outwardly uneventful life among the comforts of a country rectory in Hampshire.

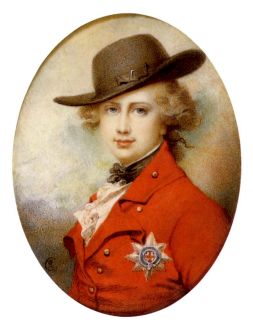

GEORGE IV 1762–1830
Watercolour on ivory, 9.8 × 7.3 (3⅞ × 2⅞)
By Richard Cosway, signed, c.1792 (5890)

Cosway was appointed Principal Painter to the Prince of Wales (later George IV) in 1785, and from that time onwards produced numerous elegant and stylish portraits of him.

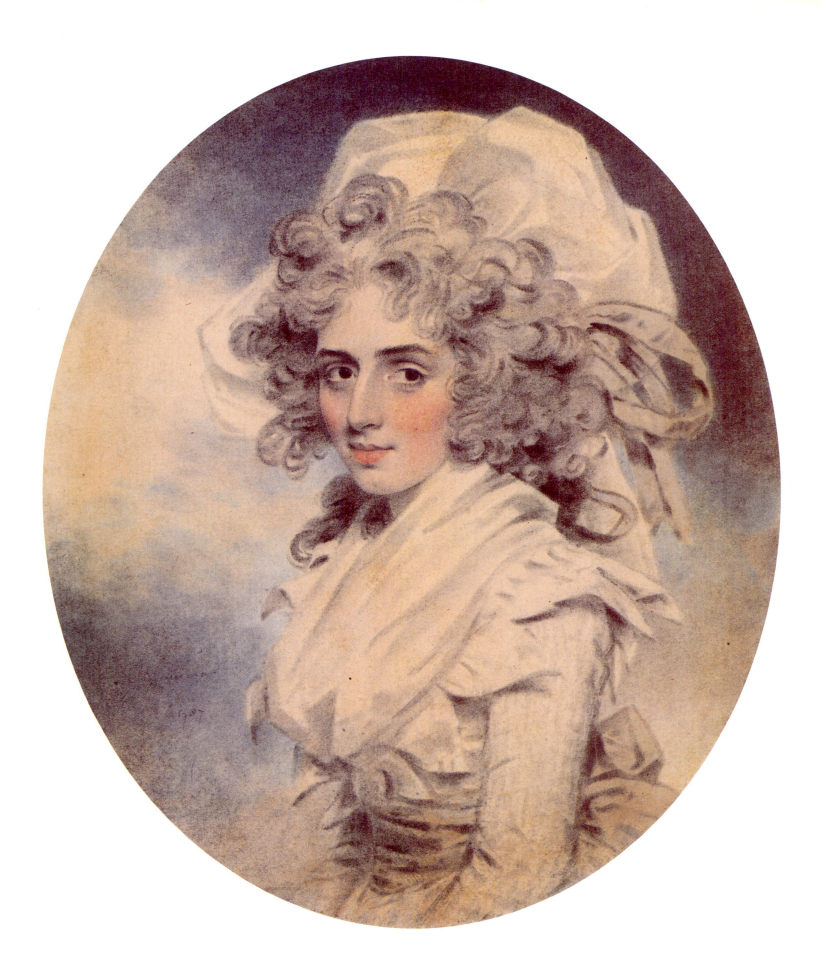

SARAH SIDDONS 1755–1831
Chalk on paper, 20.3 × 17.1 (8 × 6¾)
By John Downman, signed and dated, 1787 (2651)

England's greatest tragedienne, Sarah Siddons established
her reputation acting with Garrick (p.88) at Drury Lane and
with her brother, John Philip Kemble, at Covent Garden.

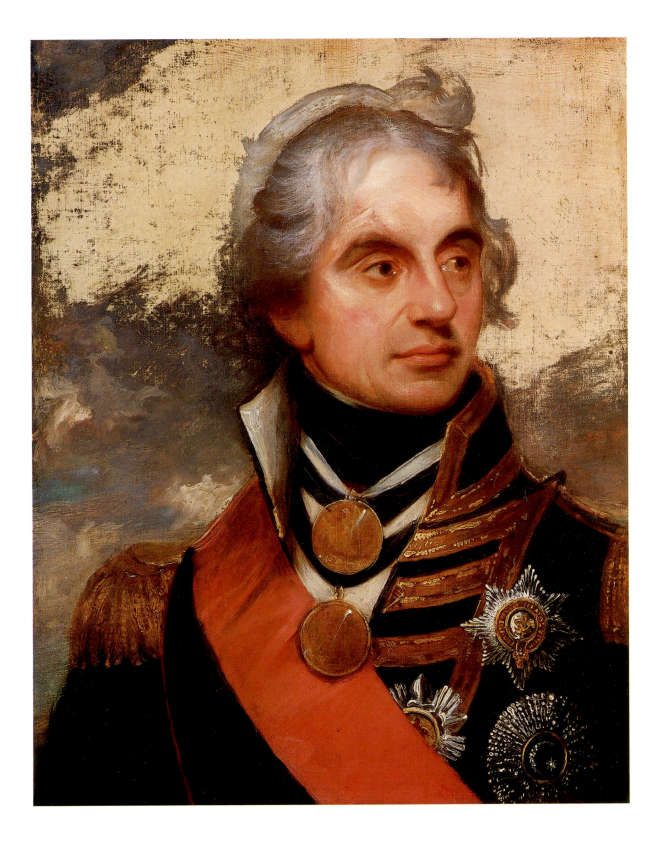

ADMIRAL HORATIO NELSON, VISCOUNT NELSON 1758–1805
Oil on canvas, 62.2 × 48.3 (24½ × 19)
By Sir William Beechey, 1800 (5798)

A brilliant sketch from life – one of Sir William Beechey's noblest portraits – of the great admiral who shattered the French Navy and who maintained the blockade of Europe which wore down Napoleon's resources. It is a study for a full-length portrait commissioned by the City of Norwich from Beechey (Norfolk-born, like Nelson), and painted between Nelson's landing at Yarmouth in November 1800 and the victory of Copenhagen in April 1801.

The sketch shows alterations made by the artist to the shape of the head, and the wound inflicted over Nelson's right eye

at the Battle of the Nile in 1798. Curiously, his eyes are shown brown, when in reality they were grey. The directness of this portrait provides as close and faithful an image of the great admiral as we are likely to see.

Nelson inspired his men with an enormous sense of respect, devotion and even love; he was a masterly tactician, but perhaps his greatest genius was for correctly anticipating the enemy's moves. He annihilated one fleet at the Battle of the Nile and finally destroyed Napoleon's sea power at Trafalgar, where he was mortally wounded.

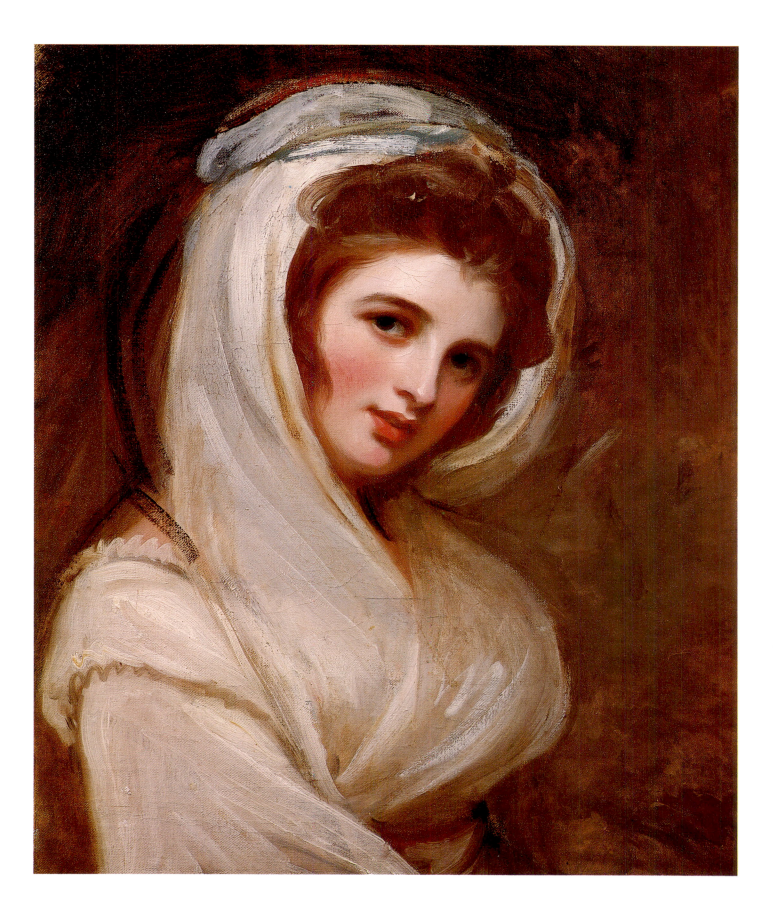

EMMA, LADY HAMILTON 1765–1815
Oil on canvas, 62.2 × 54.6 (24½ × 21½)
By George Romney, *c.*1785 (4448)

Romney painted over twenty portraits of the beautiful and talented girl who, after coming to London penniless at the age of fourteen or fifteen, became the mistress of Charles Greville and later the wife of Greville's uncle, Sir William Hamilton, the celebrated connoisseur who was British Ambassador to the court of Naples. At Naples she feted Nelson (p.98) after his decisive victory at the Nile; the relationship which developed is one of the great romances of British history. But Nelson's death in 1805 saw the beginning of her downfall: debt eventually drove her from England to a lonely exile in France, where she died in 1815.

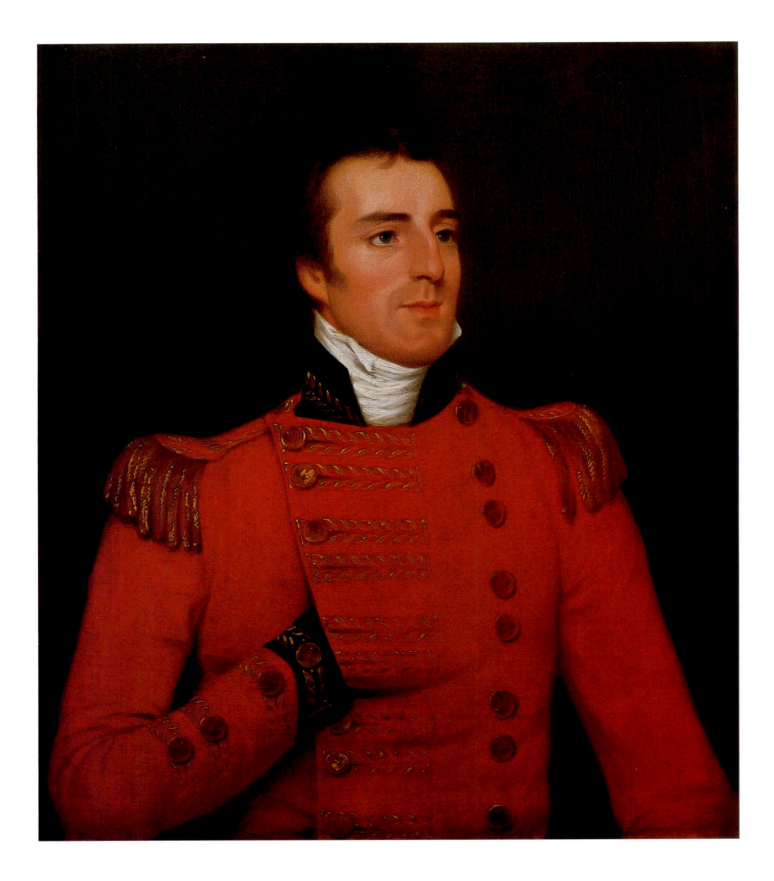

ARTHUR WELLESLEY, 1st DUKE OF WELLINGTON, 1769–1852
Oil on canvas, 76.2 × 66 (30 × 26)
By Robert Home, 1804 (1471)

The legendary hero, 'the Iron Duke', did more than any man to lead Europe to victory against Napoleon in the long-drawn-out struggle which culminated at Waterloo in 1815. A masterly strategist, industrious in day-to-day routine, and devoted to the well-being of his troops, it was these qualities which enabled him to endure and finally triumph in the long Peninsular campaign, fought through Portugal and Spain and finally into France, in the six years, 1809–14. In battle he was fearless, his genius lying in rapid adaptability to situations.

After Waterloo, his immense prestige led him into politics, and he was twice prime minister. He became Queen Victoria's trusted friend and adviser, the nation's 'elder statesman' and a legend in his own time.

This early portrait shows the future Duke in major-general's uniform; it was painted in India where he first gained his reputation for military prowess.

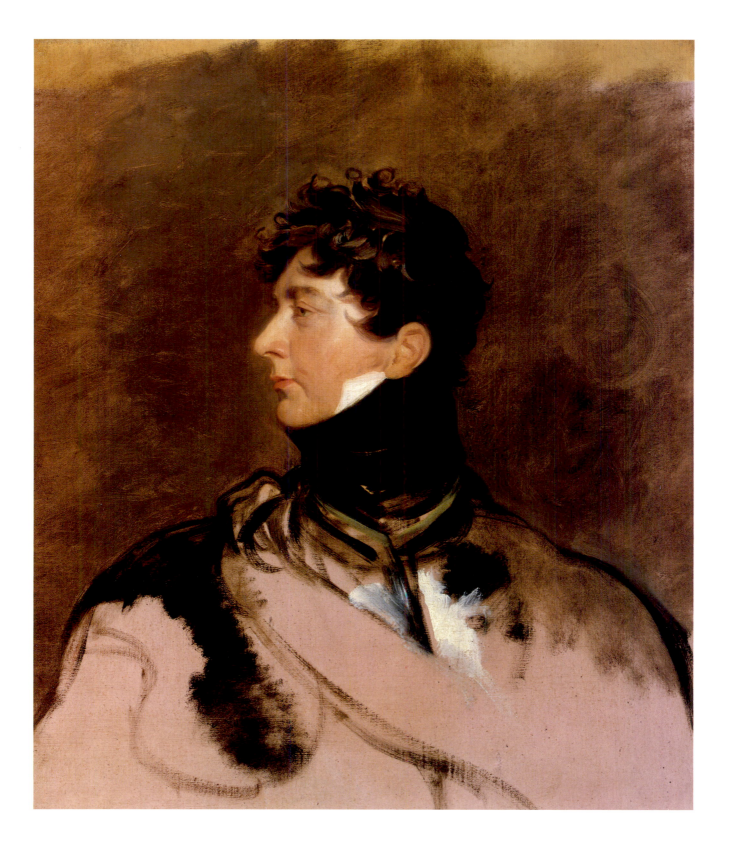

GEORGE IV 1762–1830
Oil on canvas, 91.4 × 71.1 (36 × 28)
By Sir Thomas Lawrence, *c.*1814 (123)

The eldest son of George III, he was Prince Regent from 1811 during his father's illness and insanity, and succeeded him in 1820. During his regency England won some of her proudest victories by sea and land, and produced some of her finest works of art and literature, and the Prince was a fitting, if slightly *outré*, symbol of the period. Unstable and impolitic, perhaps; selfish and self-indulgent, certainly; extravagant beyond comparison in an age of extravagance; but lively, cultured, with immense charm and perfect manners. His taste is epitomized by the Pavilion at Brighton, but he also had a fine knowledge and appreciation of old master paintings, gave encouragement to the architect John Nash, greatly admired the novels of Jane Austen, and sent £200 to Beethoven.

Lawrence was first presented to the Prince Regent in 1814, and granted four or five sittings, the prince coming to his studio for the purpose. This oil sketch, which relates very closely to a drawing in the Royal Library, is possibly one of the original studies for the innumerable glamorized portraits of him, both as regent and as king, with which Lawrence has immortalized his face and figure.

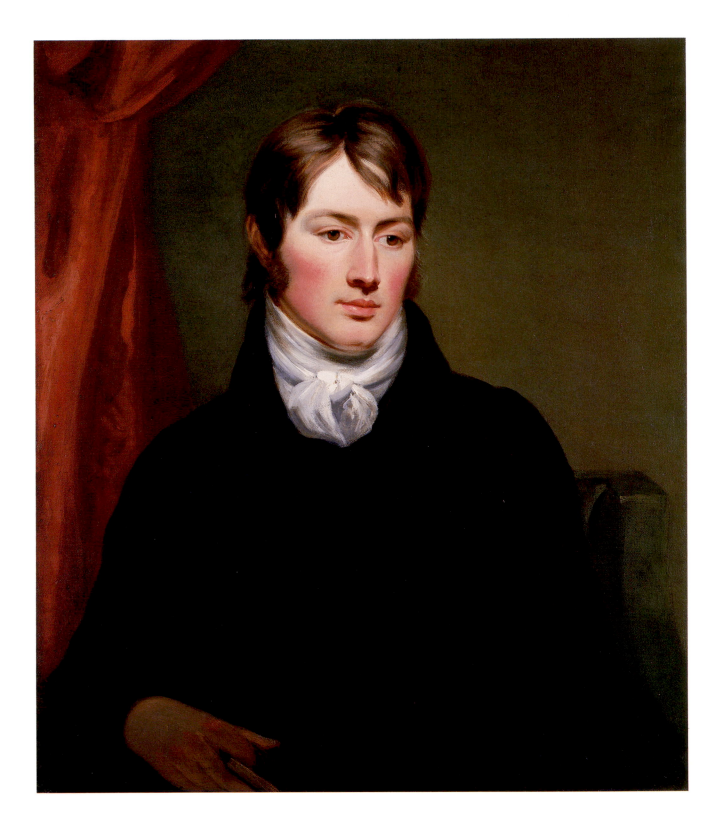

JOHN CONSTABLE 1776–1837
Oil on canvas, 76.2 × 64.0 (30 × 25⅛)
By Ramsay Richard Reinagle, *c.*1799 (1786)

'These scenes made me a painter', Constable wrote of his native Suffolk countryside, the subject of so many of his great landscape paintings. He also painted scenes of the Lake District, and more especially of Salisbury and the Dorset coast, and of Hampstead, where he lived for many years.

Constable's greatness lay in his ability to combine detailed observation of nature with the most carefully composed of landscapes. His deep understanding of the structure of fields, woods and clouds complements the Lakeland poets' observation of nature. However it was not until the 1820s that his paintings of the English countryside began to obtain wide public recognition. Even the French were astonished by the freshness of his vision, Delacroix himself repainting the background of his *Massacre at Chios* after seeing the Constables exhibited at the 1824 Paris Salon.

At his death his friends, led by Beechey, presented *The Cornfield* to the National Gallery – an act of faith and courage at a time when Constable's true greatness was only just beginning to be realised. Reinagle's portrait was probably painted in 1799 when the two young friends were spending the summer together at Constable's home in East Bergholt.

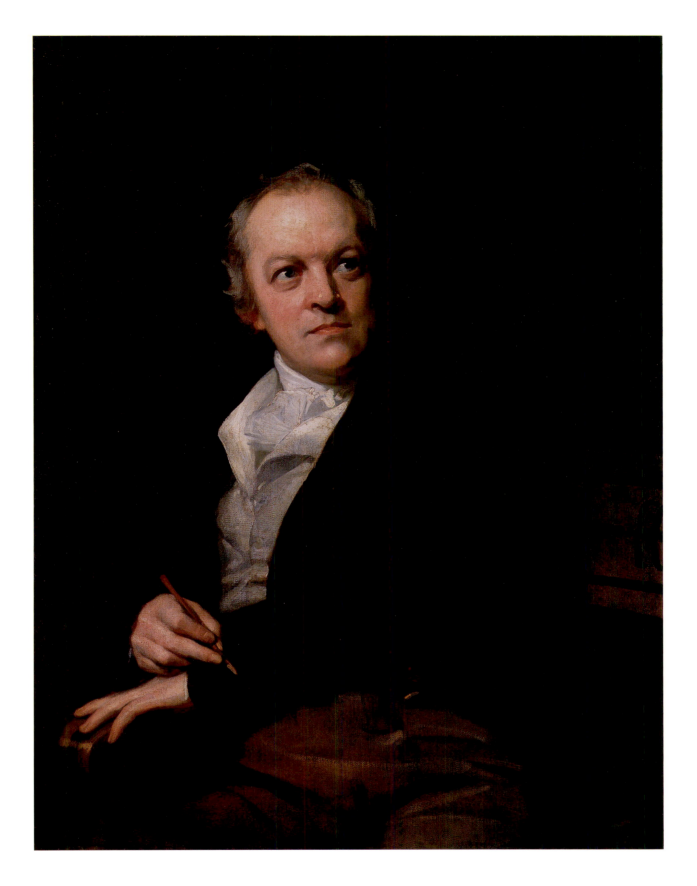

WILLIAM BLAKE 1757–1827
Oil on canvas, 91.9 × 71.5 (36½ × 28¼)
By Thomas Phillips, signed and dated 1807 (212)

Blake's genius as a mystical poet and author of *Songs of Innocence* (1789) and *Songs of Experience* (1794) overshadows his imaginative gifts as painter, engraver, illustrator and producer of illuminated books. From early childhood, when he saw angels in the sky, to his death, singing with happiness, the pursuit of the visionary experience was his life's main theme. 'Jerusalem' and 'The Tiger', two of the most familiar poems in the English language, constitute the essence of this theme. His watercolour illustrations to the *Book of Job* and to Dante, mainly dating to the 1820s, are among his masterpieces.

Thomas Phillips is said to have caught the 'rapt poetic expression' on Blake's face by luring him to talk of his friendship with the Archangel Gabriel.

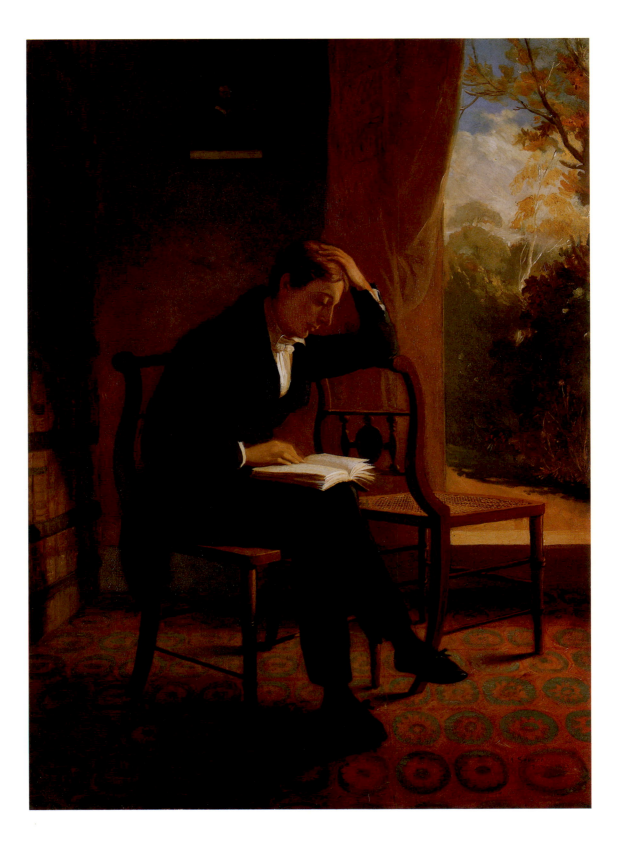

JOHN KEATS 1795–1821
Oil on canvas, 57.6 × 42.6 (22¾ × 16¾)
By Joseph Severn, signed and dated Rome 1821 (58)

Keats, one of the best-loved of Romantic poets, died of tuberculosis at the age of twenty-five. Though trained as a medical student, from his schooldays he had cared for nothing but literature. His odes 'To a Nightingale' and 'On a Grecian Urn', 'The Eve of St Agnes' and the ballad 'La Belle Dame sans Merci' are among his most magical works; his love for Fanny Brawne part of English romance. In 1820 he sailed to Italy in a vain search for health with his friend, Joseph Severn, the painter of this portrait, but he died in Rome, tenderly nursed by the artist. Keats was small but striking in

appearance: 'every feature was at once strongly cut and delicately alive'. Severn wrote of this portrait that after the poet's death the impression was so painful to him that he tried to recall 'the most pleasant remembrance in this picture . . . This was the time he first fell ill and had written the Ode to the Nightingale (1819) . . . I found him sitting with the two chairs as I have painted them and was struck with the first real symptoms of sadness in Keats so finely expressed in that poem . . . After this time he lost his cheerfulness and I never saw him like himself again'.

GEORGE GORDON, 6th BARON BYRON 1788–1824
Oil on canvas, 76.5 × 63.9 (30⅛ × 25⅛)
By Thomas Phillips, signed, *c.*1835 (142)

Byron's wild lifestyle and sombre poems possessed and haunted the imagination of Europe and have become symbolic of the Romantic Movement. The first cantos of *Childe Harold* were published in 1812 and made him famous overnight at the age of twenty-four.

Byron was a man of extraordinary complexity: exhibitionist, dandy, womaniser, idealist and realist, aristocrat and revolutionary, poet and soldier. Everything he felt about life and society, and knew about himself, he poured into his lengthy masterpiece, *Don Juan*: 'every word has the stamp of immortality', Shelley claimed. Byron died for his ideals, fighting in the Greek War of Independence.

Phillips's portrait shows the poet as one of the young lords of creation, arrayed in the Albanian costume he bought in Epirus in 1809. Byron probably sat to Phillips at the request of his publisher, John Murray, in 1813. The original of this portrait is in the British Embassy in Athens, while this version was painted by the artist in about 1835. The Albanian costume is now at Bowood in Wiltshire.

WILLIAM WILBERFORCE 1759–1833
Oil on canvas, 97.8 × 111 (38½ × 43¾)
By Sir Thomas Lawrence, 1828 (3)

A wealthy parliamentarian of high principles and great personal charm, Wilberforce was a lifelong friend of William Pitt (p.94). Though a leading evangelical and member of the Clapham Sect, he was also amusing and sociable and was pronounced by Madame de Stael the 'wittiest man in England'. He helped found the Church Missionary Society, published a popular book on practical Christianity, subsidised the good works of Hannah More, and liberally supported many in need. But his life's work was the anti-slavery campaign, of which he was parliamentary leader; his bill abolishing the slave trade was passed in 1807, and slavery itself was abolished in 1833, the year of his death.

The unfinished state of this vivacious portrait was no fault of Wilberforce's, who wrote to the ever-busy Lawrence at least twice trying to cajole him into further sittings. But at Lawrence's death in 1830, two years after the portrait was begun, it was described as 'not half finished'.

The rather uncomfortable pose, also to be found in other portraits of Wilberforce in old age, is accounted for by Wilberforce himself who says that he was obliged to wear 'a steel girdle cased in leather and an additional part to support the arms'.

THE TRIAL OF QUEEN CAROLINE
Oil on canvas, 233 × 266 (91¾ × 104)
By Sir George Hayter, 1820–3 (999)

After her disastrous marriage to the Prince Regent, and partly as a result of his unkindness and lack of sympathy, Princess Caroline gave way to a life of flagrant debauchery throughout Europe. This resulted in a series of semi-official investigations leading finally to divorce proceedings when, on the death of George III in 1820, she returned to England. The 'trial' in the House of Lords took the shape of a debate on a Bill of Pains and Penalties. It was marked by the eloquence of her defending counsel, Lord Brougham, the ludicrous behaviour of the witnesses, especially Majocchi whose repetition of 'non mi ricordo' became a popular refrain, and finally the adjournment of the proceedings by the Prime Minister, Lord Liverpool. On the whole, public feeling supported Caroline, but she was turned away from her husband's coronation at the doors of Westminster Abbey and died a fortnight later.

This picture was commissioned by George Agar Ellis, later Lord Dover, a rising young Whig politician, sympathetic to the queen's cause. The Whig leader, Lord Grey, is shown with outstretched arm questioning Majocchi through an interpreter. The queen is seated in a chair in front of Grey. The hearings took place in the House of Lords (the old Court of Requests), adapted for the occasion by the addition of galleries on either side.

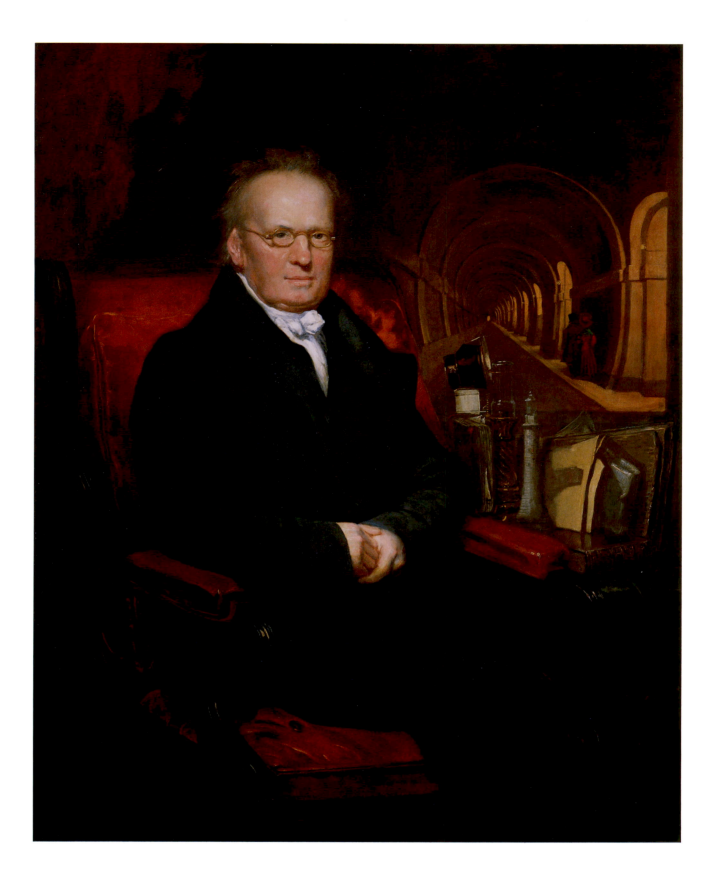

SIR MARC ISAMBARD BRUNEL 1769–1849
Oil on canvas, 127 × 101.6 (50 × 40)
By Samuel Drummond, c.1835 (89)

Brunel was one of the great figures in the history of civil engineering. He came of a family of Normandy farmers, but because of the French Revolution took up his profession in America and Canada, where he practised as surveyor and architect and planned the defences of New York. In 1799 he came to England, married Sophia Kingdom, and devoted himself to inventing machinery, of which the most successful was a device for making ships' blocks, adopted eventually by the Royal Navy for Portsmouth Dockyard. However, his chief claim to fame was the design and construction of the Thames tunnel between Wapping and Rotherhithe. Disasters, floods, strikes and panic dogged the enterprise for nearly twenty years, but finally the tunnel was opened in 1843, and it appears in the background of Drummond's portrait. Brunel's only son was Isambard Kingdom Brunel (p.122)

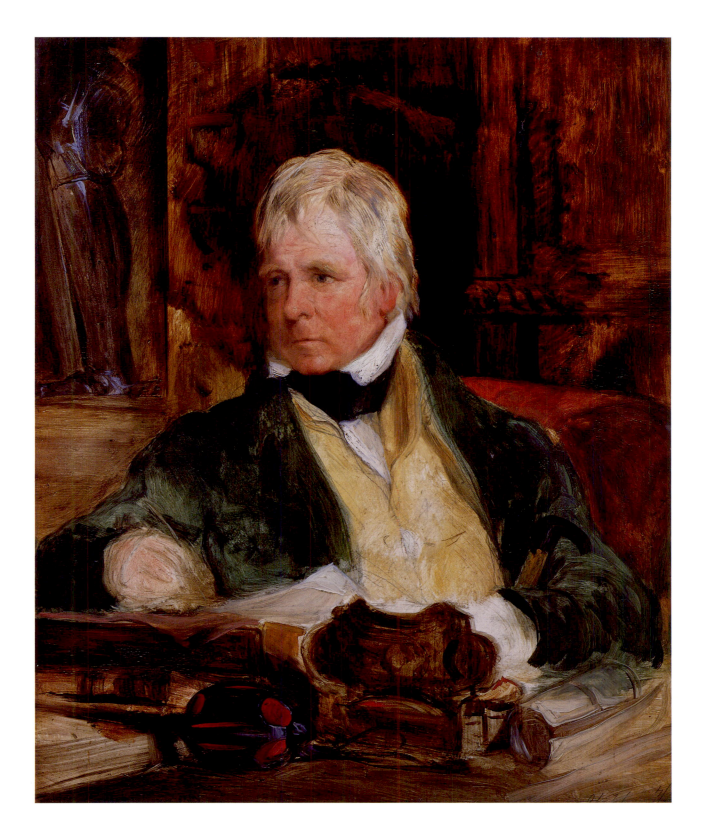

SIR WALTER SCOTT 1771–1832
Oil on mahogany panel, 30.5 × 25.0 (12 × 9⅞)
By Sir Edwin Landseer, *c*.1824 (391)

The poetry and novels of Scott are full of a unique compound of racy narrative, Scottish legend and history, antiquarian lore and a profound insight into human nature. His poem, *The Lay of the Last Minstrel* (1805) met with instant and resounding success, followed by *Marmion* and, from 1814, the Waverley novels – a prodigious output of at least one novel a year.

For Scott, his pen was a means of supporting his life as a gentleman. Gregarious and warm-hearted, a genial host and a generous friend, he loved the Tweed and the Scottish Lowlands, and spent every spare scrap of his income on his beloved Abbotsford, which he increased from a property of a hundred acres to one of nearly a thousand.

Landseer was a frequent visitor to Abbotsford from 1824 onwards; 'He has painted every dog in the house', said Scott, 'and ended up with the owner'. Landseer's brilliant oil sketch shows Scott at the height of his powers, a year or two before the financial crash which darkened the remaining years of his life and forced him into feverish literary efforts to avoid bankruptcy.

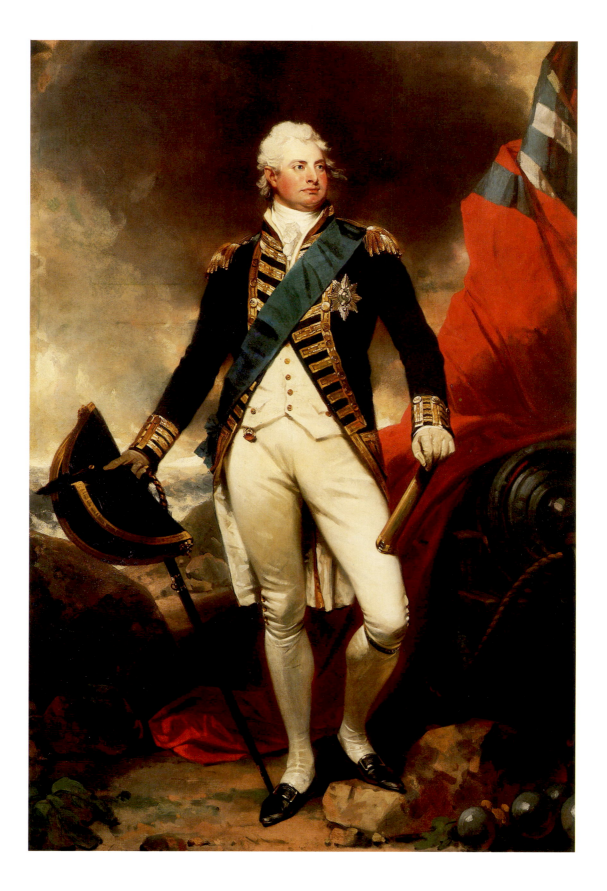

WILLIAM IV 1765–1837
Oil on canvas, 221 × 149.9 (87 × 59)
By Sir Martin Archer Shee, *c.*1800 (2199)

The third son of George III, William was Duke of Clarence until he succeeded his brother, George IV. From an early age he served in the navy and in 1807–8 was Lord High Admiral. For more than twenty years he lived in contented domesticity with the actress, Mrs Jordan, but in 1818, after the death of Princess Charlotte, heir to the throne, he married Princess Adelaide of Meiningen. He affected the bluff manners of a sailor and had an eccentric disregard for etiquette; he was choleric and had fierce likes and dislikes, but behind the bluster he had perhaps more wisdom than was generally allowed. His support of the Whigs – albeit reluctant – enabled them to pass the great parliamentary Reform Bill of 1832. This portrait, painted long before he became king, shows him appropriately in the full dress uniform of an admiral.

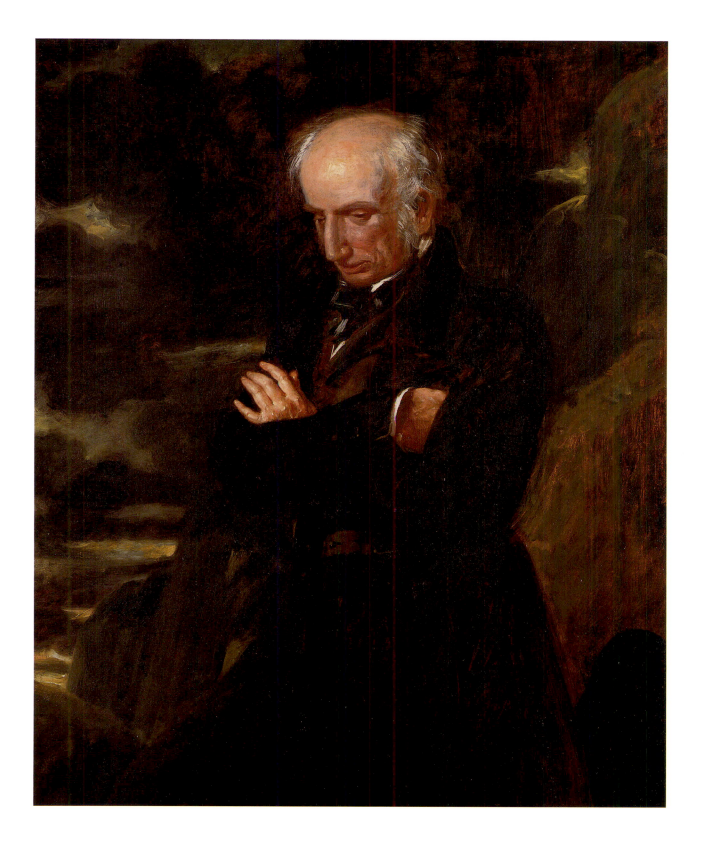

WILLIAM WORDSWORTH 1770–1850
Oil on canvas, 127.5 × 101.5 (50 × 40)
By Benjamin Robert Haydon, signed and dated on the back 1842 (1857)

Wordsworth's poetry, a mainspring of the Romantic Movement, is imbued with nature in every mood. With his friend Coleridge, he published *Lyrical Ballads* in 1778, a landmark in English Romanticism. Most of his long life was passed in the Lake District, which was a source of continuing inspiration to him; the main theme of his poetry was the relation of man to nature.

Wordsworth first met the ambitious history painter, Benjamin Robert Haydon, in about 1815, and their friendship lasted over many years, with Haydon a passionate admirer of the poet. This portrait was painted to commemorate Wordsworth's sonnet on the artist's picture, 'Wellington musing on the Battlefield of Waterloo'; the sonnet, 'By Art's bold privilege', was composed while the seventy-year-old Wordsworth climbed Helvellyn.

The portrait was intended to show the poet in romantic mood; according to Wordsworth, 'a likeness of me, not a mere matter-of-fact portrait, but one of a poetical character'. In turn it became the subject of Elizabeth Barret Browning's sonnet, 'Wordsworth upon Helvellyn'.

THE VICTORIAN AGE

The long reign of Queen Victoria was one of unprecedented change and progress. The industrial revolution transformed Britain into a modern industrial nation, the workshop of the world and the centre of world trade. With industrialization came the growth of large urban populations, which radically altered the structure of British society, and brought with it appalling problems of poverty, disease and overcrowding. The extension of suffrage meant the growth of popular democracy, and political parties were constantly reshaping to meet this new challenge. Scientific discoveries appeared to undermine traditional religious faith, and led to a crisis of doubt among the intelligentsia. The Victorians were inspired by the vision of progress in every sphere of life, and by the march of humanity towards higher goals, but became less certain of their achievement as the century progressed. Morality and high seriousness represent the temper of Victorian thought, leading sometimes to pomposity and hypocrisy, but endowing the great figures of the age with a heroic stature. A new mood of humanity and compassion paved the way to genuine social consciousness and a desire to alleviate suffering.

Abroad, British naval supremacy remained unchallenged, and the Empire expanded, providing new markets for British goods and new sources of wealth. Numerous colonies were acquired through conquest, exploration and infiltration, and required a professionally trained civil service to administer them, and British troops to protect their frontiers; the only serious threat to the peace of the Empire came with the Indian mutiny in 1857. Distrust of Russian ambitions in the East was a contributory factor to the outbreak of the Crimean War in 1854, the only major European conflict in which Britain became involved. In the last quarter of the nineteenth century the focus shifted to Africa, where Britain took over Egypt and the Sudan, acquired large tracts of territory further south, and came into conflict with the South African Boers.

Nearer to home the chief political challenges were posed by the issue of free trade versus protectionism, the intractable Irish problem, the rise of Chartism and trade unionism, and the increasing involvement of the state in industrial, educational, health and social matters.

In the field of the arts there were many outstanding achievements. The novel, in the hands of Dickens, Thackeray, George Eliot and the Brontës, reached a high pinnacle of excellence. Tennyson, Browning and Matthew Arnold were all poets of the first rank. And, at a lower level, popular literature reached out to a mass audience, in countless books, magazines and newspapers, which flourished as never before. The standard of Victorian painting was not always high, but there is an undeniable vitality to it, and a sense of excitement in the discovery of new subject-matter and styles. The cult of hero-worship and the intense interest in history and biography finds expression in countless portraits of famous figures. The advent of photography added a new dimension to portraiture, and the number and variety of surviving images enables us to scrutinize the Victorians in much greater detail than the personalities of any earlier period.

With this in mind, it is hardly surprising that it was the Victorians who first felt the need for a National Portrait Gallery. The idea was first put forward in the House of Commons in 1845, and the Gallery was founded in 1856. As an institution it was particularly in tune with the spirit of the age; the fulfilment of a high educational ideal. As Lord Palmerston said in the Parliamentary debate which led to the foundation of the Gallery:

> There cannot, I feel convinced, be a greater incentive to mental exertion, to noble actions, to good conduct on the part of the living, than for them to see before them the features of those who have done things which are worthy of our admiration, and whose example we are more induced to imitate when they are brought before us in the visible and tangible shape of portraits.

Among the first Trustees of the Gallery were men such as Disraeli, Gladstone, Macaulay and Carlyle: some of the greatest figures of the age. To them was entrusted the task of selecting those men and women whose portraits could be admitted to the 'national pantheon', and their guiding principles were clear. When considering a portrait for inclusion, they were to have regard only for the importance of the sitter, not the merit of the artist, and when estimating that importance they were to do so without any political or religious bias. Nor were 'great faults or errors, even though admitted on all sides' sufficient ground for excluding a figure who had made a significant contribution to British history and culture. No living sitter (apart from the monarch and his or her consort) was allowed. The aim was to produce a balanced and dispassionate view of the history of a great nation through the individuals who made it. As Carlyle himself wrote:

> Often have I found a portrait superior in real instruction to half a dozen written biographies . . . the portrait was as a small lighted candle, by which the biographies could for the first time be read.

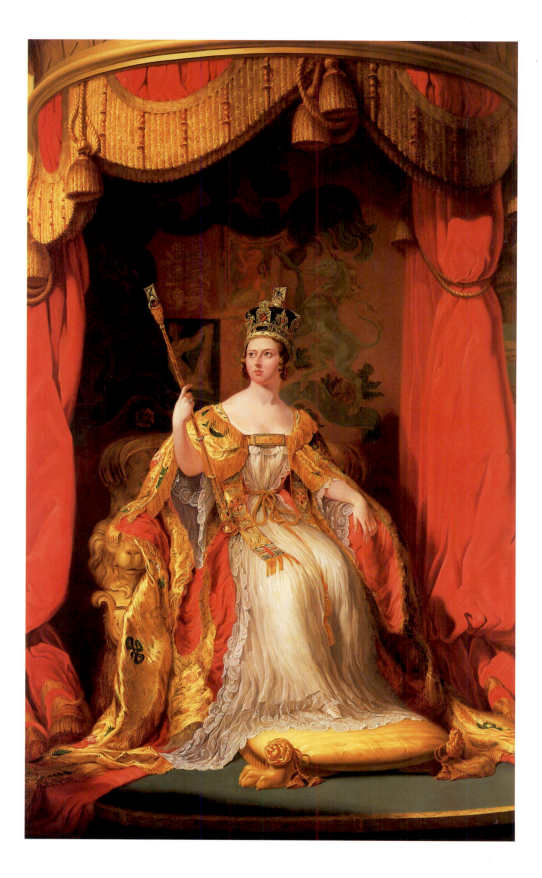

QUEEN VICTORIA 1819–1901
Oil on canvas, 285.8 × 179 (112½ × 70½)
By Sir George Hayter, signed and dated 1863 (1250)

Queen Victoria came to the throne in 1837, at the age of eighteen, on the death of her uncle, William IV, and was crowned queen on 28 June 1838. She wrote in her Journal on the day of her coronation 'I really cannot say *how* proud I feel to be the Queen of *such* a *Nation*', and some of this idealism is conveyed in Sir George Hayter's coronation portrait. In the early years of her reign Queen Victoria much preferred his work to that of the painters who had portrayed her uncle.

Hayter also undertook several large group portraits for her: of her coronation, of her marriage to Prince Albert, and of the christening of the Prince of Wales. She described a small version of this portrait, which Hayter painted for her private apartments, as 'excessively like and beautifully painted'. This version was given to the Gallery by Queen Victoria in 1900, and is an autograph replica of an original of 1838.

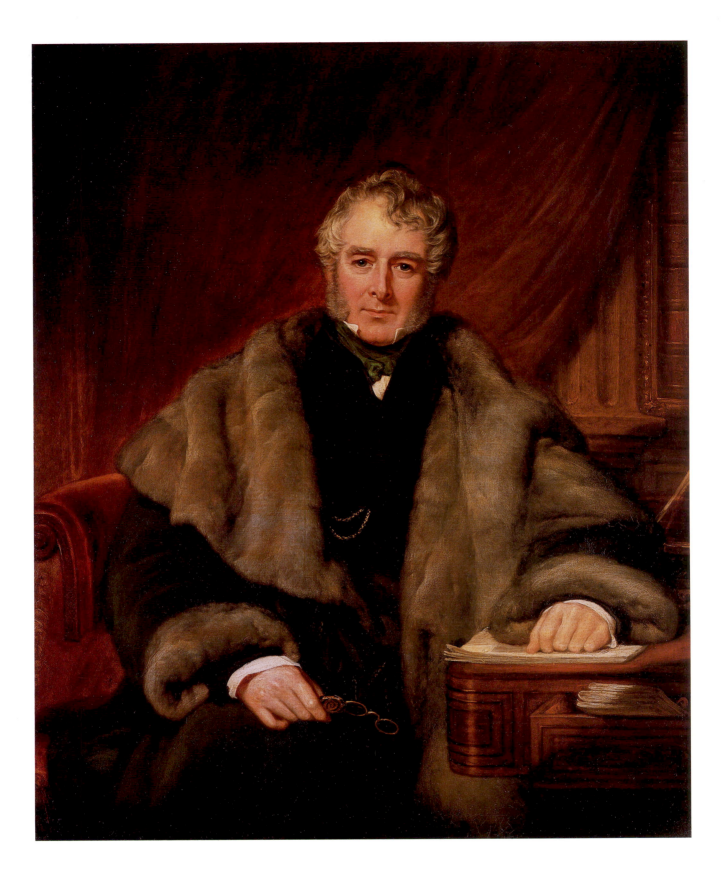

WILLIAM LAMB, 2nd VISCOUNT MELBOURNE 1779–1848
Oil on canvas, 127 × 101.6 (50 × 40)
By John Partridge, 1844 (941)

Lord Melbourne enjoyed a long political career which began when he became a Whig Member of Parliament in 1806, and culminated in two periods as Prime Minister: in 1834, when he succeeded Earl Grey (under whom he had served as Home Secretary, and played an important part in the events leading to the passing of the Reform Bill in 1832), and in 1835–41. He was Prime Minister when the young Queen Victoria came to the throne in 1837, and acted as her friend and political adviser until her marriage to Prince Albert in 1841, thereby earning her devoted gratitude.

This portrait by John Partridge, who also painted the queen, is closely related to the figure of Melbourne in Partridge's large group portrait *The Fine Arts Commissioners* (National Portrait Gallery) and was presumably painted as a finished study for it.

114

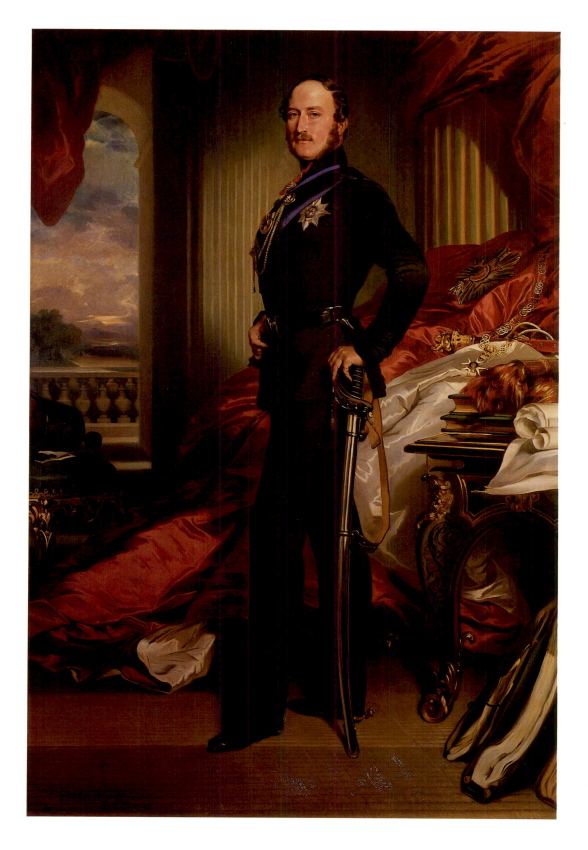

PRINCE ALBERT OF SAXE-COBURG-GOTHA 1819–61
Oil on canvas, 241.3 × 156.8 (95 × 61¾)
By Franz Xaver Winterhalter, signed and dated 1867 (237)

Prince Albert married his cousin Queen Victoria in 1841. Their marriage was an extremely happy one, and the Prince Consort was of great assistance to the queen in her role as monarch. He also pursued his own interests, and is perhaps best remembered for his vision of the Great Exhibition, which was held at South Kensington in 1851, and which celebrated the artistic and manufacturing skills of Britain and the Empire. He and Queen Victoria were enthusiastic patrons of the German-born artist Winterhalter, and commissioned over one hundred works from him. The original version of this portrait, showing Prince Albert wearing the Star of the Garter and the uniform of the Rifle Brigade, was one of the last portraits to be painted of him before his premature death from typhoid in 1861; it formed a pair with one of Queen Victoria. This version was commissioned for and given to the Gallery by Queen Victoria in 1867, and is an autograph replica of an original of 1859.

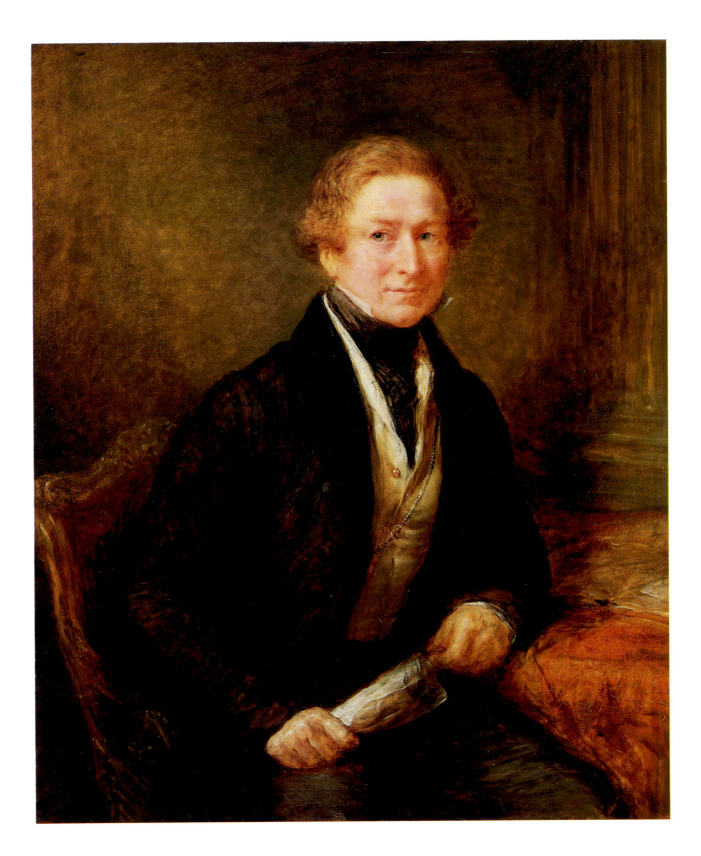

SIR ROBERT PEEL Bt 1788–1850
Oil on panel, 45.5 × 37.8 (17⅞ × 14⅞)
By John Linnell, signed and dated 1838 (772)

Peel succeeded the Duke of Wellington (p.100) as leader of the Tory party, and first became Prime Minister in November 1834. After his election as a Member of Parliament in 1809 he had served as Chief Secretary for Ireland from 1812–18, successfully opposing Catholic emancipation and establishing a police force, members of whom were popularly known as 'Peelers'. In 1828 he became Home Secretary and leader of the Tory party in the House of Commons, and had to abandon his opposition to Catholic emancipation, introducing

the bill that became the Catholic Emancipation Act in 1829.

His first period as Prime Minister lasted only a few months, but in 1841 he formed a ministry which lasted until 1846, with a brief break in 1845 as a result of the crisis over the repeal of the corn laws, when Peel was unable to carry his party with him. He finally succeeded in obtaining their repeal in 1846, but was promptly defeated on the issue of Irish reform. This sensitive portrait is by the artist son-in-law of Samuel Palmer.

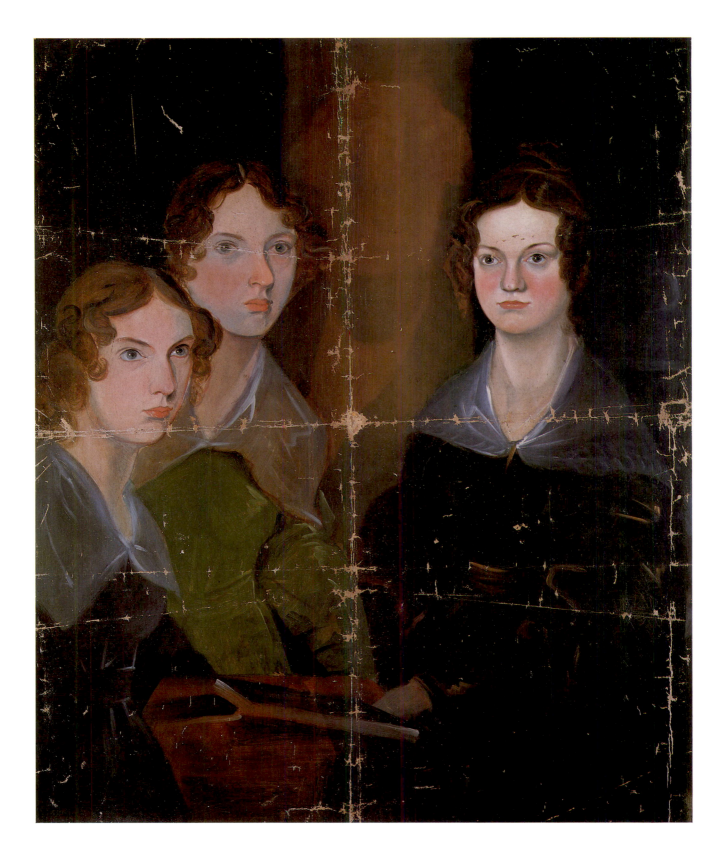

THE BRONTË SISTERS
Oil on canvas, 90.2 × 74.6 (35½ × 29⅜)
By Branwell Brontë, *c*.1834 (1725)

This is the only surviving group portrait of the three famous novelist sisters – from left to right: Anne (1820–49), Emily (1818–48) and Charlotte (1816–55) – although their brother Branwell is known to have painted more than one such family group. This composition appears once to have included a self-portrait of their brother, for the features of a man whose description corresponds to his can be seen, even with the naked eye, as a ghostly form under the central column. He perhaps painted himself out of this composition because he found the canvas too crowded. This portrait was painted some years before the sisters were made famous by the publication of their poems, issued pseudonymously in 1846. Their celebrated first novels followed: Charlotte's *Jane Eyre*, Emily's *Wuthering Heights* and Anne's *Agnes Grey*, published under their respective *noms de plume* of Currer, Ellis and Acton Bell. It was only in 1848, after Charlotte and Anne visited their publisher in London, that their real identities and sex were revealed.

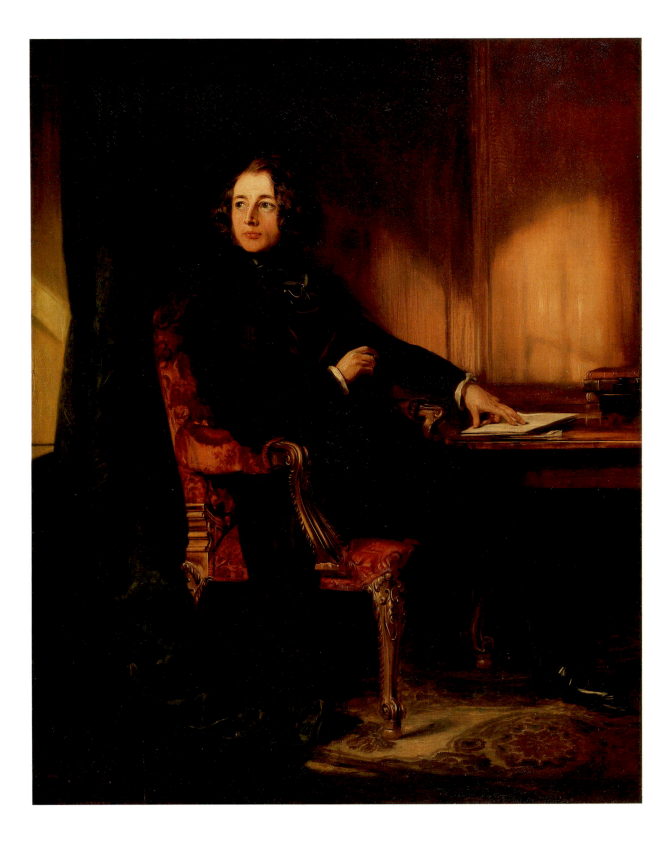

CHARLES DICKENS 1812–70
Oil on canvas, 91.4 × 71.4 (36 × 28⅛)
By Daniel Maclise, signed and dated 1839 (1172)

The most famous and best loved of all Victorian novelists, Dickens was a highly prolific writer. Like many nineteenth-century authors, his books first appeared in serial form in the periodicals of the day (a fact which their episodic construction betrays). Among his earliest successes were *The Pickwick Papers* and *Nicholas Nickleby*. In October 1839 an engraved version of this portrait accompanied the last episodes of the serialized form of the latter; it was then used as the frontispiece to the first collected edition. Dickens went on to write *David Copperfield*, *Oliver Twist* and *Great Expectations*, which contain some of his most famous characters, and, latterly, more darkly-coloured books such as *Bleak House*, which castigated abuses in the legal system.

The Irish painter Daniel Maclise was a close friend of the novelist, and portrayed him on more than one occasion, as well as making the portraits of his wife and children. This portrait, though idealized, was regarded by contemporaries as a good likeness: Dickens's fellow novelist Thackeray wrote: 'as a likeness perfectly amazing; a looking-glass could not render a better facsimile. Here we have the real identical man Dickens'.

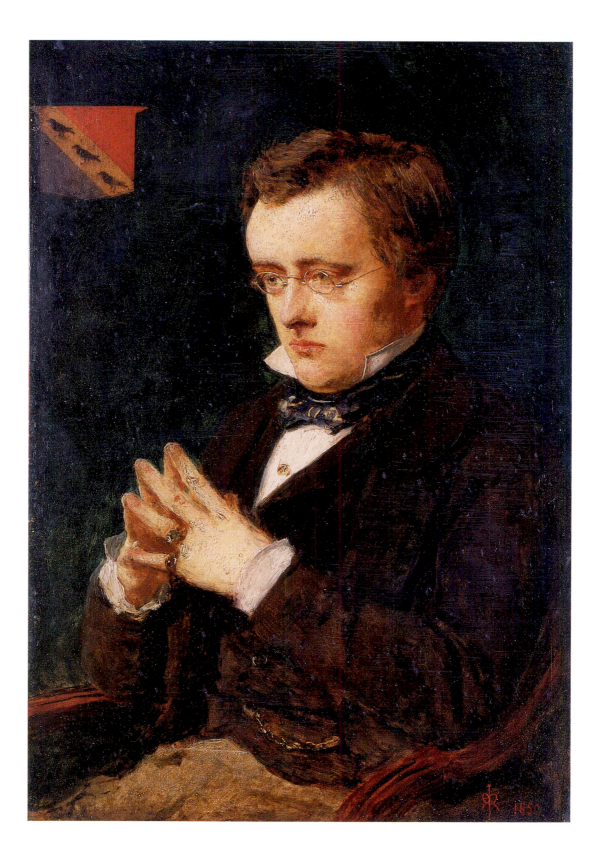

WILLIAM WILKIE COLLINS 1824–89
Oil on panel, 26.7 × 17.8 (10½ × 7)
By Sir John Everett Millais, signed and dated 1850 (967)

The son of a popular and successful painter, William Collins, the novelist William Wilkie Collins began his career articled to a firm of tea merchants and was subsequently called to the bar. His literary career developed through the friendship and encouragement of Charles Dickens (p.118), and Collins became a regular contributor to Dickens's magazine *Household Words.* He collaborated with Dickens in the *Lazy Tour of Two Idle Apprentices* and *Perils of Certain English Prisoners* (1857) and again in *No Thoroughfare* (1867). His acclaimed novel *The*

Woman in White appeared in serialized form in 1860, and his later work included *The Moonstone* (1868) and several plays.

This small, beautifully painted picture was one of a handful of portraits undertaken by the painter Millais while he was a member of the Pre-Raphaelite Brotherhood. Its detailed, introspective air is characteristic of the integrity and truth to nature which the Brotherhood aimed to restore to painting, which they felt had become pompous and empty.

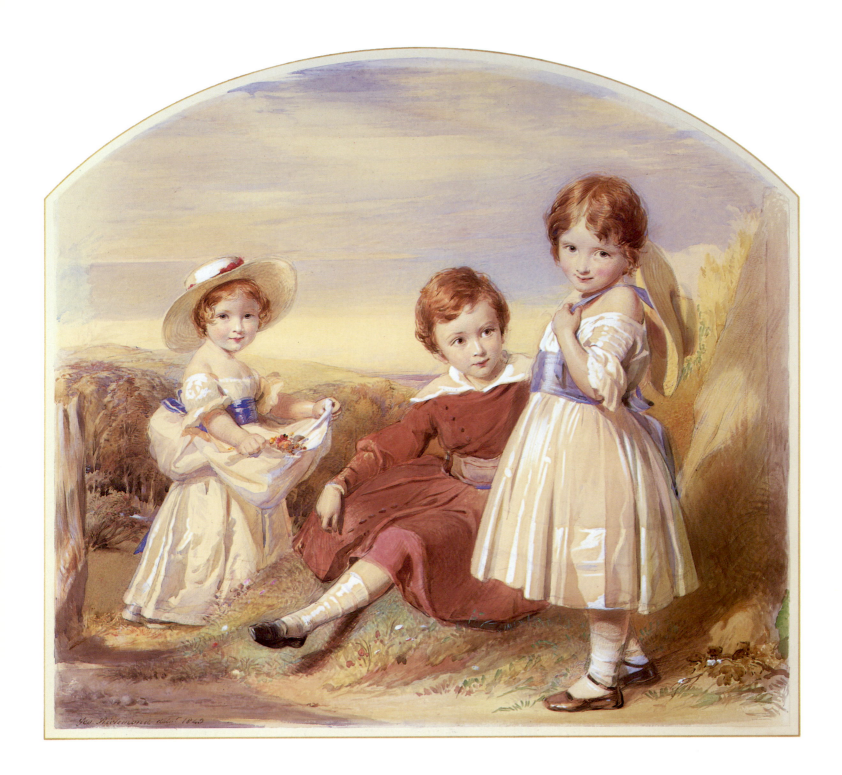

SWINBURNE AND HIS SISTERS
Watercolour on paper, 52.7 × 57.2 (20¾ × 22½)
By George Richmond, signed and dated 1843 (1762)

Algernon Swinburne (1837–1909) first won literary acclaim for the brilliance of his poetic drama *Atalanta in Calydon*, published in 1865. He was already in the forefront of literary and artistic circles, being a close friend of the Pre-Raphaelite painter Dante Gabriel Rossetti (p.125) and his circle and a champion of contemporary French poets, including Baudelaire. Subsequent poetry attracted condemnation on moral grounds, but Swinburne's literary output continued unabated, despite ill-health, to the end of his life.

He was the eldest of the six children of Admiral Charles and Lady Jane Swinburne, and is shown here with Alice, the eldest sister, on his right and Edith, who died in her early twenties, on his left. The Swinburne family lived on the Isle of Wight, and the children spent their time there walking, riding and swimming. The portrait of them was commissioned by their mother from the fashionable society portraitist Richmond, and the cost of £90 including postage is recorded in Richmond's account book for 1843.

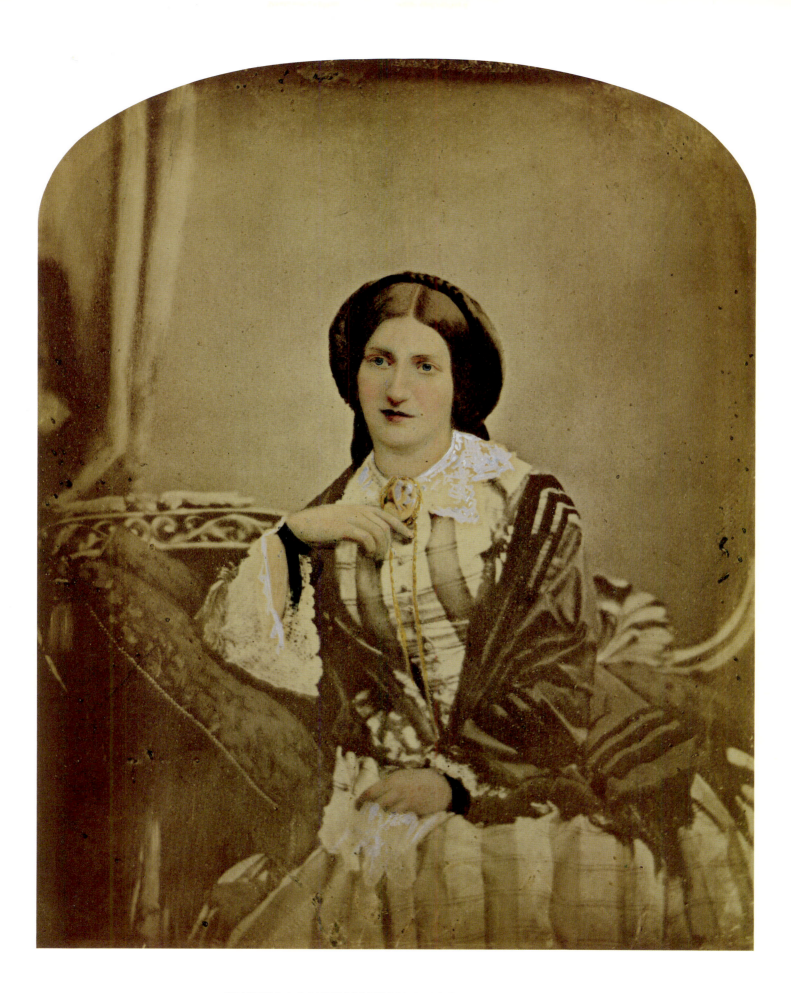

ISABELLA MARY MAYSON, MRS BEETON 1836–65
Hand-tinted albumen print, 18.4 × 14.9 (7¼ × 5⅞)
By Maull & Co, *c.*1860–5 (P3)

'Mrs Beeton', authoress of the perennial
Book of Household Management.

CHARLES BABBAGE 1791–1871
Daguerreotype, 7 × 6 (2¾ × 2⅜)
By Antoine Claudet, *c*.1847–51 (P28)

Lucasian Professor of Mathematics at Cambridge, Babbage
was the founder of the Statistical Society, and devoted his
life's efforts to the perfecting of a calculating machine, an
early form of computer.

ISAMBARD KINGDOM BRUNEL 1806–59
Albumen print, 28.6 × 22.5 (11¼ × 8⅞)
By Robert Howlett, November 1857 (P112)

The great civil engineer, photographed in front of the anchor
chains of the Great Eastern steamship which he designed.

FITZROY SOMERSET, 1st BARON RAGLAN 1788–1855
Salt print, 20 × 12.4 (7⅞ × 4⅞)
By Roger Fenton, 1855 (P19)

The commander of the British forces in the Crimea, Raglan,
though he was at first successful, was ultimately blamed for
the sufferings of the British troops and their heavy
losses. Photographed in the Crimea by the first British war
photographer.

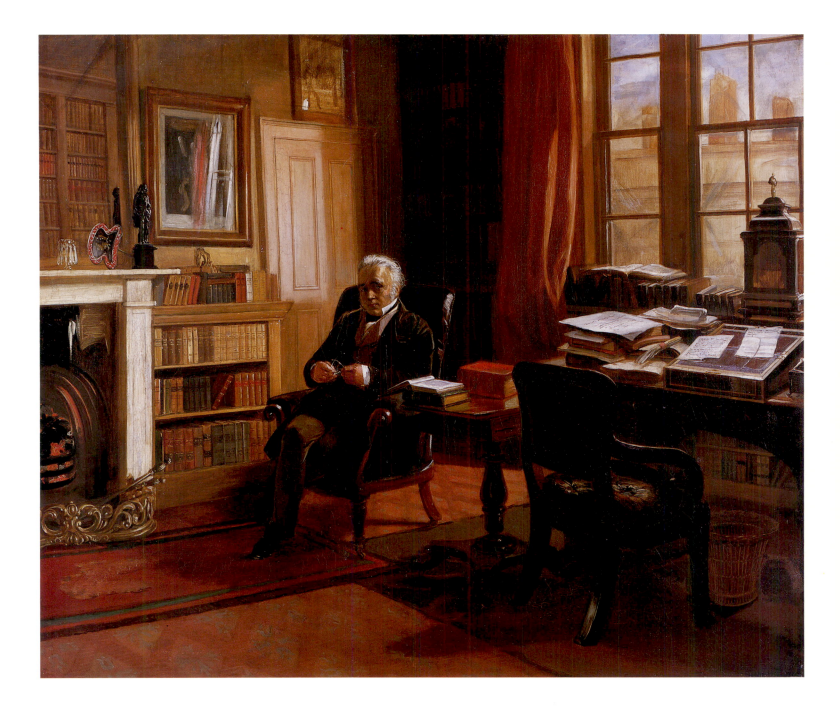

THOMAS BABINGTON MACAULAY, 1st BARON MACAULAY 1800–59
Oil on canvas, 63.5 × 76.2 (25 × 30)
By Edward Matthew Ward, 1853 (4882)

Macaulay is best known for his *History of England* (1848–55), and his narrative poem 'Lays of Ancient Rome' (1842), but he was also a prolific essayist as well as following an active political career; he became a Member of Parliament (1830) and served on the supreme council of India and as Secretary for War, 1839–41.

This portrait shows Macaulay at home in his lodgings in the Albany in central London, surrounded by his familiar possessions. Although the result is both a highly evocative scene of the life of a scholar in mid-Victorian England and a characterful portrait, Macaulay complained that he had been poisoned by the smell of paint, and that the artist had made him look worse than a daguerreotype would have done.

WILLIAM HOLMAN HUNT 1827–1910
Pencil on paper, 23.5 × 18.9 (9¼ × 7½)
By Sir John Everett Millais, 1853 (5834)

With Dante Gabriel Rossetti, Millais and their associates, Hunt helped in 1848 to found the Pre-Raphaelite Brotherhood of artists dedicated to truth to nature, and who took as their model the earliest masters of the Italian Renaissance.

THE ROSSETTI FAMILY
Albumen print, 17.5 × 22.2 (6⅞ × 8¾)
By Charles Lutwidge Dodgson (Lewis Carroll), 7 October 1863 (P56)

The sitters are (left to right): Dante Gabriel Rossetti (1828–82); his sister, Christina, the poetess (1830–94); his mother, Frances (1800–86), and brother, William Michael (1829–1919), the writer and critic. They were photographed in the garden of the family home, Tudor House, Cheyne Walk, Chelsea.

SIR JOHN EVERETT MILLAIS 1829–96
Pastel and chalk on paper, 32.7 × 24.8 (12⅞ × 9¾)
By William Holman Hunt, signed and dated 1853 (2914)

ROBERT BROWNING 1812–89
Oil on canvas, 72.4 × 58.7 (28½ × 23⅛)
By Michele Gordigiani, signed, 1858 (1898)

ELIZABETH BARRETT BROWNING 1806–61
Oil on canvas, 73.7 × 58.4 (29 × 23)
By Michele Gordigiani, signed, 1858 (1899)

This pair of portraits of the Brownings, both among the most well-known and popular of Victorian poets, was painted in Florence, where at various times they lived following their elopement in 1846. Elizabeth Barrett had already published both poetry and prose when she met Robert Browning in 1845. While she lived in Italy she was a keen supporter of Italian nationalism. She died prematurely from tuberculosis, three years after these portraits were painted. Her husband then returned to live in England, but often revisited his beloved Italy.

Robert Browning had attracted attention as a playwright as well as a poet early in his career, and much of his best and most influential poetry takes the form of monologues spoken in character. His work includes *Dramatis Personae* (1864) and *The Ring and the Book* (1868–9).

SIR EDWIN HENRY LANDSEER 1802–73
Oil on canvas, 80 × 113 (31½ × 44½)
By John Ballantyne, signed, *c*.1865 (835)

Landseer was one of the most popular painters of the Victorian period. His works, especially his animal pictures, were appreciated by Queen Victoria and Prince Albert, as well as by thousands of ordinary people, who bought engravings after them. He is probably best known for the paintings which attribute well-nigh human emotions and actions to animals, such as the *Monarch of the Glen* or *Dignity and Impudence*, but his range was greater than this, and encompassed dramatic scenes of outdoor life as well as a number of highly perceptive portraits.

This picture, one of a series by the painter John Ballantyne depicting artists at work in their studios, shows Landseer working in the studio of the sculptor Baron Marochetti on the clay models for the bronze lions he created for the base of Nelson's column in Trafalgar Square. The picture was exhibited in 1865, much to Landseer's fury, as it was to be another two years before the lions were formally unveiled, and he did not want them to be seen in an unfinished state. Ballantyne had to withdraw the picture, and he later altered the lions to conform with the appearance of the finished casts.

DAME ALICE ELLEN TERRY 1847–1928
Oil on panel, 48 × 35.2 (18⅞ × 13⅞)
By George Frederic Watts, 1864 (5048)

Ellen Terry first appeared on the stage as a child in 1856. Regarded as the greatest English actress of the period, she first acted with Henry Irving in 1867, and played many leading roles in Irving's productions between 1878 and 1896, most notably Portia in Shakespeare's *The Merchant of Venice*.

Known as *Choosing*, this delicately sensuous portrait shows the seventeen-year-old sitter choosing between the camellias, symbolising worldly vanities, with which she is surrounded, and the small bunch of violets in her left hand, symbolising innocence and simplicity. She married the artist G.F. Watts, thirty years her senior, the year before this portrait was painted, when she was still unknown as an actress; the marriage proved disastrous, however, and lasted barely a year.

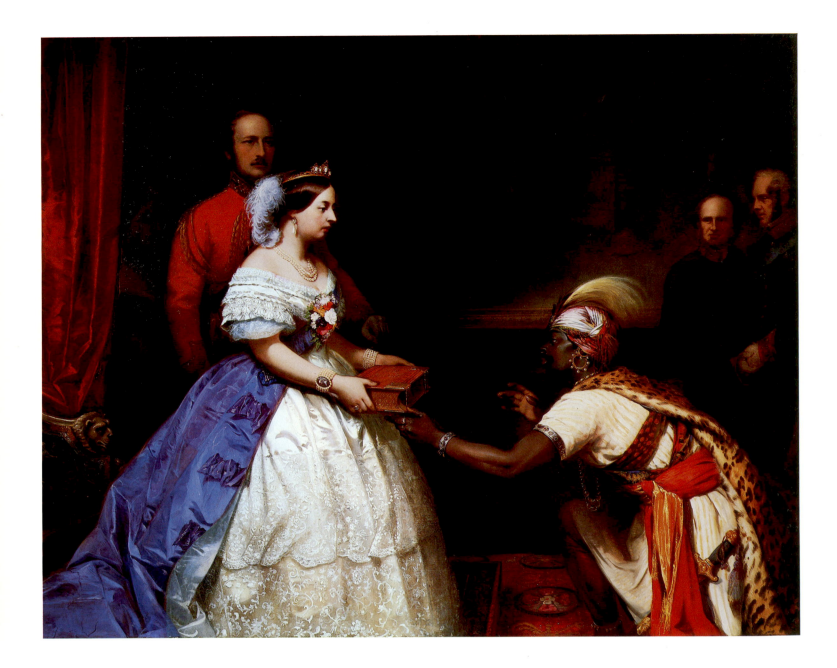

QUEEN VICTORIA PRESENTING A BIBLE IN THE AUDIENCE CHAMBER AT WINDSOR
Oil on canvas, 167.6 × 213.8 (66 × 83⅛)
By Thomas Jones Barker, signed, c.1861 (4969)

This group epitomizes the Victorian concept of the British Empire, which was seen as conferring the benefits of Western civilisation, and Christianity in particular, on the nations over which they ruled. Here Prince Albert stands to the left of Queen Victoria, while on the right in the background are the Prime Minister, Lord Palmerston, and Lord John Russell. In the foreground Queen Victoria presents a Bible to a man wearing central African dress. The picture does not apparently represent an identifiable occasion, and may indeed have been conceived as an allegory of Empire, rather than a record of a particular event.

FLORENCE NIGHTINGALE 1820–1910 AT SCUTARI
Oil on canvas, 40.6 × 61 (16 × 24)
By Jerry Barrett, signed, c.1856 (4305)

Barrett's painting is a sketch for a large picture of Florence Nightingale (left) tending the sick and wounded at the gates of the hospital at Scutari in the Crimea during the British campaign against the Russians, the work for which she is most famous. Although conditions in the Crimea were chaotic, she successfully established a regime of sanitary reforms which greatly improved conditions for the wounded there and lessened the incidence of diseases such as cholera. Standing next but one to the left of Florence Nightingale is the renowned chef Alexis Soyer (1809–58), whose cooking also came to the relief of the soldiers and their families.

Florence Nightingale had been keenly interested in nursing from an early age, although it was not then considered to be a respectable profession for women. She trained as a nurse and gained considerable experience visiting hospitals at home and abroad. As a result, in 1853 she was invited by the Secretary for War, Sidney Herbert, to take nurses out to the Crimea. She was subsequently much in demand by foreign governments, who consulted her regarding the improvement of hospital conditions during other wars.

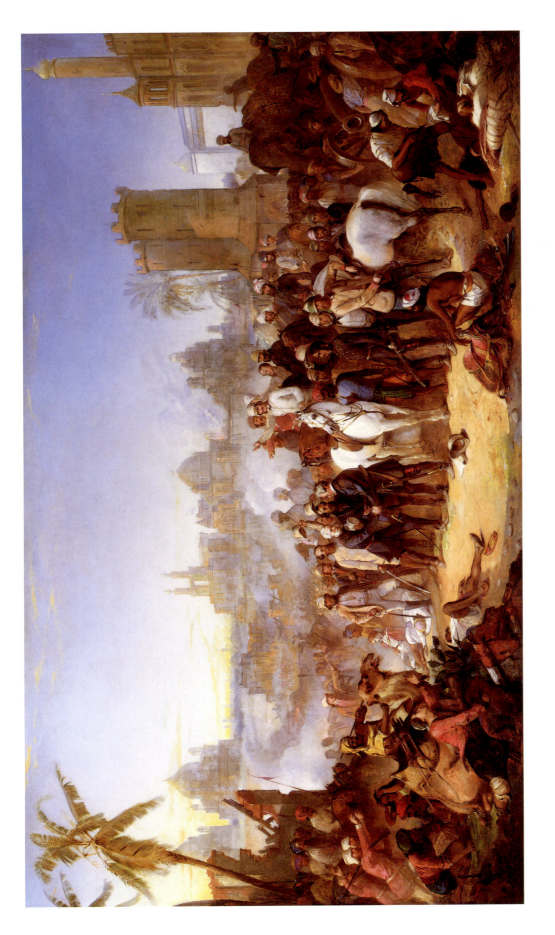

THE RELIEF OF LUCKNOW
Oil on canvas, 105.4 × 181.3 (41½ × 71⅜)
By Thomas Jones Barker, signed and dated 1859 (5851)

The scene depicted is one of the key events of the Indian Mutiny of 1857, when the siege of Lucknow, which had lasted from July to November 1857, was at last raised by Sir Colin Campbell, the new commander of the British armies, on 17 November. Campbell, later Baron Clyde (1792–1863), is depicted on the right of the central group of three figures: the other two are, on the left, General Sir Henry Havelock (1795–1857), who died only a week after the ending of the siege, and, in the centre, Sir James Outram (1803–63). Havelock and Outram had brought much-needed reinforce-

ments to bolster the small number of troops initially under siege. In the background are the towers and minarets of the city of Lucknow. Thomas Jones Barker, who painted this scene, did not himself visit India, but worked from the sketches of Egron Lundgren, who had been commissioned by the London art firm of Agnew's to record events at Lucknow. Barker painted two versions of this picture (the other is in the Glasgow Museum and Art Gallery), and an engraving of it was then sold by Agnew's.

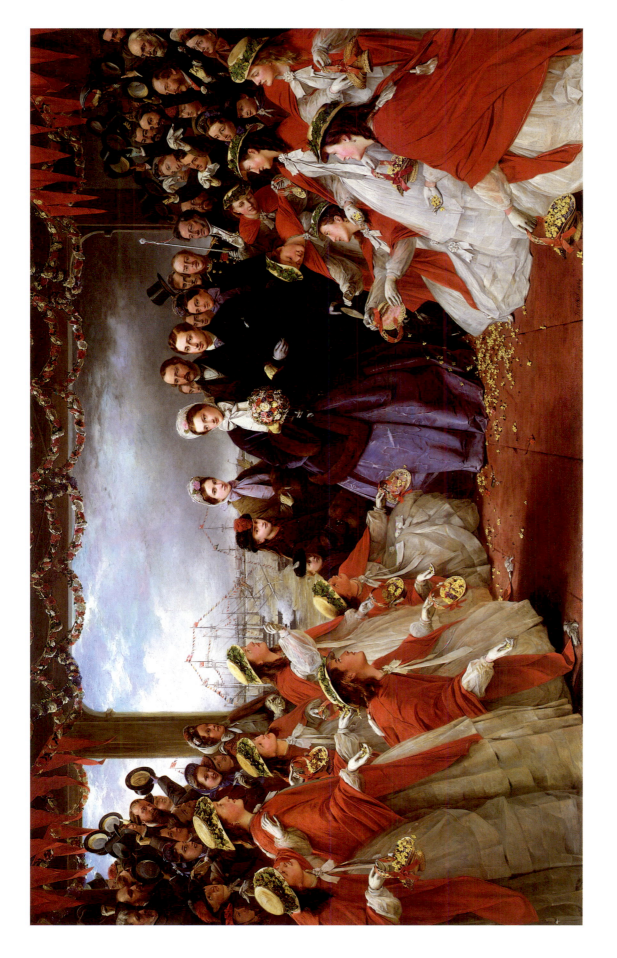

THE LANDING OF PRINCESS ALEXANDRA AT GRAVESEND, 7 March 1863
Oil on canvas, 132.1 × 213.4 (52 × 84)
By Henry Nelson O'Neil, signed and dated 1864 (5487)

This group of over fifty figures commemorates the arrival in England of Princess Alexandra of Denmark (1844–1925) for her marriage to the then Prince of Wales, later Edward VII (p.147). It shows the Prince leading his betrothed along the Terrace Pier at Gravesend, after her disembarkation from the royal yacht *Victoria and Albert*. The Prince and Princess are accompanied by the King and Queen of Denmark (who stand immediately behind them) and other members of the Danish royal family, officials and dignitaries, and, as the *Illustrated London News* reported, a 'bevy of pretty maids, who, ranged on each side of the pier, awaited, with dainty little baskets filled with spring flowers, the arrival of the Princess, to scatter these, Nature's jewels, at the feet of the Royal lady'.

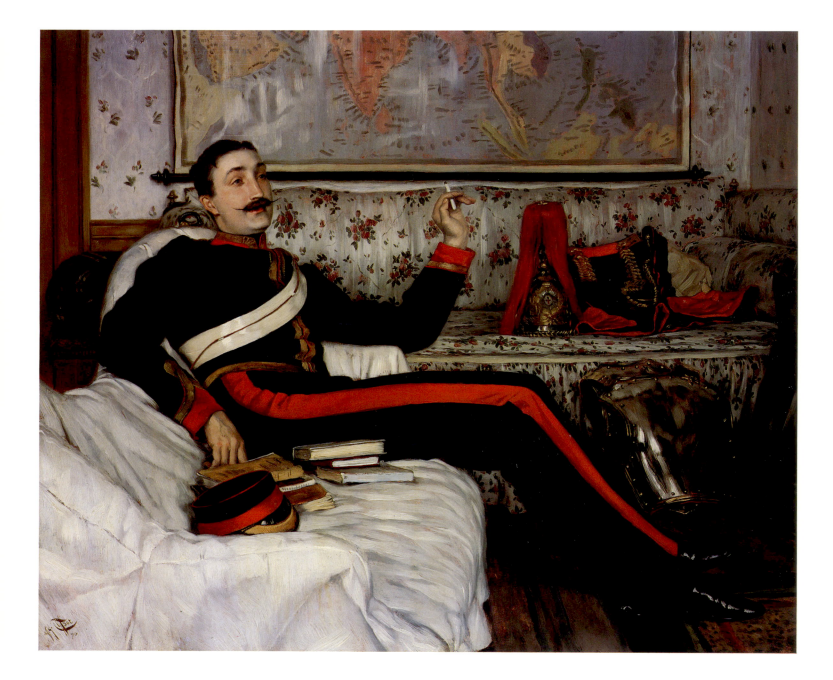

FREDERICK GUSTAVUS BURNABY 1842–85
Oil on panel, 49.5 × 59.7 (19½ × 23½)
By James Jacques Tissot, signed and dated 1870 (2642)

An army officer with a gift for languages and a penchant for travel and exploration, Burnaby became renowned both for his exploits and his writings about them. His *A Ride to Khiva* (1876), the narrative of a journey on horseback across three thousand miles of the Russian steppes in winter, and *On Horseback through Asia Minor* (1877), describing a tour of Asia Minor during which he fought on behalf of the Turks against the Russians, were both best-sellers. A huge man, six feet four inches in height, he was reputed to be the strongest man in the British Army, and to have proved it by feats such as carrying a pony under his arm. He was also a keen balloonist,

and in 1882 succeeded in a solo crossing of the Channel from Dover to Normandy. In 1884 he joined the expedition to relieve Khartoum in the Sudan, and died from a spear wound at the battle of Abu Klea.

The French artist Tissot, who worked for a time for the periodical *Vanity Fair*, made a number of portraits of fashionable English sitters, characteristically setting his elegantly-posed subjects in highly-decorative interiors, as is the case here, where the man-of-action reclines nonchalantly smoking, the horizontal composition emphasising his long legs.

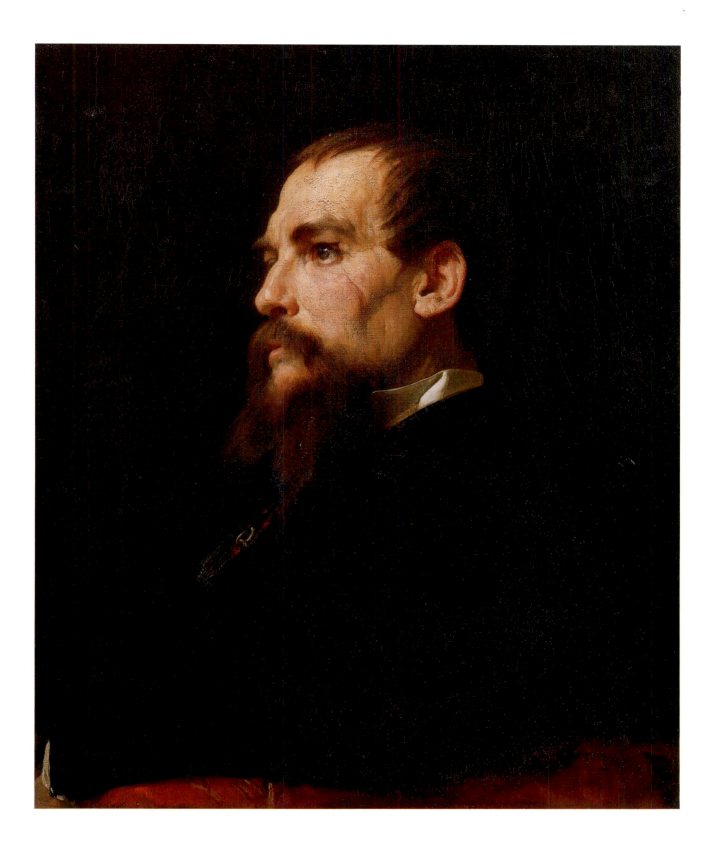

SIR RICHARD FRANCIS BURTON 1821–90
Oil on canvas, 59.7 × 49.5 (23½ × 19½)
By Frederic Leighton, Baron Leighton, c.1872–5 (1070)

Sir Richard Burton first won fame with the publication of several books on travel and culture in India, the fruits of a period as a subaltern in India, after he had been sent down from Oxford. Unlike other Englishmen in his position, Burton set about learning the languages and culture of India from the Indians themselves: this was to set the pattern for his career. In 1849 he was commissioned by the Royal Geographical Society to travel to Mecca in disguise, did so successfully, and published a book about his adventures. He subsequently went to Africa, where, with the explorer John Speke, he discovered Lake Tanganyika and searched – in vain – for the source of the Nile. He spent most of the rest of his life abroad. Besides publishing his famous translation of the *Arabian Nights*, there were also numerous books and articles on tribal customs, the importance of which was not fully appreciated at the time.

This portrait was begun shortly after Burton had been sacked as British Consul in Damascus. He told the artist: 'Don't make me ugly, there's a good fellow', but as he never acquired the portrait the result may not have pleased him.

ALFRED TENNYSON, 1st BARON TENNYSON 1809–92
Albumen print, 30.5 × 25.4 (12 × 10)
By Julia Margaret Cameron, 3 June 1869 (P124)

CHARLES ROBERT DARWIN 1809–82
Albumen print, 33 × 25.6 (13 × 10⅛)
By Julia Margaret Cameron, 1868–9 (P8)

ISABELLA ANNE THACKERAY, LADY RITCHIE 1837–1919
Albumen print, 30.2 × 23.2 (11⅞ × 9⅛)
By Julia Margaret Cameron, c.1867 (P53)

THOMAS CARLYLE 1795–1881
Albumen print, 33.3 × 24.1 (13⅛ × 9½)
By Julia Margaret Cameron, 1867 (P122)

Julia Margaret Cameron was aged almost sixty when she was given her first camera, and, undaunted by the cumbersome nature of photographic equipment in the 1860s, as well as the long exposures needed, she embarked on a new career as a photographer. Many of her photographs were illustrations of literary themes, such as those of Tennyson's *Morte d'Arthur*, for which family and friends posed, but she is probably best known for her striking portrait photographs. Some of her work – the portrait of Lady Ritchie, the novelist daughter of Thackeray is an example – is quite conventional, but she also took striking close-up views of heads, such as those of Tennyson, her neighbour on the Isle of Wight, the historian Thomas Carlyle, and the scientist and author of the *Origin of Species*, Charles Darwin. Like the painter George Frederic Watts, whom she knew well, Mrs Cameron aimed to communicate a sense of the spirit and intellect of the sitter, rather than a straightforward likeness, and in the intensity of the gazes emerging from her slightly unfocused images she succeeds brilliantly in doing so.

WILLIAM MORRIS 1834–96
Oil on canvas, 64.8 × 52.1 (25½ × 20½)
By George Frederic Watts, 1870 (1078)

Morris was one of the most important and inventive artistic figures of the Victorian period. His name has become synonymous with the Arts and Crafts Movement of the latter part of the century, and his firm, Morris & Co, designed and manufactured furniture, fabrics, wallpapers and other decorative materials, espousing standards of craftsmanship which Morris traced back to the medieval period, rather than following the general trend of factory mass-production. Both his approach and his characteristically rich and colourful designs, heavily influenced by a love of the Middle Ages, were highly influential. Towards the end of his life, in 1890, Morris

founded the Kelmscott Press, which produced ornately decorative hand-printed books, illustrated by artists such as Burne-Jones. Morris was also a poet and translator, and, in later life, a committed socialist.

Watts's portrait of Morris, forms part of his 'Hall of Fame', a series of portraits of his most eminent contemporaries, whom he selected himself, and later bequeathed to the National Portrait Gallery. The head and shoulders format is characteristic of the series, although poses vary. Other portraits from this series now hang at Bodelwyddan Castle (p.239).

DINNER AT HADDO HOUSE, September 1884
Oil on canvas, 36.2 × 57.8 (14¼ × 22¾)
By Alfred Edward Emslie, signed, c.1884 (3845)

Emslie's small painting offers a glimpse of a political dinner party at the end of the last century. The host and hostess are the Earl and Countess of Aberdeen, and the composition takes as its focus the conversation between Lady Aberdeen and Gladstone (1809–98), the veteran statesman and then Prime Minister, who was on a speaking tour of Scotland.

To the left of Lady Aberdeen is Archibald Philip Primrose, 5th Earl of Rosebery (1847–1929), who succeeded Gladstone as Prime Minister. Other guests include Mrs Gladstone and Lady Rosebery, and the Earl and Countess of Elgin. It was customary at Haddo to entertain guests at dinner with the sound of the bagpipes. The piper is Andrew Cant.

138

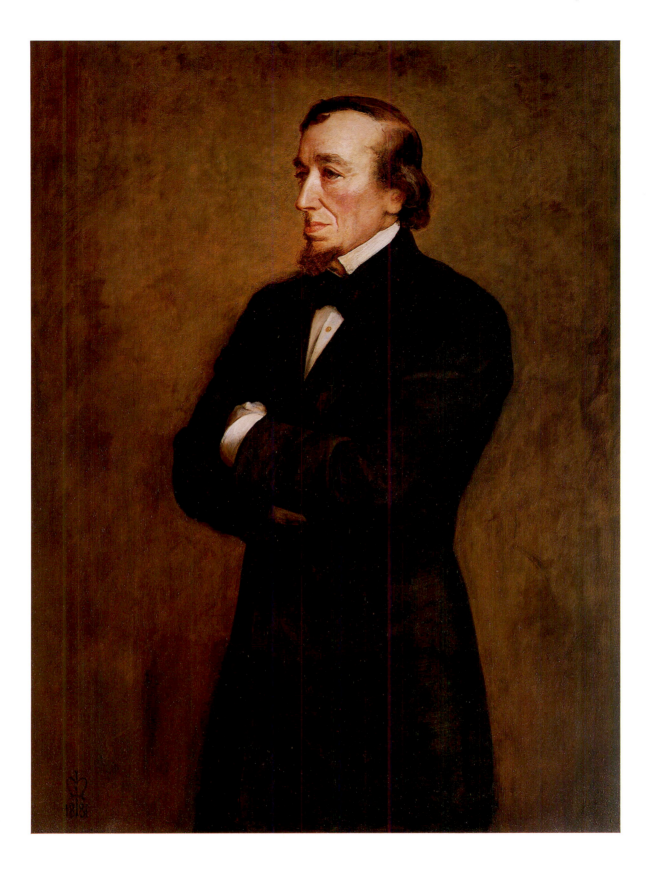

BENJAMIN DISRAELI, EARL OF BEACONSFIELD 1804–81
Oil on canvas, 127.6 × 93.1 (50¼ × 36⅝)
By Sir John Everett Millais, signed and dated 1881 (3241)

Benjamin Disraeli's political career spanned nearly half a century: he was first elected a Conservative Member of Parliament in 1837, but did not become Prime Minister until 1868, for a brief time, and again from 1874–80. He had first attained political prominence during the 1840s, when he attacked the Prime Minister, Sir Robert Peel, for repealing the Corn Laws, and in his novels *Sybil* and *Coningsby* set out the principles of Toryism anew, under which England was no longer to be 'two nations', rich and poor, but united under church and crown. He was three times Chancellor of the Exchequer: in 1852, 1858–9 and 1866–8, but his periods of office as Prime Minister were particularly notable for his interest in foreign affairs; a close friend of Queen Victoria, he caused her to assume the title of Empress of India in 1876. He was created Earl of Beaconsfield in the same year.

ANTHONY TROLLOPE 1815–82
Watercolour and body-colour on toned paper
29.5 × 18.4 (11⅝ × 7¼)
By Sir Leslie Ward ('Spy'), c.1873
study for cartoon published in *Vanity Fair*, 5 April 1873 (3915)

SIR HENRY IRVING 1838–1905
Watercolour and body-colour on toned paper
56.2 × 34 (22⅛ × 13⅜)
By Carlo Pellegrini ('Ape'), signed, c.1882
(5073)

This selection of caricatures represents only a very small proportion of the Gallery's holdings of original cartoons for the magazine *Vanity Fair*, but they show the range of sitters encompassed and the style of illustration. The Victorian caricature was very different from its eighteenth-century predecessor: by comparison restrained and respectful, it was only rarely that the work of a *Vanity Fair* artist gave offence.

The caricature of Gladstone, four times Liberal Prime Minister, was only the second to be published in *Vanity Fair*; the first was that of his great political rival, Disraeli. The artist, Carlo Pellegrini, was a prolific contributor to the magazine under the pseudonym 'Ape'.

Another caricaturist was Sir Leslie Ward, known as 'Spy'. His caricature of the novelist Anthony Trollope, author of the Barchester and Palliser novels, was one of his first contributions to the magazine, and Ward records that he made a

WILLIAM EWART GLADSTONE 1809–98
Watercolour on paper
30.2 × 17.8 (11⅞ × 7)
By Carlo Pellegrini ('Ape'), signed, c.1869
published in *Vanity Fair*, 6 February 1869 (1978)

OSCAR WILDE 1856–1900
Watercolour on paper
30.8 × 17.8 (12⅛ × 7)
By Carlo Pellegrini ('Ape'), signed c.1884
published in *Vanity Fair*, 24 May 1884 (3653)

close study of Trollope at first hand. The novelist however was furious when the caricature appeared.

Pellegrini's depiction of Henry Irving shows the great Shakespearean actor as Benedick in his own production of *Much Ado About Nothing*, which opened in 1882. He dominated the London stage for the last thirty years of Victoria's reign, and was the first actor to be knighted.

The dramatist and wit Oscar Wilde is depicted in the year

in which he made a sensational lecture tour of the United States, where his 'aesthetic' wardrobe attracted as much attention as his witty epigrams. In the 1890s his comedies, among them *The Importance of Being Earnest*, enjoyed great success, but in 1895 his career came to an abrupt end when he was imprisoned for homosexual offences.

SIR WILLIAM SCHWENK GILBERT 1836–1911
Oil on canvas, 100.3 × 125.7 (39½ × 49½)
By Frank Holl, signed and dated 1886 (2911)

Gilbert wrote numerous plays, sketches and stories, but his name is irrevocably linked with that of Sir Arthur Sullivan (p.143), for whose music he wrote the libretti of the 'Savoy' comic operas. His wit, skilled precision as satirist and versifier, and the deft marriage of his words with Sullivan's music, combined to produce such popular and apparently timeless successes as *HMS Pinafore* (1878), *Iolanthe* (1882), *The Mikado* (1885) and *The Yeomen of the Guard* (1888). Though the partnership lasted over twenty years, it was never an easy or a very happy one. Gilbert was irascible, quarrels became increasingly frequent, and after *The Gondoliers* (1889) he and Sullivan parted. They occasionally collaborated later, but never approached the popularity of their earlier operas. Gilbert built the Garrick Theatre with the profits from his plays, and was knighted in 1907. He bequeathed this portrait to the Gallery.

SIR ARTHUR SEYMOUR SULLIVAN 1842–1900
Oil on canvas, 115.6 × 87 (45½ × 34¼)
By Sir John Everett Millais, signed and dated 1888 (1325)

Sullivan achieved early success as a composer of serious music, but in 1866 he wrote *Cox and Box*, a comic operetta, and in 1871 collaborated for the first time with W. S. Gilbert (p.142), on *Thespis*. This marked the start of a long, stormy and prolific partnership. With Gilbert as librettist, Sullivan composed a series of triumphantly successful comic operas, which were performed, after 1881, in the Savoy Theatre, built specially for them by Richard d'Oyly Carte. The huge success of the 'Savoy' operas continually frustrated Sullivan's longing to devote more time to serious music. He composed numerous songs, orchestral and sacred pieces and one grand opera, *Ivanhoe* (1891), but with the exception of his setting of *The Lost Chord*, these are seldom heard now. Like Gilbert, Sullivan bequeathed his portrait to the Gallery.

143

AUBREY VINCENT BEARDSLEY 1872–98
Oil on canvas, 90.2 × 71.8 (35½ × 28¼)
By Jacques-Emile Blanche, signed and dated 1895 (1991)

In a short life of intense and fevered activity, and despite – or perhaps because of – the ill health which dogged him from childhood, Beardsley produced an enormous quantity of brilliantly original and highly finished black-and-white drawings. His illustrations for the *Yellow Book* and the *Savoy* attracted attention and aroused furious controversy. The drawings were strange – often morbid or erotic. His work included designs for Pope's *The Rape of the Lock*, for Oscar Wilde's *Salomé* and for Ernest Dowson's *Pierrot of the Minute.* As well as an accomplished artist and draughtsman, Beardsley was immensely erudite, musically gifted and a conversationlist of mannered elegance and charm. Shortly before his death from consumption at Menton, he was received into the Roman Catholic church. This dandified portrait was painted in Dieppe in the summer of 1895.

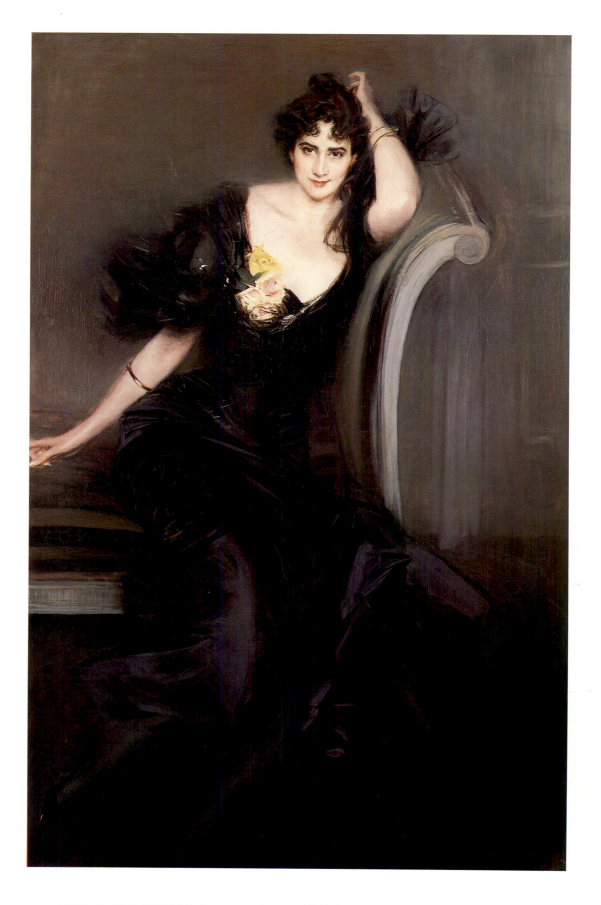

GERTRUDE ELIZABETH BLOOD, LADY COLIN CAMPBELL 1858–1911
Oil on canvas, 182.2 × 117.5 (71¾ × 46¼)
By Giovanni Boldini, signed, *c.*1897 (1630)

Gertrude Blood married Lord Colin Campbell, younger son of the Duke of Argyll, in 1881, but separated from him in 1886 after a scandalous case in which he alleged her adultery with four co-respondents. She worked as an art critic for the *World* and the *Ladies' Field*, and was admired for her athletic prowess in fencing, swimming and riding. Her published works include *A Book for the Running Brook*, articles on English freshwater fish, *A Miracle in Rabbits*, and *Etiquette of Good Society*.

The Italian society painter Boldini imparts a special glamour to this alluring sitter, revelling in her provocative expression and voluminous black dress, and treating the rules of anatomy with magnificent contempt.

THE TWENTIETH CENTURY

The history of the first half of the twentieth century is one of rapid advances in science and technology, two shattering world wars, and economic and social revolution. After the long-drawn-out summer of Victoria's reign, the Empire moved into its final phase under Edward VII, and the country enjoyed a brief period of gaiety and elegance which still bears his name. Already, however, there were strong forces at work beneath an apparently assured and prosperous surface. Pressure for home rule in Ireland, a difficult political and economic situation at home, and ominous tremors from Europe, were key factors during the early years of George V's reign. All these problems were engulfed in the holocaust of the First World War, only to re-emerge before the armistice had been signed.

Intellectual and artistic life in Britain was dominated for the first twenty-five years of the century by that close-knit group of kindred spirits (and relatives), the Bloomsbury Group. Although associates of the group produced a number of interesting painters and writers, certain figures like Maynard Keynes, Virginia Woolf and Bertrand Russell tower above their fellows. Keynes it was who helped to formulate the economic thinking which was slowly to drag the country out of the bleak years of depression, although even this process was halted by the outbreak of hostilities in 1939. The Second World War brought out the best in people, and certainly the country had not for a long time been as united as it was under politicians of the calibre of Churchill and military leaders such as Montgomery.

Post-war life has seen a slow but sure recovery, with economic and consequent social changes which would have seemed impossible at the beginning of the century. Scientific developments in communications, transport and industry, which were the wonders of the pre-war world, are now commonplace. Even in the visual arts and music, where Britain had for so long lagged behind the rest of Europe, there has been a revival of exceptional vigour which has raised London to rank as a major cultural centre in the world.

In portraiture, the camera has almost entirely relieved the artist of his function as recorder of appearances. It is not surprising therefore that no major painter of talent since Sargent has devoted the majority of his time to portraiture. The very multiplicity of images of the famous available today is a hindrance to the artist seeking to create a portrait which is both memorable and profound, and the greatest twentieth-century portraits have therefore often been private works: self-portraits, or portraits of members of the artist's family or close circle of friends, unencumbered by the restrictions of public taste or by over exposure of their sitters in the news media.

Portraiture has, especially in the period between the wars, often seemed to be the preserve of an enfeebled academic conservatism, and the great portraits of the period to be isolated flashes of brilliance from avant-garde artists better known for their work in other fields. However, there are signs that a younger generation of artists has recovered from the long domination of abstract art and is also prepared to rise to the challenge posed by photography.

The Gallery is fortunate enough to be able to participate in this revival of interest. In 1969 the rule which barred the Trustees of the Gallery from acquiring the portraits of living sitters (apart from members of the royal family) was abolished, and from 1980 a sum of money has been set aside annually for the commissioning of portraits of living sitters whose eminence was beyond doubt. These include Suzi Malin's *Lord Home*, R B Kitaj's *Lord Sieff*, and Maggi Hambling's *Dorothy Hodgkin*. At the same time the Gallery's annual Portrait Award (instituted in 1980) has done much to stimulate and publicise younger artists and to arouse a new interest in portraiture as an art form. In addition to a substantial cash prize, the winner of the Award receives a commission to paint a portrait for the collection, and such works include Humphrey Ocean's *Paul McCartney* and Michael Taylor's *Julian Bream*.

This revival of interest in portrait-painting has gone hand in hand with an increasing awareness of the significance of portrait photography (and indeed other photographic forms such as film and video), and the Gallery's twentieth-century collection can now truly be said to represent portraiture in all media.

All this is part of an overall drive to make the modern collection more representative of the values of contemporary society, and to redress imbalances inherent in the collection. With this in mind, the Trustees have commissioned portraits of figures who might otherwise not have been formally portrayed at all: some of our greatest scientists, trade union leaders, civil servants, pop musicians and sportsmen. The resulting mixture – full of contrasts, social, moral and aesthetic – is one of the many things which makes the National Portrait Gallery a unique institution.

EDWARD VII 1841–1910
Oil on canvas, 275.6 × 180.3 (108½ × 71)
By Sir Luke Fildes, 1912 (1691)

By the time Edward VII came to the throne in 1901 it was well over half a century since his mother, Queen Victoria, had herself commissioned a formal coronation portrait (p.113), and it is perhaps surprising that, at the beginning of the twentieth century, when formal portraiture was on the wane, such an exercise in grandeur should still be considered *de rigueur*. The artist chosen, Sir Luke Fildes, had made his reputation by painting pictures with social realist themes, but by the end of the century he had turned to society portraiture for his living. Unusually, the king came to sit for Fildes at his studio in Melbury Road, Kensington. However, as always in the case of such state portraits, the sitting served only to establish the facial likeness, and the pose was painted from a

model, who wore the costume of the portrait. Fildes's son describes how Queen Alexandra (who was painted in a pendant portrait) visited the studio and commented on the sleepy appearance of the king's eyelids, which Fildes then hastened to alter. The grand marble steps in the foreground of the picture were painted from an artfully arranged roll of cloth purchased by Lady Fildes.

Edward VII's reign was a brief one, in comparison with the years he had spent as heir to the throne, and was marked by important social reforms and by the rivalry with Germany which led ultimately to the outbreak of the First World War. The Gallery's portrait was given in 1912 by George V in memory of his father, and is a replica of the original of 1902.

ROBERT BADEN-POWELL, 1st BARON BADEN-POWELL 1857–1941
Oil on canvas, 141.9 × 112.1 (55⅞ × 44⅛)
Sir Hubert von Herkomer, signed and dated 1903 (5991)

Baden-Powell is forever associated with the Boer War, and the holding of Mafeking, which was under siege for a total of two hundred and seventeen days, until it was finally relieved on 17 May 1900. He had previously taken part in the Zululand (1888), Ashanti (1895–6) and Matabeleland (1896) campaigns, and ended his distinguished career as a lieutenant-general, retiring in 1910 to devote himself to the organisation for which he is best known, the Boy Scout movement, which he had initiated with the publication of his

Scouting for Boys in 1908. Artist and sitter enjoyed a lengthy correspondence about the portrait, Baden-Powell writing in October 1901: 'What dress would you like me in? Khaki uniform? Khaki shirt and hat? General's red tunic? General's black tunic? Plain clothes? "The Altogether", or what??' The choice was khaki, and the resulting portrait, essentially informal in conception, captures the alertness, humanity and humour of the sitter.

SIR FRANK SWETTENHAM 1850–1946
Oil on canvas, 170.8 × 110.5 (67¼ × 43½)
By John Singer Sargent, signed and dated 1904 (4837)

A portrait of the colonial administrator Sir Frank Swettenham was commissioned in 1903 from the leading society portraitist of the time, the American-born Sargent, by the Malay Straits Association of London. Swettenham had enjoyed a long career in Malaya, encouraging social and economic progress, while showing great interest in and sympathy for the people and customs. He was made governor of the Malaya States in 1903, and retired three years later. Sargent first painted a full-length portrait of him, which was sent to Singapore, where it remains, and a replica was commissioned from one of Sargent's regular copyists. However, Sargent took over the painting of the replica; Swettenham gave fresh sittings for the head, and this new three-quarter-length portrait, with significant differences from the first portrait, is the result. Swettenham is shown surrounded by accessories evoking his Far-Eastern career: a huge globe just visible in the top left hand corner hovers over a chair draped with the magnificent Malayan brocades which he collected; he wears his white uniform and adopts an elegant Van Dyckian pose, more vigorous than the original upright pose, leaning against the chair, gripping it with his right hand; his claw-like fingers provide a note of tension.

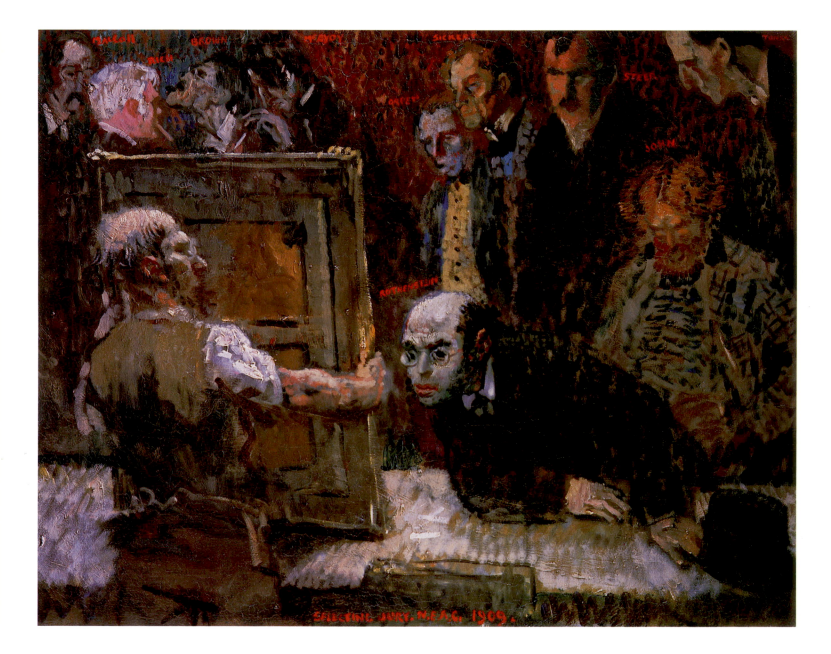

THE SELECTING JURY OF THE NEW ENGLISH ART CLUB
Oil on canvas, 69.9 × 90.2 (27½ × 35½)
By Sir William Orpen, signed and dated 1909 (2556)

The New English Art Club was founded in 1886 – along the lines of the French 'Salon des refusés' supported by the Impressionists – to provide exhibitions for those progressively-minded painters who found the rulings of the Royal Academy jury timid and stifling. However, by 1909 most of its members had themselves become Academicians, and the interest of the young generation of painters had moved away from the Impressionism which Orpen's brush evokes here, to Post-Impressionism. Orpen caricatures his ageing contemporaries – himself included – Augustus John dozes, while Sir William Rothenstein gazes intently at the porter's offering; Walter Sickert, perhaps the most important of the artists portrayed is shown behind him, while Henry Tonks, the influential teacher of drawing at the Slade School, who warned his pupils not to risk 'contamination' by the drawing of Henri Matisse, is shown top right.

GWENDOLEN MARY JOHN 1876–1939
Oil on canvas, 61 × 37.8 (24 × 14⅞)
Self-portrait, *c*.1900 (4439)

This self-portrait was painted when Gwen John was at the beginning of her artistic career. She had followed her brother, Augustus, to the Slade School of Fine Art in London, where she studied from 1895–8, winning a prize for figure composition. On leaving she worked briefly in Paris with Whistler and returned to London in 1899, where she began to exhibit her work and where this portrait appears to have been painted. It is one of two self-portraits from this period: the other is in the Tate Gallery, and presents a somewhat wistful characterisation of the artist, whereas here the jutting hand on hip and a stance which seems deliberately to burst the bounds of the picture frame, allied to an expression of watchful superiority, indicate a much more confident view of herself. By 1904 Gwen John settled in Paris where she continued to paint, as well as modelling for the sculptor Rodin, whose mistress she became.

HENRY JAMES 1843–1916
Oil on canvas, 85.1 × 67.3 (33½ × 26½)
By John Singer Sargent, signed and dated 1913 (1767)

The American-born novelist Henry James had settled in England, at Lamb House, Rye, in 1898. By the time this portrait was painted he was at the end of a career which had seen the success of early novels such as *Portrait of a Lady*, followed by the late masterpieces *The Wings of a Dove* and *The Golden Bowl*. This portrait was commissioned to celebrate James's seventieth birthday by a group of two hundred and sixty-nine subscribers organised by the American novelist Edith Wharton, although ultimately Sargent, a fellow-American and friend, waived his fee. James had ten sittings, and records admiringly the artist's ability to make details such as his waistcoat and sleeves of interest in the finished composition. When it was finished he pronounced it 'a living breathing likeness and a masterpiece of painting'. It was exhibited at the Royal Academy in 1914, where it was slashed by a suffragette.

THE ROYAL FAMILY AT BUCKINGHAM PALACE
Oil on canvas, 340.3 × 271.8 (134 × 107)
By Sir John Lavery, signed, 1913 (1745)

This imposing group shows George V (1865–1936; reigned 1910–36) and Queen Mary (1867–1953) with their eldest children, the Prince of Wales (the future Edward VIII, later Duke of Windsor; 1894–1972) and Princess Mary, later Countess of Harewood (1897–1965). It was commissioned by the printer, W.H. Spottiswoode, for presentation to the nation, and shows the royal family amid the splendours of the White Drawing Room at Buckingham Palace.

Although this painting appears to modern eyes as one of the last truly grand state images of European royalty, it seemed to contemporaries when first exhibited at the Royal Academy in 1913 to be a work of great originality: atmospheric, impressionistic, and 'a veritable triumph over the formalism to which in such pictures we are accustomed . . . the urbanity that links royal persons with the other gentlefolk of England is well seized'.

SPENCER FREDERICK GORE 1878–1914
Oil on canvas, 41 × 30.5 (16⅛ × 12)
Self-portrait, with studio stamp, 1914 (4981)

ROBERT POLHILL BEVAN 1865–1925
Oil on canvas, 45.7 × 35.6 (18 × 14)
Self-portrait, 1913–14 (5201)

Robert Bevan and Spencer Gore were founder members of the group of painters who formalized themselves in 1911 as the Camden Town Group; Gore himself was elected their president. The immediate stimulus for its formation had been Roger Fry's Post-Impressionist exhibition in London in 1910. Most of the Camden Town painters had studied or worked in France and were familiar with the work of the major Post-Impressionist painters such as Cézanne, Gauguin and Van Gogh. Bevan had been to Pont-Aven in 1894, where he had encountered Gauguin, and Gore had worked in Paris and Dieppe in 1904–6. The influence of Post-Impressionism is clear in both these self-portraits, in the use of bright colours, boldly-applied paint and clearly-defined shapes.

HORATIO HERBERT KITCHENER, 1st EARL KITCHENER OF KHARTOUM 1850–1916
Oil on canvas, 139.7 × 109.2 (55 × 43)
By Sir Hubert von Herkomer, signed and dated 1890, with a background painted by Frederick Goodall (1782)

Kitchener was the epitome of the successful imperialist general. He served under Wolseley in the relief expedition to Gordon in Khartoum, and subsequently commanded armies in Egypt and the Sudan. His reputation for invincibility was enhanced later by his victories during the Boer War. He made the transition from active command in the field to military administration with great aplomb. It was he who was chiefly responsible for converting the small British army into a military machine of three million men during the early years of the First World War, and he is remembered for his slogan 'Your country needs *you*'. He went down on *HMS Hampshire* off Scapa Flow on his way to Russia. This portrait by Herkomer was painted soon after a successful campaign against the Dervishes, and stresses Kitchener's commanding qualities as a leader.

JOHN FISHER, 1st BARON FISHER OF KILVERSTONE 1841–1920
Oil on canvas, 172.7 × 119.4 (68 × 47)
By Sir Hubert von Herkomer, signed and dated 1911 (2805)

One of the greatest of naval administrators, 'Jackie' Fisher was First Sea Lord from 1904 to 1910 and from the outbreak of the First World War until his resignation in 1915 over the attempt to force the passage of the Dardanelles, which he saw as jeopardising the major naval strategy of the war. Throughout his life his hero and model was Nelson, and his constantly quoted motto: 'The fighting efficiency of the fleet and its instant readiness for war'. He is forever associated with masterminding the building and development of the 'dreadnought' battleships. This portrait was presented to the Gallery by his son.

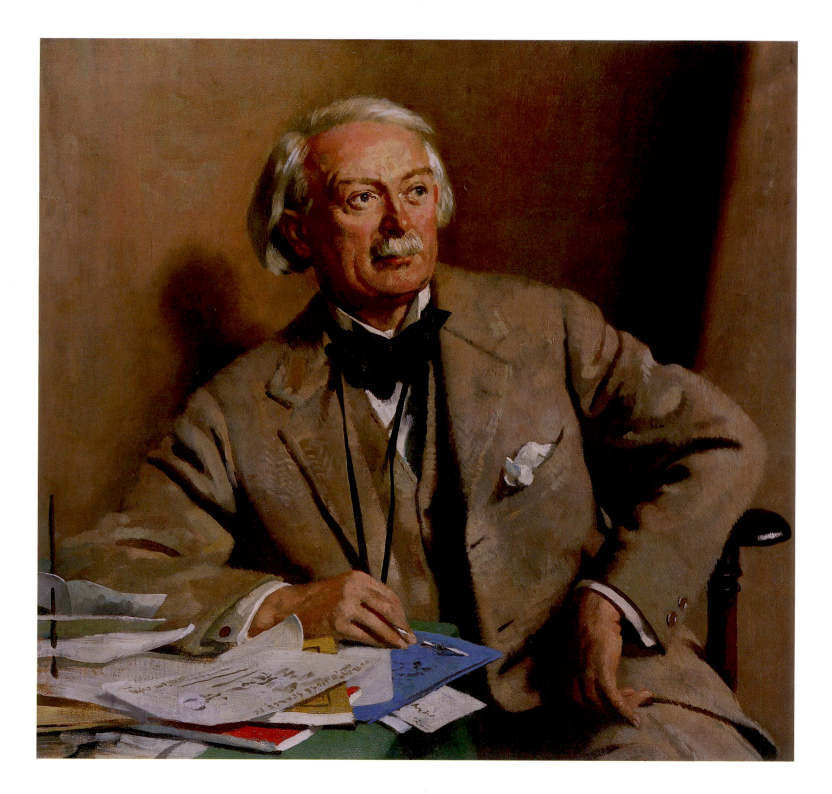

DAVID LLOYD GEORGE, 1st EARL LLOYD-GEORGE 1863–1945
Oil on canvas, 88.9 × 94 (35 × 37)
By Sir William Orpen, signed and inscribed, 1927 (3244)

Known as the 'Welsh Wizard', Lloyd George established a reputation as a speaker on religious, temperance and political subjects while still in his twenties. He began his successful career as politician and statesman as Liberal Member of Parliament for Caernarvon Boroughs in 1890. As Chancellor he introduced a number of social services reforms, and succeeded Asquith as Prime Minister in 1916, gaining immediate impact as the most widely-known, eloquent and dynamic figure in British politics of the day. This portrait was originally a private commission, but it was rejected on completion and remained in Orpen's possession until his death. Although it now seems a fairly conventional likeness, it was considered at the time to be unusually informal for the portrait of a leading politician. Orpen, however, is successful in catching the blend of idealism and sound common sense which characterized Lloyd George's distinguished career.

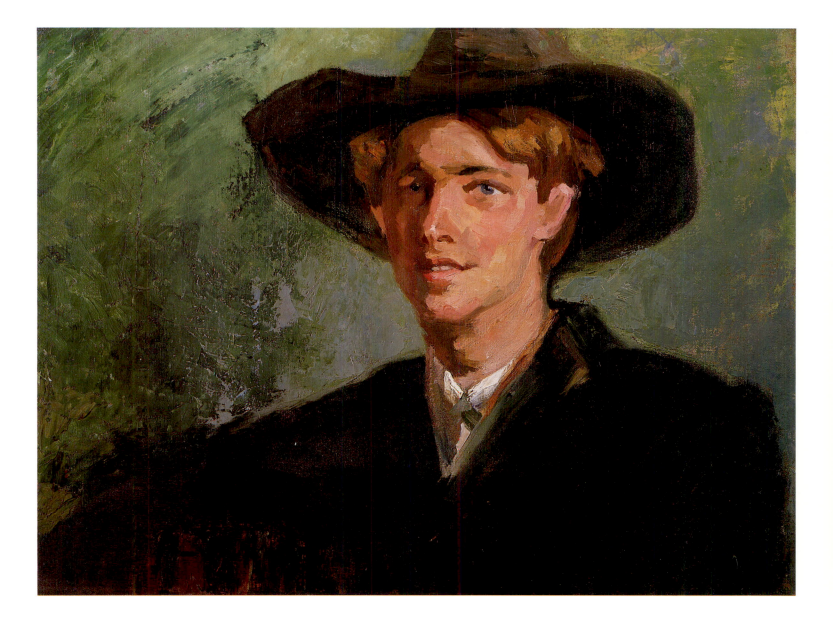

RUPERT BROOKE 1887–1915
Oil on canvas, 54.6 × 73.7 (21½ × 29)
By Clara Ewald, 1911 (4911)

This unfamiliar image of the popular poet – author of 'The Soldier' and 'The Old Vicarage at Grantchester' – who met a tragically early death in the First World War, only came to light in 1972, when the artist's son presented it to the Gallery. It was painted early in 1911 in Munich, where Brooke was staying after taking his BA at Cambridge. Frau Ewald kept more or less open house for Cambridge students and decided to paint him, 'partly, perhaps to cheer him up'. The hat was not typical and belonged to her son. Although Brooke's Cambridge contemporaries were divided in their opinions of the portrait, they agreed that it gave a good idea of his fresh and vivid colour, which no photograph could convey.

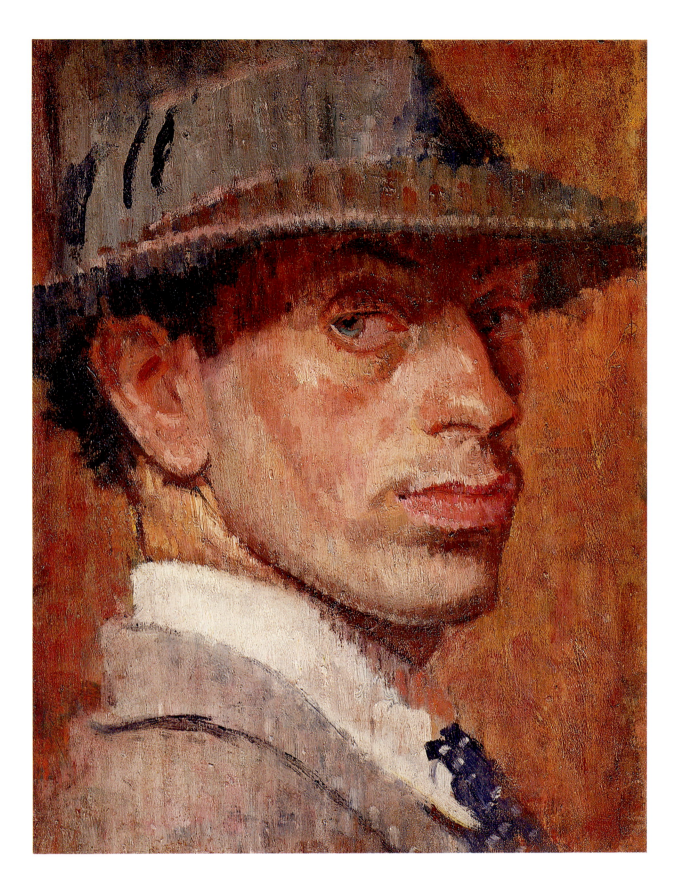

ISAAC ROSENBERG 1890–1918
Oil on panel, 29.5 × 22.2 (11⅝ × 8¾)
Self-portrait, 1915 (4129)

A poet of striking originality, and a painter, Rosenberg grew up in a poor Jewish immigrant community in Whitechapel. He attended the Slade School of Art, where he was a contemporary of Mark Gertler, and in 1912 published a collection of poems, *Night and Day*, at his own expense. He was encouraged by the poets Ezra Pound and Gordon Bottomley, and another volume of verse, *Youth*, followed in 1915, the year of this self-portrait. In the same year he joined the army, and was killed in action in 1918. Rosenberg's poetry is forceful, rich in vocabulary and starkly realistic in its attitudes to war; it was slow to gain recognition and it was not until the publication of his *Collected Works* in 1937 that his importance generally became accepted.

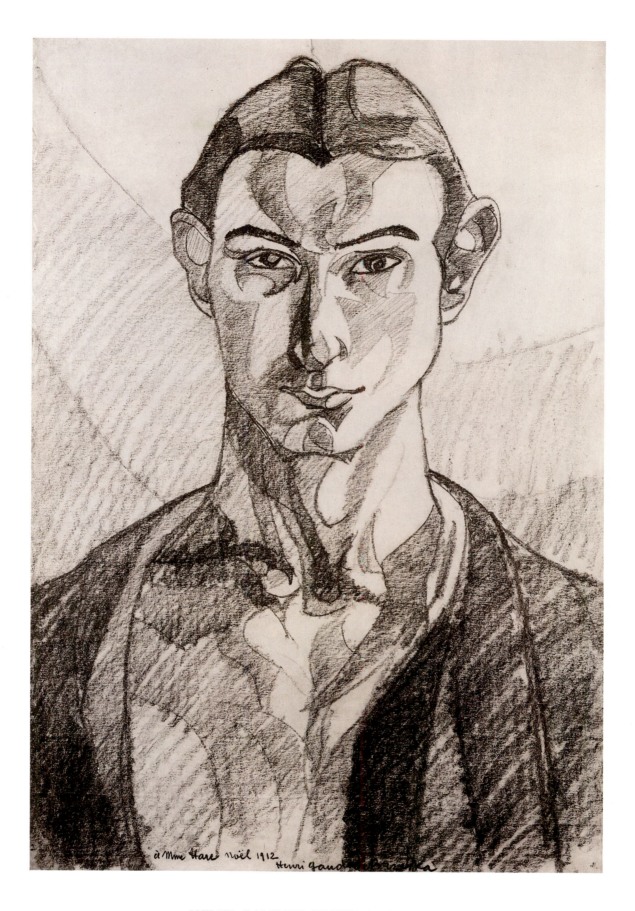

HENRI GAUDIER-BRZESKA 1891–1915
Pencil on paper, 55.9 × 39.4 (22 × 15½)
Self-portrait, signed, inscribed and dated 1912 (4814)

In 1911 Gaudier-Brzeska moved from his native France to London where he was to spend the whole of his short working life. He exhibited in Roger Fry's Grafton Group exhibition in 1914, and contributed to the first London Group exhibition in the same year. His powerful drawings and small compact sculptures, like Epstein's, show the influence of primitive art. He also worked for the Omega workshops until, like Wyndham Lewis, he broke with the Bloomsbury Group. He signed the Vorticist Manifesto in the first number of the magazine *Blast*, and exhibited in the Vorticist exhibition in June 1915, the month that he was killed fighting in the French army in France.

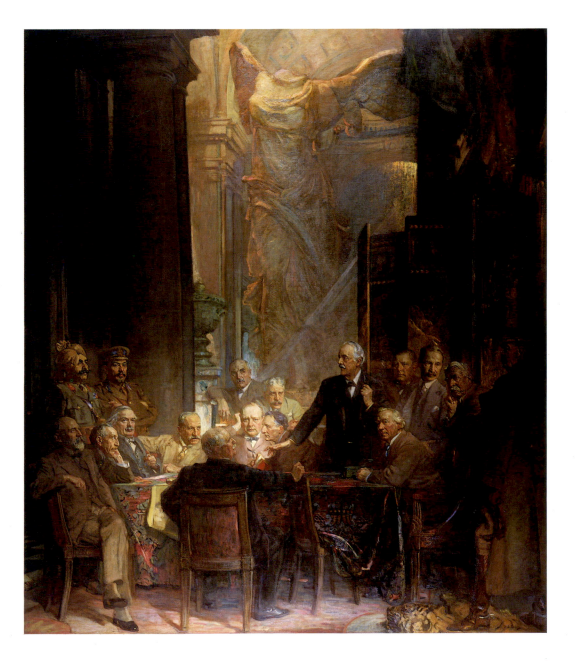

SOME STATESMEN OF THE FIRST WORLD WAR
Oil on canvas, 395.2 × 335.5 (156 × 132)
By Sir James Guthrie, 1924–30 (2463)

The sitters are (standing, left to right):

The Maharaja of Bikaner (1880–1943)
Louis Botha (1862–1919)
George Nicoll Barnes (1859–1940)
Sir Robert Laird Borden (1854–1937)
Arthur James Balfour, 1st Earl of Balfour (1848–1930)
Sir Eric Campbell Geddes (1875–1937)
Andrew Bonar Law (1858–1923)
Edward Patrick Morris, Baron Morris (1859–1935)
Horatio Herbert Kitchener, 1st Earl Kitchener of
Khartoum (1850–1916)

(seated, left to right):

Sir Joseph Cook (1860–1947)
William Morris Hughes (1864–1947)
David Lloyd George, 1st Earl Lloyd-George (1863–1945)
Alfred Milner, Viscount Milner (1854–1925)
William Ferguson Massey (1865–1925)

Sir Winston Spencer Churchill (1874–1965)
Edward Grey, 1st Viscount Grey of Falloden (1862–1933)
Herbert Henry Asquith, 1st Earl of Oxford and Asquith
(1852–1928)

This impressive and dramatic group is one of a series of three large paintings commissioned by the South African financier Sir Abe Bailey for presentation to the Gallery. The other two works in this grandiose scheme show the general officers and the naval officers of the war, and were painted by John Singer Sargent and Sir Arthur Cope respectively. Together they were to constitute a pantheon of victorious leadership and, by implication, a tribute to the British Empire.

The Glasgow artist Guthrie took eleven years of sustained work to complete his painting, which was unveiled just months before his death, and was universally hailed as a triumph. The setting for the group is Guthrie's invention, but includes, towering in the background as an appropriate symbol, the famous statue in the Louvre of the Winged Victory of Samothrace.

EDMUND HENRY HYNMAN ALLENBY, 1st VISCOUNT ALLENBY 1861–1936
Pastel on paper, 44.5 × 33.7 (17½ × 13¼)
By Eric Kennington, *c*.1926 (2906)

Nicknamed 'The Bull' and a man of abounding energy, Allenby served in France under Generals French and Haig on the western front from 1914 to 1917, and commanded the Third Army at the Battle of Arras (1917). In the same year he took command of the British Expeditionary Force based in Egypt, and conducted a masterly campaign against the Turks in Palestine, in which Lawrence of Arabia (p.165) was one of his key officers. In 1919 he was promoted Field Marshall and created a Viscount, and was appointed High Commissioner for Egypt, three years later securing the recognition of that country as a sovereign state.

Eric Kennington was an official war artist in both world wars, but this drawing, which communicates much of Allenby's strong character and fiery temper, dates from peacetime, shortly after his resignation as High Commissioner when he retired from public life. It belonged to Lawrence of Arabia, whose *Seven Pillars of Wisdom* (1926) Kennington helped to illustrate.

ERNEST RUTHERFORD, BARON RUTHERFORD OF NELSON 1871–1937
Oil on canvas, 76.2 × 63.5 (30 × 25)
By Sir James Gunn, signed and dated 1932 (2935)

A New Zealander by birth, Rutherford carried out his research in Montreal, Manchester and Cambridge. A scientific genius and a methodical and careful worker, his astonishingly original theory of radioactivity was received with scepticism in its year of publication (1904), only achieving wide acceptance when the weight of proof rendered it indisputable. Between 1906 and 1914 he developed the nuclear theory of the atom, and expressed in 1916 the hope that man would not learn to use atomic energy for practical purposes until the world was at peace.

This comparatively slight sketch by Gunn conveys much of what we know of the man: heavily built, unassuming and almost boyish in behaviour, animated in conversation, supremely confident of his own powers, but with no trace of vanity.

THOMAS EDWARD LAWRENCE 1888–1935
Pencil on paper, 35.6 × 25.4 (14 × 10)
By Augustus John, 1919 (3187)

The legendary 'Lawrence of Arabia' began his career as an archaeologist working at Carchemish, where, on lonely wanderings, he acquired a knowledge of the Arabs and their language. During the First World War he showed himself a leader of genius, and with extraordinary enterprise, courage and military skill, allied the Arab tribes in revolt against Turkey. Living as one of them and using 'the smallest force, in the quickest time, at the furthest place', he achieved repeated successes, giving invaluable support to Allenby (p.163). He did his best for the Arab interest at the Paris Peace Conference (1919) and at the Colonial Office (1921–2),

but then retired, disillusioned, joining the RAF as an Aircraftsman. Ever after he clung to obscurity, changing his name more than once. His sudden death in a motorcycle accident has only added to the enigma of his life and personality. He published *The Seven Pillars of Wisdom*, his account of the Arab revolt, privately in 1926.

This drawing of Lawrence in his Arab robes was 'done in two minutes' when in Paris, and Lawrence chose it for inclusion in *The Seven Pillars*. It was presented to the Gallery by George Bernard Shaw in 1944.

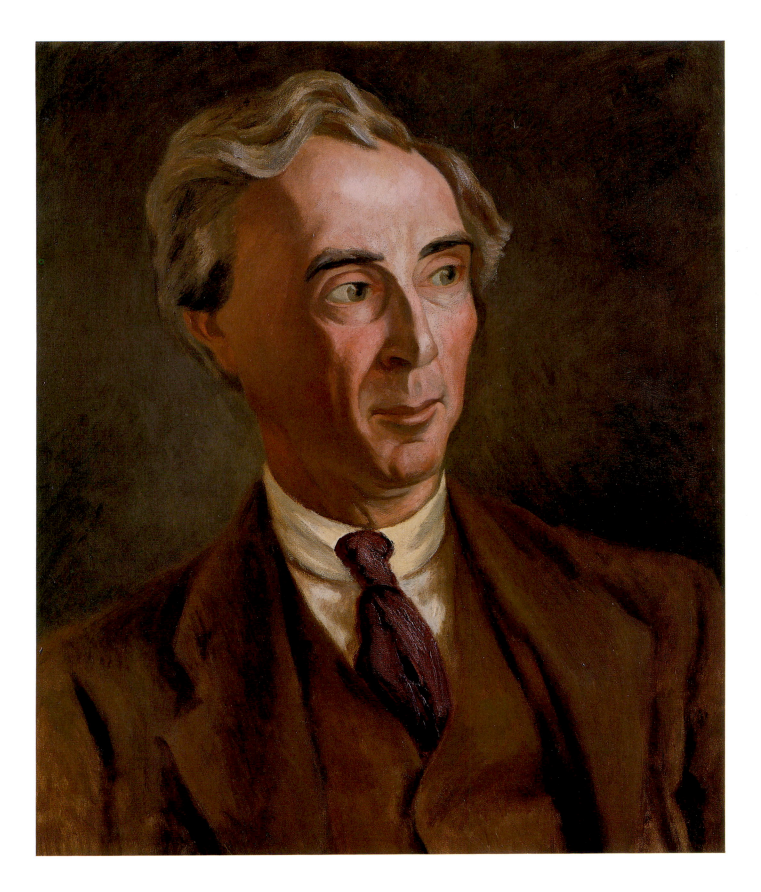

BERTRAND RUSSELL, 3rd EARL RUSSELL 1872–1970
Oil on canvas, 54 × 45.1 (21¼ × 17¾)
By Roger Fry, c.1923 (4832)

As a philosopher and social reformer, Russell was indisputably one of the century's major intellects, and was closely associated with the Bloomsbury Group, of which the artist of this portrait was himself a key member. A philosopher whose reputation was established with the *Principia Mathematica* (1910–13), Russell was also a writer, lecturer, Nobel Prize Winner for Literature (1950), an ardent pacifist and the first President of the Campaign for Nuclear Disarmament (1958), an organisation which he split in 1960, to form the more militant Committee of 100, dedicated to civil disobedience in pursuit of its ends. He lived for nearly a hundred years, keeping his mental vigour to the end. His high-pitched voice, precise and pedantic delivery and whinnying laugh were much parodied.

HARRY GORDON SELFRIDGE 1858–1947
Ink and watercolour on paper, 50.7 × 35.6 (20 × 14)
By Powys Evans, *c.*1930(?) (5806)

Born in Ripon, Wisconsin, Selfridge retired from the mail-order business in 1904, and two years later came to London to look for new commercial opportunities. The Oxford Street store which bears his name was the result. It opened in 1909 with £900,000 capital and 130 departments, and from the start set new standards for London's retailers. Throughout his life Selfridge looked on business as an exciting and glorious adventure – he published *The Romance of Commerce* in 1918 and lectured on the subject – and this caricature by Powys Evans, who worked under the pseudonym 'Quiz', conveys much of his energy and determination. It is entitled 'The Golden Road to Eldorado', and shows Selfridge doing a 'turn' on stage: the chain in his left hand perhaps suggests that he is pulling others along after him.

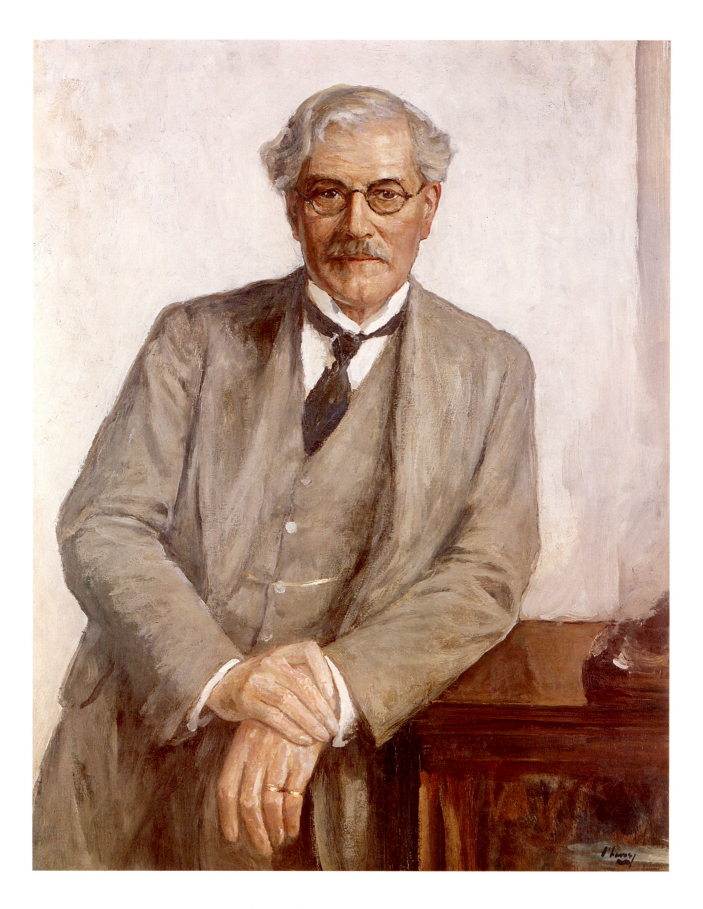

JAMES RAMSAY MACDONALD 1866–1937
Oil on canvas, 95.3 × 69.9 (37½ × 27½)
By Sir John Lavery, signed and dated 1931 (2959)

An ingenuous but dedicated politician, Ramsay MacDonald became the first Labour Prime Minister of this country in 1924. His initial, short-lived, ministry was followed in 1929 by a two-year term of Labour rule, brought to an abrupt end in August 1931 by the country's devastating financial crisis. On the fall of the Labour government, MacDonald immediately accepted the proffered premiership of a Government of National Unity, thereby alienating his former colleagues and creating a breach with his party which was never to be healed.

This portrait, which was painted in MacDonald's year of crisis, was presented to the Gallery by the artist.

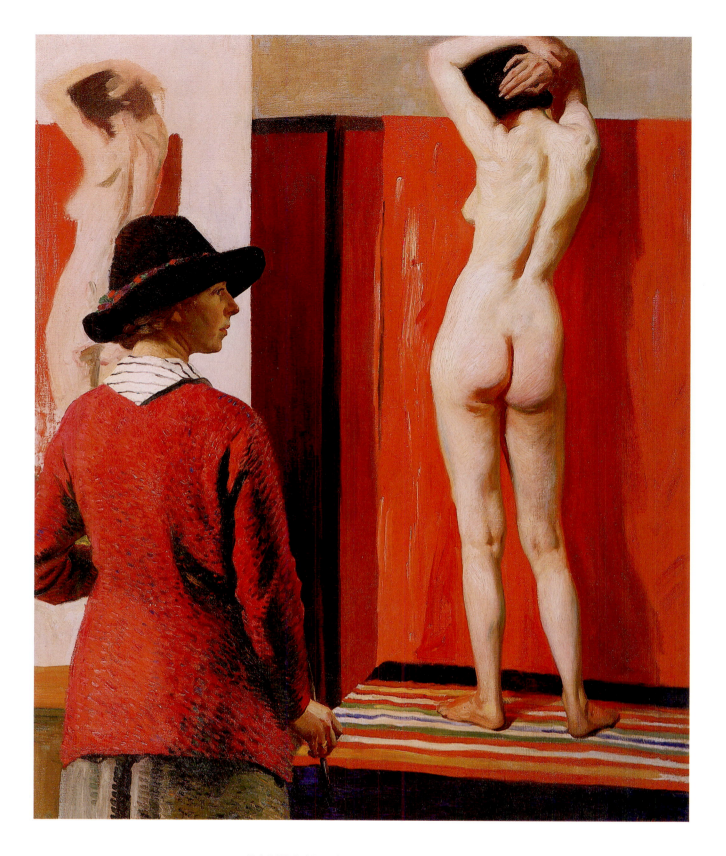

DAME LAURA KNIGHT 1877–1970
Oil on canvas, 152.4 × 127.6 (60 × 50¼)
Self-portrait, signed, 1913 (4839)

An exhibitor at the Royal Academy at the age of twenty-nine and at fifty-nine the first woman to be a full Academician, Dame Laura Knight is best known for the studies of circus and gypsy life which she painted from an old Rolls-Royce fitted out as a miniature studio. She also made drawings of the Diaghilev Ballet, capturing the expressive poses of the dancers with great economy of line. During the Second World War she served on the War Artists' Advisory Committee, and in 1946 as a war correspondent was assigned to make a pictorial record of the Nuremberg War Trials.

This self-portrait was painted early in her career, when she and her husband, Harold, were working as part of the colony of artists which had settled at Newlyn in Cornwall, now known as 'the Newlyn School', devoted to 'the simple truth of nature' as opposed to the idealised subject matter of much Victorian painting. The model for the nude was a neighbour, Ella Naper, who with her artist husband, Charles, were close friends of the Knights.

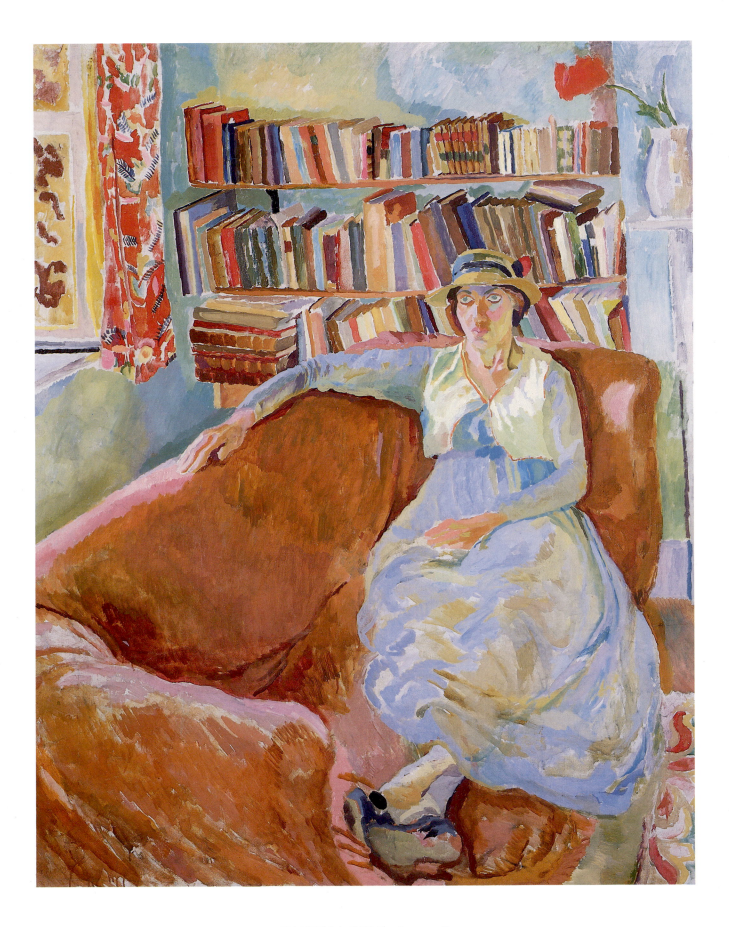

VANESSA BELL 1879–1961
Oil on canvas, 127 × 101.6 (50 × 40)
By Duncan Grant, c.1916–17 (5531)

Sister of Virginia Woolf (p.171) and wife of the writer Clive Bell, Vanessa Bell was at the centre of the Bloomsbury Group, which in the first thirty years of the century was the focus of much of the liveliest of British intellectual and artistic activity. Her work as an artist is closely allied to that of Duncan Grant, with whom she lived from 1913. She is seen here in the downstairs sitting-room of her home, Charleston Manor, Sussex. The curtains and the artificial flowers on the mantelpiece were made at the Omega workshops (founded 1913) which both artists actively supported.

VIRGINIA WOOLF 1882–1941
Bromide print, 15.2 × 10.8 (6 × 4¼)
By George Charles Beresford, 1902 (P221)

Novelist and critic, and central member of the Bloomsbury
Group, she was photographed by Beresford in July 1902 on
the same day as her father, the writer Sir Leslie Stephen, and
her sister, the artist Vanessa Bell (p.170).

A.A. MILNE 1882–1956 WITH HIS SON CHRISTOPHER ROBIN, born 1920
Bromide print, 22.9 × 26 (9 × 10¼)
By Howard Coster, 1926 (Reference Collection)

The celebrated playwright and children's writer with the son
who inspired much of his best work; photographed in the
year of the publication of *Winnie the Pooh*, and with the
original Pooh Bear.

CHRISTOPHER ISHERWOOD 1904–86
Bromide print, 21 × 14.6 (8¼ × 5¾)
By Humphrey Spender, 1935 (P41)

The writer, best known for his evocative novels set in Berlin
during Hitler's rise to power, notably *Goodbye to Berlin* (1939),
photographed in his Berlin apartment.

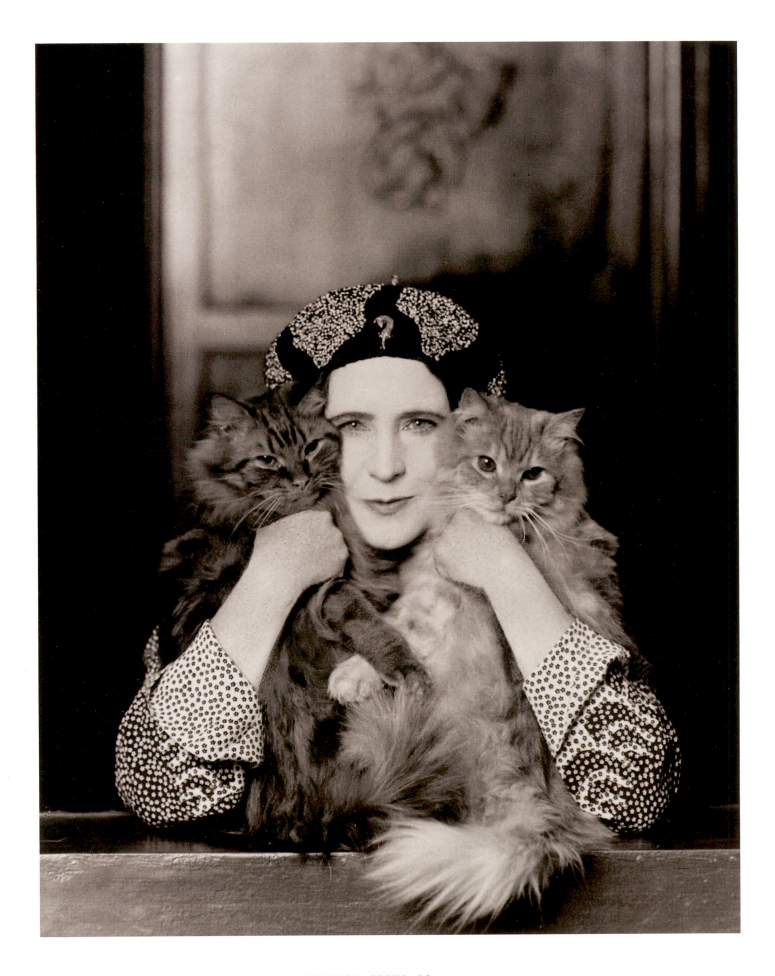

ELINOR GLYN 1864–1943
Bromide print, 23.2 × 14.1 (9⅛ × 5½)
By Paul Tanqueray, 1931 (Reference Collection)

The authoress of outré romantic novels like *Three Weeks*
(1907) and *It* (1927) with her cats Candide and Zadig.

174

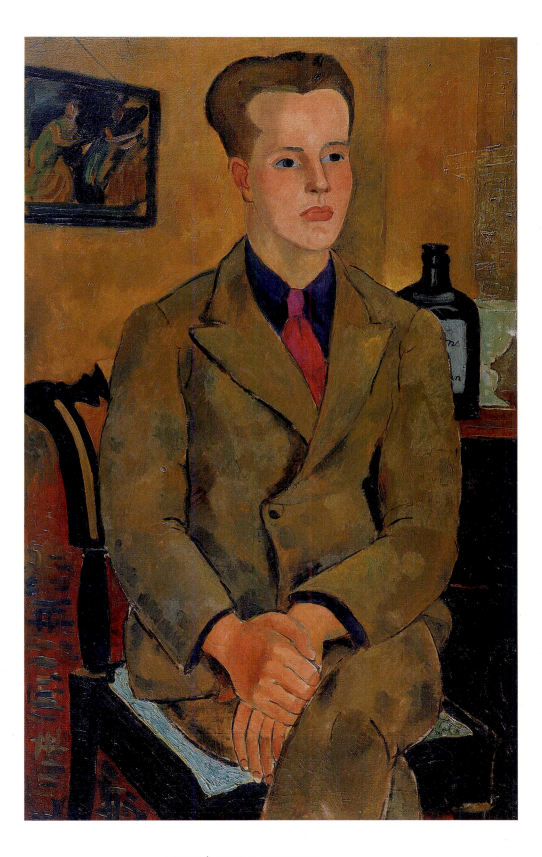

CONSTANT LAMBERT 1905–51
Oil on canvas, 91.4 × 55.9 (36 × 22)
By Christopher Wood, 1926 (4443)

Constant Lambert, friend of the Sitwells, and the witty, erudite author of *Music Ho!* (1934), was one of a very small number of musicians to perceive the challenge presented by popular to classical music in the 1930s. A composer, musician and music critic of the *Sunday Referee*, he later became musical director of Sadler's Wells and was a frequent conductor at Covent Garden and the promenade concerts. In still popular works such as *The Rio Grande*, he bridged the gulf between Stravinsky and Duke Ellington, Ravel and Cole Porter,

finding musical quality where the establishment had thought it unnecessary to look.

Christopher Wood trained in Paris, where he became a friend of Picasso, Cocteau and Diaghilev. He was a member of the Seven and Five Society, and had his first major exhibition with Ben Nicholson (p.178) in 1927, the year after this portrait was painted. He was killed by a train at Salisbury in 1930 at the age of twenty-nine.

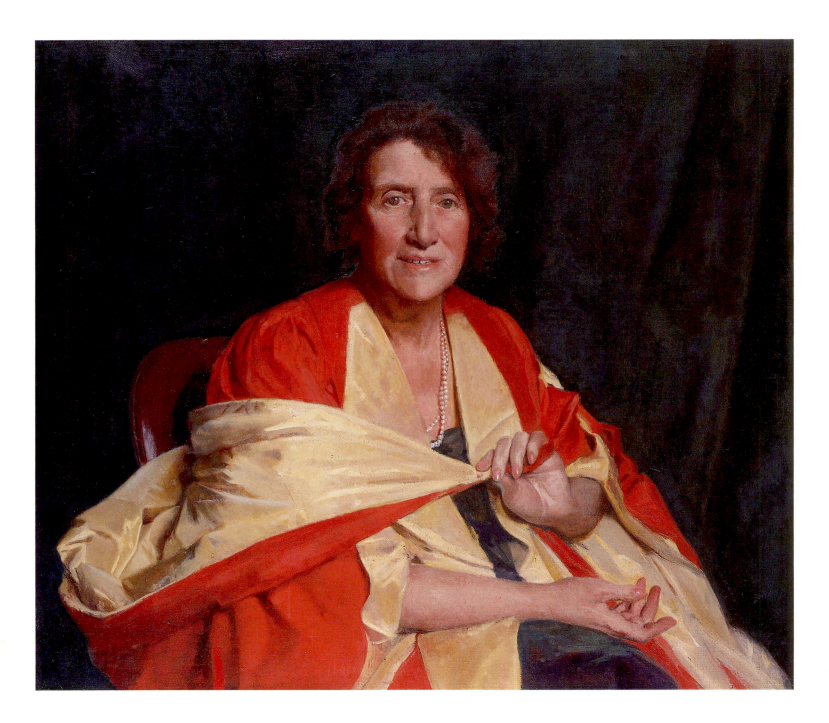

MARIE CARMICHAEL STOPES 1880–1959
Oil on canvas, 72.4 × 85.7 (28½ × 33¾)
By Sir Gerald Kelly, signed and dated 1953 (4111)

Educated in Edinburgh and London, Marie Stopes was a lecturer in palaeo-botany before publishing *Married Love* in 1918, a book which advocated and made respectable the use of contraceptive methods. With her husband, Humphrey Verdon-Roe, she founded the Mothers' Clinic for Birth Control in London in 1921 and, despite considerable opposition and ridicule from many sources, devoted herself to popularising family planning. She was fearless, passionately dedicated, arrogantly argumentative, and with a touch of the mystic.

This portrait in academic robes was commissioned by her, and bequeathed to the Gallery.

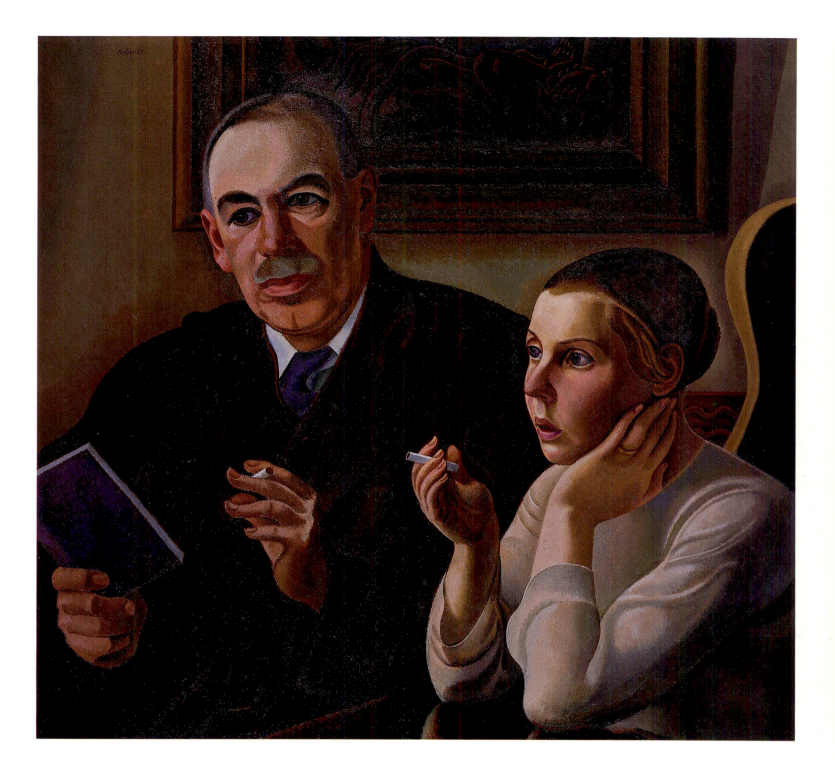

JOHN MAYNARD KEYNES, BARON KEYNES 1883–1946 AND HIS WIFE LYDIA LOPOKOVA 1892–1981
Oil on canvas, 72.4 × 80.6 (28½ × 31¾)
By William Roberts, signed, *c*.1932 (5587)

No one has exercised so profound an influence on twentieth-century economic theory and practice as John Maynard Keynes. He was editor of the *Economic Journal* (1912–45), and published *The Economic Consequences of the Peace* (1919), *A Treatise on Money* (1930) and the *General Theory of Employment, Interest and Money* (1936). It is his advocacy of massive and reflationary state intervention, and active participation in investment and employments which has largely shaped the character of the British economy. Closely connected with the Bloomsbury Group, he married the Russian ballerina, Lydia Lopokova, in 1925. He had an enduring interest in the arts, and was an early supporter of William Roberts, a leading member of the Vorticists, whose *Odalisque* hangs in the background of this portrait.

BEN NICHOLSON 1894–1982 AND DAME BARBARA HEPWORTH 1903–75
Oil on canvas, 27.3 × 16.8 (10¾ × 6⅝)
By Ben Nicholson, signed and dated 1933 (5591)

Entitled *St Rémy Provence*, where it was painted, this is one of a series of pictures executed in the 1930s which reflects the extremely close relationship between two of the most distinguished British artists of the century. Its purity of line and near-abstract shapes illustrate the trend in Nicholson's work at this time towards an art of absolute form, under the influence of Braque, Brancusi and Picasso, whom he met in 1932. He was married to the sculptress Barbara Hepworth from 1933, the year of this painting, until 1951. Her work, like his later paintings and reliefs, is based on formal structures of balance, rhythm and inner harmony, and quickly achieved international recognition.

178

THOMAS STEARNS ELIOT 1888–1965
Oil on canvas, 76.2 × 62.9 (30 × 24¾)
By Patrick Heron, signed and dated 1949 (4467)

American by birth, British by adoption, and culturally a European, Eliot remains probably the greatest poet of this century to write in English. The publication of *The Love Song of J. Alfred Prufrock* (1915) and *The Wasteland* (1922) signalled a new anti-romantic spirit in English poetry which had a profound influence on young writers of his time, and has remained of supreme importance in the literary tradition ever since. This is one of two Cubist portraits by the painter and art-critic Patrick Heron in the Gallery's collection; the subject of the other, the art-critic Herbert Read, was suggested to the artist by Eliot.

JAMES AUGUSTINE JOYCE 1882–1941
Oil on canvas, 125.1 × 87.6 (49¼ × 34½)
By Jacques-Emile Blanche, signed and dated 1935 (3883)

It is surprising to find the author of the controversial novels *Ulysses* (1922) and *Finnegans Wake* (1939) looking in this portrait more like the head of a successful family business than a bohemian and revolutionary. The French society-portraitist Blanche's urbane image is undoubtedly misleading, and his reminiscences, *More Portraits of a Lifetime*, present a less idealised portrait of the Irish writer and his eccentricities.

The two met through 'Les Amis de 1914', an art society in Paris, where both were living. Joyce expressed a desire to sit to Blanche, but was particular that he should not be painted full-face, as he was self-conscious about the very thick lenses of his spectacles.

WILLIAM MAXWELL AITKEN, 1st BARON BEAVERBROOK 1879–1964
Oil on canvas, 176.2 × 107.3 (69⅜ × 42¼)
By Walter Richard Sickert, signed and dated 1935 (5173)

Born in Canada, Beaverbrook came to England in 1910 and with the help of Bonar Law became Conservative Member of Parliament for Ashton-under-Lyne. Proprietor of the *Daily Express* and *Evening Standard*, he played a significant role in British public life, and remained in close touch with his editors right up to his death. He backed Lloyd George (p.158) to succeed Asquith as Prime Minister in 1916, supported Chamberlain (p.182) over the Munich Crisis in 1938, and using all his considerable influence in the interests of discretion, proved a loyal ally of Edward VIII during the abdication. Churchill brought him into the War Cabinet as Minister of Aircraft Production in 1940. Sickert, as was often his practice in later years, based this portrait on a snapshot, and has created from slight material an image of great power.

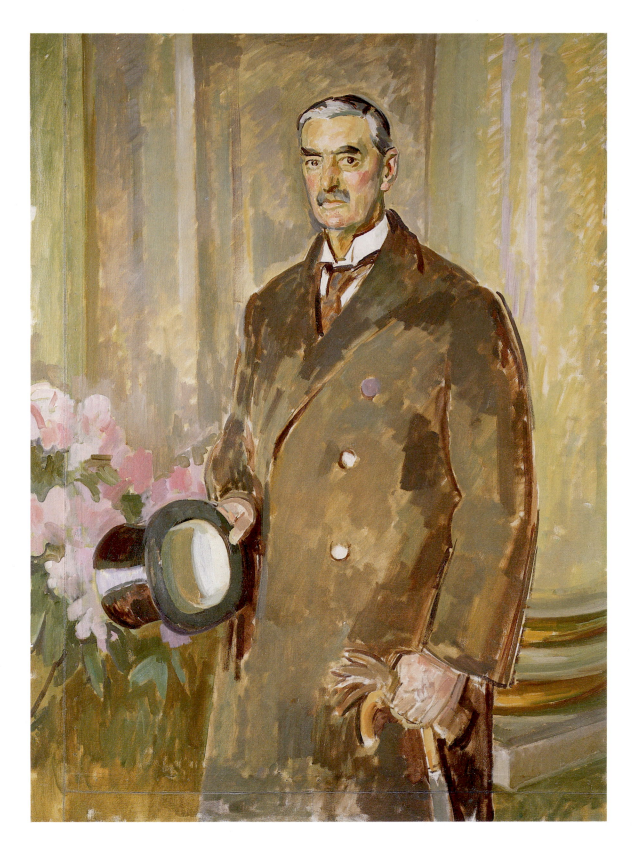

ARTHUR NEVILLE CHAMBERLAIN 1869–1940
Oil on canvas, 129.5 × 94 (51 × 37)
By Henry Lamb, *c.*1939 (4279)

An efficient peacetime Prime Minister, who had been an industrious and reforming Lord Mayor of Birmingham and Minister of Health, Chamberlain is inevitably remembered for his part in the events surrounding the Munich Crisis of 1938. Passionately dedicated to avoiding war in Europe, but inexperienced in foreign policy, he went with Daladier to meet Hitler and Mussolini at Munich, and returned with a settlement which he described as 'peace with honour'. A popular hero on his return to England, his hour of triumph was brief; war broke out the following year and in the wake of early defeats and mounting criticism he was forced to resign in May 1940. He declined all titular honours (including the Order of the Garter), preferring to remain plain 'Mr Chamberlain'. In Lamb's portrait, painted in the years of crisis, it is impossible, with the benefit of hindsight, not to see the Prime Minister's confident stance as undermined by the anxiety and insecurity betrayed in his face.

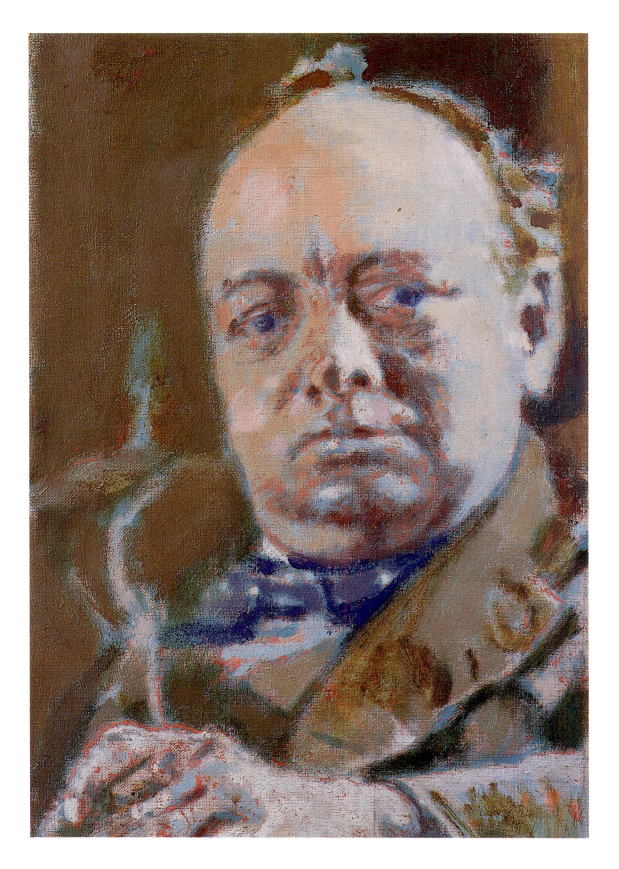

SIR WINSTON SPENCER CHURCHILL 1874–1965
Oil on canvas, 45.7 × 30.5 (18 × 12)
By Walter Richard Sickert, 1927 (4438)

From Omdurman and the Boer War to his state funeral in 1965, Winston Churchill's life was almost synonymous with the major events in contemporary British history. The son of Lord Randolph Churchill, he naturally gravitated into politics, after brief but eventful careers as a soldier and then as a journalist, and for the next fifty years was to be one of the dominant figures in the House of Commons. A vociferous and eloquent enemy of appeasement, he succeeded Chamberlain (p.182) as Prime Minister in 1940, and became Britain's leader and inspiration in her darkest hour.

This informal and relatively youthful portrait was painted in Sickert's studio at 27 Highbury Place, in the year following the General Strike, in which, as Chancellor of the Exchequer, Churchill had played a controversial role. Despite the superficial air of relaxation about his portrait, Churchill's expression suggests a profound thoughtfulness.

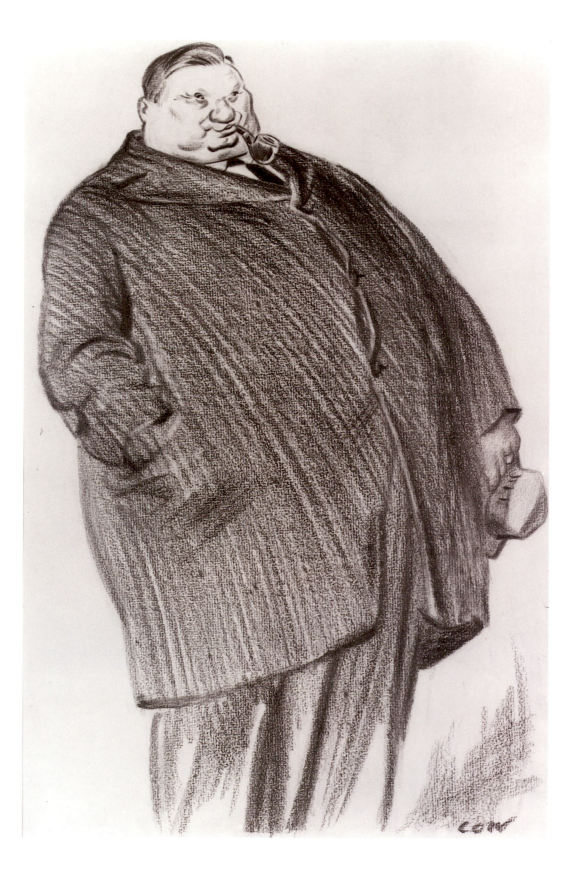

ERNEST BEVIN 1881–1951
Chalk on paper, 45.7 × 29.5 (18 × 11⅝)
By Sir David Low, signed, *c*.1933 (4558)

Bevin in later life described himself as 'a turn-up in a million'; the illegitimate son of a Somerset village midwife, he never knew his father, had little formal education, and began work as a farm boy on a wage of 6s 6d a quarter. He nevertheless rose to become a powerful trade-union leader, Minister of Labour in Churchill's War Cabinet, and a brilliant Foreign Secretary in Attlee's post-war government. He was one of the first to recognise the dangers of Russian expansionism; he achieved the foundation of NATO, and was responsible – even more than Marshall himself – for the development of Marshall Aid for Europe.

This caricature, published in *The New Statesman and Nation* in 1933, conveys something of the massive physical presence of the man, who in debate could seem like 'something resembling a force of nature'.

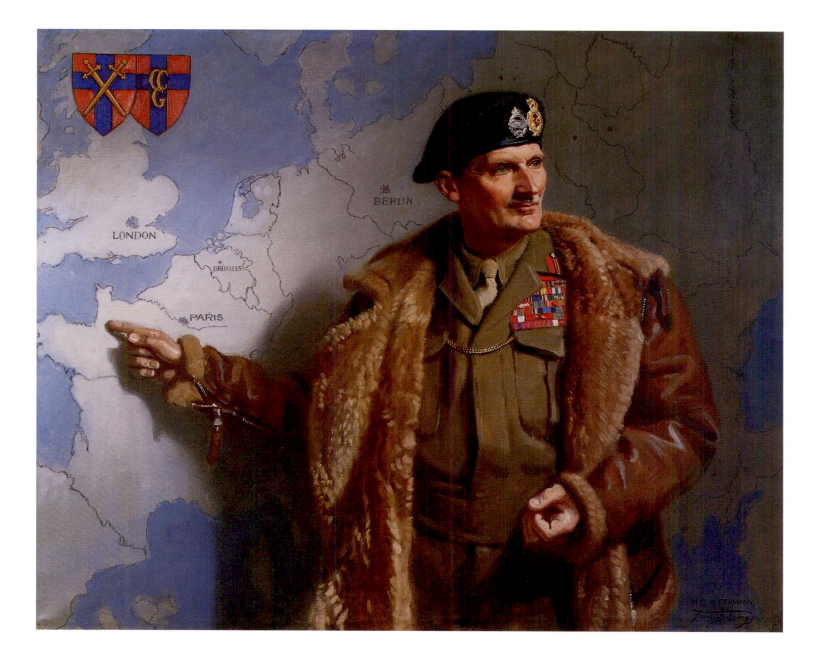

BERNARD LAW MONTGOMERY, 1st VISCOUNT MONTGOMERY OF ALAMEIN 1887–1976
Oil on canvas, 102.2 × 126.7 (40¼ × 49⅞)
By Frank O. Salisbury, signed and dated 1945 (L165)

Before Alamein we never had a victory, pronounced Churchill; after it we never suffered a defeat. The victory of the 8th Army at Alamein in 1942 was pre-eminently Montgomery's victory and assured his reputation as Britain's finest field commander since Wellington. An exacting disciplinarian and meticulous planner, his genius lay in his extraordinary ability to inspire enthusiasm and loyalty in his troops. Admired by Churchill, he was entrusted with the command of the 21st Army Group in the invasion of Europe, and is seen in Salisbury's portrait pointing to a map of the Normandy beaches.

This portrait was commissioned by Montgomery himself, and is on loan to the Gallery from his son.

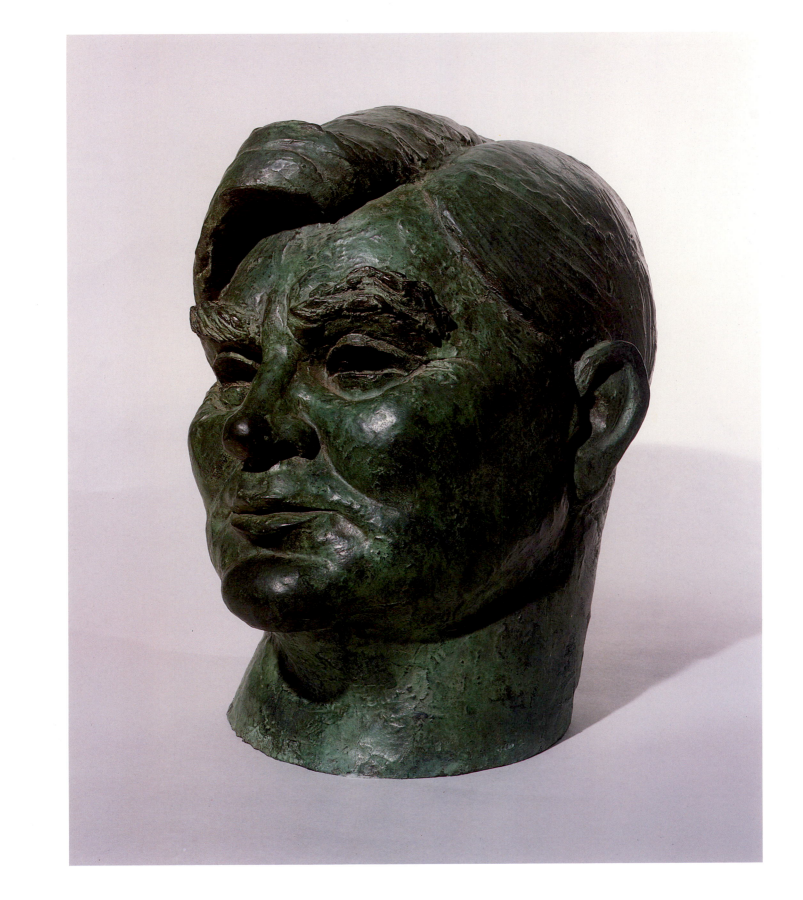

ANEURIN BEVAN 1897–1960
Bronze, 40 (15¾) high
By Peter Lambda, 1945 (4993)

Nye Bevan, first elected to Parliament in 1929 as Labour member for Ebbw Vale, proceeded to impress, delight and exasperate the House of Commons for the next thirty-one years. As Minister of Health and Housing in Attlee's post-war government he secured the passage of the National Health Service Act in 1946 and the establishment of the Health Service in 1948. Contentious, difficult, frequently in conflict with his own party as well as the opposition, he was nevertheless a much-loved, much-valued and energetic personality in the post-war political scene.

The original cast of this larger-than-life bust was made for the Tredegar Workmen's Institute.

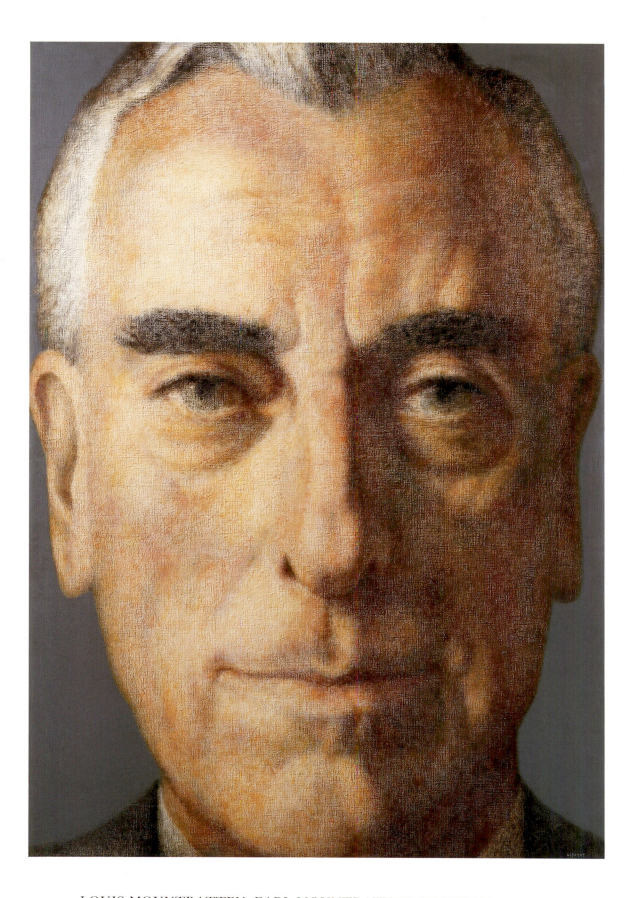

LOUIS MOUNTBATTEN, EARL MOUNTBATTEN OF BURMA 1900–79
Oil on canvas, 162.6 × 114.3 (64 × 45)
By John Ulbricht, signed, 1968 (4617)

The great-grandson of Queen Victoria and the uncle of Prince Philip, Lord Mountbatten enjoyed a meteoric naval career, which took him from midshipman at Jutland in 1916 to First Sea Lord in 1955, and included the legendary command of HMS Kelly and the Supreme Command of the Far East during the Second World War. In 1947 he was appointed by the Attlee government to supervise the transfer of power in India from the British Raj, and was the last Viceroy and the first Governor-General of the new dominion. He was assassinated by Irish terrorists.

Ulbricht's monumental head conveys much of the personal magnetism of this patrician figure; handsome, courageous, ambitious and proud.

JESSIE MATTHEWS 1907–81
Bromide print, 28.9 × 23.1 (11⅜ × 9⅛)
By Dorothy Wilding, signed, *c.*1928 (P210)

This vibrant and mischievous actress, dancer and singer who starred in many stage and film musicals in the 1930s and 40s, regained her popularity on radio as 'Mrs Dale' in *Mrs Dale's Diary* (1963–9).

SIR CHARLES ('CHARLIE') CHAPLIN 1889–1977
Bromide print, 21.8 × 17.2 (8⅝ × 6¾)
By an unknown photographer, 1928 (P287)

The great comic film actor, writer, producer and director,
taken at the time of his film *The Circus*.

LAURENCE OLIVIER, BARON OLIVIER OF BRIGHTON born 1907
Bromide print, 46.5 × 37.2 (18½ × 14⅝)
By Laszlo Willinger, signed, 1940 (P236)

The most renowned British actor of recent times, equally
brilliant in Hollywood films and Shakespearian tragedy,
photographed in Hollywood.

VIVIEN LEIGH 1913–67
Bromide print, 50.5 × 40 (19⅞ × 15¾)
By Angus McBean, signed, 1952 (P62)

A stage and screen actress of exceptional beauty, Vivien
Leigh is best remembered as 'Scarlett O'Hara' in *Gone with the
Wind* (1939). She was at one time married to Laurence Olivier.

CONVERSATION PIECE AT ROYAL LODGE, WINDSOR
Oil on canvas, 151.1 × 100.3 (59½ × 39½)
By Sir James Gunn, signed, 1950 (3778)

Commissioned by the Trustees of the National Portrait Gallery from the established society-portraitist Gunn, this charming group shows George VI (1895–1952; reigned 1936–52), Queen Elizabeth (now the Queen Mother), and Princess Elizabeth (the present Queen) at tea in the Royal Lodge, with Princess Margaret about to take her seat. While almost self-consciously emulating the eighteenth-century conversation pieces of Johann Zoffany and Arthur Devis,

especially in the exquisite still-life of the tea-table, it is nevertheless an accurate and valuable record of a much-loved family, relaxing in the privacy of their own home. In its informal presentation – it would be unthinkable to show the monarch smoking in a portrait today – it is perhaps influenced by the popular photographs of the royal family relaxing at Windsor which had been released during the Second World War, and which did so much to boost national morale.

SIR WILLIAM WALTON 1902–83
Oil on canvas, 61.3 × 91.5 (24⅛ × 36)
By Michael Ayrton, signed, 1948 (5138)

Although Walton first came to prominence in the early 1920s as an *enfant terrible*, composing the witty and satirical score for Edith Sitwell's *Façade*, he belongs in essence to the late romantic tradition of English musical composition, the tradition of Elgar. He was not at all prolific as a composer, but worked in many different genres, including oratorio – *Belshazzar's Feast* was first performed in 1931 – concerto, symphony, opera and ballet. He also wrote music for the coronations of George VI and the present Queen, as well as film scores, of which the best known is that for Olivier's *Henry V*.

A thoroughgoing Lancastrian, Walton nevertheless lived the greater part of his life on the island of Ischia, where this portrait was painted. Although it did not enter the collection until 1977, Wyndham Lewis, writing in 1954, said that it should find its place here.

193

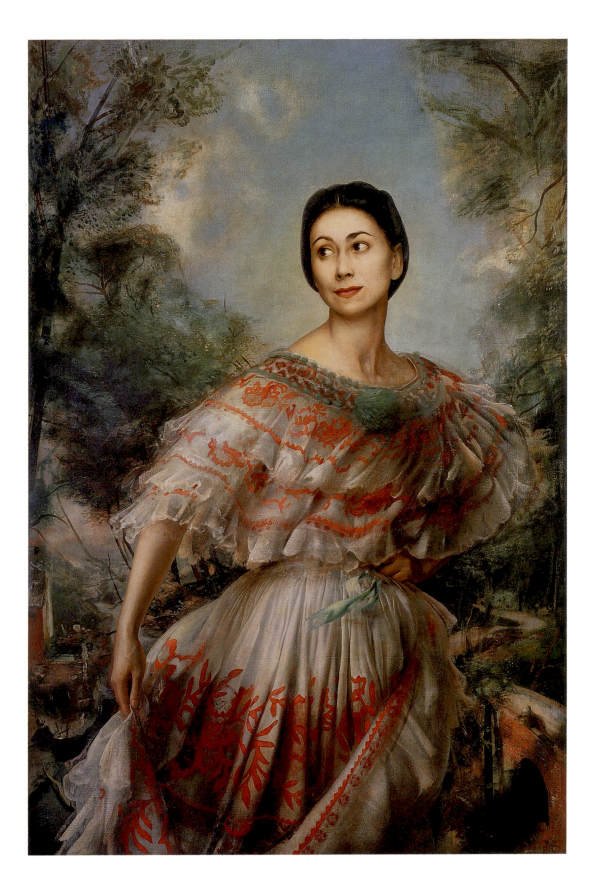

DAME MARGOT FONTEYN DE ARIAS born 1919
Tempera on canvas, 153.3 × 100 (60⅜ × 39⅜)
By Pietro Annigoni, signed and dated 1955 (L189)

One of the greatest British-trained ballerinas, Margot Fonteyn joined the Sadler's Wells Ballet School in 1934, and made her debut as a snowflake in *Nutcracker*. Trained by Ninette de Valois and nurtured by the choreographer Frederick Ashton, she rapidly developed an international reputation for her innate musicality and flawless technique. Her partners included Robert Helpmann, Michael Somes, and, particularly, Rudolph Nureyev, who helped her reveal unsuspected dramatic powers. This graceful portrait is among Annigoni's finest early works, and shows Dame Margot in Panamanian national costume; an allusion to her marriage in 1955 to Dr Roberto Arias, the then Panamanian ambassador to London. The painter appears in the landscape background, leaning over a bridge.

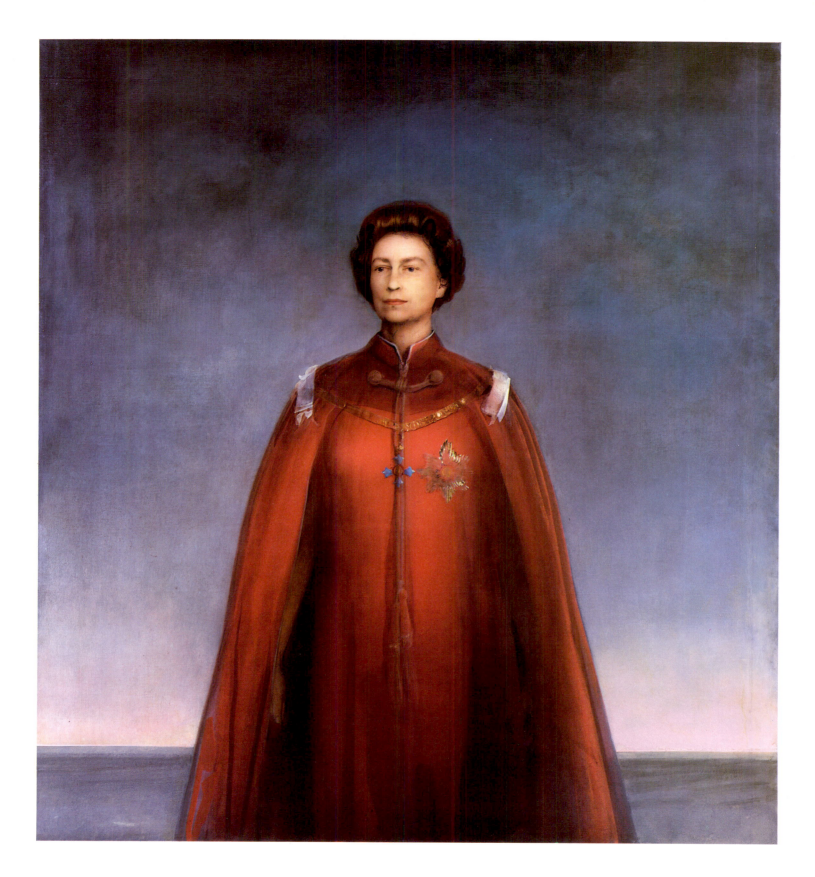

HM QUEEN ELIZABETH II born 1926
Tempera on panel, 198.1 × 177.8 (78 × 70)
By Pietro Annigoni, signed and dated 1969 (4706)

This portrait of the Queen in her robes as Sovereign of the Order of the British Empire by the leading Italian artist Annigoni was presented to the Gallery by Sir Hugh Leggatt, head of Leggatt Brothers, the well-known firm of art dealers. The painting took ten months to complete, and the Queen gave no less than eighteen sittings. The artist has said of his work: 'I did not want to paint her as a film star; I saw her as monarch, alone in the problems of her responsibility'. It is a measure of the personal significance of the portrait for him that he incorporated above his signature in the silk ribbon on the Queen's right shoulder the initials of his ex-wife and model, Anna Maggini, who had died a few months before the painting was completed. Despite the artist's serious intentions, the portrait was widely criticised when it was unveiled, and has proved one of the Gallery's most controversial acquisitions.

HUGH GAITSKELL 1906–63
Oil on canvas, 91.4 × 75.6 (36 × 29¾)
By Judy Cassab, signed, 1957 (4923)

Educated at Winchester and New College, Oxford, Gaitskell joined the Labour Party as an undergraduate. He was a lecturer in political economy at University College, London, from 1928–38 and first entered Parliament in 1945. His rise in politics was rapid: Chancellor of the Exchequer by 1950, leader of the party in 1955. During the seven years in which he led the opposition, he was the most outspoken critic of

Britain's policy on Suez, and constantly strove to imbue the Labour Party with his own heartfelt morality and practical understanding of the economy.

This portrait by the Viennese-born artist Judy Cassab, who now lives and works in Australia, was presented to the Gallery by the sitter's widow, Baroness Gaitskell.

ALEXANDER FREDERICK DOUGLAS-HOME, BARON HOME OF THE HIRSEL born 1903
Tempera on panel, 111.8 × 75.6 (44 × 29¾)
By Suzi Malin, signed, 1980 (5367)

This informal portrait of the Tory statesman, who relinquished his title as 14th Earl of Home in 1963 to become Prime Minister, was commissioned from the London artist Suzi Malin in 1980. It was painted from life studies made at Lord Home's Scottish home, The Hirsel, Berwickshire, in April that year, and shows him with a fishing-rod and his retriever, Crispin. It is painted in tempera on a white ground, and the meticulous analytic technique recalls the work of the Pre-Raphaelite painters of the nineteenth century.

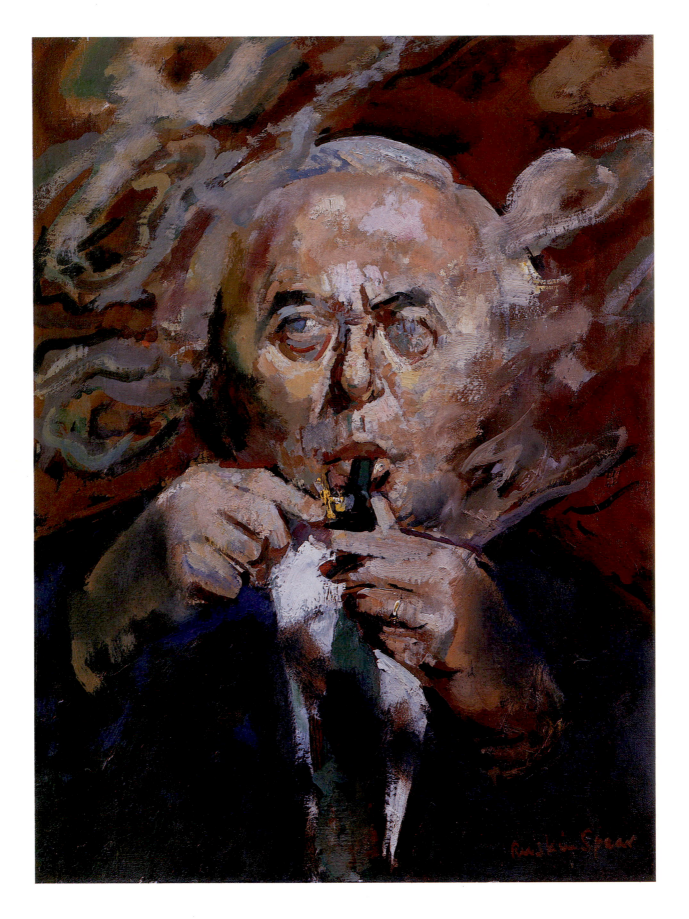

HAROLD WILSON, BARON WILSON OF RIEVAULX born 1916
Oil on canvas, 51.1 × 38.1 (20⅛ × 15)
By Ruskin Spear, c.1974 (5047)

A Member of Parliament at twenty-nine, and at forty-eight Britain's youngest Prime Minister of the century, Harold Wilson led a series of cabinets through the 1960s and 70s which confirmed Britain's commitment to a welfare state. A gifted speaker and a skilful politician, he is portrayed with that air of hard-won informality which distinguished his public style. This painting is a characteristic work of the Royal Academician Ruskin Spear, whose impressionistic portraits – often based on newspaper photographs – subject familiar public figures to gently satirical scrutiny.

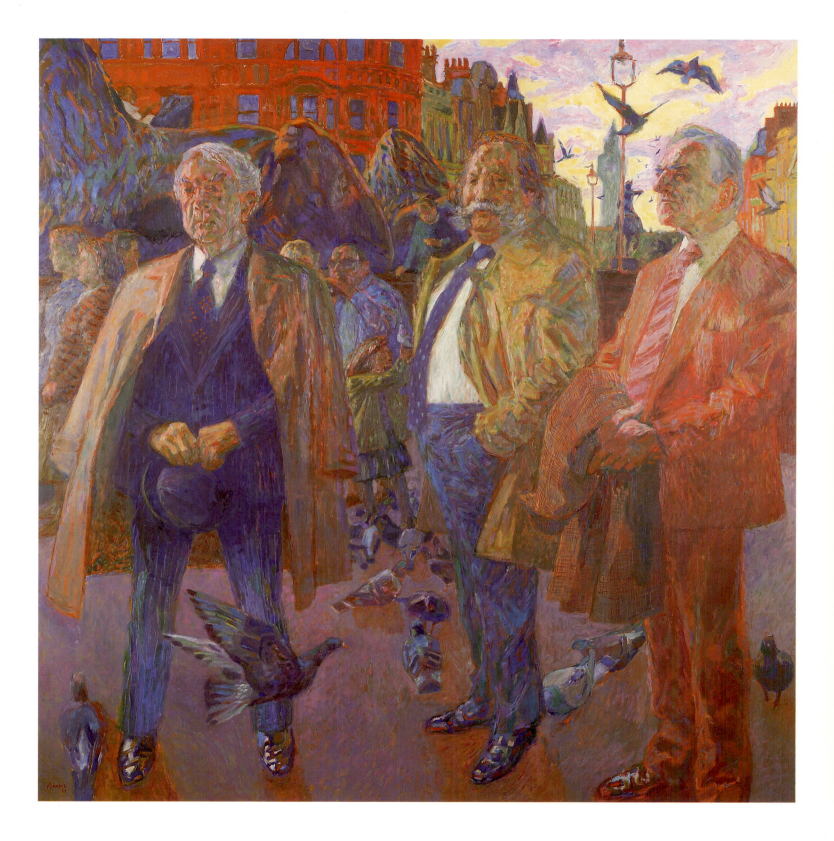

THREE TRADE-UNION LEADERS
Oil on board, 183 × 183 (72 × 72)
By Hans Schwarz, signed and dated 1984 (5749)

The sitters are (left to right): Joe Gormley, Baron Gormley of Ashton-in-Makerfield (born 1917), President of the National Union of Mineworkers (1971–82); Tom Jackson (born 1925), General Secretary to the Union of Communications Workers (formerly Post Office Workers) (1967–82); Sid Weighell (born 1922), General Secretary to the National Union of Railwaymen (1975–83).

This portrait was commissioned by the Gallery in 1984 from the Vienna-born artist Hans Schwarz, who came to England in 1939 and trained at Birmingham Art School. It shows the trade-union leaders in Trafalgar Square, close to the Gallery and to Westminster, and, at the suggestion of Sid Weighell, is in a wood and metal frame made by British Rail Engineering, Derby, to a design by the artist.

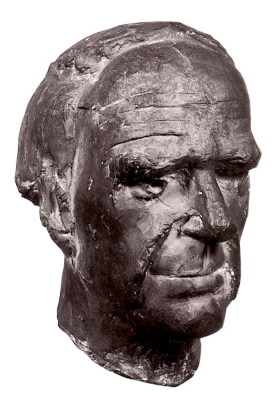

HENRY MOORE 1898–1986
a) Bronze, 31.1 (12¼) high
By Marino Marini, 1962 (4687)

This head of the greatest British twentieth-century sculptor, renowned for his monumental seated and reclining figures, was modelled at his cottage at Forte dei Marmi near Carrara, at the foot of a marble mountain which has provided the raw material for much of his sculpture. The Italian Marini, a friend and neighbour, has sculpted only a handful of portraits, and is best known for his series of sculptures of horsemen. This head was presented to the Gallery by artist and sitter jointly.

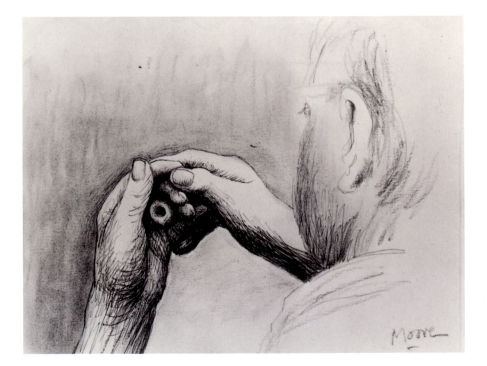

b) Charcoal, ballpoint, brown pastel, carbon line and gouache, 24.3 × 29.5 (9½ × 11⅝)
Self-portrait, signed, 1982 (5694)

This very late self-portrait, which concentrates on the sculptor's hands, and is an expression of the creative forces latent in them, was executed for his eighty-fifth birthday exhibition.

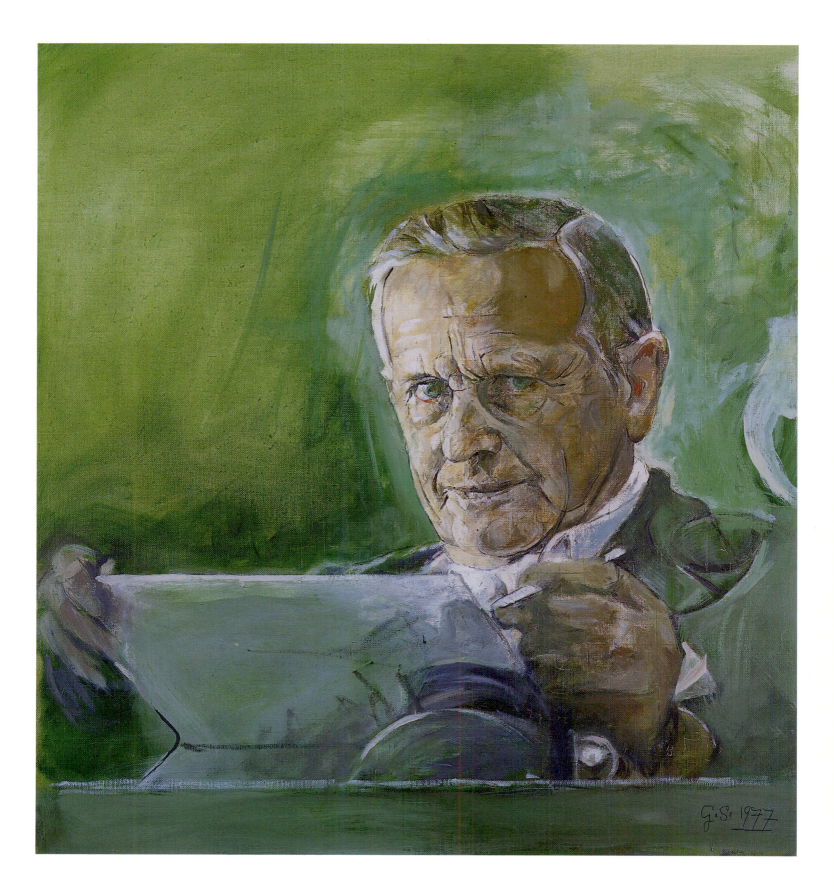

GRAHAM SUTHERLAND 1903–80
Oil on canvas, 52.7 × 50.2 (20¾ × 19¾)
Self-portrait, signed and dated 1977 (5338)

Trained as an etcher, Graham Sutherland only turned to painting in the 1930s when, inspired by the Pembrokeshire countryside, he began to develop an idiosyncratic, neo-romantic style based on his observation of organic forms in nature. In 1949 he painted his portrait of Somerset Maugham (Tate Gallery), which established him as a portrait painter of the first rank. He is equally well known as a war artist, whose work has 'a bold, crucified poignancy', and for such religious works as the vast tapestry *Christ in Majesty* in Coventry Cathedral (1962).

This rare self-portrait was painted for the exhibition of Sutherland's work held at the Gallery in 1977, and presented to the Gallery by his widow in 1980.

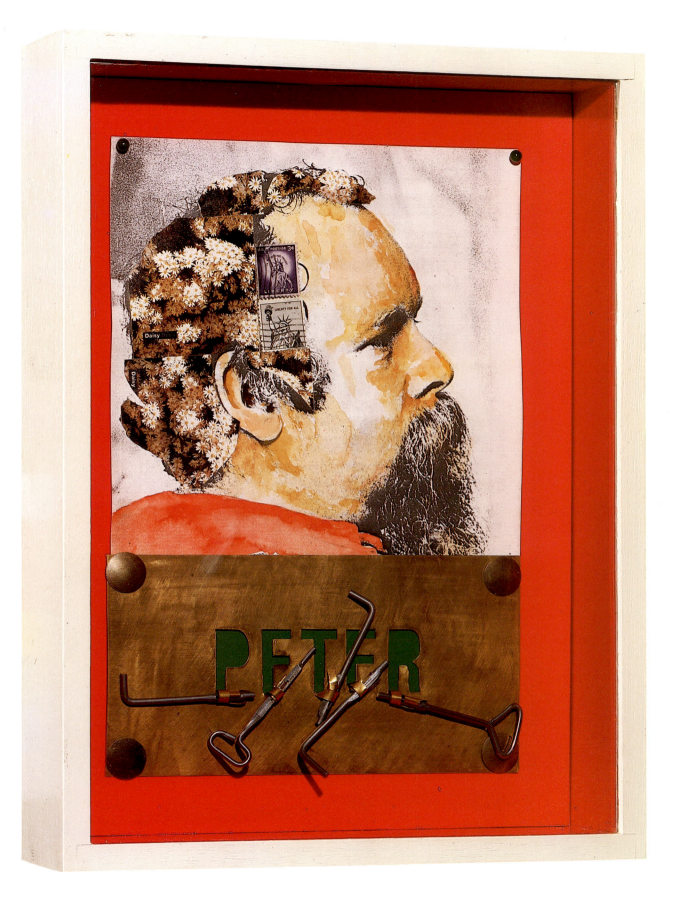

PETER BLAKE born 1932
Boxed collage, 27.9 × 19 (11 × 7½)
By Clive Barker, 1983 (5845)

The 'Peter Blake Box' is an appropriately witty portrait of this leading figure in the Pop Art Movement of the 1950s and '60s, who in 1969 co-founded the Brotherhood of Ruralists, and was elected a Royal Academician in 1980. The artist Clive Barker was himself associated with Pop Art in the early 1960s, and is noted for his bold and brightly coloured portraits of fashionable personalities, and for elegantly stylized chrome and brass sculptures. In this collage the daisies in Blake's hair and the two American 'Liberty' stamps allude to the sitter's daughters Daisy and Liberty.

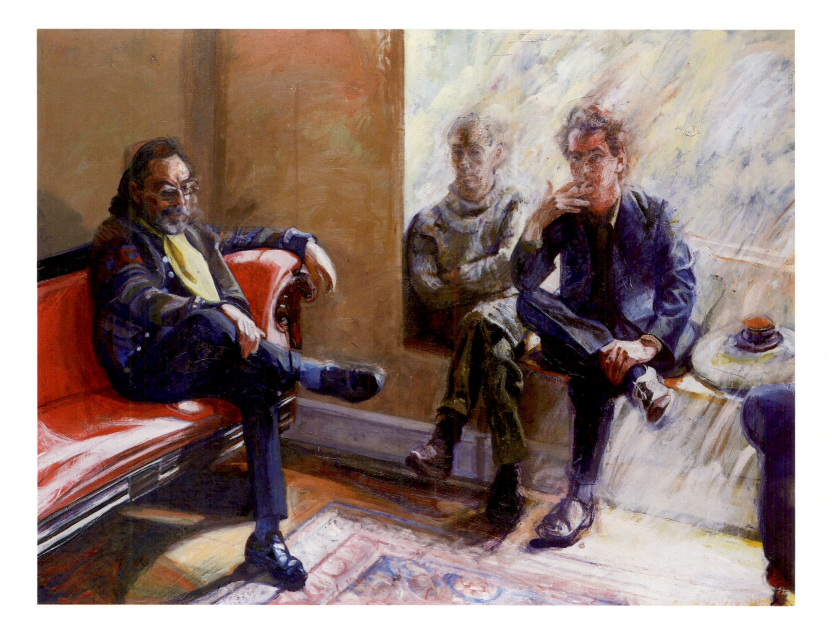

THE LIVERPOOL POETS
Oil on canvas, 175.9 × 237.5 (69¼ × 93½)
By Peter Edwards, 1985 (5853)

The sitters are (left to right): Adrian Henri (born 1932), Roger McGough (born 1937) and Brian Patten (born 1946), who came together in the 1960s, in the period of Liverpool euphoria encouraged by the success of the Beatles, and were collectively known as 'The Liverpool Poets'. They published together in various periodicals and anthologies, including *The Mersey Sound* (1967) and *The Liverpool Scene* (1967), but their verse – witty, urban, subversive, 'pop' – was made for public performance.

The young Shropshire artist, Peter Edwards, a regular exhibitor in the Gallery's annual Portrait Award, has painted them as part of a projected series of portraits of poets, in a smoke-filled room, in autumnal mood, bohemians on the brink of middle-age.

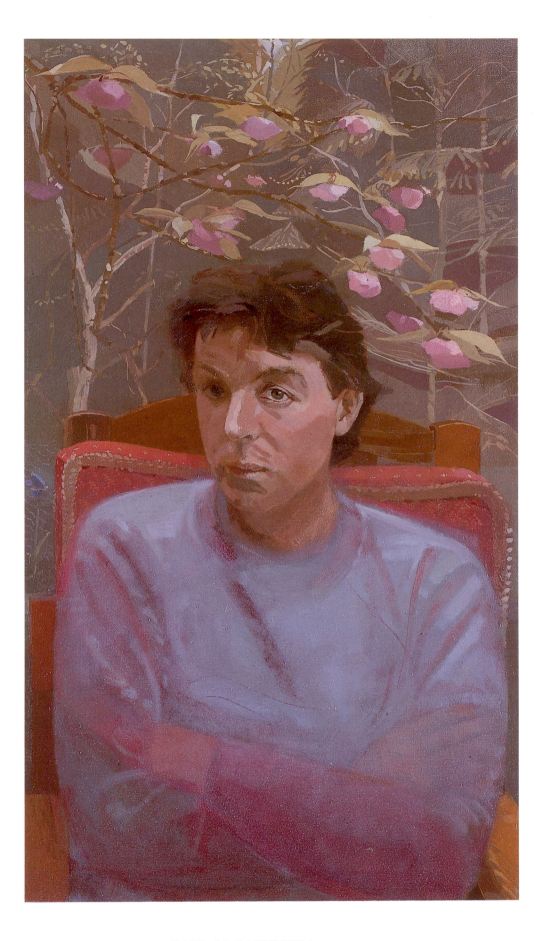

PAUL McCARTNEY born 1942
Oil on canvas, 85.4 × 49.5 (33⅝ × 19½)
By Humphrey Ocean, signed and dated 1983 (5695)

This portrait of the pop-musician and former Beatle was commissioned from the artist as part of his prize as the winner of the John Player Portrait Award in 1982. It is appropriately lyrical and reflective in tone, and is the fruit of a relationship with McCartney which began when Ocean was artist-in-residence on the tour of his group, Wings, to America in 1976. The artist has also painted portraits of the poet Philip Larkin (p.211) and the philosopher Sir Alfred Ayer for the Gallery.

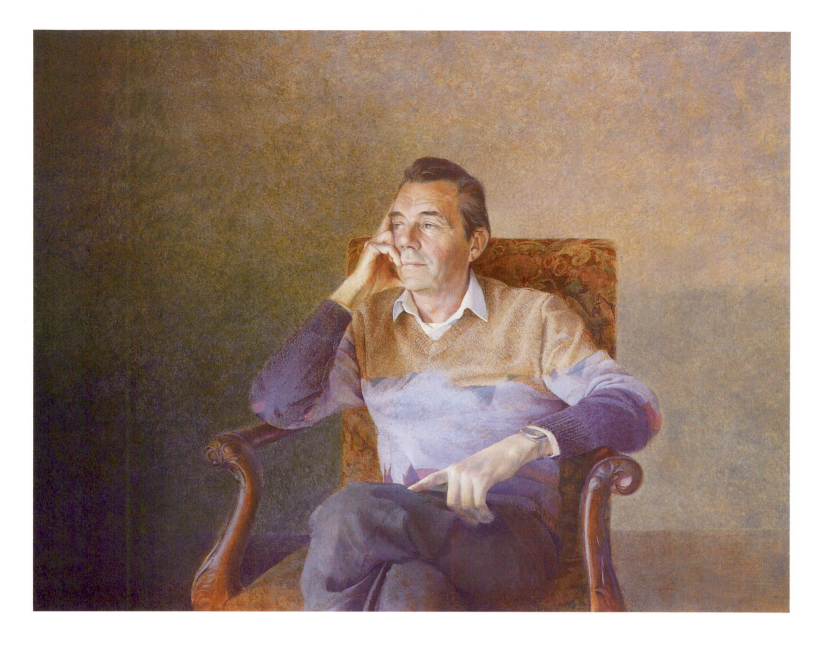

DIRK BOGARDE born 1921
Egg tempera on canvas, 64.8 × 94.1 (25½ × 33⅛)
By David Tindle, signed and dated 1986 (5891)

As a film actor Dirk Bogarde first came to the public eye in *The Blue Lamp* (1950), and was Britain's top romantic male lead from the mid-1950s, in such films as the popular *Doctor* series (1954–63) and *A Tale of Two Cities* (1958). Later roles in, among others, *The Servant* (1963) and *Death in Venice* (1971), have demonstrated an increasing depth and range.

This portrait, painted in the delicate and fragile medium of egg tempera at Bogarde's home in the South of France, reveals the private man behind the film star, and, in its reflective mood, reminds us that in recent years he has produced three highly acclaimed volumes of autobiography as well as several novels.

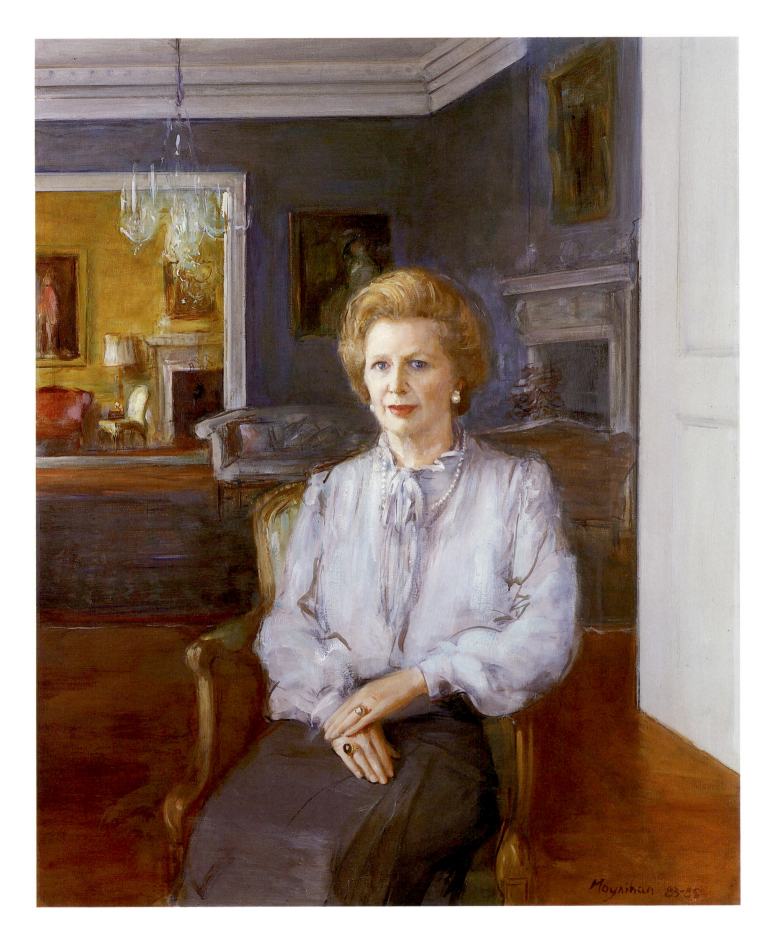

THE RT. HON. MRS MARGARET THATCHER born 1925
Oil on canvas, 126.5 × 101.5 (49¾ × 40)
By Rodrigo Moynihan, signed and dated 1983–5 (5728)

This portrait of the Prime Minister at 10 Downing Street was commissioned by the Gallery, and painted from some ten sittings spread over approximately two years. The artist trained at the Slade School, and after an early interest in abstraction, turned increasingly to still-life and portrait-painting. Three other portraits by him are in the Gallery: the artist and critic Sir Lawrence Gowing, the economist Friedrich von Hayek and the actress Dame Peggy Ashcroft.

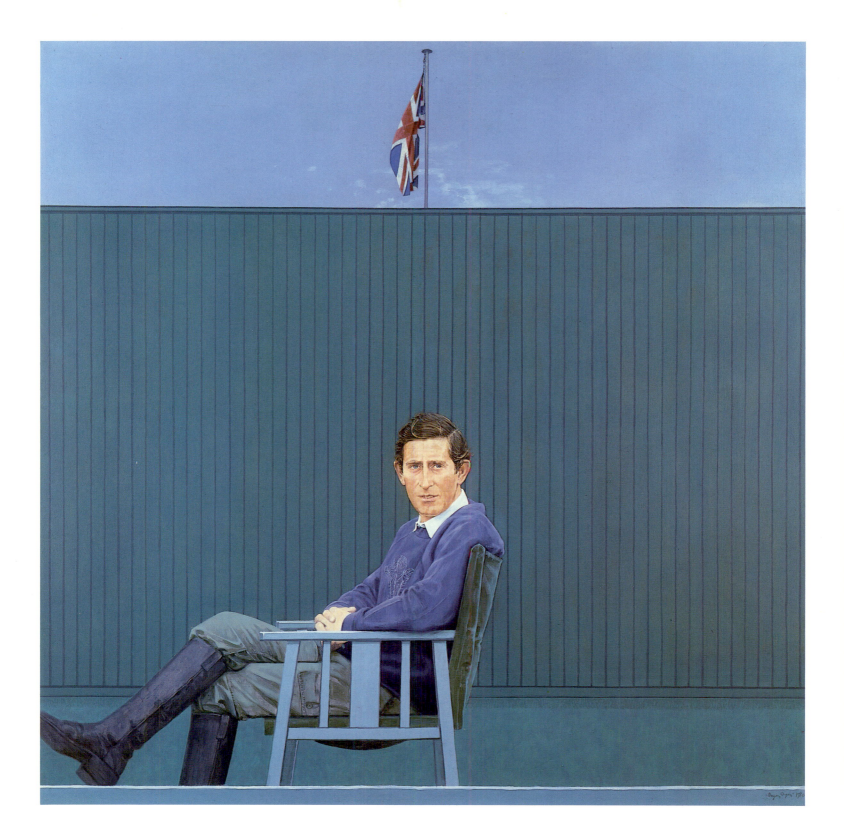

HRH THE PRINCE OF WALES born 1948
Acrylic on canvas, 177.8 × 178.2 (70 × 70⅛)
By Bryan Organ, signed and dated 1980 (5365)

This is the first portrait of the heir to the throne to enter the Gallery's collection. Superficially the presentation is informal: he wears polo clothes and is seated in a relaxed position; but the mood is serious, and the Prince in Organ's brilliant likeness appears thoughtful, as if considering his future responsibilities. This effect is intensified by the analytical style, the impersonal use of paint and underlying formal geometry. A year after this portrait the artist also painted HRH the Princess of Wales for the Gallery, and, in 1983, HRH the Prince Philip, Duke of Edinburgh.

MARCUS JOSEPH SIEFF, BARON SIEFF OF BRIMPTON born 1913
Pastel on paper, 57.5 × 85.7 (22⅝ × 30¾)
By R.B. Kitaj, signed and dated 1985 (5815)

This portrait of Lord Sieff, Chairman of the family firm of Marks and Spencer from 1972 and President from 1984, is the first portrait of a leading British businessman to be commissioned by the Trustees of the Gallery. It marks the singular contribution he has made to the post-war economy of the country as well as to the work of a number of Anglo-Israeli organisations. It is also the first work by the distinguished American-born artist Kitaj to enter the collection, and reflects the generally figurative and humanist trend in his later work. The profile presentation, strong and simplified, suggests Italian Renaissance prototypes – both painted portraits and medals.

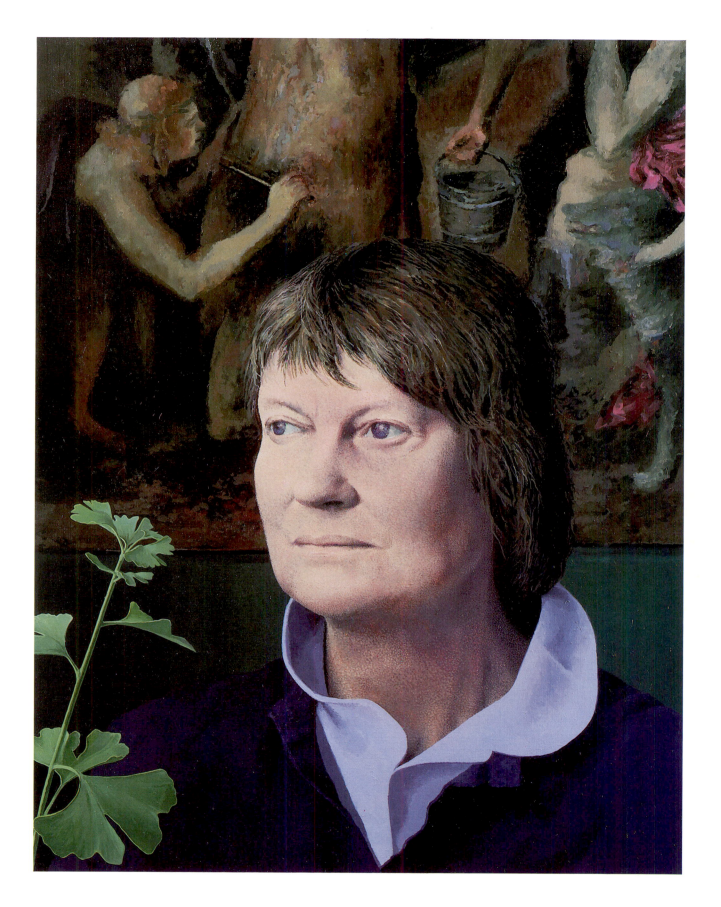

DAME IRIS MURDOCH born 1919
Oil on canvas, 91.1 × 70.8 (35⅞ × 27⅞)
By Tom Phillips, 1986 (5921)

Work on this larger-than-life-size portrait of one of the most fertile of contemporary novelists spanned three years, and there were in all fifteen sittings, each lasting up to two hours, at Tom Phillips's studio in Peckham. When artist and sitter first met they talked about Titian's *Flaying of Marsyas*, which both had seen at a recent exhibition at the Royal Academy, and this painting is seen in the background of the portrait; in the foreground is a twig from the world's oldest tree, the Ginko. Phillips has described the resulting portrait as 'an ikon', and has written of his 'image of Iris' as 'a luminous presence, and the visual metaphor in my head was of an electric light-bulb in that gloomy corner, glowing, casting out darkness'.

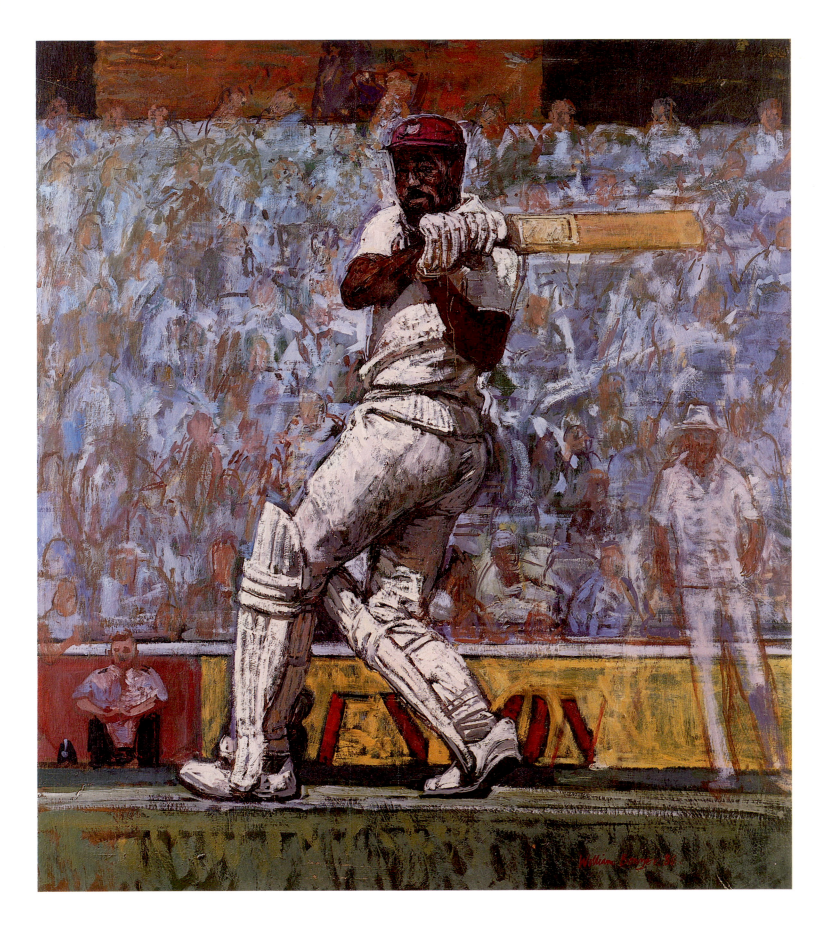

ISAAC VIVIAN ALEXANDER ('VIV') RICHARDS born 1952
Oil on board, 81.3 × 70.2 (32 × 27⅝)
By William Bowyer, signed and dated 1986 (5999)

This action portrait of the great West Indian batsman Viv Richards, who has played county cricket for Somerset for more than ten years, and been a distinguished captain of the West Indian team, is one of a number of portraits of outstanding contemporary sportsmen and athletes acquired in recent years (others include John Bellany's *Ian Botham* and Martin Rose's *Sebastian Coe*).

The Royal Academician William Bowyer is himself a keen cricketer, and he has written of his cricketing portraits: 'My interest is in the action, the feeling of the ball coming off willow'.

210

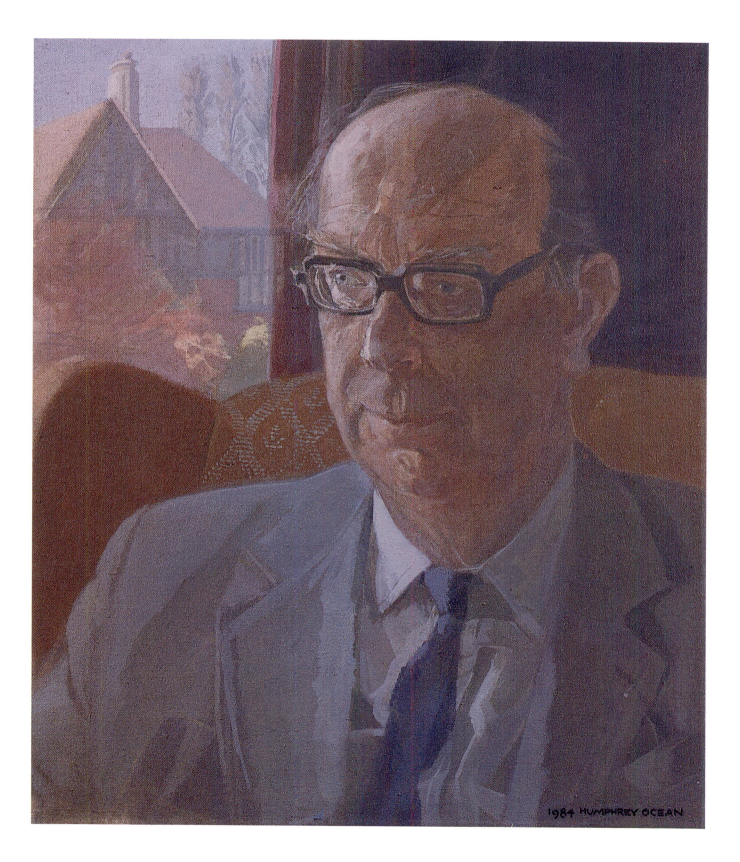

PHILIP LARKIN 1922–85
Acrylic on canvas, 52.3 × 44.8 (20⅝ × 17⅝)
By Humphrey Ocean, signed and dated 1984 (5746)

This portrait of the poet and jazz critic Philip Larkin was painted at his home in Hull, and completed on 10 August 1984, the day after his sixty-second birthday. 'That' he said 'is my birthday present', and writing later, with characteristic self-consciousness, added: 'It could not have been more flattering without being less of a likeness, nor more of a likeness without being less flattering, which I take to be the definition of a successful portrait . . . I can certainly recommend Mr Ocean as a portrait painter, in the sense that he was punctual, industrious, entirely untemperamental and full of consideration for the comfort of his sitter'. The artist in his turn found Larkin 'not the misanthrope of public note', reporting that at their first meeting 'halfway through lunch, he produced the postcard . . . of my McCartney picture (p.204), took my sleeve like a fifteen year old girl and whispered: "Tell me ALL about him" . . . from then on nothing was too much trouble'.

211

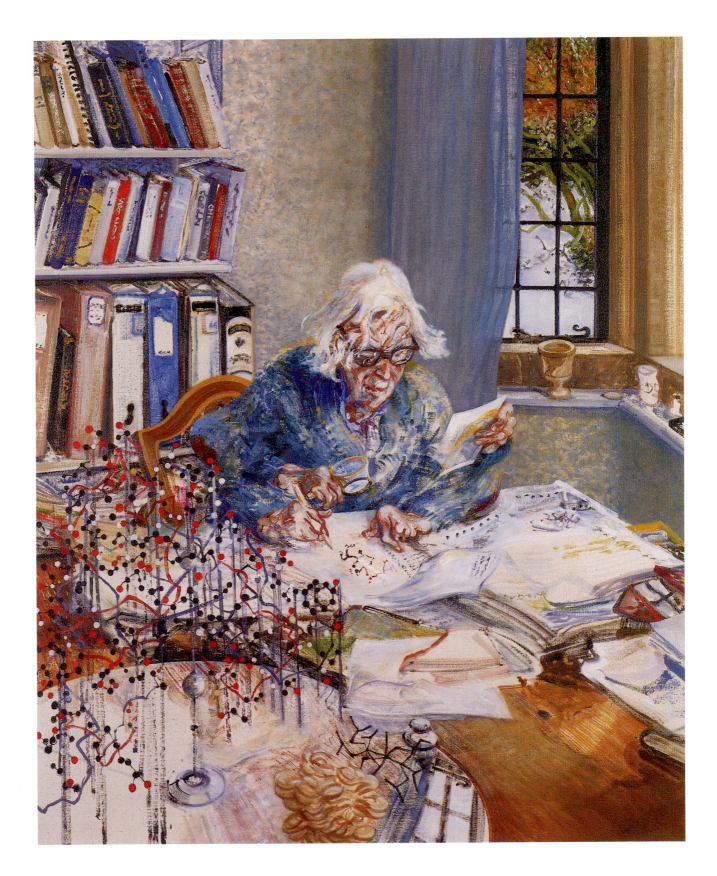

DOROTHY MARY HODGKIN born 1910
Oil on canvas, 93.2 × 76 (36¾ × 30)
By Maggi Hambling, 1985 (5797)

One of the outstanding scientists of her generation, Professor Hodgkin carried out pioneering work on the structure of penicillin in the 1940s, and in 1964 was awarded the Nobel Prize for Chemistry for her work on the structure of Vitamin B^{12}. In 1969 she established the chemical structure of insulin, and continues to work on its description. In 1965 she was admitted to the Order of Merit, the second woman, after Florence Nightingale, to receive this honour. In addition to

her scientific work, she has been a prominent worker for international peace and understanding.

This portrait, painted at her home in Warwickshire, shows her surrounded by computer print-outs and structural models. Maggie Hambling's expressionistic technique and the crowded composition stress the sitter's intense intellectual activity, and this is further emphasised by the way the artist has given her four hands, distorted by arthritis, but busy.

JULIAN BREAM born 1933
Oil on canvas, 106.2 × 91.7 (41¾ × 36⅛)
By Michael Taylor, 1984 (5747)

The guitarist and lutenist Julian Bream, who has done so much to encourage the revival of Elizabethan lute music, was painted as part of the Dorset artist Michael Taylor's prize as winner of the John Player Portrait Award in 1983. It shows Bream at home in Dorset playing the guitar, and Taylor, whose portraits have a hyper-realistic intensity and often include disturbing effects of distorted perspective, revels in the curvaceous form of the instrument and its case with emerald green lining.

HRH THE PRINCESS ROYAL, MRS MARK PHILLIPS born 1950
Oil on canvas, 188 × 96.5 (74 × 38)
By John Ward, signed and dated 1987–8 (5992)

A decidedly romantic portrait of Princess Anne, who is known for her love of horses – she was an Olympic horse-woman and is an enthusiastic amateur jockey – and for her dedicated presidency of the Save the Children Fund. The artist, who was elected a Royal Academician in 1965, has written of it: 'I first saw the Princess Royal in the white dress in her portrait at a Royal Academy dinner. She looked marvellous, and immediately I could see how she should be painted. The room in Buckingham Palace with a view down the Mall is the one which is invariably given for sittings for royal portraits. Although many artists ignore the chinoiserie setting, I have chosen to paint the princess against this exotic background of birds, snakes, and flowers and dragons. It is like a magic garden and I found it quite irresistible'.

The portrait was sponsored and presented to the Gallery by the Austin Reed Group. Other works by John Ward in the Gallery include his group portrait *The Cabinet Secretaries* (1984).

THE NATIONAL PORTRAIT GALLERY
AT
MONTACUTE HOUSE, SOMERSET

Montacute House, the first outstation established under the Gallery's regional policy, was built in the last decade of the sixteenth century by Sir Edward Phelips, a successful lawyer, who entered Parliament in 1584, became Speaker in 1604, and was later Master of the Rolls. It has long been recognised as one of the most harmonious and best preserved of Elizabethan houses, and stands tall and proud in beautiful grounds on the edge of the village of Montacute, beneath the conical hill ('mons acutus' in Latin) from which both village and house take their name.

Inside the house much of the original decoration, including fine plasterwork and panelling, survives, but the contents have long since been dispersed. In 1931 the house was saved from demolition and presented to the National Trust, who refurnished it with numerous loans, gifts and bequests, among them important tapestries, fine furniture and paintings.

As part of the final phase of Montacute's rehabilitation, in 1975 the Gallery placed on loan there in the magnificent Long Gallery and adjoining rooms on the top floor more than a hundred Elizabethan and Jacobean portraits, which together form the largest collection of portraits of this period on public view in the country.

HENRY VIII 1491–1547
Oil on panel, 88.9 × 66.7 (35 × 26¼)
By an unknown artist, *c.*1542 (496)

This picture is a version of the very last portrait-type of Henry VIII, painted perhaps five years before his death. To an eye-witness the king appeared 'tall of stature, very well formed, and of very handsome presence', and it is possible to feel in the four-square presentation of this portrait something of the physical impact which he had on his contemporaries.

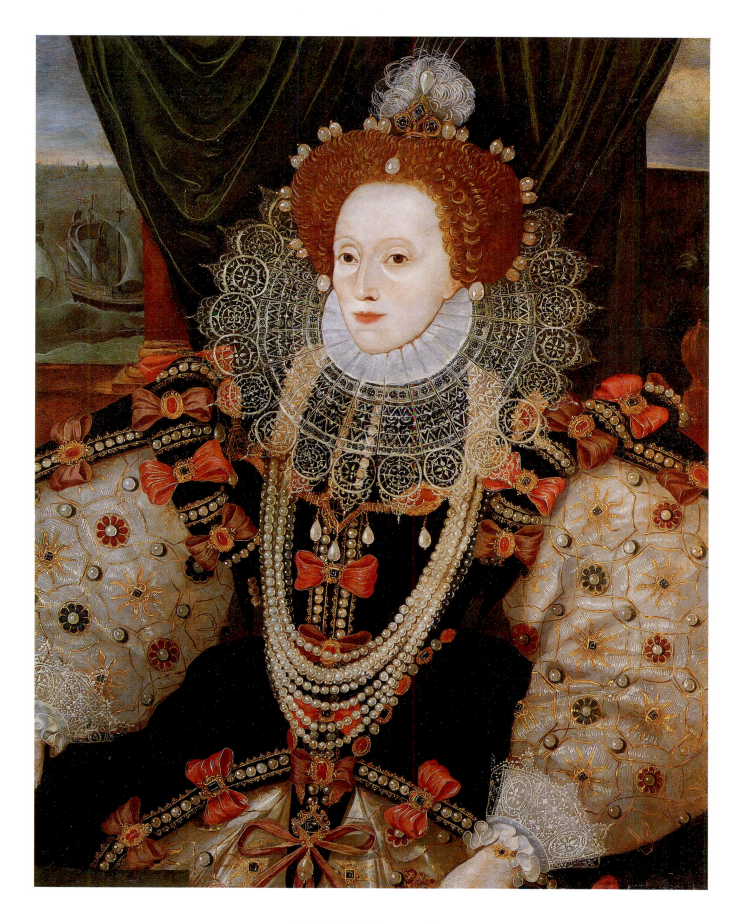

ELIZABETH I 1533–1603
Oil on panel, 97.8 × 72.4 (38½ × 28½)
By or after George Gower, *c*.1588 (541)

A version of the celebrated 'Armada' portrait of the queen, of which the best known version hangs at Woburn Abbey, and which commemorates the defeat of the Spanish Armada in 1588. This portrait by the queen's Serjeant Painter Gower well illustrates the fate of many early portraits, for it has evidently been reduced in size on all sides. Probably at the same time that it was cut down it was given a plain green background. This was cleaned off in recent restoration, revealing the original seascape beneath.

IVVENTVS

INDISIPINABILE

1572
ÆᵗSVÆ·21
THO:CONYNGESBY
NEL LA IVVENTVTE

SED NVNC Q
AB

SIR THOMAS CONINGSBY 1551–1625
Oil on panel, 94 × 69.9 (37 × 27½)
Attributed to George Gower, inscribed and dated 1572 (4348)

This appealing portrait of Coningsby as a young soldier is painted in the highly decorative manner of George Gower. It shows the sitter with the accoutrements of falconry: he holds the falcon's hood in one hand, and with the other swings the lure, while in the sky above flies the falcon itself. The fragmentary Latin and Italian inscriptions suggest an allegory in which the falcon symbolises youth and indiscipline, and the falconer maturity and control.

SIR EDWARD HOBY 1560–1617
Oil on panel, 95.3 × 75.6 (37½ × 29¾)
By an unknown artist, dated 1583 (1974)

Like that of Sir Thomas Coningsby (p.218), this portrait of the young soldier Hoby is conceived in allegorical terms. The sitter, whose arms are proudly displayed (top left), is shown in martial guise, wearing a Greenwich armour. By him is a baton inscribed in Latin 'Vana sine viribus ira' ('anger without strength is vain') and, top right, an inset scene of a lady coming out of a castle, bearing a scroll with a legend signifying 'laid aside but not blunted'. In front of her is a pile of discarded weapons and military trophies with a veil over them. Painted a year after Hoby's marriage and his knighthood, the allegory probably refers to some temporary abandonment of his military career.

FRANCIS BACON, BARON VERULAM AND VISCOUNT ST ALBAN 1561–1626
Oil on canvas, 200 × 127 (79 × 50)
By an unknown artist after an original of *c*.1618 (1288)

The founder of modern scientific thought, Bacon was in early life vastly ambitious, and made his way to the top as a brilliant prosecuting counsel, to become Attorney General in 1613, Lord Keeper (1617), and Lord Chancellor (1618). In 1621 however he was impeached for bribery, and admitted that he was guilty of 'corruption and neglect'. He spent the rest of his life in enforced retirement, devoting himself to the development of his scientific and philosophical ideas, and to their publication. This portrait shows Bacon before his fall, in his robes as Lord Chancellor, with his seal bag on the table by him. It was almost certainly painted in the eighteenth century, after an original still at his family home, Gorhambury, near St Albans, and illustrates the demand there was for portraits of this great man in the 'age of reason', more than a hundred years after his death.

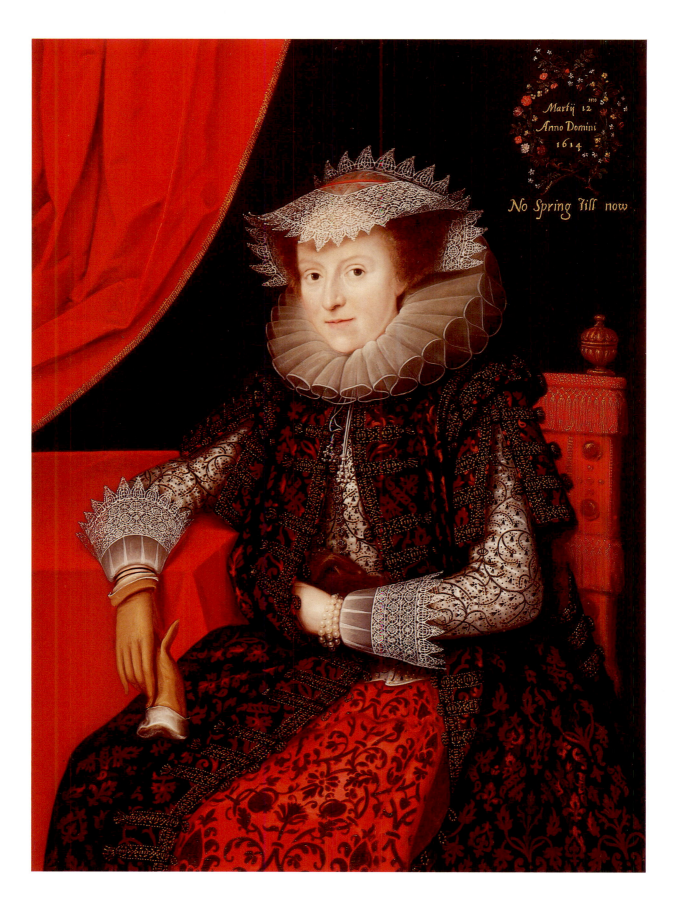

MARY THROCKMORTON, LADY SCUDAMORE died 1632
Oil on panel, 114.3 × 82.6 (45 × 32½)
By Marcus Gheeraerts the Younger, inscribed and dated 1614 (64)

This portrait is one of the masterpieces of early painting in England, in which the clichés of Jacobean portraiture – the curtain, hand resting on a table, red upholstered chair – are transformed by Gheeraerts's delicate rendering of an especially sympathetic personality, and his brilliant deployment of her elaborate costume of scarlet brocade, black-work embroidery, and fine lace. The emotional effect of the portrait is intensified by the sitter's motto 'No Spring till now', above which, encircled with flowers, is the date 12 March 1614 (Old Style), on which day her son, John, was married to Elizabeth Porter of Dauntsey, Wiltshire.

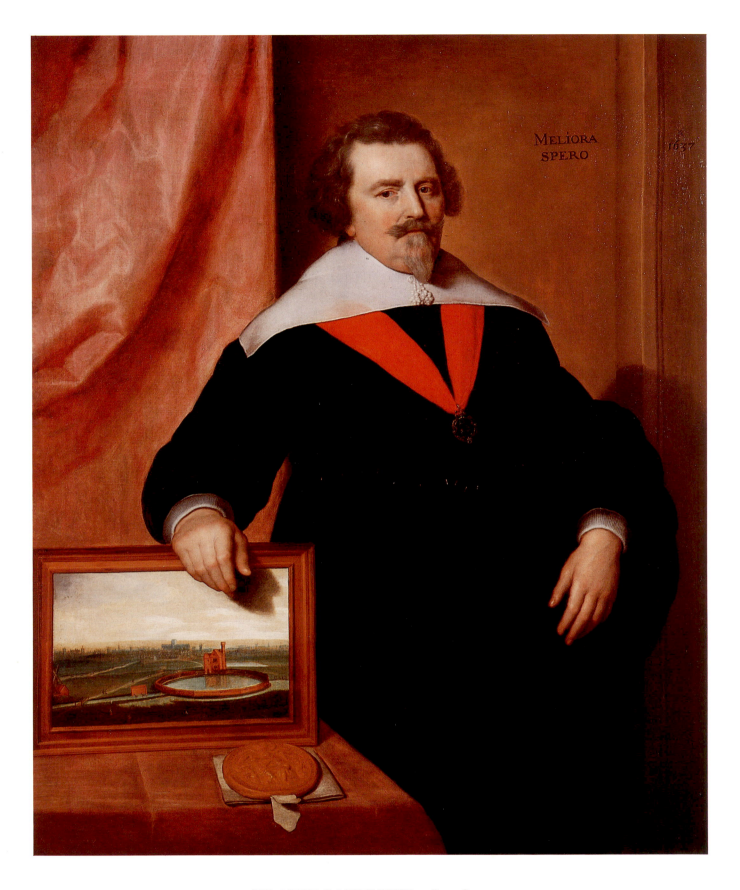

SIR JOHN BACKHOUSE 1582–1649
Oil on canvas, 128.3 × 104.1 (50½ × 41)
By the monogrammist VM, signed, inscribed and dated 1637 (2183)

One of the original shareholders in the New River Company, which revolutionised London's water-supply, Backhouse owned the land in Islington on which the reservoir was built. As befits a successful entrepreneur, his portrait is inscribed (top right) 'Meliora spero' ('I hope for better things'), and proudly proclaims his status. He wears the ribbon of the Order of the Bath (he was installed at the coronation of Charles I); on the table lies an important document with the royal seal, and he holds a painting of London with Old St Paul's in the distance, and, prominent in the foreground, his own achievement, the New River Head.

The identity of the Dutch artist of this portrait remains a mystery, and only three other works by him are known.

THE NATIONAL PORTRAIT GALLERY
AT
GAWTHORPE HALL, LANCASHIRE

Gawthorpe Hall, in an extensive park on the outskirts of Padiham, was built in the first five years of the seventeenth century for the Rev. Laurence Shuttleworth, perhaps to designs by that prodigious architect Robert Smythson, and extensively remodelled in the mid-nineteenth century for Shuttleworth's descendants by Sir Charles Barry. The house has recently been completely restored by the National Trust, to reflect its appearance in its heyday in the nineteenth century. A group of portraits from the Civil War and Restoration period is displayed there, appropriate to the period of the house and its first occupants, as well as suggesting the antiquarian tastes of the nineteenth-century owners. As at Montacute, the bulk of the portraits hang in the spectacular Long Gallery on the top floor, but others are displayed in the Hall, Dining Room and elsewhere. A number of the portraits have been chosen for their costume interest, to complement the Rachel Kay-Shuttleworth Collection of textiles and associated items, which is also on show at the house.

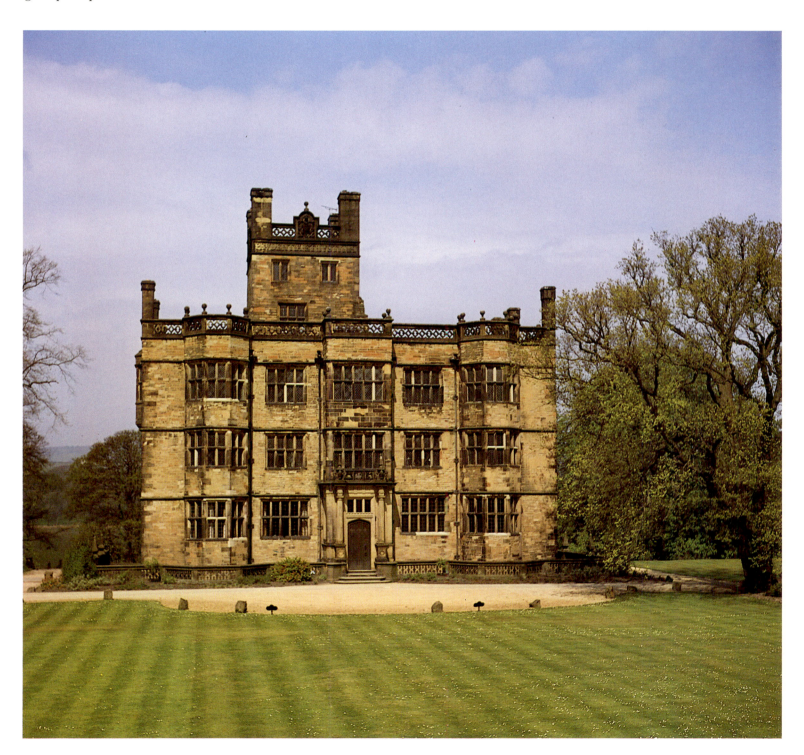

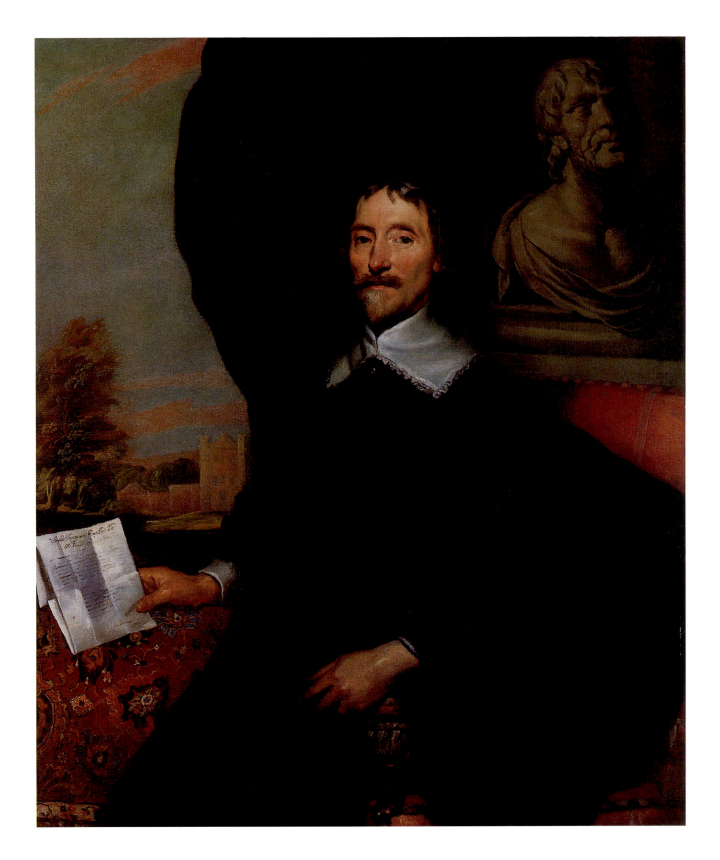

SIR THOMAS AYLESBURY 1576–1657
Oil on canvas, 125.7 × 99.1 (49½ × 39)
By William Dobson, c.1642 (615)

Thomas Aylesbury prospered under the influence of Charles I's favourite the Duke of Buckingham (p. 44), becoming Master of Requests, Master of the Mint and a baronet in the space of a year. At the outbreak of the Civil War he was 'stripped of his place, and plundered of his estate' by Parliament, and in 1642 he followed the king with his wartime court to Oxford, where he continued to hold the Court of Requests.

In this sober portrait he is shown wearing his robes as Master of Requests, holding, as emblem of his office, a petition to the king. Top right in the portrait is an antique bust thought at the time to represent the stoic philosopher, dramatist, and pleader of causes, Seneca.

After Charles I's execution, Aylesbury went into exile in the Netherlands, where he died in poverty. His daughter married Lord Clarendon, Charles II's Lord Chancellor, and through their daughter, Anne Hyde (p.64), Aylesbury was great-grandfather of both Queen Mary and Queen Anne.

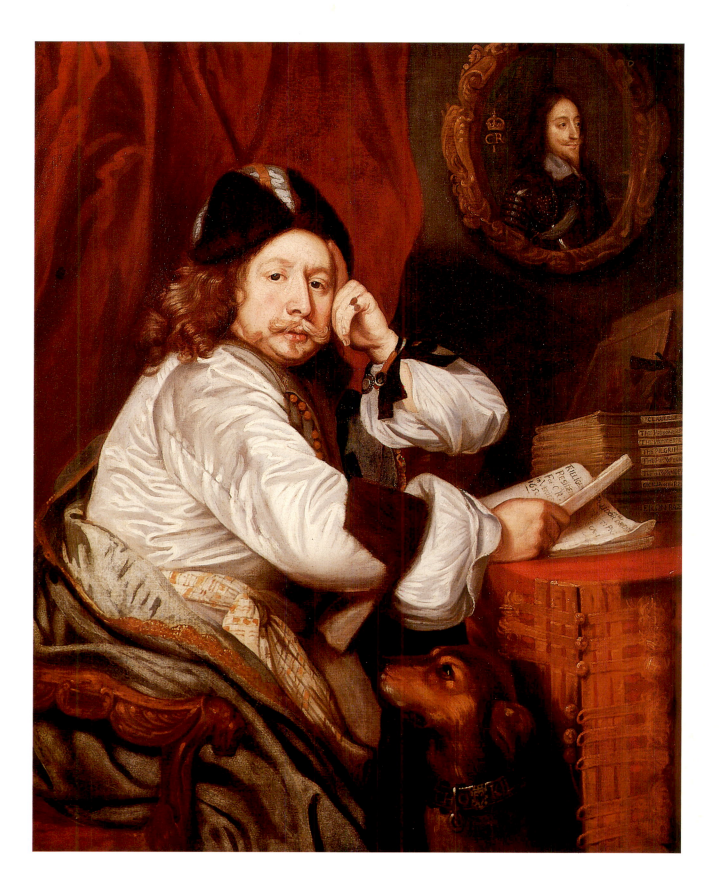

THOMAS KILLIGREW 1612–83
Oil on canvas, 124.5 × 96.5 (49 × 38)
By William Sheppard, signed, inscribed and dated 1650 (3795)

Witty, dissolute and eccentric, the playwright and theatre manager Killigrew was one of the most colourful figures of his time. It is not surprising therefore that this portrait, painted by the obscure artist Sheppard (it is his only known work) should be a striking affair. It was painted just a year after the execution of Charles I, when Killigrew was in Venice as Resident (political agent) for the exiled Charles II, and is conceived as a statement of Killigrew's loyalty to the monarchy. Charles I's portrait hangs on the wall behind him, while a pile of Killigrew's plays rests on top of a copy of *Eikon Basilike* ('the image of the king'), a meditation on Charles's martyrdom. Killigrew's dog, with his name on his collar, is perhaps included as a traditional emblem of fidelity.

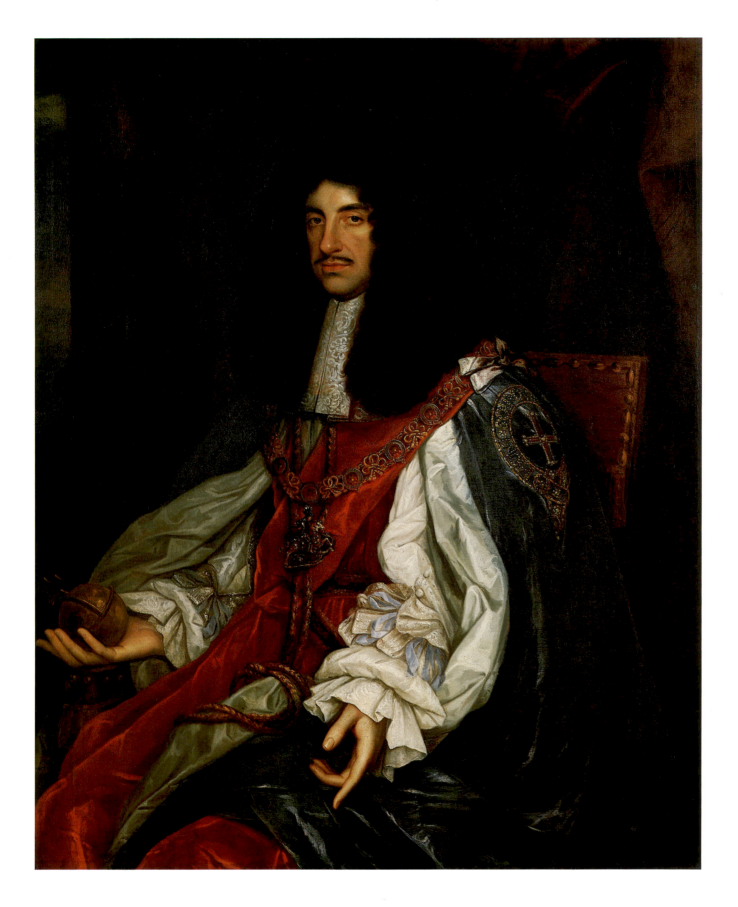

CHARLES II 1630–85
Oil on canvas, 126.4 × 101 (49¾ × 39¾)
Studio of John Michael Wright, c.1660–5 (531)

This portrait of the king in Garter Robes shows him as he appeared to his subjects at the Restoration, and is in marked contrast to the tired figure in the portrait by Hawker (p. 56). It recalls the description issued after the battle of Worcester in 1651 offering a reward of £1000 for the capture of Charles Stuart, 'a tall man, above two yards high, his hair a deep brown, near to black'. The artist Wright, though he obtained royal commissions, was overshadowed throughout his career by the success of Sir Peter Lely. However, his cooler more linear style, reflecting his studies in Italy, makes a welcome change from Lely's sumptuousness.

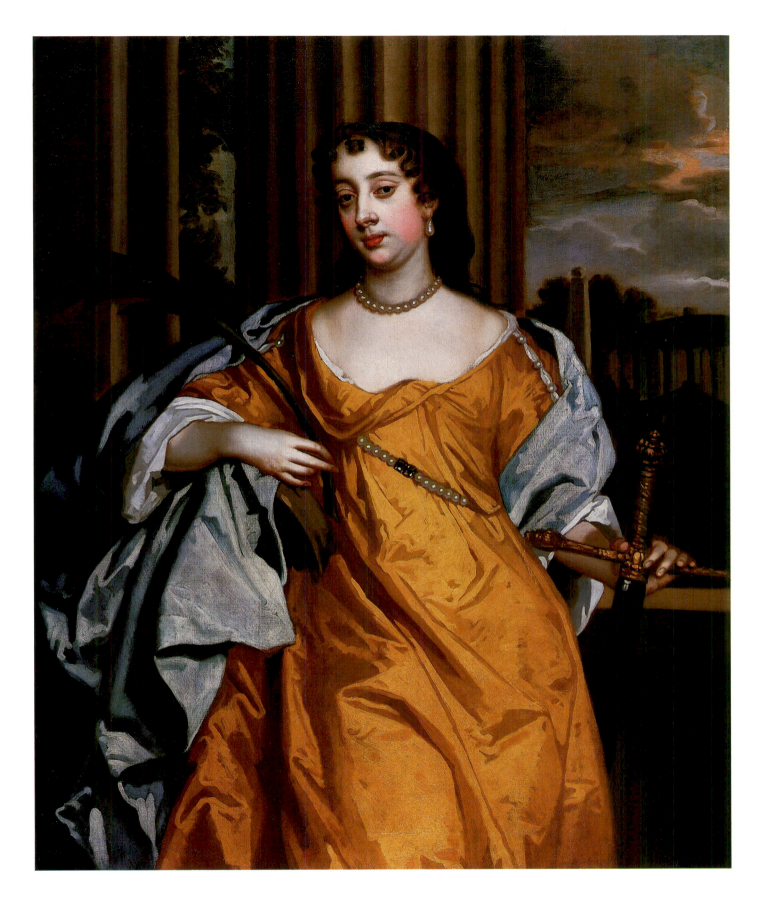

BARBARA PALMER, DUCHESS OF CLEVELAND 1640–1709
Oil on canvas, 124.5 × 101 (49 × 39¾)
Studio of Sir Peter Lely, *c.*1666 (387)

Beautiful, rapacious and promiscuous, the Duchess typifies that unsettled generation, brought up in the Civil War and Interregnum, who launched themselves into a life of pleasure at the Restoration. As mistress of Charles II she bore him six children, and was created Duchess in 1670 more or less at the time his desire for her waned. She was painted by Lely more than any other sitter, and it is said that 'he put something of Cleveland's face, as her languishing eyes, into every one picture, so that all his pictures had an air one of another, all the eyes were sleepy alike'. In this portrait she is shown as St Catherine, with sword and broken wheel.

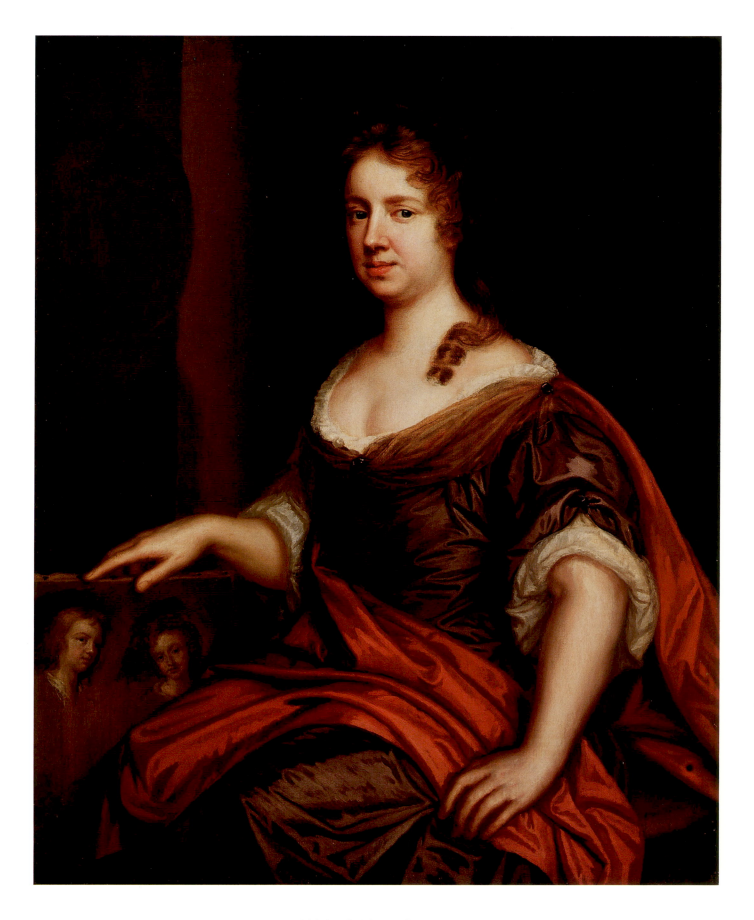

MARY BEALE 1633–99
Oil on canvas, 109.2 × 87.6 (43 × 34½)
Self-portrait, *c*.1665 (1687)

Mary Beale was one of the very few women artists working in England in the seventeenth century, and the only one to whom a substantial body of work may be attributed. She was born Mary Cradock, the daughter of a Suffolk clergyman, and married the artists' colourman Charles Beale. Little is known of her training, but the dominant influence on her work is that of her friend Sir Peter Lely, whom she follows at a distance. In this self-portrait she holds an unfinished portrait of her two sons, Bartholomew and Charles.

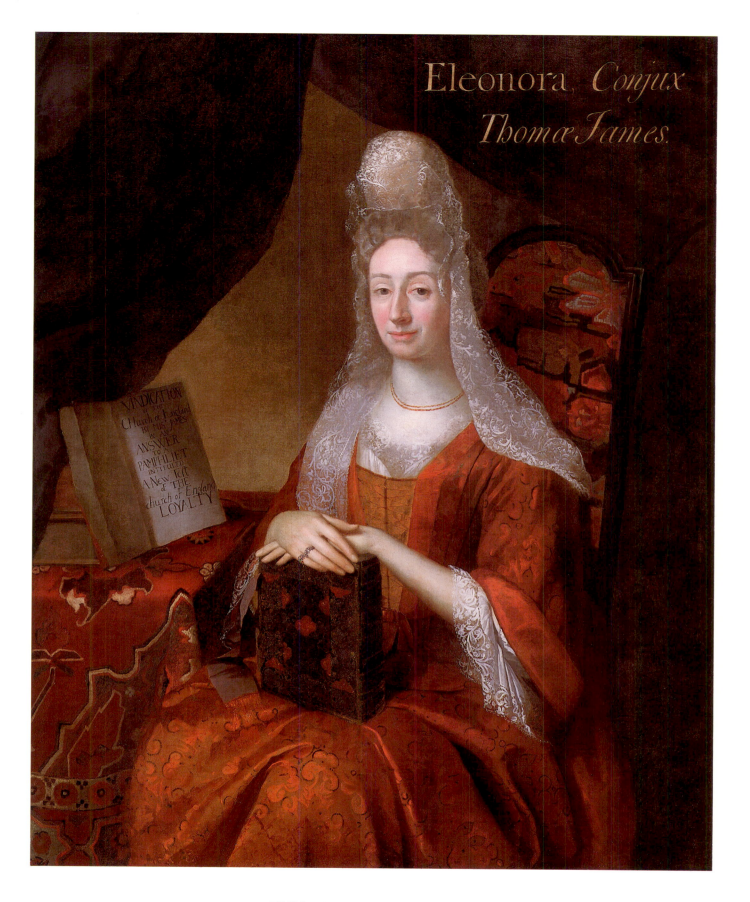

Eleonora, Conjux Thomæ James.

ELEANOR JAMES fl.1675–1715
Oil on canvas, 126.8 × 103.5 (49⅞ × 40¾)
By an unknown artist, inscribed, *c.*1690 (5592)

The wife of a London printer, Thomas James, 'a man that reads much, knows his business well, and is . . . something the better known for being husband to that she-state-politician Mrs Eleanor James', she was herself described by a contemporary as 'a mixture of benevolence and madness'. This portrait by an unknown artist well conveys the force and idiosyncracy of her character, which led her for forty years to publish pamphlets and broadsheets of advice to the reigning sovereigns from Charles II to George I. A religious enthusiast, and instinctively intolerant, she published in 1687 her *Vindication of the Church of England*, which is included in this portrait. She was much satirised, and for a time imprisoned in Newgate.

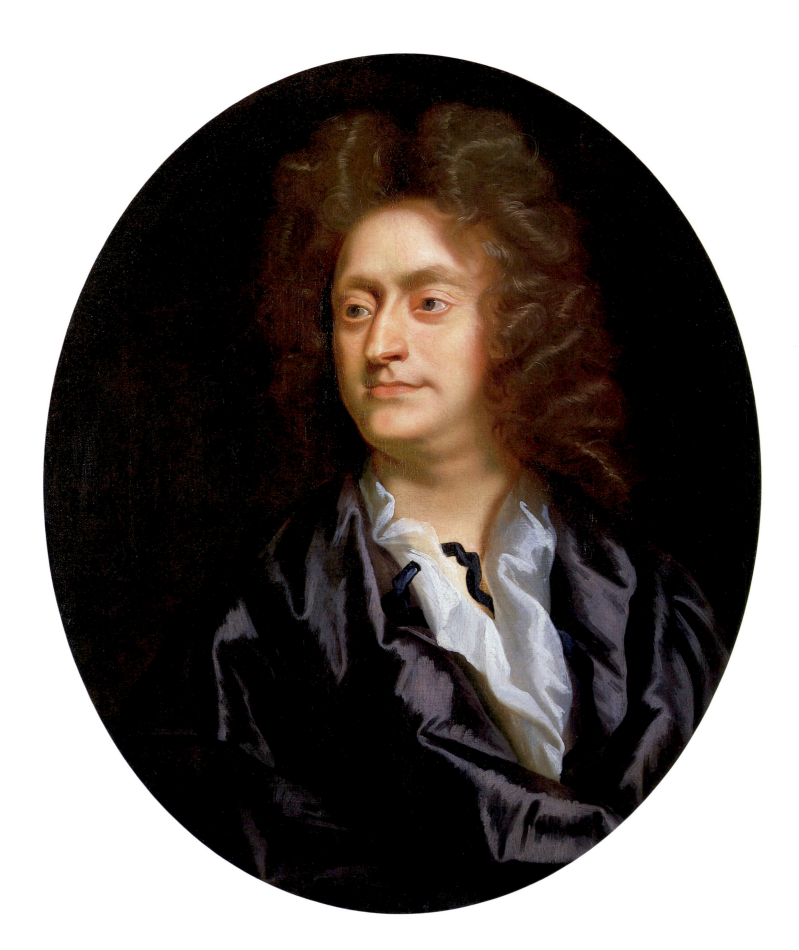

HENRY PURCELL 1659–95
Oil on canvas, 73.7 × 61 (29 × 24)
By or after John Closterman, 1695 (1352)

Painted in the year of the death of the composer of *Dido and Aeneas* and the *Faery Queen*, this portrait was engraved as the frontispiece to the anthology *Orpheus Britannicus* in 1698, as a tribute to his unequalled position in British musical history.

Although possibly by Closterman himself, the portrait does not give the impression of being taken from life, and it is likely that it was worked up posthumously from an *ad vivum* drawing (also in the Gallery's collection).

THE NATIONAL PORTRAIT GALLERY
AT
BENINGBROUGH HALL, YORKSHIRE

Beningbrough Hall was built for John Bouchier, High Sheriff of Yorkshire, by William Thornton of York and completed in 1716. A handsome red brick house with elaborate architectural dressings in stone, it is set in the Vale of York some eight miles from York itself. Its 365 acres of rich parkland and farmland border the wooded banks of the meandering River Ouse.

Since 1979 Beningbrough has housed a collection of a hundred and twenty portraits from the National Portrait Gallery from the period 1688–1760, spanning the reigns of William and Mary, Queen Anne and the first two Georges. After a varied history – Beningbrough was occupied by the Dawnay family after the Bouchier line died out in 1827, and was sold in this century to the 10th Earl of Chesterfield – the house passed to the National Trust in 1957 as a transfer from the Treasury, who had accepted it in lieu of death duties. But following the great Beningbrough sale of 1958, few of the original contents remained, and a visit to the house was a forlorn experience. Now, Beningbrough has taken on a new lease of life.

On entering the house the visitor is greeted by the magnificent hall rising through two storeys, one of the most impressive of English baroque interiors. Here are ranged portraits of the royal family from Queen Anne to George II and his son Frederick, Prince of Wales. The portraits in the following rooms recall James II and the events which brought about his downfall. In the Dining Room hang many of Sir Godfrey Kneller's portraits of the Kit-Cat Club, a celebrated Whig dining club of influential politicians and writers, dedicated to the Hanoverian succession. Other notable portraits on the ground and first floors include those of Pepys, Dryden, Pope, Handel, Garrick and Bonnie Prince Charlie. The second floor is devoted to a special exhibition on particular aspects of English eighteenth-century life.

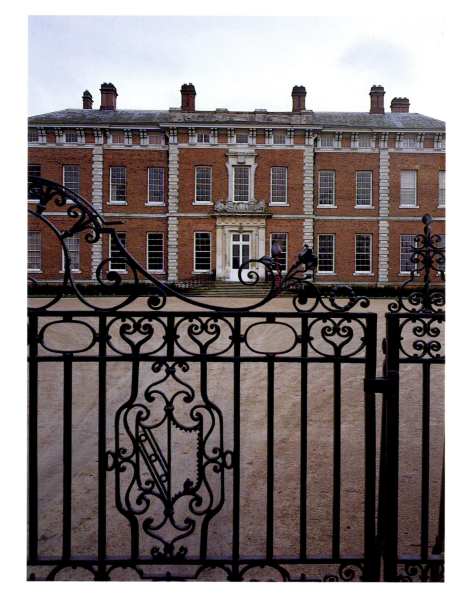

DANIEL FINCH, 2nd EARL OF NOTTINGHAM AND 7th EARL OF WINCHILSEA 1647–1730
Oil on canvas, 78.7 × 104.1 (31 × 41)
By Sir Godfrey Kneller, inscribed, c.1715–20? (3910)

A moderate Tory, Winchilsea was alienated by the extreme policies of James II but refused to join in the invitation to William of Orange to take over the throne in 1688. Nevertheless he was completely faithful to William III after he had become king, and was Secretary of State in the early years of his reign, and again under Queen Anne. He was leader of a group of Tories pledged to the Hanoverian Succession (known as the 'Whimsicals'), and his loyalty to the Revolution Settlement saved many Tories from straying into Jacobitism.

This striking portrait, showing the Earl's noble head bald and wigless in three different positions may have been painted as an aid to the sculptor John Michael Rysbrack when he was carving his bust of Winchilsea.

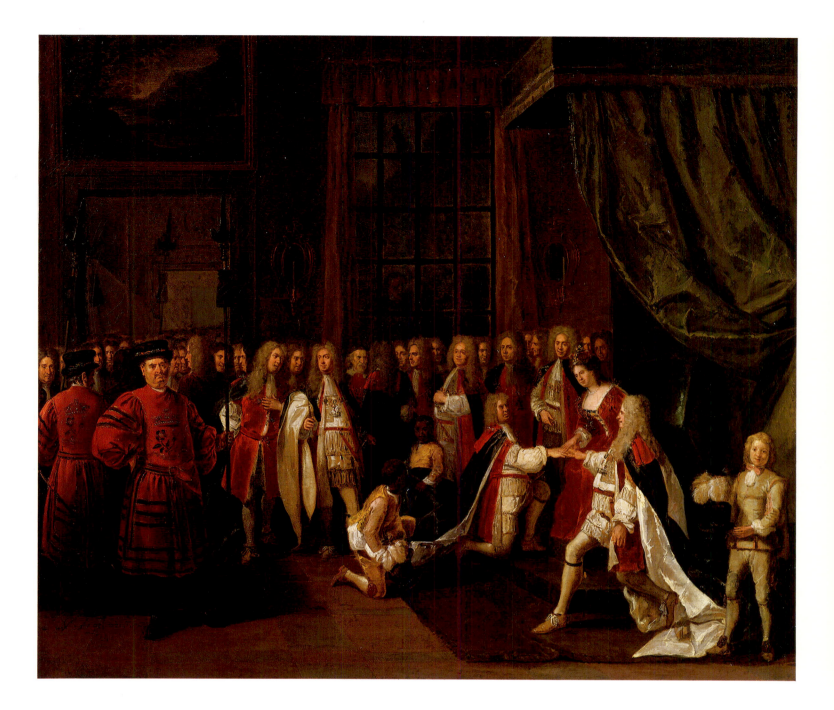

NEW KNIGHTS OF THE GARTER BEING PRESENTED TO QUEEN ANNE AT KENSINGTON PALACE
Oil on canvas, 62.2 × 75 (24½ × 29½)
By Peter Angelis, signed, 1720s? (624)

This rare representation of the court of Queen Anne is thought to show the institution of the new Knights of the Garter at a ceremony held at Kensington Palace on 4 August 1713, the year before the queen's death. Though the six knights then invested with the insignia of the Order cannot be individually identified in the picture, they were all of high rank, and included most notably the politician Robert Harley,

1st Earl of Oxford, and the erstwhile soldier and diplomat Charles Mordaunt, 3rd Earl of Peterborough.

This scene is the work of Peter Angelis, a Flemish artist who worked in London c.1716–28, painting small conversation pieces; possibly this scene belongs to an intended series of paintings illustrating Stuart history.

SIR JOHN VANBRUGH 1664–1726
Oil on canvas, 90.2 × 69.9 (35½ × 27½)
Attributed to Thomas Murray, *c.*1718 (1568)

Soldier, dramatist, and architect, Vanbrugh passed from one profession to another with striking ease. As a young man he was imprisoned in the Bastille in Paris for spying. His first plays were produced in 1697 – *The Relapse*, a favourite throughout the eighteenth century, and *The Provok'd Wife*, the indecencies of which, it was said, 'ought to explode it out of society'. His sudden emergence as an architect in 1699 seems to have been unheralded by any technical apprenticeship. His design for the Earl of Carlisle's Castle Howard remains a magnificent and inexplicable achievement. His other great monument is Blenheim Palace, designed for the Duke of

Marlborough, started in 1705, but still unfinished when Vanbrugh fell into disgrace with the Duchess in 1716. His style was an extremely personal modulation of the baroque and he worked on a vast scale, with a superb sense of mass and grouping, producing a heroic and picturesque quality recognised by Sir Joshua Reynolds as 'painter-like'.

Vanbrugh is shown wearing a herald's badge on a gold chain, for he also acted as Garter King of Arms for a spell (1715–18): one further demonstration of his extraordinary range of accomplishments.

MARGARET ('PEG') WOFFINGTON 1714?–60
Oil on canvas, 90.2 × 106.7 (35½ × 42)
By an unknown artist, c.1757–60 (650)

One of the most celebrated actresses of the eighteenth century, 'Peg' Woffington, as she was to be known, first took to the stage in Dublin, her native city, at the age of ten. Over the space of twenty years from c.1737 she reigned supreme in comic parts in Dublin and then in London.

Peg Woffington's dark and vivacious beauty, her magnetism and wit, brought her a reputation as the handsomest woman ever to appear on the stage. She became known for her bitter rivalries with other actresses – she stabbed Mrs Bellamy during a performance – and for her numerous love affairs,

most notably with David Garrick (p.88) who wrote 'My Lovely Peggy' and other songs for her. She openly preferred the company of men to women who, she said, talked of 'nothing but silks and scandals'.

Sick-bed portraits are rarely found at this period, being more a practice of the previous century. Why this striking image was created is not known, but it must date to after her last performance in May 1757 – as Rosalind in *As You Like it* – during which she was stricken with palsy; she remained bedridden until her death nearly three years later.

ANGELICA KAUFFMANN 1741–1807
Oil on canvas, 73.7 × 61 (29 × 24)
Self-portrait, c.1770–5 (430)

Angelica Kauffmann had an immense international reputation in her lifetime. Winckelmann, Reynolds (p.87), Goethe and Canova were among her admirers, and her work was widely circulated abroad in the form of prints by Bartolozzi. Swiss-born and Italian-trained, she came to London in 1766 where she spent fifteen years, before returning to Italy for the rest of her life. Her richly coloured history pieces and decorative work in the neo-classical manner found a ready market in England – Robert Adam and James 'Athenian' Stuart both used her work in their houses – while British sitters were keen to be painted by her even after her return to Italy. She was a founder-member of the Royal Academy, and a close friend of Reynolds, even to the extent of rumours of a personal attachment.

This self-portrait of the early 1770s shows her with crayon-holder in hand.

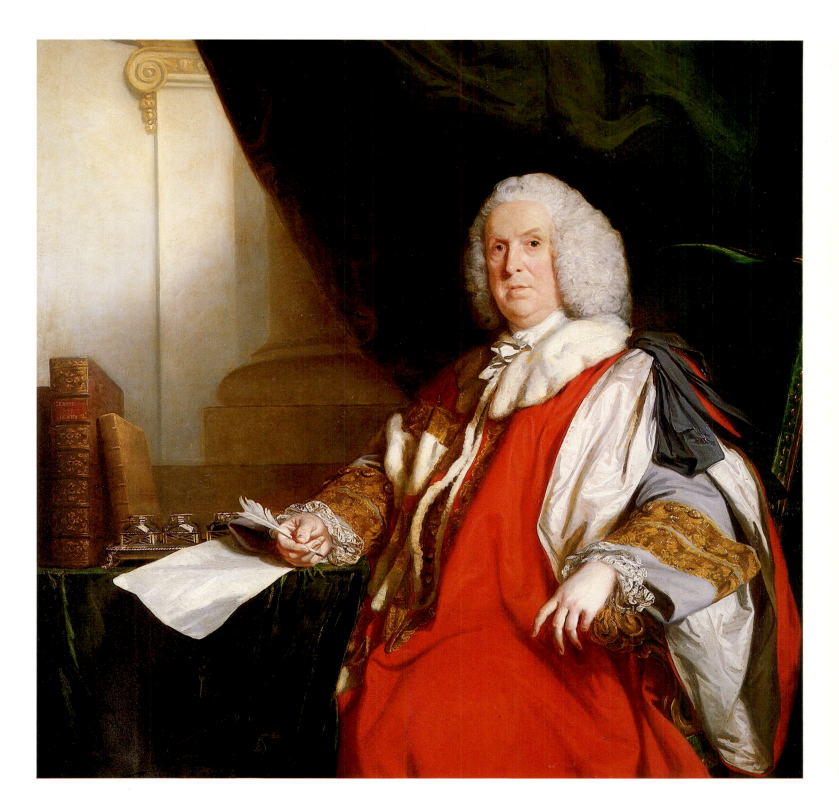

WILLIAM PULTENEY, 1st EARL OF BATH 1684–1764
Oil on canvas, 154.9 × 147.3 (61 × 58)
By Sir Joshua Reynolds, inscribed, 1761 (337)

A celebrated orator and Member of Parliament for Middlesex, William Pulteney took an active part in politics over more than forty years. He entered the Commons in 1705, and served under Sir Robert Walpole as Secretary for War (1714–17). However his political reputation dates from the breach of his friendship with Walpole in 1725 and the creation of a powerful opposition; with Wyndham, he formed the 'Patriots', a group of moderate Whigs and Jacobites opposed to the government's Hanoverian policy. His brilliant and astute Parliamentary assaults on Walpole were supported outside the House by a series of anti-government pamphlets and articles. Though he played a leading part in the final collapse of Walpole's administration in 1742, he refused to succeed him and, to the amazement of his contemporaries, he accepted a peerage a few months later.

A Fellow of the Royal Society and the friend of Addison and Steele, his gift lay in oratory, having 'arguments, wit and tears at his command'; but, 'naturally lazy' and 'formed by nature for social and convivial pleasures', he lacked steadfastness of purpose and balanced judgement. His avarice was legendary. Reynolds's portrait, showing him in his earl's parliamentary robes, was painted just a few years before his death in 1764.

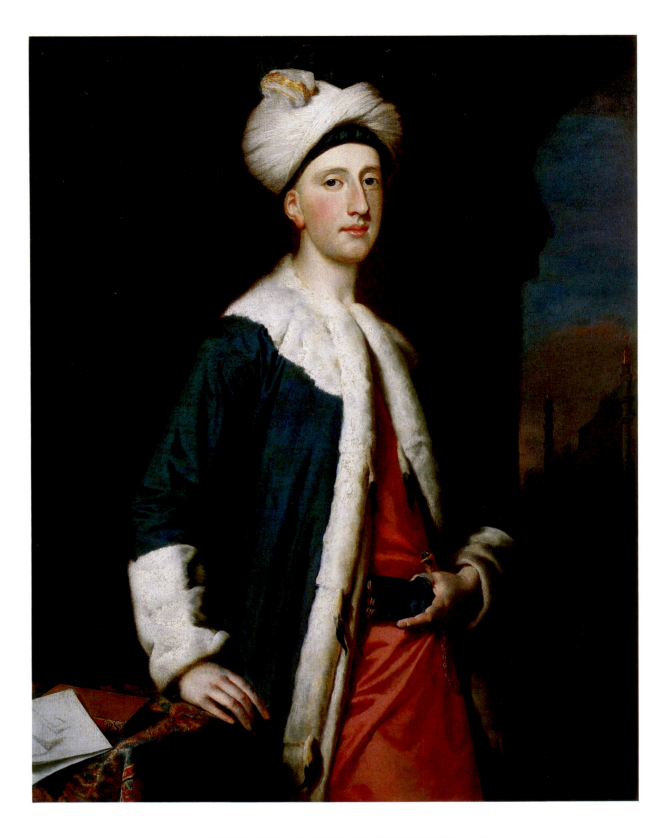

JOHN MONTAGU, 4th EARL OF SANDWICH 1718–92
Oil on canvas, 121.9 × 91.4 (48 × 36)
By Joseph Highmore, signed and dated 1740 (1977)

At the age of eleven Montagu inherited the Earldom of Sandwich from his grandfather; at nineteen he left on a prolonged Grand Tour to Italy, Greece, Constantinople, Smyrna and Egypt. On his return in 1740 he posed for several portraits wearing the same splendid oriental costume; this painting by Joseph Highmore includes a background view of Santa Sophia at Constantinople.

In 1748 he began the first of three terms as First Lord of the Admiralty and, with Admiral Anson's help, he successfully reformed the running of the Naval dockyards. But in later life he met with massive unpopularity, firstly for his part in the prosecution of his former friend John Wilkes in 1763, and then in the 1770s, during his last and longest term of office at the Admiralty, when he was attacked for bribery and for failing to have sufficient ships ready at the outbreak of war with France in 1778. Many senior naval officers refused to accept a command while he remained at the Admiralty. It was said of the Earl: 'Too infamous to have a friend, Too bad for men to commend'. No public man of his century was the mark of such bitter, violent invective.

THE NATIONAL PORTRAIT GALLERY
AT
BODELWYDDAN CASTLE, NORTH WALES

Bodelwyddan Castle, near St Asaph in Clwyd, North Wales, is the National Portrait Gallery's Victorian outstation, and opened in July 1988. The Castle was formerly the home of the Williams family, baronets of Bodelwyddan, who acquired in the late seventeenth century what was originally a house dating from the sixteenth century or earlier. The present castellated exterior results principally from work carried out in the 1830s by the architects Joseph Hansom and Edward Welch.

The Castle was acquired by Clwyd County Council in 1983, after over fifty years as a girls' school, and the National Portrait Gallery appointed the architect Roderick Gradidge to redesign and decorate the interiors in order to provide suitably flamboyant Victorian settings for its portraits.

The Gallery occupies two floors of the Castle. The ground floor rooms and a first floor bedroom are hung with portraits which reflect the varying periods of the rooms and their functions and decoration, and are grouped under appropriate themes. Thus the Billiard Room is hung with original *Vanity Fair* cartoons, mostly of sporting characters; the Ladies' Drawing Room houses paintings and drawings of notable women of the 1830s and 1840s as well as musical portraits; and the Library contains portraits of historians and scientists, as well as an interesting collection of miniatures.

Two rooms are devoted to particular artists: the Sculpture Gallery has a display of works by the North Wales sculptor John Gibson, some of which have been loaned by the Royal Academy. Watts's Hall of Fame is a corridor hung with twenty-six portraits of eminent Victorians by George Frederic Watts. The rooms also contain appropriate period furniture from the Clwyd County Council collection and on loan from the Victoria and Albert Museum.

The upstairs rooms are for the most part devoted to a simpler, museum style display, under themes such as Victorian Portraiture and the Victorian Art World. One room contains a changing display of Victorian photographs.

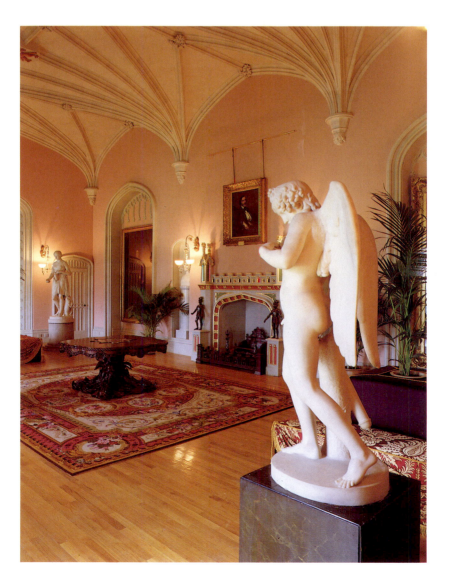

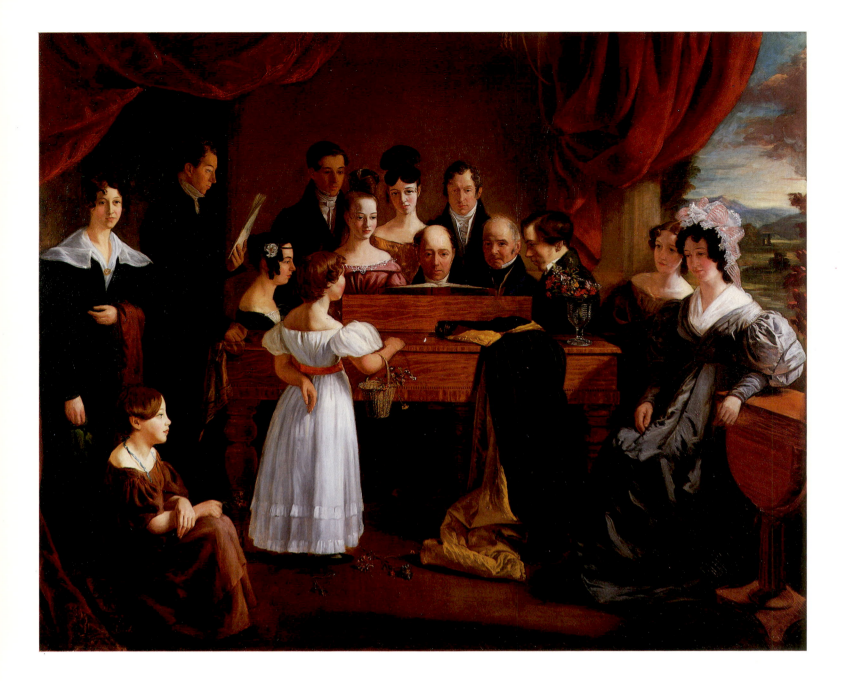

THE NOVELLO FAMILY
Oil on canvas, 146 × 184.7 (57½ × 72)
By Edward Novello, *c*.1830 (5686)

Vincent Novello (1781–1861) was organist, conductor, composer, editor and arranger of music. Born in London, of an Italian father and English mother, he became organist of the Portuguese Embassy Chapel at the age of sixteen. His success brought him an offer from George IV of a similar post at Brighton Pavilion, but he declined, owing to his numerous commitments in London. In 1811 he published a selection of music as performed at the Chapel, and this laid the foundation of the famous music publishing house of Novello and Co. In 1813 he became one of the founding members of the Philharmonic Society, and often officiated as pianist and conductor. His house in Oxford Street was the meeting place for many well-known figures in the world of arts and letters, including the writers Charles and Mary Lamb and the poets Keats and Shelley.

In this group portrait, painted by his son, Edward, he is shown seated at a square piano, surrounded by some of his eleven children. His wife, Mary Sabilla Hehl, sits on the far right, and his daughter Clara (1818–1908) stands at his right. Clara was one of the outstanding sopranos of the period, and was the original soprano soloist in Rossini's *Stabat Mater*.

THE ARCTIC COUNCIL DISCUSSING A PLAN OF SEARCH FOR SIR JOHN FRANKLIN

Oil on canvas, 117.5 × 183.3 (46¼ × 72⅛)
By Stephen Pearce, signed and dated 1851 (1208)

This group represents the officials, naval officers and explorers most active in the search for Sir John Franklin (1786–1847), whose expedition, consisting of two ships, had been sent out by the Admiralty in May 1845 to find a way through the North-West Passage from the Atlantic to the Pacific Ocean. The ships were last seen in July 1845 by a whaling ship in Baffin Bay, and by 1847 there was some anxiety about the fate of the expedition, and the Admiralty decided to organise a search. Three expeditions were sent in 1848 and more in 1850, but it was not until 1854 that it was discovered from evidence provided by Eskimos that the members of the expedition had died of starvation.

This group does not depict an actual meeting, nor, despite its title, an official body. It was commissioned by Colonel John Barrow, one of the secretaries at the Admiralty, to commemorate the various search efforts. The sitters include, third and fourth from left, Captain Edward Bird (1799–1881) and Sir James Clark Ross (1800–62), who led the first search party in 1848, and, sixth from left, John Barrow himself. In the background are portraits of Sir John Franklin and of his second in command Captain James FitzJames.

SIR FRANCIS BURDETT Bt 1770–1844
Oil on canvas, 250.2 × 143.5 (98½ × 56½)
By Sir Thomas Lawrence, *c.*1793 (3820)

Sir Francis Burdett was first elected in 1796, and served as Member of Parliament for Westminster from 1807–37. He was a vigorous advocate of parliamentary reform and an opponent of the wars with France, during which *Habeas Corpus* had been suspended, an action which Burdett condemned. He spoke against the practice of flogging in the army and against corruption in Parliament. He was twice imprisoned on political charges, first in 1810, when he was confined in the Tower of London, and then in 1820. He was

an active campaigner both for Catholic emancipation and the reform of the electoral system, and had the satisfaction of seeing both these measures carried through towards the end of his long Parliamentary career. He remained a Member of Parliament until his death in 1844.

This portrait forms one of a pair with a portrait by Lawrence of Sophia Coutts, Lady Burdett, who married Sir Francis in 1793, the year the portraits were begun.

ANGELA GEORGINA BURDETT-COUTTS, BARONESS BURDETT-COUTTS 1814–1906
Watercolour on ivory, 41.9 × 29.2 (16½ × 11½)
By Sir William Charles Ross, *c.*1847 (2057)

The daughter of the politician Sir Francis Burdett (p.242), she took the additional name of Coutts in 1837, when she inherited the property and share in Coutts Bank of her maternal grandfather, Thomas Coutts. Known as 'the richest heiress in all England', she not only took an active interest in the family banking business of Coutts, but also worked keenly to improve the working conditions of women, children and animals. She was also concerned with practical ways of improving poor economies abroad, and took a close interest in, among other projects, the Irish fishing industry and the cotton industry of South Nigeria. The friend of many distinguished figures in England and abroad, including the royal family and several Prime Ministers, she was raised to the peerage in 1871.

The large size and detailed treatment of this miniature is characteristic of the miniatures of the early Victorian period, just before the increasing availability of photography ensured miniature painting's virtual demise. Sir William Ross, miniature painter to Queen Victoria, was one of the leading practitioners of the art.

HENRY FAWCETT 1833–84 AND DAME MILLICENT GARRETT FAWCETT 1847–1929
Oil on canvas, 108.6 × 83.8 (42¾ × 33)
By Ford Madox Brown, signed and dated 1872 (1603)

As a young man, in 1858, Henry Fawcett was blinded in a shooting accident. Despite this disability he had a distinguished career: as professor of political economy at Cambridge (1863–84), and as a Member of Parliament, active in the passing of the 1867 Reform Bill. He was particularly concerned with the position of women in employment. Fawcett married Millicent Garrett in 1867. A leading feminist, she was an active campaigner for women's suffrage and joined the first women's suffrage committee in the year of her marriage, making the first public speech on the subject in 1868. In 1897 she became president of the influential National Union of Women's Suffrage Societies, which opposed the more militant suffragettes active in the early 1900s. She retired from the presidency after women gained their first, restricted, voting rights in 1918.

This portrait is a late work by Ford Madox Brown, the close associate of the Pre-Raphaelites, and one of a small number of portraits by him. Its informal composition admirably depicts the close relationship between husband and wife.

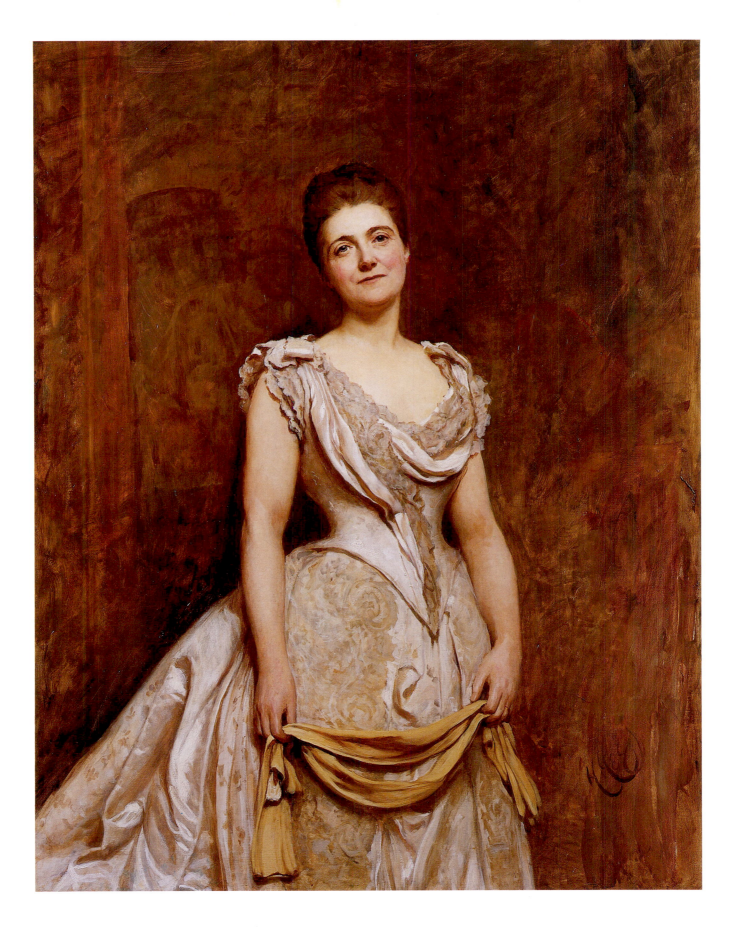

EMILIA FRANCES STRONG, LADY DILKE 1840–1904
Oil on canvas, 139.7 × 109.2 (55 × 43)
By Sir Hubert von Herkomer, signed and dated 1887 (5228)

Both an art historian and a feminist, Lady Dilke studied at the South Kensington Art Schools. She published numerous works on French art and a study of her contemporary Lord Leighton. Lady Dilke was also actively involved in movements for reforming the conditions of working women and for women's suffrage; as a member of the women's Trade Union League she attended the Trades Union Congresses 1884–1904. Her husband, the politician Sir Charles Dilke, was in 1885 cited in a notorious divorce case, which brought his political career to an end, but Lady Dilke remained loyal to him.

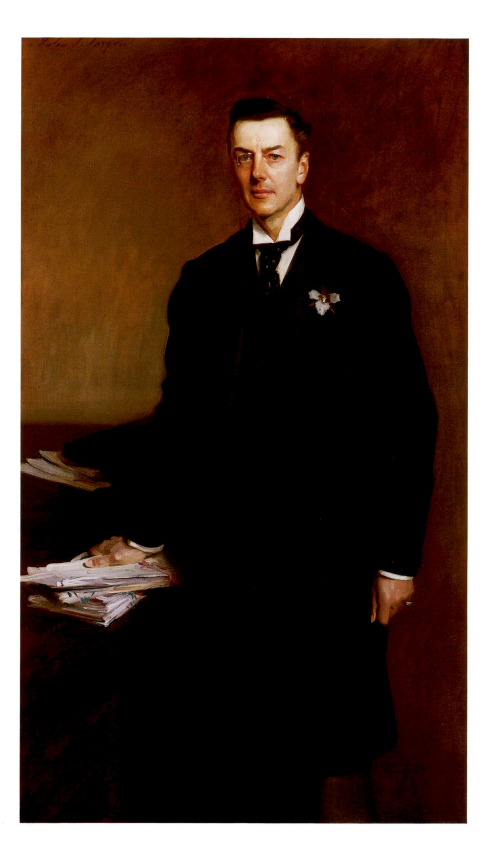

JOSEPH CHAMBERLAIN 1836–1914
Oil on canvas, 161.9 × 91.4 (63¾ × 36)
By John Singer Sargent, signed and dated 1896 (4030)

An ardent social reformer, Chamberlain began his political career as mayor of Birmingham (1873–5), where he helped to bring about improvements in housing and sanitation. He was president of the Board of Trade in Gladstone's second cabinet (1880–5), and although out of sympathy with most of his political colleagues, as well as offending Queen Victoria by the violence of his language, he managed to carry through a number of reforms. He resigned from the cabinet in 1886 over the issue of home rule for Ireland, but was subsequently a vigorous Secretary of State for the Colonies under Lord Salisbury (1895–1903), though, despite his conciliatory efforts, his period of office saw the outbreak of the Boer War. Chamberlain visited South Africa when it was over, in 1902, the first Secretary of State to do so. Convinced of the need for closer imperial union, which he thought would be achieved by commercial union, Chamberlain then resigned, and campaigned energetically for tariff reform, instead of the free trade he had earlier espoused.

Index of Sitters and Artists

Names of painters or photographers are given in italics, names of sitters in roman.